The Permanent Crisis

Film Theory in Media History explores the epistemological and theoretical foundations of the study of film through texts by classical authors as well as anthologies and monographs on key issues and developments in film theory. Adopting a historical perspective, but with a firm eye to the further development of the field, the series provides a platform for ground-breaking new research into film theory and media history and features high-profile editorial projects that offer resources for teaching and scholarship. Combining the book form with open access online publishing the series reaches the broadest possible audience of scholars, students, and other readers with a passion for film and theory.

Series editors: Prof. dr. Vinzenz Hediger (Goethe Universität, Frankfurt am Main), dr. Trond Lundemo (Stockholm University), and prof. dr. Weihong Bao (Berkeley, University of California)

Advisory board: Prof. dr. Dudley Andrew (Yale University), prof. dr. Ray Raymond (CNRS Paris), prof. dr. Chris Berry (Goldsmiths, University of London), prof. dr. Francesco Casetti (Università Cattolica del Sacro Cuore, Milano, Yale University), prof. dr. Thomas Elsaesser (Universiteit van Amsterdam), prof. dr. Jane Gaines (Columbia University and Duke University), prof. dr. André Gaudreault (University of Montréal), prof. dr. Gertrud Koch (Free University of Berlin), prof. dr. John Mac (Yale University), prof. dr. Markus Nornes (University of Michigan), prof. dr. Patricia Pisters (Universiteit van Amsterdam), prof. dr. Leonardo Quaresima (University of Udine), prof. dr. David Rodowick (Harvard University), prof. dr. Philip Rosen (Brown University), prof. dr. Petr Szczepanik (Masaryk University, Brno), prof. dr. Brian Winston (Lincoln University)

Film Theory in Media History is published in cooperation with the Permanent Seminar for the History of Film Theories.

The Permanent Crisis of Film Criticism

The Anxiety of Authority

Mattias Frey

Amsterdam University Press

This book is published in print and online through the online OAPEN library (www.oapen.org).

OAPEN (Open Access Publishing in European Networks) is a collaborative initiative to develop and implement a sustainable Open Access publication model for academic books in the Humanities and Social Sciences. The OAPEN Library aims to improve the visibility and usability of high quality academic research by aggregating peer reviewed Open Access publications from across Europe.

Cover illustration: From *Speak Easily* (1932), courtesy of Everett Collection / Rex Features.

Cover design: Suzan Beijer, Amersfoort
Lay-out: JAPES, Amsterdam

Amsterdam University Press English-language titles are distributed in the US and Canada by the University of Chicago Press.

ISBN 978 90 8964 717 7
e-ISBN 978 90 4852 447 1
NUR 670

Printed and bound by CPI Group (UK) Ltd, Croydon, CR0 4YY

To the permanent memory of my father

Table of Contents

Acknowledgements

I would like to thank series editors Vinzenz Hediger, Trond Lundemo, and Weihong Bao as well as the anonymous reviewer for their enthusiasm for this project and their expert comments on the manuscript. I extend my gratitude to Jeroen Sondervan and the Amsterdam University Press team for their professionalism and efficiency.

Colleagues at the University of Kent were instrumental to the development of this work. In particular, I thank the members of the Cultural Criticism research group and the Centre for the Interdisciplinary Study of Film and the Moving Image co-directors Cecilia Sayad, Peter Stanfield, Antonio Lázaro-Reboll, and Núria Triana-Toribio. The students in my Film Criticism module inspired me with their inquisitive appreciation of the subject.

My family and friends provided support, nourishment, and welcome distraction as I researched and wrote; I cannot thank them enough. I dedicate this book to the permanent memory of my father: never a critic, always calm in a crisis, forever admired, revered, and beloved.

In this book all translations are mine unless otherwise noted. Earlier and different versions of Chapter 3 and Chapter 4 appeared respectively as "The Critical Question: Sight and Sound's Postwar Consolidation of Liberal Taste," *Screen* 54.2 (2013): 194-217 and "*Filmkritik*, with and without Italics: Kracauerism and its Limits in Postwar German Film Criticism," *New German Critique* 120 (2013): 85-110.

Introduction

The aims and status of arts and culture criticism are currently up for revision and under attack, according to a whole host of indicators. Numerous articles and academic monographs offer jeremiads on *The Crisis of Criticism* or mourn *The Death of the Critic*.[1] Regular symposia and conferences dwell on the many, sometimes prominent film journalists made redundant at newspapers, magazines, and other "old media" in past years;[2] Sean P. Means lists 55 American movie critics who lost their jobs between 2006 and 2009 as pithy obituaries of the profession.[3] The reasons provided to explain the current situation include the worldwide recession and, more fundamentally, reluctant and increasingly apathetic consumers of print media. These developments have brought forth serious questions about the purpose and worth of criticism in the age of WordPress blogospheres and a perceived democratization of criticism.

Gerald Peary's 2009 documentary *For the Love of Movies: The History of American Film Criticism* is a disaster movie; it begins with the following epigraph over a black screen: "Today, film criticism is a profession under siege. According to VARIETY, 28 reviewers have lost their jobs in the last several years." Peary is referring to the trade paper's contemporaneous article, which asked, "Are Film Critics Really Needed Anymore ... Or Is It a Washed-Up Profession?"[4] But it is not only industry insiders – long antagonistic or sceptical towards criticism in the mainstream press – who are posing earnest questions.[5] All critics today, according to historian Raymond J. Haberski, "believe that the movies are in a state of crisis"; this is because "a public debate over art no longer exists."[6] In October 2008, *Sight and Sound* devoted its title article to the necessity and use of critics.[7] Although criticism has from time to time "enjoyed its teeth-baring and wound-licking moments of 'crisis,'" editor-in-chief Nick James writes, "this time there is real pain."[8] Among the many, perhaps insurmountable and irreversible challenges James lists include the free access to reviews from established sources on the internet, the "army of [unpaid] opinionated bloggers," the falls in print advertising and readership, and distributors' willingness to bypass reviewers altogether.[9] Worst of all, James concludes, is the new generation's attitude towards analysis and, even, the truth: "The culture prefers, it seems, the sponsored slogan to judicious assessment."[10]

More or less simultaneously, the American *Cineaste* magazine published a dossier on "Film Criticism in the Age of the Internet," which covered similar ground.[11] Although attempting to provide a "neutral" dialogue between print and internet critics and "put to rest some of the hoarier accusations [...] that Internet criticism is

riddled with amateurs who are diluting once-vibrant standards," the editors admit that the changes to criticism are irrevocable: "We are now – unavoidably – part of a hybrid landscape and can only hope that good criticism will prevail over bad in both magazines and the Internet."[12]

Elsewhere, I argue that the debates around film criticism in the digital age revolve around the following questions:[13] How have the new media altered the purpose of criticism? Should evaluation be a function of criticism, or even its principle aim? What should be the nature of the relationship between the critic and his or her audience? How have the new media changed film criticism as an activity and form? How have new media transformed film criticism as a profession and institution? Has criticism become more "democratic"?

Nevertheless, all of these overlapping and interlocking questions – which pertain to economic, institutional, professional, aesthetic, cultural, and other concerns – can be more or less reduced to the one that has been asked and answered most widely and heatedly. It regards the role of the critic in the public sphere (the authoritative critic vs. a democratic plurality of voices) and can be encapsulated in the demand: Today, who is entitled to speak about film and in what way? Although some internet utopians have responded to this question with a celebration of the new democracy to compose criticism and universal access to consume it, among professional critics and academics the overwhelming and most vocal stance – as the initial quotations above have demonstrated – has been to argue that in the digital age critics have lost their traditional authority to speak and be heard by the public: the critic, several prominent commentators have concluded, is dead.

Despite the existential urgency and brave-new-world rhetoric underpinning the debate, these "new media" problems are hardly without precedent. The history of film criticism and moments of self-reflection and crisis in the face of perceived threats to the profession reveal the roots to these problems and also serve as productive examples to contextualize and confront what initially appears to be a new challenge. Specifically, this project examines historical discourses of crisis in film criticism in order to understand the current crisis and intervene in the contemporary debate over the role of the critic in the digital age. This book reveals how the discourse of crisis is hardly new; indeed, it has been endemic in criticism since the earliest professional film critics. The need to assert critical authority, and the anxieties over challenges to that authority, are longstanding tropes; they have, I argue, animated and choreographed the trajectory of international film criticism since its origins.

The Death of the Critic?

Before defining critical authority and proposing my own approach and contribution to this debate, I first need to outline the major works that I set out to contest. To understand how professional critics have responded to the question of the new role

of the critic in the public sphere, let us examine a 2007 *Film Ireland* article entitled "The Critic is Dead ... ," one that has been cited by other critics as an instrumental programmatic piece.[14] Jasmina Kallay argues that, in the age of the digital, film critics no longer have the ability to decisively shape taste and have also lost their traditional power to "make or break" a film. "Printed opinion has lost its hold," Kallay claims, "and the plethora of individuals proffering their two-pence worth in blogs means we are no longer governed by a hierarchy within which a select few opinion-makers shape views and attitudes."[15] Indeed, Kallay writes, referring to Mark Dery's book on cyberculture discourses, we now live in a world unmediated by respected authorities and trusted experts: "In this climate of co-creation," in which the roles of critic and audience are reversible and interchangeable, "the average internet user is more likely to post his/her opinion before seeking out a more qualified criticism."[16] Citing special "press" screenings for bloggers and the frequent lists of the Top 1000 movies or "films to see before you die," Kallay argues that such phenomena are, in the first instance, evidence of the print critic's growing irrelevance to the industry and audiences and, in the second instance, "a last ditch attempt to exert some ever-diminishing authority."[17] Seen symptomatically, these examples show that the critic – if not dead – is critically ill: "The simple lesson to be gleaned from this case in point is that the film reviewer's influence is firmly on the wane and powerless."[18]

The rhetoric of crisis and death in Kallay's journalistic squib is similar to that employed in the academic discourse and indeed in the most comprehensive recent scholarly work addressing this debate. In *The Death of the Critic*, Rónán McDonald proposes a historical process by which criticism has come to be devalued as a social good and the critic's status in the public sphere has diminished. He mourns the end of a particular kind of criticism and how the role of the critic has shifted from mediator, "a figure to whom a wide audience might look as a judge of quality or a guide to meaning," to a marionette who "confirms and assuages their prejudices and inclinations rather than challenging them."[19] Specifically, he defends the need for "public critics" along the lines of Lionel Trilling, Pauline Kael, or Susan Sontag, who, McDonald posits, no longer have a place in contemporary media and society. In this regard, McDonald echoes earlier commentators. Already in 1984, Terry Eagleton diagnosed a "crisis of criticism" and argued that, "in a period in which, with the decline of the public sphere, the traditional authority of criticism has been called into serious question, a reaffirmation of that authority is urgently needed."[20] McDonald's assessment also resounds with Maurice Berger's collection of prominent critics' essays on *The Crisis of Criticism* from 1998: "now the critic is often expendable in the process of determining what is good art and what is bad art"; Berger is quite clear that "the critic has lost his or her aura of respect."[21]

Unlike Berger, however, McDonald pinpoints what he believes to be the origins and historical caesura of the "crisis" in criticism. Although he sketches a history of arts criticism from the earliest articulations of modern aesthetics with Baumgarten, Hume, and Kant through Coleridge, Hazlitt, and Arnold, the major focus lies on what

McDonald (quoting Martin Amis) refers to as the "age of criticism" (1948 to the early 1970s) and on the prominent, neo-Arnoldian figures such as F.R. Leavis and Lionel Trilling.[22] Nostalgic for this period, in which critical writing was more or less indistinguishable between learned journals and broadsheets, McDonald maintains that the end of the era also signalled the end of an authoritative, public criticism: in other words, the "death of the critic." From this point on – and paradoxically at a time when student numbers were surging and pop culture was becoming a more acceptable object of inquiry at universities – scholarly and journalistic criticism began to diverge and the public imagination became "immune to issues and debates" in academia.[23] Rather than more bloggers and a further atomization or "democratization" of critical writing, McDonald asserts, the public wants recognized, erudite, authoritative critics in an Arnoldian vein who are able to challenge prevailing tastes and communicate to a wide audience.[24]

Raymond J. Haberski's narrative of American film criticism strikingly resembles McDonald's death of the critic. *It's Only a Movie! Films and Critics in American Culture* presents a sprawling survey of American film culture and a synopsis of the country's film critics. His appraisal introduces "a series of case studies of the gradual inclusion of movies as art and what that development did to the cultural authority of critics."[25] He chronicles debates about the aesthetic value of cinema; *Cahiers du cinéma* and the American "auteur theory"; the establishment of the New York Film Festival and the American Film Institute; New Hollywood and the rise of film-school directors. In so doing he charts a familiar rise of film as art, a brief "golden age of criticism" and "heroic age of moviegoing" until the early 1970s, and then a subsequent fall of criticism that Haberski blames for the loss of authority once held by prominent critics such as Pauline Kael and Andrew Sarris.[26] Leading a charge against film scholars, who "attempt to fit commonplace occurrences into large methodological schemes," and "champions of populist criticism" alike, Haberski claims that this decline of authority has meant that the role of the critic has become "polarized into the twin camps of academia and irrelevance."[27] The "democratization of criticism" associated with blogs, Twitter, and the current crisis, Haberski claims, have "undermined the national conversation over the meaning of culture."[28] Today we live in a world experiencing "a general waning of interest among the most recent generation of moviegoers who replaced the faith of their parents with a sense of apathy."[29] Because of the decline of critical authority, the "meaning of culture has fractured into parts that no longer need to be defined with a common culture."[30] Like McDonald, Haberski advocates a return of "influential" public critics such as Kael and Sarris: "Without something to fight against – such as the cultural authority of critics – there remains little reason to get excited."[31]

In sum, Kallay, McDonald, and Haberski represent variations on the most vocal theme in recent theoretical questions about arts criticism: the internet's plurality of interchangeable opinions must be combatted with authoritative critics committed to artistic evaluation and (more or less Arnoldian) public engagement. A remarkable

aspect of their responses is the extent to which they echo traditional discourses about the state of the public sphere. Indeed, the commentators nearly always service what scholar Alan McKee calls the "five major themes" common to concerns about the public sphere: that it is too trivialized, commercialized, spectacular, and fragmented, and that it has caused citizens to become too apathetic.[32] In particular and above all, discussions of the "death of the critic" rehearse cultural anxieties over "trivialization/dumbing down" and the "fragmentation/atomization" of culture. Before moving to my own approach to the question of film critics' perceived loss of critical authority, I need to examine more closely how this rhetoric informs the debate.

According to sociologist Herbert J. Gans, the "dumbing-down" thesis "can suggest that the culture being supplied is less sophisticated or complicated, or tasteful, or thoughtful, or statusful than a past one," although sometimes it is also employed to describe the audiences being addressed, "who are thought to have declined in taste, intelligence, and status."[33] The "dumbing-down" thesis is frequently employed to express disapproval of "blockbuster" exhibitions by venerable museums or when public television channels replace documentaries and foreign films with popular music programmes. Its basic patterns, occasionally conflated with the "commercialization" argument, inform much of the "crisis of criticism" debate. Examples abound, from Terry Eagleton's remarks that criticism is today a corporate "part of the public relations branch," to Nick James's assertion that "the sponsored slogan" has replaced considered assessment, to Armond White's polemics about "Internetters" who "express their 'expertise,' which essentially is either their contempt or idiocy about films, filmmakers, or professional critics."[34] Indeed, following White, a major iteration of this critique suggests that today's "critics" are not educated professionals at all, but rather prejudiced self-promoters parachuted in from other walks of life, comparable to reality TV stars and more versed in the teachings of Kim Kardashian than interested in the artistic value of Jean Renoir or Michelangelo Antonioni. McDonald, in a more elegant articulation of this sentiment, places the shibboleth between the public "critic" (who represents an endangered, if not extinct breed today), and the mere "reviewer," of which there is no dearth.[35]

The second common anxiety about the public sphere, the "atomization/fragmentation" argument, follows from the first. It causes Eagleton to claim that "criticism today lacks all substantive social function" because of a "disintegration of the classical public sphere" and an "increasingly fragmented and uneven" audience; McDonald argues for the return of authoritative, public intellectuals whose pronouncements will guide the reader and find a common artistic heritage of quality.[36] One key to understanding McDonald's arguments for an authoritative critic (and which also accounts for White's outburst above) has to do specifically with unease about the position of intellectuals vis-à-vis popular culture and the public sphere. Andrew Ross has investigated this rhetoric in his book *No Respect* and showed, via historical analysis, the shifting and often awkward constellations by which this relationship has been negotiated.[37] Nevertheless, the second half of McDonald's argument, about the role

of uniting the public behind a tradition of quality arts and letters, is perhaps more telling. Indeed, Alan McKee has shown how common this language is. "Too much choice" and the "increasing numbers of niche audiences, more television channels, radio channels, magazines and Internet sites mean," in the eyes of these commentators, "that the public is no longer coherent."[38] Such journalists and scholars worry that abandoning the idea of a single public sphere means losing "the idea of a common interest in all people," which would entail an "irretrievable loss."[39] These thoughts also echo the opponents of cultural studies, who mourn the loss of canons, which they see as cohesive forces that unite the humanities behind common objects of appreciation.[40] As McKee argues, however, "the public sphere has *always* been fragmented."[41] Even Jürgen Habermas, whose pronouncements on the subject are still considered definitive, notes "the coexistence of competing public spheres [...] from the very beginning."[42] Niche public spheres inflected by different classes, ethnicities, genders, political beliefs, geographical locations, and leisure activities have existed for at least two hundred years; broadcast media have simply made these distinct spheres accessible to others.[43]

From Monocultural Downfall to International Crisis History

The previous section telegraphed and dissected the current conventional views on the role of the critic and his or her supposed loss of authority, but also anticipated my own position within these debates. This book challenges Haberski's and McDonald's findings and scrutinizes their nostalgic tone by arguing that the narrative of "past authority" and "present democratization/anarchy of criticism" is a fallacy. My research demonstrates that, much in the way that current commentators avail themselves of persistent tropes about the dumbing-down or fragmentation of the public sphere, the current "crisis" and perception of lost authority picks up on traditional themes. Focused in scope to examine the domain of film criticism, it shows that this crisis is in fact not new, but rather an iteration (this time precipitated by a certain development in technology) of an old motif: critics' longstanding desire for cultural recognition and the fear over the loss, dumbing-down, or democratic liberation of authority.

While endless meta-journalistic squibs have touched on the issue and some recent studies have attempted to bring film criticism back onto the agenda of academic film studies,[44] the debates around the current crisis of critical authority have not been thoroughly contextualized with and interrogated by examples from the history of international film culture. How has the status of the critic and the relationship between the critic and the audience been at stake, in crisis, and subject to revision in the past? How can prior perceived crises of authority and "democratic" developments in film culture illuminate the current one and help us solve or at least resolve it?

This book addresses these questions by examining how critics have conceptualized and understood their purpose and role in film culture. Specifically, it explores the

ways in which they have – at crucial junctures in the history of film culture – directly or indirectly responded to perceived crises of authority, whether these crises ostensibly came in the form of, for example, an impasse in terms of how: to justify the cultural respectability of the profession and its object (i.e. film); to form an authoritative relationship with readers and the industry; to deal with the perceived diversification or fragmentation of their audience; to meet the challenges of rival critics and of recalcitrant readers; to exert influence; and to master media and technological changes.

These historical examples serve to show that the perception of a crisis of authority in film criticism is not a unique phenomenon. Indeed, this book demonstrates that such rhetoric has long been and remains the *sine qua non* of this mode of writing. Anxieties about the status of critical authority have come to the fore in response to various triggers – be they new developments in filmmaking and film culture (such as the *nouvelle vague* or the "blockbuster"), renegotiated relationships with readers (e.g. sophisticated cinephile audiences), or new channels of dissemination (institutional magazines, television, Twitter). At the same time, the rhetoric of crisis and its resolutions have also had larger effects or served grander agendas. These include: the search for radical or new purposes for critical writing; partisan taste-making and self-promotion or the erection of a canon; or a positioning vis-à-vis national institutions, culture, and the domestic cinema. Nevertheless, it has been present throughout. This fact – and thereby this book – is a challenge to nostalgic periodizations of criticism in the vein of Haberski, McDonald, Eagleton, or Berger, who seek to posit a healthy past and an ailing present of criticism and the role of the critic in society.

This project understands criticism as an act of communication and a potential critic-audience dialogue that takes place as part of the wider public sphere(s). In this, my methodology engages criticism via critics' writings and self-reflexive utterances, as well as with the understanding of members of the public who receive and respond to criticism. This method uses critical writing as a major primary source. This entails the careful consideration of historical examples of criticism (i.e. film periodicals, film magazines, trade papers, and the arts sections of mainstream daily and "quality" newspapers) and especially writings in which critics reflect on the (changing) purpose(s) of criticism, the role of the critic, and the relationship between critic and reader. In sum, this study endeavours to gain insights via an analysis of public and above all metacritical discourse. It covers some instructive, yet widely unknown episodes of international film criticism and scrutinizes other more familiar episodes in a new light.

The case studies focus on the leading film cultures of France, Germany, the United States, and Britain. These countries set the pace in reflecting on criticism and from the beginning sought to establish authority over its development; to this day these territories constitute four of the five largest markets for film.[45] Although it is clear that at some junctures certain other national cinemas or critics maintained influence, the ways in which these other film cultures were received, popularized, and

transposed by the hegemonic four (e.g. the French celebration of Italian neo-realism or the British and American reception of Soviet cinema and theory) should not be underestimated. To be sure, case studies charting developments in Japan, Sweden, Brazil, or other nations could also illuminate some of the issues under consideration here. Nevertheless, for the sake of coherence there are limits that need to be placed on any attempt to write history; there is a balance that must be struck along axes of breadth and depth. It is vital to pursue research that is international in scope and a major part of the present book pays attention to a variety of film cultures for this very reason: too many previous studies narrowly focus on discrete regards of a phenomenon that was from its very beginnings making transnational and often universalist claims and which has time and again been self-aware of international debates (see, for example, Chapters 3 and 4). This comparative project thus seeks a broader, stronger claim than single-nation studies. It challenges, too, the assertions of the "death of the critic" advocates, who base their claims on one linguistic tradition (in the case of McDonald: English) or one national film culture (e.g. Haberski).

Before previewing in depth the case studies that will follow this Introduction, it is essential to engage with two key concepts: to explain what I mean by "authority" and to outline how a "crisis history" may better explain – rather than the downfall narratives provided by McDonald or Haberski – the history of film criticism and put the current crisis into a more productive context.

Authority

The question of authority is vital for the critic: through its possession he or she is granted the legitimacy to describe, explain, elucidate, contextualize, and/or evaluate a certain cultural object or topic to a certain audience. It implies the quasi-contractual obligation for this audience to listen to, engage with, and ultimately respect the critic's pronouncements – not necessarily to agree with them, but to grant the critic the right to make them. For the purposes of this book, critical authority is a textual position that assumes the privilege to speak on a certain matter; the authority is asserted by critics and tacitly granted by their readers.

In this study we will see various interpretations of what authority might ultimately mean for critics in practice: an irreproachable, pedagogical distance or objectivity; the ability to influence filmmakers or the industry; the capacity to affect attendance numbers, box-office returns, or "make or break" a film ("short-term authority"); the power to define a film's cultural value and place in a canon ("long-term authority"). Nevertheless, according to Daniel G. Williams, questions "of position, of insiderness and outsiderness," are "central" to the study of critical authority (in his idiom "cultural authority").[46] Indeed, one of the primary factors of authority – again, based on a tacit contract between speaker and listener, writer and reader – is critics' relationship to their object, but above all to their audience.

How do critics come to possess authority? Many of these positionings are purely textual: that is, performed in words in a variety of ways, including exalting the object of critique, comparisons (or contrasts) to other arts, canon-building, references to legitimate critics from the past, and by many other means. We will also see examples about how this is achieved in the type, size, and look of a published printed page or in the format of magazines; in banding together in unions or associations; in representing a national-cultural institution or a publication of historical merit; and so on. Demonstrating these various assertions of authority will be an important part of this book.

The negotiation of a proper tone towards and relationship with the audience is a key matter in creating authority. In the next chapters we will see how some critics – such as Louis Delluc, Gilbert Seldes, some *Filmkritik* authors, and Pauline Kael – established legitimacy by reminding the reader of their shared experiences or worldview or by creating the appearance of their conspiracy against elites' tastes. Nevertheless, we will also see how film criticism began by assuming a tone and relationship reminiscent of the Enlightenment, Lessing, and Arnold; often challenged and out of style, this disinterested, pedagogical, "objective" means of establishing authority has nonetheless never truly disappeared. For this reason and as a means to preview the underlying issues of the crises of criticism in this book, let us very briefly outline Matthew Arnold's writings about the functions of culture and the critic in society. Although it is clear that Arnold was and is read more often in some national contexts (above all Britain, the United States, and the Anglophone world), whereas the traditions of Lessing and the Enlightenment are more specifically at the root of other cultures' understandings of "objective" didacticism, it is equally certain that Arnold remains perhaps the most influential and most alluded to in metacritical discussions and even in the latter cultures his ideas have consciously or unconsciously inflected basic understandings of criticism's purposes.

Writing at a time of perceived moral and social crisis (the waning of religious and aristocratic influence), Arnold proposed in *Culture and Anarchy* a way to counteract the malaise befalling the nation in the 1860s. Arnold noted that authority resides not in the halls of Parliament; rather it exists in the "fermenting mind of the nation; and his is for the next twenty years the real influence who can address himself to this."[47] In culture, Arnold argued, "we have got a much wanted principle, a principle of authority, to counteract the tendency to anarchy which seems to be threatening us."[48]

> The whole scope of the essay is to recommend culture as the great help out of our present difficulties; culture being a pursuit of our total perfection by means of getting to know, on all the matters which most concern us, the best which has been thought and said in the world; and through this knowledge, turning a stream of fresh and free thought upon our stock notions and habits, which we now follow staunchly but mechanically, vainly imagining that there is a virtue in following

them staunchly which makes up for the mischief of following them mechanically.[49]

Critics, in turn, had a vital role to play in this effort to bind society together with culture. It was their task to form the tastes that would determine which works would function as general culture: that is, what was "the best which has been thought and said in the world." For Arnold, the decisive question was therefore "how to organise this authority, or to what hands to entrust the wielding of it?"[50] This question would not only vex Arnold in the 1860s; indeed, it is the argument of my book that it has motivated film critical discourse since its origins.

Crisis History

I am not the first scholar to note the discourse of crisis surrounding criticism, nor am I the first to link crisis and criticism, as concepts, to one another. Crisis and criticism have been connected literally since ancient times: both derive etymologically from the Greek root word *krino*, which means to separate, select, decide, judge, size up, clash, or fight.[51] Over the years, many scholars (albeit chiefly in the field of literature) have deliberated in one way or another about the conjuncture of criticism and crisis or, in the manner of today's film critics, proclaimed criticism to be in crisis. Exemplary works range from Alick West's *Crisis and Criticism* (1937) and Irshad-ul-Hasan's *Criticism in Crisis* (1992), to Paul Crosthwaite's recent collection on *Criticism, Crisis, and Contemporary Narrative: Textual Horizons in an Age of Risk*, among many other contributions.[52] In the early 1930s, Walter Benjamin and Bertolt Brecht – together with prominent film critics such as Herbert Ihering and Siegfried Kracauer – envisioned a journal entitled *Krise und Kritik*, whose topics would include the role of the critic and intellectual in a time of crisis in art, theory, and society.[53] This Weimar-era experiment speaks to a point in Paul de Man's 1967 essay on "Criticism and Crisis," which claims that "the notion of crisis and that of criticism are very closely linked, so much so that one could state that all true criticism occurs in a mode of crisis"; in periods where there is no crisis, "there can be no criticism."[54] These essential associations lead Paul Crosthwaite to conclude that the "history of modern thought might, then, be best narrated as a history of attempts to register and amplify conditions of crisis in the pursuit of a radical renewal of the intellectual and social order."[55] In fact, historians such as Pitirim A. Sorokin, who conceive of the past as a chronicle of crises, have organized the history of ideas in such a way.[56]

Reinhart Koselleck is perhaps the most prominent historian to have posited a historical concept of crisis. In his monograph *Critique and Crisis* and other writings, moreover, he has linked crisis to criticism.[57] Koselleck describes how the Hippocratic School used *krino* to refer to "the critical stage of an illness in which the struggle between life and death was played out, where a verdict was pending but had not yet arrived."[58] By the eighteenth century, the word was being used in a metaphorical

sense – for example, by Rousseau – to describe the state of a nation.[59] Today, crisis "indicates uncertainty, suffering, an ordeal, and suggests an unknown future"; its use has become inflated and "anyone who opens a newspaper" can find references to it.[60] Despite – or perhaps precisely because of – its widespread currency, crisis, for Koselleck, has become a powerful and fundamental historiographical paradigm that:

> ushered in the claim to interpret the entire course of history from a particular point in time. Since then it has always been one's point in time that is experienced as critical. And reflection of one's temporal circumstances not only arrays the entire past for judgement, but displays the future for prognosis as well.[61]

Koselleck outlines three semantic models for how crisis functions as a way to interpret history. First, "history can be interpreted as a continual crisis." In this mode, Koselleck explains, citing Schiller and alluding to Hegel, "world history is world judgement [...] every situation is stamped with the same decisive earnestness [...] everyone faces the consequences of his actions."[62] This semantic model is also the one that Zygmunt Bauman uses to claim that "crisis, in as far as the notion refers to the invalidation of customary ways and means and the resulting lack of certainty as to how to go on, is the normal state of human society."[63]

Second, crisis "can designate another singular accelerating type of process, in which conflicts burst open an existing system; following the crisis the system reconstitutes itself in a new set of circumstances." This is a notion of crisis as "historical watershed," the passing of an epoch, a process that repeats again and again. The modern notion of economic crisis is an example:

> crisis appears when the equilibrium between supply and demand, between production and consumption, between the circulation of money and the circulation of goods, is disturbed; when this happens recession and the slide down the economic scale are said to become visible everywhere. Yet it is held as a law of experience that a general rise in productivity follows a recession induced by a crisis.[64]

Third, according to Koselleck, crisis "can suggest the last crisis within a prevailing historical moment." This model of crisis is future-oriented, utopian, and gestures towards a final resolution of conflict.[65] One example of this concept of history is the biblical idea of the Last Judgement. The Marxist notion of a final crisis of capitalism leading to the end of class differences and a utopian future represents another iteration of this historiography.[66]

These three notions of crisis can be isolated theoretically but, in the practice of historical discourse, Koselleck maintains, are never pure and often come in tangled, bundled, or overlapping forms.[67] Indeed, in describing the crisis of film criticism – and clarifying which conceptual notions of "crisis" it may underlie – we must be care-

ful about defining it while at the same time acknowledging how these meanings slide and shift over time and even within individual episodes. For example, in the present crisis, evidently triggered by technologies such as blogs and Twitter, the "death of the critic" commentators would view the situation as in Koselleck's second model – that of a historical watershed, an end of an era by which a rose-tinted past ("golden age of criticism") is contrasted with the present calamity and uncertain future. Other, more utopian commentators (internet democrats/anarchists) might interpret it as an instance of the third model: new social media and online criticism function as a final crisis and resolution of authority (because of its eradication) in an epoch where "everyone can be a critic." For these commentators, crisis is eschatological.

The crises under scrutiny in this book may subscribe, depending on perspective, to all three models in an interconnected fashion. It is true that in every case under discussion, some commentators saw the challenges to their authority as an existential dilemma that needed to be identified and resolved. Crises, as Crosthwaite reminds us,

> are discursive phenomena, and there is invariably a strategic element to invocations of the language of crisis, whether this be as a means of engendering fear, stifling dissent, and consolidating hegemonic power structures, or, conversely, of mobilizing disaffection, laying bare societal divisions, and agitating for radical change.[68]

Nevertheless, my examination of film critical discourse argues that, as a historical narrative, it exemplifies the first concept of a crisis history: a "continual," permanent crisis. Nina Witoszek and Lars Trägårdh have written that crisis "is always a déjà vu experience; it invokes the memory of past imbroglios, solutions, and failures and exhumes authoritative narratives that prompt a community what to feel and how to respond to new challenges."[69] I would submit, however, that in the case of film critical discourse precisely this sort of retrospection has not occurred; the "death of the critic" commentators, even when they employ historical approaches, have failed to invoke the memory of prior crises in order to understand the present anxieties. Koselleck notes that in every instance where "crisis is expected to utterly change the world, the expectation is easily exposed as an illusion of perspective."[70] This, indeed, is my view towards both the "death of the critic" commentators and the internet democrats: "It is characteristic of the finitude of all human beings," Koselleck elaborates, "to regard their own situation as more important and more serious than all of the crises that have actually taken place."[71] An approach that sees film critical discourse as an episodic history of permanent crisis – rather than as a unique contemporary event that marks a singular, "final crisis" or as a steady downfall – is therefore the most appropriate historiographical model.

The Permanent Crisis of Film Criticism: Chapter Summaries

The remainder of this book is arranged as a chronological series of historical case studies and a final chapter and conclusion that deal directly with the contemporary scene. Dealing with both individual critics and critical institutions, these historical episodes unearth the key moments in the course of film criticism where authority was especially at stake, under duress, and in a perceived crisis; these specific pressure points, I submit, best illuminate and contextualize the current impasse and debate.

Chapters 1 and 2 examine the crisis of early film criticism and illustrate how the concerns and anxieties about critical authority preview to a large extent all subsequent crises, including today's "death of the critic" discourse. In order to establish film criticism as a legitimate activity, writers needed to advocate the cultural respectability of film as a medium, gain access to mainstream periodicals, and create their own outlets. Rather than a consensual procession towards a definition of film as an art and easy attainment of authority, critics engaged in a messy dispute, Chapter 1 reveals, with complex and shifting fronts that included the need to both compare and contrast the medium to other arts, erect standards and police bad practice, and develop unique methods. Even after these initial goals were more or less achieved and film criticism began appearing regularly in mainstream dailies and weeklies and in arts and culture periodicals in the 1920s, Chapter 2 demonstrates, critics were tasked with maintaining influence with but also asserting their authority over the industry and negotiating complex regimes of proximity and distance to readers – an especial challenge because of film's diverse audiences and unique status as a "democratic art." Examining French, German, British, and US critics, these chapters show that a crisis of authority was a professional concern *internationally* from the beginning. This complicates McDonald's and Haberski's histories of criticism.

Once film critics had established their right to exist on arts pages and postwar film culture began to flourish, practitioners were faced with a renewed challenge to their authority: sophisticated arthouse audiences. Chapters 3 and 4 chronicle the crises of authority that followed the successful institutionalization of criticism in the form of cinephile magazines and the "democratic" challenge posed by a reinvigorated French film culture and *Cahiers du cinéma*'s breezy styles and brash assertions. The two chapters examine the unique responses of the leading film journals in Britain (*Sight and Sound*, the most important Anglophone specialist film magazine) and the Federal Republic of Germany (*Filmkritik*, which, at the time, was the Western world's second-most subscribed to cinema periodical). These comparative, institution-based accounts examine how each journal respectively perceived and resolved the postwar crisis of authority and furthermore used the challenge of French film culture to renegotiate their own relationship to developments in their countries. In Britain, *Sight and Sound*'s institutional remit and imperatives led, Chapter 3 demonstrates, to an appeal to "English" traditions and to a broad-church, liberal repositioning of the magazine. In this way, the British Film Institute organ sought to accommodate young

dissenting voices and yet still assert a long-term authority to define canons, foregoing a subjective, political, or aesthetic criticism in favour of a light-touch pedagogy that could service the associated arms (National Film Theatre, National Film Archive, London Film Festival) and larger aims of the organization. In turn, Chapter 4 shows how the dark German history inflected *Filmkritik*'s response to the French and the domestic cinephile challenge. Initially using Siegfried Kracauer and his brand of ideological-symptomatic criticism as a legitimate model for their authority, *Filmkritik* transformed within a decade into a forum for subjective auteurism. *Cahiers du cinéma* provided some approaches, vocabularies, and inspiration for a transition in the magazine's style, perspective, and mediating role. In addition, however, the development allowed the German writers to conceive of and position their own national cinema and to form a more personal relationship with – but nonetheless stay ahead of – readers, who had largely internalized the Kracaueran methods and no longer needed critics' guidance.

Chapters 5 and 6 re-approach the current crisis of criticism. The many "death of the critic" commentators often describe an authoritative "golden age of criticism" in the 1960s and 1970s and a subsequent fall in the aftermath of this period, which witnessed the birth of the modern blockbuster and the rise of syndicated print and television criticism. In retrospective assessments – not only of film criticism, but also larger histories of criticism such as McDonald's *Death of the Critic* – this transition is seen as the demise of the public critic and the beginning of an anarchic, populist, and ultimately useless explosion of opinion. Chapter 5 challenges this view as a fallacy. Dissecting today's rosy memories of the "golden age" of US film criticism and in particular of the supposedly most influential critic ever, Pauline Kael, it contests the idea of critical influence – Kael's and otherwise – and deliberates on what today's myth-making about authority reveals. Chapter 6 picks up on these themes by surveying the current state of play and in particular critics' fears about democratic, dumbed-down online criticism. Using Rotten Tomatoes – the most popular "aggregate" film review site – as a case study, I show that, far from being radically democratic, such new media developments actually serve to *reinforce* traditional notions of authority. The Conclusion then returns to the notion of crisis and critical authority and asks: What is so good about authority and what do fears of its loss tell us about our cultural commentators?

1. The Birthing Pains of the First Professionals: Promotion and Distinction

As outlined in the Introduction, today's histories of film criticism chart a clear itinerary of rise and fall. Haberski, for example, argues that while "critics helped legitimize movies as art, the cultural authority that provided critics the power to do so waned."[1] This led, according to Haberski, to a steady decline of critic's authority; this trajectory was broken briefly during the "golden age of criticism" in the 1960s and 1970s only to continue to this day. In other words, the repositioning of film as an art – an early task of critics – precipitated a deterioration of their status that in turn has caused the present "spiritual crisis" of criticism, but also the lack of public debate about film and art in general.[2] Haberski sees in early film writings the last days before "cultural criticism gradually lost its relevance and critics grew powerless to distinguish art and artists from bogus products and hucksters."[3]

Haberski's utopian history of a paradise lost and found and a steady dumbing down resonates strongly with broader recent reckonings, such as McDonald's *Death of a Critic*. The latter argues that criticism, which in the early twentieth century supposedly represented a unified discourse, steadily fragmented into atomized niche commentators and audiences:

> the public critic has been dismembered by two opposing forces: the tendency of academic criticism to become increasingly inward-looking and non-evaluative, and the momentum for journalistic and popular criticism to become a much more democratic, dispersive affair, no longer left in the hands of experts.[4]

After early film criticism, Haberski similarly concludes, "maintaining a balance between obscure, inaccessible cultural standards and meaningless criticism" – between elitist film theorists and populist pundits – "would henceforth consistently befuddle movie critics."[5]

Haberski's and McDonald's downfall narratives do not adequately explain the history of film criticism. The field is better described as having suffered a series of crises. Many of them, as we shall see, were productive ones, while others simply replayed prior crises.

This chapter and Chapter 2 examine early writing on film and the establishment of film criticism as a profession. Synthesizing and building on the national case studies of Richard Abel, Claude Beylie, Helmut Diederichs, Sabine Hake, Sabine Lenk, Myron Lounsbury, Laura Marcus, and others, these chapters – for the first time – comparatively approach early film criticism in Britain, France, Germany, and the United States in order to sketch existential debates that attended the establishment of the activity and profession as well as to set up an international basis for the subsequent crises.

These first chapters investigate the crisis rhetoric surrounding the profession and purpose of criticism. Furthermore, they show how these discussions overlapped with justifying the nascent medium of film as an appropriate object of critique and clarifying the critic's role vis-à-vis the industry and the audience. These rhetorical gestures, I argue, were instrumental in asserting a critical authority and anticipate later crises and positionings in the chapters to come. Early critics' arguments for and anxieties about the foundations of authority are rehashed in later decades.

Furthermore, this and the subsequent chapter reframe these discourses as – rather than a celebratory appraisal of a teleological march towards film as art or an unproblematic establishment of authority – an uncertain scene of crisis, anxiety, and dispute with complex and shifting fronts. Rather than appearing increasingly over time or suddenly in the digital age, notions of "crisis" – and in particular a crisis of authority – were immanent within the profession from its very beginnings. This fact casts serious doubts on McDonald's and Haberski's periodization and trajectory of criticism.

In further contrast to their studies, the body of evidence I provide is international. Indeed, of all the chapters in this book, the first two examine the widest national and historical range. They begin with the origins of cinema and extend until the Second World War, although the focus will cluster around points in the 1910s and 1920s, when the most serious self-reflexive reckonings with criticism as an activity and profession took place. The discourses of crisis are most prevalent in these moments: in the early 1910s, with the birth of modern film criticism as an activity in response to the increasing lengths and sophistication of film; and in the 1920s, with the broader acceptance of film as an important aesthetic and/or mass-cultural phenomenon and the advent of professional film criticism in mainstream dailies and weeklies and with the concomitant need to define the profession vis-à-vis the industry and audiences.

Examining the early period in Britain, France, Germany, and the United States provides the possibility to make a stronger claim about film criticism than monocultural histories such as Haberski's. However, I do not intend to occlude differences. There are surely subtleties and nuances at work in these national histories. Writers were responding to different imperatives and developments in national film culture, including censorship laws, exhibition quotas, vagaries of domestic production, foreign imports, before we even mention historically inflected matters (blockades during the First World War, limitations on free speech, culturally specific moral and

religious objections, and so on). Such differences should not be brushed over; indeed, as I have argued elsewhere, in order to understand the contours of early film writing, cultural matters must be taken into account.[6] Too often in the history of this period in film culture abstraction abounds and messy distinctions are elided in order to arrive at tidy categorizations and neat conclusions.[7]

Nevertheless, there is also a remarkable similarity to a few major themes in the development and progress of film criticism before the Second World War, especially regarding the crisis of authority. Whereas these developments surely bear the markers of national contingencies and take place within slightly different timescales (in general, events in France or the United States preceded those in other countries by a year or more through the 1910s; or to cite another example, among the German-speaking countries, Austria lagged behind Switzerland and Germany), by the 1920s regular, serious film criticism was established in all of the nations under discussion here. Whether the cinema reform movements in Germany and the United States or the rivalries between cinema and theatre critics in France and Germany, debates across borders often ran in parallel if not outright overlapped.[8] Furthermore, critics persistently referenced foreign film cultures as examples for their domestic cinema to emulate or avoid and transnational figures (Béla Balázs, Iris Barry, Ricciotto Canudo) and projects (*Close-Up*, *Scénario*) abounded.[9] Thus, I present these broad stages of the history of early film criticism neither with the intention to write a definitive or comprehensive history, nor to attempt to erase national differences. Rather, my aim is to quickly provide a background framework in order to pick up on these themes as I turn to the particular discursive categories of the birthing crises of criticism.

Early film writing, from the beginnings of cinema to the Second World War, shows a dramatic shift in mode, purpose, address, and venue of publication. These changes, especially those that took place through the 1920s – when professional film criticism became established and a regular feature of mainstream dailies and weeklies – both introduced critical authority and, simultaneously, precipitated its initial crises.

Although histories often date the first film review to 1896, such claims are typically qualified as not representing film criticism in the modern sense: in other words, a piece of writing that describes but also evaluates or interprets a film or set of films on the basis of artistic merit or entertainment value and which addresses primarily the cultural consumer. The earliest reviews from this period are best termed event reportage. French dailies registered the cinematograph as "one of the most curious things of our age."[10] Rachel Low and Roger Manvell's seminal history of the British context, to cite a further example, reproduces a 10 November 1896 excerpt from the *Star* of Newport. The notice describes the subjects of a programme of shorts and the audience's reaction to them: "A street fight and the arrest of the offenders by the police caused some laughter, as also did a bathing scene in Brighton."[11]

In the first ten to twelve years of cinema history, in other words, film was seen as an extension of photography and its "criticism" existed largely as a protocol of audience reactions to shows (of films among other entertainments), as a scientific/tech-

nological discussion of invention and innovation, or as a business discourse. Specialized film publications began appearing in the first decade of the twentieth century, but the vast majority is best described as trade press. These were service organs to the industry and in many cases were affiliated with a particular company. They included *Phono-Ciné-Gazette*, *Bulletin phonographique et cinématographique*, and *Ciné-Journal* in France; *Views and Film Index*, *Moving Picture World*, and *Moving Picture News* in the United States; *Der Kinematograph*, *Erste Internationale Film-Zeitung*, and *Die Lichtbild-Bühne* in Germany; and *Kinematograph Weekly*, *The Cinema*, and *The Bioscope* in Britain.[12]

These publications purported, to cite *Ciné-Journal*, to catalogue "new releases, technical advances, and profitable ideas" on a weekly basis.[13] In general, the early trade press celebrated advances in cameras and projectors, disclosed news of patent disputes, and delivered business reports about competing manufacturers and film companies.[14] In addition, previously established entertainment and theatre magazines, such as *Billboard* and *Variety* in the United States, introduced plot descriptions of new motion pictures as a way to encourage film companies to place advertisements.[15]

Although there are exceptions – notably, religious organs such as the French Catholic *Le Fascinateur*, which treated film as part of a moral-pedagogical agenda[16] – as a rule, the writing on film and proto-criticism of the cinema's first decade-and-a-half occurred in trade journals and entertainment periodicals. It largely pertained to advancements in production and exhibition technology; pointing out flaws in cinematography, editing, continuity, and script; or describing business models and practices. For this reason, its ultimate addressees were the makers and exhibitors of film and its goal was to enable this demographic to manufacture and deliver better product.

The first film columns began appearing – albeit irregularly – in mainstream newspapers from 1908 in France and shortly thereafter in the United States and Germany, coinciding with the establishment and consolidation of the French film industry and the progressive lengthening and sophistication of narrative-driven fiction films.[17] Panic about film's potentially pernicious appeal to and effects on the lower classes, controversies over censorship, and debates about the aesthetic value and properties of the medium meant that writing on film began to surface in journals of political opinion and art and literature magazines.[18] In the 1910s, several specialized magazines started up that attended at least in part to film's aesthetic potential (e.g. the German *Bild und Film* and the French *Le Film*). In France, several major newspapers, such as *Le Temps*, *Le Petit Journal*, *Le Journal*, and *Le Matin*, began occasionally or regularly printing film notices; from 1914 and increasing in the years that followed there was a surge of (albeit often ephemeral) specialist magazines, such as *L'Ecran* and *La Cinématographie Française*.[19]

After the First World War there was increased and more diverse critical activity through the 1920s, as most mainstream newspapers began consistently and seriously

MATTIAS FREY

writing on cinema, recognized critics emerged, and further film periodicals concerned with aesthetic issues, such as *Ciné-pour-tous* in France and *Experimental Cinema* in the United States, were founded.[20] By this stage the foundations of modern film criticism were emerging: the widespread acceptance of film as art and/or mass entertainment and of film criticism as an autonomous discourse (i.e. distinct from event reportage or publicity). There was the growth of a more aesthetic criticism of one or more works addressed to the public – rather than, as prior, a report of flaws aimed at the industry. This writing advised the public's consumption choices or, in some cases, tried to educate them or improve their tastes.

This section has telegraphed the development of early criticism from a service sector for producers to a more widely recognizable cultural apparatus whose purpose to evaluate aesthetic and entertainment value made it more or less parallel to the functions of theatre, literary, or music criticism. With this change, and with the establishment of institutional parameters for film criticism as a profession – in other words, the birth of the film critic – a bifurcated crisis of criticism ensued. In France, Germany, Britain, and the United States – in the first instance already in the early 1910s and then through the 1920s – writers on film developed the means to establish their authority as critics. Rather than, as Haberski chronicles, the pinnacle of cultural authority (to be matched only in the 1960s golden age), the origins of film criticism were a scene of existential crisis: the birth of the profession was marked by debate over the right of film critics to exist and over their proper profile in mediating between object and reader.

This chapter and Chapter 2 examine the debates of early film writing as discursive manoeuvres to establish critical authority. The birth of film criticism is characterized by difficult positionings between fronts, which served to (1) establish film as a respectable object of critique and (2) to define the relationship between the critic, the industry, and – perhaps most crucially – the audience. Chapter 2 will deal with the latter, i.e. the critic's relationship with the industry and audience.

The remainder of this chapter presents and dissects discourses about the former, i.e. the promotion of film as a phenomenon of aesthetic or cultural import. This includes comparisons – but also contrasts – to theatre and the other arts for models of cultural respectability. Such rhetorical moves thereby assert the critical authority to speak because or despite film's status as "popular" art. This line of debate resulted in calls for a new criticism for the new art and the erection of professional rules and standards.

The Promotion of Film as a Culturally Respectable Object

Already by 1907, as the length, ambition, and sophistication of film narratives increased and the economic and mass-cultural potential of the new medium was rapidly becoming apparent to those in the industry and beyond, calls for film criticism arose. "Interminable, protracted critiques are being written about everything under

the sun," the German trade paper *Der Kinematograph* opined in their 13 January edition that year, "but regarding the cinema there is an ignorance and to a certain extent a prejudice that is difficult to explain."[21] In competitor publications, such as *Die Lichtbild-Bühne*, there were demands for regular reviews of individual cinema programmes,[22] and by 1910 even mainstream publications outside the industry press were beginning to agitate for film evaluation. "Where a cinema-theatre," Ferdinand Hardekopf asked in the *Münchner Neuste Nachrichten*, "claims literary ambitions: why should its premieres not be subject of critical and aesthetic considerations."[23] For commentators such as Walter Turszinksy taking up the question of "Should the Film Drama Be Criticized?" in 1912, reviewing was especially important and essential for the development of the new artistically ambitious productions. "One will of course have to limit oneself to scrutinizing those works which via peculiarities of form or content quite clearly stimulate approval or objection," Turszinsky wrote, adding that refined set design, acting, screenplays, and mise en scène – but also the mistakes and failures of the film author and director – should be highlighted in equal measure.[24]

The emphasis on aesthetic intentions and refinement in these statements gestures towards a key fact of the birth of film criticism: it arose at the same time that cinema was making claims to be art. Furthermore, the establishment of film criticism went hand in hand with the promotion of film as an independent art form. The latter created cultural respectability for the medium, justified the need for criticism, and worked towards ascribing authority to those writing about film. As we shall see, this fact already anticipated criticism's first crisis. On the one hand, there was a need to establish film as an art (and thus parallel to theatre, sculpture, music, and so on) in order to justify its critique as warranted and required and its arbiters as cultural authorities. On the other hand, there was the necessity to differentiate film from these other arts, e.g. to argue that it was not a subset of or poor substitute for theatre. Writers advocated a new form of criticism – and basis of authority – for a new medium.

By the second half of the twentieth century's first decade, some commentators in France began referring to cinema as an art.[25] Richard Abel's research into this period suggests that such polemics often emerged from within the industry itself, in order to promote more sophisticated films (such as adaptations) and to expand its demographic into the middle classes. In 1907 Edmond Benoit-Lévy called film a "literary and artistic property"; sustained, serious, and widespread advocacy for film's entry into the aesthetic pantheon did not reach a critical volume until 1911.[26] The arguments took hold quickly, however, as the writings of German critic Herbert Tannenbaum reveal. In his 1912 treatise on "Art in Cinema" he observed that "since recently one can dare speak of and even write about cinema *art* without the danger of being declared uncultivated, uncouth (and so on) by people in the know. But only since recently; for about six months."[27]

At the same time in the United States, a select number of writers began agitating publicly for cinema's artistic respectability and countering claims that film was merely an automatic recording of reality. Frank Woods's column in the New York *Dramatic Mirror* regularly presented the case for film as an art and attempted to define the role of the critic.[28] As a collaborator of D.W. Griffith, Woods defended cinema against moral objections and attempts at censorship and praised the "gradual and irresistible growth" of film art.[29] This, according to Woods, was the proper role of the critic: the identification of progress in the new art, "the bestowal of praise where it is deserved – the recognition of merit where it exists."[30] As in France, Germany, and Britain, such claims – unorthodox in 1909 – became more accepted among writers on film in the United States by the late 1910s and early 1920s. With the publication of Vachel Lindsay's *The Art of the Motion Picture* (first edition 1915), Victor Freeburg's *The Art of Photoplay Making* (1918), Henri Diamant-Berger's *Le Cinéma* (1919), and others[31] – not to mention the proliferation of film-specific journals, which increasingly treated the new medium as an aesthetic object, *Le Film* in France, *Bild und Film* in Germany, and *Exceptional Photoplays* in the United States being exemplary[32] – the notion that the motion picture was a popular art was uncontroversial, at least among the culturally initiated.

Nevertheless, even in the 1920s the first professional critics continually acted to reassert film's rank, calling for more refined productions and cinematic techniques and pointing out the need for individual creativity to enable the cinema to achieve the established arts' level of sophistication.[33] Screenwriter and critic Willy Haas, to cite an example from the German scene, argued in *Die neue Schaubühne* that film had not yet developed into a high art such as theatre; according to him, it was inappropriate to criticize a medium that dwells on the cultural level of a folk song.[34] Such claims were made, no doubt, under the duress of moralists' insistence on the insipid or pernicious nature of motion pictures. In the United States, *Life* film critic Robert Sherwood called for the photoplay to reach a refinement that might favourably compare to the traditional arts; at the same time, he recognized the popular appeal of the medium. His inaugural 1921 column presented an ironic scenario in which cinema applies to Apollo to become the tenth muse. "'The cinema has conquered the earth,'" Sherwood imagined the new medium arguing, "'[t]hat is why I have come to Olympus. As the symbol of cinema, I crave recognition. I desire to break into the snobbish Muse colony.'"[35] The fantasy ends with a note of explanation: "In all future issues of this department we shall publish a list of the more important current pictures, with brief comments, favorable or otherwise." Sherwood's ambivalent position on film as a popular art – and the self-deprecating definition of his activity as differing from that of a traditional critic, as the expression of opinions of taste – epitomizes the early film critics' precarious position between the fronts.

Other critics of the era, such as Clayton Hamilton, shared Sherwood's hopes for the medium and even more explicitly yoked critical authority to the cultural respectability of the medium. In a formulation that we shall see throughout the history of film

criticism, Hamilton linked the quality, form, and status of criticism to the condition of its object of critique. "So long as motion pictures continued to dash up the story of the rich and wicked banker who endeavored to seduce the poor but virtuous stenographer," Hamilton wrote, "so long as they continued to falsify the bathroom habits of the aristocracy, they offered no material for criticism."[36] Invoking Matthew Arnold's critical maxim to propagate the best and brightest cultural productions, Hamilton found little reason to review the childish, commercial, or inane. "To achieve criticism," according to Hamilton, "the motion picture must first deserve it."[37] Sherwood's attempts to insert cinema as the Tenth Muse and Hamilton's invocation of Arnold anticipate a major feature of the attempt to legitimize and professionalize film criticism: comparing film to other arts and asserting authority by referring to legitimate critics of previous eras.

The Comparison to Theatre and the Other Arts Criticism

In Germany, Britain, France, and the United States, the earliest critics attempted to gain legitimacy via comparisons – but also contrasts – between film and the established arts and by invoking the ideals and functions of arts criticism of the past, and especially, of the eighteenth century.[38] In the history of early writing on film it is well documented how – from Herbert Tannenbaum and Ricciotto Canudo to Vachel Lindsay and Rudolf Arnheim – attempts were made to reference other forms, such as sculpture, music, literature, and painting, in order to define the specificities of the new medium and nevertheless position it as a parallel or even (in the case of Canudo) composite entity.[39] For this reason, the comparisons between film and other arts criticism cannot be divorced from the comparisons that were being made between film and the other arts in general. Scholars have elaborated upon these latter metaphors, which served film culture's need for recognition but also resulted from observers' anxieties about the established arts' loss of both cultural and economic power.[40] In Germany and France, the "theatre-cinema quarrel" between the theatre lobby and moralist cinema reformers on the one side, and the film industry and its advocates on the other, reached its climax in 1912.[41] In that year, for example, Berthold Viertel diagnosed the heated discussions about cinema among theatre professionals as symptoms of the former's public success. The inverse relationship of theatre and cinema profits indicated that both forms resided on the same level, if with opposite tendencies: the stage was becoming more vulgar, the screen more artistic.[42]

Against the attacks from conservative literary and theatre critics, who argued that cinema lacked essential aesthetic features and therefore could not qualify as an art, there were frequent attempts to outline film's unique features and many invocations of Lessing and *Laocoön*.[43] These appeals to an established element of the literary canon and an authoritative aesthetic theorist – made over two decades by J. Ecclestone, Béla Balázs, Rudolf Arnheim, C.A. Lejeune, and Sergei Eisenstein, to name just a few international examples[44] – helped early critics justify film as an autonomous form of significant aesthetic value that required serious criticism.

If programmatic statements by critics and theorists fully probed film's connections (and distinctions from) a wide variety of arts, on the level of journalistic praxis, however, theatre became the most important battleground. The German example is instructive. In 1913, the films of canny producers who had employed famous authors and actors, the so-called *Autorenfilme*, began to appear. The cultural status of adaptations and the personnel overlap from the stage caused editors to send their resident theatre critics – rather than a local reporter charged with compiling listings and observing audience reactions – to review these productions as works.[45] Regarding the premiere of *Der Andere* (*The Other*) on 21 January 1913, the trade paper *Erste Internationale Film-Zeitung* registered the remarkable presence of representatives from the dailies, observing that this was the first time that the best and most important men of letters attended a film screening with the intention of deliberating seriously and at length on the cinema: "For the first time these men have spoken about a film in the same section of the newspaper that otherwise is dedicated to the great theatre premieres. For the first time the photoplay has been seriously compared to theatre in the entire daily press. Film has become ripe for the arts page."[46] Herbert Tannenbaum's 1912 comparative aesthetic between "Cinema and Theatre," to cite a further effort in this vein, argued that the cinema's development to the level of theatrical art could be helped above all by a "good newspaper criticism." Moreover:

> the press has the duty to work towards the consideration of artistic viewpoints by introducing a regular and in-depth film criticism. It must shore up the judgement of the audience by pointing out mistakes and possibilities for improvement and seek to funnel these demands through the proper channels. The cinema urgently needs the regard and cooperation of all those who call themselves the intellectual leaders of the people.[47]

A similar process was already underway in France. There too, as Sabine Lenk has detailed in depth, a theatre-cinema rivalry took place across a wide spectrum of publications. Although cinema was largely ignored by theatre personnel in the new medium's first decade, the rise of the nickelodeons caused some to consider film as a threat. In a 1907 column, drama critic Félix Duquesnel attributed the significant decrease in theatre spectators to the "crisis" that was cinema.[48] Because of legal judgements regarding adaptation royalties and the reorganization of the industry in the early 1910s, there was a large influx of cast and crew entering the film industry from the theatre world, a proliferation of artistic films based on high-cultural aspirations, and an increasing number of adaptations based on classic and popular dramatic works. This shifted the basic attraction of the medium from the local cinema or cinemagoing as activity, to the artistry of individual works.[49] At the same time, it put pressure on newspaper editors to review films, lest their publications be seen as behind the times.[50] In many ways the French reception of *L'Assassinat du duc de Guise* (*The Assassination of the Duke of Guise*, 1908) resembled (and anticipated) the

effect of *Der Andere* on the German press outlined above: the Pathé Brothers' production garnered serious attention in mainstream national publications.[51] Nevertheless (and despite the fact that prestige French films pre-dated those in Germany and Britain), this transition took place gradually and the first French film critics complained bitterly about their treatment vis-à-vis their drama colleagues. In 1909, Georges Dureau accused the media of encouraging puff pieces on dramatic productions in order to support the theatre business while treating the new medium with disdain if not outright contempt. Dureau called for the equal treatment of film and drama in French journalism.[52] In 1912, Yhcam similarly detected a conspiracy between the press and the theatre business to limit film reportage to back-page advertisements. Newspaper bosses were not only guilty of ignoring the public's widespread enthusiasm for cinema; introducing reviews and regular columns would actually raise papers' profits by increasing circulations, not to mention positively influencing the quality of future productions.[53]

The new films' narrative and intellectual aspirations as well as the recently built cinemas' plush architectonics helped the industry compete directly with theatre, mimicking its cultural standing.[54] For journalists and other commentators, according to Abel, this "created an aesthetic problem for writers in clearly distinguishing cinema from theater."[55] Moreover, these developments inspired angry commentaries from early friends of cinema who felt that film's short-sighted pursuit of theatrical legitimacy threatened to betray its very essence. "Once relegated to the suburbs and small screens," Kurt Pinthus observed on the occasion of a picture palace's 1913 opening, the cinema "pretends to be ready for high society" and tries "to imitate the theatre." Such servile aping, he opined, forgets that cinema "has nothing to do with theatre."[56] A few years later Carl Hauptmann wrote that film "as mere copy of theatre leads it a priori into a narrow dead end."[57] In turn, Alfred Lichtenstein admonished theatres to stop attempting to compete with cinemas; the lack of self-esteem and formal integrity meant that the former "are achieving the exact opposite of what they want: they're dying."[58]

Despite such rancour, the form and parameters for the early film reviews that focused on individual works were more or less modelled on theatre criticism. Notices dwelled on acting performance, mise en scène, plot, and genre; they made brief mention of artistic quality or evaluated entertainment value.[59] Not only was film as an industry attempting to gain respect (and new middle-class audiences), film criticism simulated and hoped to achieve the status that theatre criticism enjoyed. In a 1912 compendium of programmatic statements from German newspapermen about whether film should be the subject of critique along the lines of theatre, the *Hamburger Neue Zeitung* opined that such serious film reviewing would indeed help cinemas: "They would then improve their programmes, increase their attractiveness, and then hopefully kill off all those theatres which by showing tawdry, weak, and false pieces represent the only serious danger for dramatic art."[60] In France, to cite another example, André Antonie proposed that "it is necessary to create a veritable, indepen-

dent screen criticism, as now exists for the theater."[61] And in Britain, George Bernard Shaw wrote frequently about the parallels between the stage and screen and how each affected the other; his comments are credited with influencing critical discourse in that country. Remarking on the serious rivalry between the two, Shaw submitted in 1920 that the "kinema will kill the theatres which are doing what the film does better, and bring to life the dying theatre which does what the film cannot do at all."[62]

A New Criticism for a New Art

Although initially and especially before the First World War the comparisons with theatre served to establish film's legitimacy and justify its evaluation, when the battle for artistic consideration appeared to be won, commentators increasingly wished to highlight film's uniqueness and thereby the need for an independent film criticism.[63] Already in 1913 and 1914 in Germany, there were first pleas for a film criticism to be performed by specialists and not left to drama pundits. "Film criticism," according to Eugen Kürschner in trade paper *Die Lichtbild-Bühne*, "should take as its task to see cinema images with different eyes than theatre performances."[64] In Victor Freeburg's 1918 book *The Art of Photoplay Making*, the American begins by claiming that it is "a common error to judge the photoplay by the standards of the stage drama, and to condemn it because it cannot do exactly what the stage drama can do."[65]

The foundations of professional film critic societies and the first full-time film critics would largely take hold in the early 1920s, however. By that time, the backlash against comparisons with theatre and its criticism was widespread. In Britain in 1923, Betty Balfour argued that, despite "unqualified critics" who argued the contrary, to "appreciate or to try to understand Cinema Art one must dispossess oneself of all thoughts of the theatre in particular and of literature and other forms or art in general." Critics "whose only knowledge is of the theatre," Balfour maintained, "have no right or qualification to criticise an art of which they are entirely ignorant, and which they frequently do not even attempt to study."[66] The editor of *Close Up*, Bryher, complained along similar lines about the inadequacy of interloping theatre critics. Most "film critics of the various daily, weekly or monthly journals have come to cinematography via dramatic criticism," Bryher wrote, but "if there ever was a gulf between two arts it is between the theatre and the cinema [...]. The excellence of a play is a defect in film. Yet many critics [...] search for the same qualities that they were accustomed to look for in the drama." In sum, she maintained, there was a lack of knowledge among moonlighters, since "many critics make no effort to see pictures that could give them a standard of criticism."[67]

Internationally there was in these years a clear reversal of the earliest film critics, who attempted to establish critical authority by appealing to the traditions of theatre and other arts criticism. When Rudolf Arnheim recollected the development of film criticism a few years later, the move towards medium specificity and an independent film criticism was complete. "It has taken a long time for film criticism to stop func-

tioning as a second-rate job for local reporters and theater and book critics," Arnheim wrote; "film criticism finally worked with its own filmic terms and reached a satisfactory intellectual level – as well as a position on the page that was comparable to that of theater and art criticism [...]. Today the film critic's main failing is that he judges films in the same manner that his colleagues judge paintings, novels, and theater pieces."[68]

These comments illuminate how by the middle to late 1920s writing on cinema in France, Britain, Germany, and the United States had become a recognized, distinct discourse. The 1910s advocacy of film and film criticism addressed to those hostile to the new medium had prevailed; defining the unique contours and professional standards of an independent film criticism became the much more pressing task.[69] In this context, differentiating film from theatre criticism was an important exercise, as was, in general, ontological and often utopian formulations of a new mode of criticism for the new medium.

Film criticism, according to one contemporary German trade paper, needed its own rules, "just like 150 years ago Lessing set out general principles for theatre criticism."[70] Internationally and especially in the 1920s, there emerged a consensus that a new language and fresh idioms were necessary to establish a distinctive field and activity. In Britain, writers such as C.A. Lejeune lamented the emergence of a film criticism prone to "loose technical verbosity" and wont to borrow ways of seeing and writing from other formats. "Every other form of expression, music, drama, painting, poetry, sculpture, drawing, has its own critical language: the movie alone is subject to a criticism that has neither established measure nor technical currency," Lejeune opined.

> We stumble along, doing the best we can with the old terms while we try to rough out a new vocabulary, borrowing from this art and from that, compromising, slipping in a tentative technicality here and there; without quite the courage to invent, as the movie actually demands, a new vernacular [...] relying on the reader's patience to carry us through this period of transition and experiment in the chronicles of the screen.[71]

Lejeune's compatriot Iris Barry expressed a similar view with a more optimistic, prescriptive attitude: "I ask then: critics arise, invent terms, lay down canons, derive from your categories, heap up nonsense with sense."[72] For the American Louis Reeves Harrison, a member of the trade press and early advocate for an independent film criticism, a good critic must possess "creative and critical instinct in high degree" and "appreciate the necessity of tremendous changes to meet the requirements of a different art."[73]

In the 1920s, some commentators on how film should be criticized continued to use categories and criteria of traditional arts criticism; thus, for example, Victor Freeburg's *Pictorial Beauty on the Screen* implied an evaluation that sought in "cinema

composition" the liberal values of "directness, ease, emphasis, unity."[74] More often, however, critics sought a medium-specific, formal criticism or one that respected a different sort of "unity" than Freeburg meant: a holistic criticism of film's aesthetic, mass-social, and commercial aspects. In this way, for example, the German critic Herbert Ihering defined criticism as neither "taste," nor "niggling," but rather as "the inner drive to grapple with the principles of an art."[75] In a formulation that previews critics' objections to "thumbs up thumbs down" evaluation in the television and digital age, Ihering claimed that professional film criticism "is not the rejection or affirmation of a work. In that case every spectator who expresses his opinion would be a critic."[76] Instead, criticism is the "experience of an artwork according to its elements and therefore the automatic affirmation of the productive, the automatic rejection of the unproductive elements."[77] For Rudolf Arnheim, the film critic must see "the film production of the entire world as a unified work in which each individual piece has its place; it's the critic's task to identify that place."[78] Moreover, the criticism of film should be entrusted to experts. Despite "claims that film is an art for the people, that it is more easily understood than the others," in actuality "true understanding of film is the same as understanding of art in general: it is infinitely rare."[79]

The Beginnings of Professional Standards

For many early critics, the erection and maintenance of professional standards entailed the castigation of rogue and recalcitrant colleagues; the catty infighting that would later mark the writings of Pauline Kael, Andrew Sarris, John Simon, and Armond White began in the earliest days. Already in 1909, for example, *Moving Picture World* bemoaned the domestic press's lack of perception, "downright stupidity," and "condemnatory, unfavorable, and unfair" attitude towards the motion picture.[80] The "sooner more intelligent writers are employed," the American trade paper opined, "the better for the newspapers' reputation for common sense, which at present is not so high as it might be."[81] "Have done with foolish sensations," it recommended, "exaggerations; falsehoods; loose writing and not disinterested attacks, brothers. Encouragement not depreciation is needed. Criticize if you will, but criticize justly, impartially, and above all with knowledge."[82] In France, similarly sceptical assessments of the domestic press's poorly researched and unknowledgeable writing about film abounded. In rhetoric that partook of typical promotional discourses, French film journalists in the early 1910s agitated for colleagues to write better informed and less negative articles on the fledgling medium.[83] Such calls for greater professionalism sometimes took the form of general invectives (as above) or polemical diatribes, such as Laroche's 1919 comparison of German critics to psychopaths and his calls for legislation against the publication of reviews.[84]

At other times, the complaints, which continued unabated, served more as position papers of the critic's own reviewing methods, perspective, or mechanics. "Why do some *film critics* make it so easy on themselves," Arnheim asked in a 1927 reflection on his task as reviewer.

They retell the exact plot in a moody or bad-tempered tone, add a couple of names and pronouncements, and that's it. The critic should only mention individual themes or even the course of the plot when he wants to illustrate a point, describe a philosophy, or identify a great success. But why unnecessarily rob the public in advance of the suspense which is so important to film?[85]

In crucial ways, Arnheim's statement previews a number of attempts to define standards and distinguish the critic from other colleagues, such as St. John Greer Ervine's jeremiad that to "read about the cinema is almost as boring as to go to it,"[86] or Lindsay Anderson's comments on the state of "liberal" criticism in the postwar British period, a case that Chapter 3 will examine.

The establishment of critical authority – and its crises – must be seen in conjunction with other professional developments in film culture in the late 1910s and 1920s, such as the ciné-club movement, Louis Delluc's calls for individual screenings at set times, the critique of individual films as "works," and the (at the time) fanciful ideas about creating a repertory of significant films to be collected for repeated screening, or Arnheim's utopian predictions about cinema museums and university departments.[87] These moves foretell critics' needs to establish canons and create permanent value over time ("long-term authority"), upon which Chapter 3 will elaborate, but also point to a proportion of cultural respectability that would trickle down to the observer of film culture. Pleas for (and the introduction of) press screenings in France and Germany provided critics with discrete space and advanced knowledge, which served to reinforce their authority and distinguish them from mere viewers. According to one German commentator, these special projections finally put film critics on the respected level of their theatre colleagues.[88] The growth of regular film columns are also symptomatic of this development: in France, *Le Temps* began a biweekly column of film notices by its music critic Émile Vuillermoz in 1916; the 1918 debut of Louis Delluc's weekly (and subsequently daily) column in *Paris-Midi* marked another milestone in the establishment of a regular, serious, and independent film criticism and by the end of 1921 all of the major Parisian dailies had a film review column.[89]

Internationally, we find a similar, if slightly delayed timeframe. Béla Balázs began duties as the first regular critic for an Austrian newspaper in December 1922. In her memoir, C.A. Lejeune – who began a weekly column at the *Manchester Guardian* in 1922 – recalls 1920 as a time when the "profession of film criticism had not yet come into being." James Bone, the editor to whom she applied in 1921, told her that she was the twenty-seventh person who had pitched the idea that the newspaper needed a film critic.[90] Film criticism was at this point expanding from being solely a task or activity to becoming a profession.

By 1927, the American intellectual and film critic Harry Alan Potamkin claimed that his (particularly French) colleagues represented "a body of critics, as authentic and authoritative as the critics of the other arts."[91] To whatever extent that statement

was true in the implicit imaginary authority asserted and accepted by critics and their public, the profession and its legal status had its own stages of development. These included a 1926 resolution by Le Ciné-Club de France calling on newspapers to be required to provide notices with bylines on all advertised films. "Today more than ever," the society claimed, "the creation of cinema criticism is indispensable to the artistic existence of cinema."[92] A libel lawsuit brought against Léon Moussinac for a 1926 column in *L'Humanité* in which he referred to a production as "the perfect example of a bad American film" was successful in the first instance in 1928; two years later the decision was overturned on appeal, setting a precedent for the freedom of speech in French film criticism and granting film reviewers the rights that their colleagues in drama, literature, and other arts criticism enjoyed.[93] Herbert Ihering and other critics founded the Association of Berlin Film Critics in 1923; this was a concrete legal step to militate collectively against libel claims and government interference and censorship.[94] Furthermore, such bodies in effect established the activity as a profession. As sociologists such as Pierre Bourdieu and Shyon Baumann have elaborated, associations serve as sources of cultural legitimacy and authority.[95]

Béla Balázs's inaugural column for the Viennese daily *Der Tag* on 1 December 1922 occasioned yet another plea for a professional form of film criticism. It is also an important artefact that points to the internal contradictions at work in 1920s criticism, to the delicate balancing act between film as art and popular medium, and ahead to the second-wave mediation crises on the horizon in Chapter 2.

Balázs's column begins as an (somewhat delayed, especially vis-à-vis the more advanced American, French, and German film cultures) agitation for film to be considered an art and a justification for regular criticism in Austria: "Why is there no film criticism in Vienna? Why is every operetta turned into a cultural event, but no critics bother with film? Why does no one bother with the art of the people?"[96] Balázs's justification for film criticism hinges on an inclusive and comprehensive approach to its object: film is a serious art *and* a popular phenomenon of the people.

> Aesthetes may turn up their aristocratic noses, but that does not alter the fact that the cinema has become the art, the poetry, the vision of the people, a decisive element of popular culture. Wondering whether this is good or bad is silly; for in Vienna alone there are already 180, I repeat, 180 cinemas showing films every night. One hundred and eighty cinemas with an average of 450 seats, presenting two or three programs every day. If we figure houses three-quarters full, this amounts to *200,000 people a day.*[97]

In essence, Balázs argues for legitimacy on both fronts. To aesthetic-minded commentators he praises film's "poetry" and "vision." Hoping to do away with the "aesthetic prejudice against the cinema," Balázs suggests that "film can serve even the most zealous of aesthetes as a subject for interesting study."[98] Since cinema is also important as an event and sociological, cultural, and national phenomenon, however,

he also appeals to moralists, arguing that the medium is both beyond good and evil, but also vital to understanding contemporary culture and the "millions" who go to the cinema every day. Balázs seeks to include those of such views in the debate and wrest the subject from elitist discourse:

> from now on no one will be able to write a history of culture or national psychology without devoting a major chapter to the cinema. Those who see this fact as a great danger are the very ones who have an obligation to help out with constant, earnest, systematic criticism. For this is not something confined to literary salons but a matter of a nation's health.[99]

Despite the occasional lack of quality in individual films, cinema's "potential is incalculable." In fact, Balázs hopes, professional criticism of standard is the vehicle by which film might achieve its promise: "Perhaps that potential will be greatly influenced by serious, pertinent, penetrating criticism. Beginning today, I plan to open my columns to just such pertinent, methodical criticism."[100]

In one sense, Balázs's column represented a victory for regular, serious film criticism. It resolved thereby the first-order crisis of criticism: the establishment of cultural recognition for the new medium and of film criticism as a professional pursuit in the mainstream press. His statement already contains, however, the seeds of the next crisis.

2. Second-Wave Crises of Proximity and Distance: Relating to the Industry and the Audience

The discourses of promotion and distinction anatomized in the previous chapter – suggesting film is worthy of criticism, borrowing elements from established (and especially theatre) critical formats, invoking authoritative critics from the past, elaborating rules unique to an independent film criticism, founding professional standards, and distinguishing good practice from bad – served to create the perception of authority needed to justify film critics' activity and be recognized professionally. By the early 1920s, discussion of film was becoming more common in the mainstream press and in arts and culture periodicals. These new venues entailed new audiences and new ways of addressing them; as stated, film criticism's readership broadened from industry insiders to both producers and consumers. Nevertheless, as we shall see, this transition was not as smooth as sometimes implied. The struggle marks the entire history of criticism to this day.

Indeed, the solutions to the initial crises highlighted in the previous chapter created secondary problems. If a film critic acted as an *advocate* for film how could he or she still maintain the relationship towards culture that professional criticism demanded (i.e. objective distance)? If film was a *fine* art how could critics relate to a public clearly wider and more diverse than the audiences of sculpture, classical music, or theatre? But if film was a *democratic* art, how could critics maintain the authority they needed to lead opinion and make taste? These questions, already anticipated in Balázs's first column for *Der Tag* above, were especially problematic in the domain of film, which, unlike literature or theatre, came from recent and recognizable scientific, technological, and commercial origins, rather than ancient aesthetic ones. Thus, in a second-wave crisis of early film criticism, debates about objectivity, competence, and influence ensued. Critics needed to negotiate both an in-touch proximity and authoritative distance to two key stakeholders: audiences and the industry.

Before proceeding to these two issues – the critic's relationship to the industry, the critic's relationship to the audience – in turn and in detail, Iris Barry's 1926 book *Let's Go to the Movies* serves as an introduction and indicator of how vexing these issues of mediation were. Her remarkable contribution dealt with both matters simulta-

neously and imagined the critic's role as an uneasy part of a "vicious" triangulation: filmmakers, audience, press.

Barry was (together with C.A. Lejeune) the most prominent early British film critic who wrote for the *Spectator* (1923-1927) and *Daily Mail* (1925-1930), cofounded the first English film society, and later became the first curator of the Film Library at New York's Museum of Modern Art.[1] Barry's *Let's Go to the Movies* represents a key early monograph on several issues of film aesthetics, history, and culture. Its relevance to the present study largely resides in the chapter entitled "A Vicious Triangle," where she elaborated on "the most obviously tiresome things about the cinema," the fraught, complex relationship "between the producer, the public, and the cinema critic."[2] According to Barry, the "issue" between the former two is clear: "The producer is catering for an unknown quantity. The public doesn't care at all about the producer, only about films and it is inarticulate save as the box office speaks for it."[3]

For Barry, the critic is caught in the middle and ideally he or she should be mediating between industry and audience: "The critics ought to be the *trait d'union* between the manufacturer and the buyer, they ought to turn light on all the issues involved, make the films significant and help the public to see what there is to be seen in them in a stimulating way."[4] Presently, however, colleagues were not performing this role properly: "Though all the daily newspapers give film notes, film criticisms are not on the whole arranged in such a way as to guide the public easily towards the films which the several sections of it would most appreciate."[5] In a lament that we shall see is typical in the literature of the time – but has continued, unabated, as a permanent crisis to this day – Barry complained that the profession remained too close to the industry and too blithely adopted its discourses as news: "what is written about films rather confines itself to fascinating but unhelpful stories about production, comment on the behaviour of film stars, and in fact, matter which is rather personal than critical."[6] Although criticism had become better in the last two years, Barry maintained, formerly "it was no uncommon thing for certain papers to print regularly mere publicity matter exactly as issued by the film producing companies, in place of criticism."[7]

Barry's portrait of a profession too close to the industry and not responsive enough to its other clientele, the public, concluded that this constellation had made critics largely irrelevant. Producers openly advertised films as having the worst press, but best attendance.[8] For their part, most audiences do "not care for real criticism"; anticipating the insights about class, genre, and the influence of critics presented in Chapter 5, Barry intuited that it is "only the smaller special public, which really goes shopping for the best films and plays, which welcomes real criticism."[9] In the face of these "sad" facts, which give "the appearance that films are not worth taking seriously," Barry exhorted her colleagues to exert authority: film reviewers should provide "definite opinions" and "attempt to discriminate" in the vein of critics of the other arts, whose "judgment acts as a crystallizing agent, and it makes the public think twice about what they see."[10] Implying a purpose of criticism that aimed to

advise filmmakers and to educate audiences in an Arnoldian way, Barry instructed colleagues to "lead the producers with constructive analyses of either the matter or the manner of the films they send us" and to "bring to the notice of the public in an inviting way the merits of the best films and the demerits of the worst."[11] Only in such a way could film critics escape their present, low status. Illustrating her point with an imagined anecdote about what would happen if the reader were to meet a film critic (he would not even bother to tell his wife), Barry claimed that despite rising esteem for the cinema, "even now, a certain something attaches itself to the name of the Film Critic, whereas a Dramatic Critic is a grand and eminent person."[12]

Barry's notion of the "Vicious Triangle" vividly illustrates the crises that critics in the 1920s faced in order to assert their authority: there was a sense of being caught between a set of imperatives and fronts. The first part of this chapter deals with one such balancing act: critics' relationship to the industry. How could early film critics be respected by the industry – and even influence production – without sacrificing their claims to objectivity and creating the appearance of complicity in its commercial projects? Wrestling with this question, a permanent feature of film criticism, contributed in this period to the formulation of new modes of criticism, in particular aesthetic criticism.

Part I: The Industry

Early Influence of the Industry and Trade Press

"From the beginning," Sabine Hake writes, "film criticism was defined within an institutional framework that represented economic rather than aesthetic concerns."[13] Indeed, film criticism has always been a service sector, but, rather than consumers, the original task was to guide the industry. A major theme in the earliest film criticism was the advisory mode of guiding the cinema's aesthetic progress. Whether Yhcam in France or Louis Reeves Harrison in the United States, writers agitated for a film criticism that would, in Harrison's idiom in his 1914 trade-paper piece "The Art of Criticism," help the industry to navigate "this new art out of a labyrinth of mediocrity."[14] The German writer and screenwriter Walter Turszinsky's vision of criticism in 1912 was to "influence film poets' and cinema directors' choice of subject."[15] Charged with improving the quality of films, early criticism addressed directors, studios, and exhibitors. This function – to herald and to agitate for better films – would reappear over the years. In 1932, Herbert Ihering would pronounce that it was clear that criticism should help and nourish film.[16] Here, Iris Barry's "vicious triangle" persists; a 1960s cinephile version of this impetus to plea and moan for a better national cinema reappears in Chapter 4.

Because of cinema's origins, the understood task of improving the new medium, and early publication venues (e.g. the trade press), it was perhaps only logical that early cinema "reviews" took cues from advertisements.[17] Moreover, some early writers

felt that cinema criticism was impossible in newspapers, which increasingly depended on adverts for cinema programmes or individual films, for this very reason. A theatre-like, serious "cinema criticism," one German commentator objected in 1912, "would either relieve cinema advertisements of their value, or else contradict them."[18] For its part, the industry initially saw film critics and their early promotional discourses as an ideal buffer against the theatre lobby and moralistic cinema reformers; production companies set up public relations departments that sought to influence critical opinion.[19]

Arguments for Proximity to the Industry and Authority via Influence and Technical Competence

Despite such studio machinations, some critics insisted on good relations with the industry and close knowledge of its practices. One of the powerful arguments for maintaining close ties was, in fact, to preserve authority among industry professionals. Hans Siemsen, a colleague of Rudolf Arnheim at the leading German arts weekly *Die Weltbühne*, maintained that critics' lost enthusiasm for formerly constructive relations with the studios only forfeited their influence on improving productions and actually precipitated perceptions of a crisis of criticism.[20]

Another strong charge regarded incompetence: surely, some commentators argued, critics without close ties to the industry and insider technical knowledge had no basis to judge the merits of the new medium. One major source of such views was, unsurprisingly, the industry itself. Aligning themselves with the studios, trade paper writers became another group who disagreed with those advocating a more independent criticism. This triangulation, reminiscent of Barry's, sometimes became a rivalry: both groups sought to assert authority vis-à-vis their proximity or distance to the industry.

Although such attitudes and debates would climax in the 1920s, they were already anticipated much earlier. In 1911, the American trade paper *Moving Picture World* noted suspiciously the emergence of film reporting and criticism in mainstream publications in an editorial, "Film Criticism in the Lay Press."[21] Observing calls from exhibitors that drama critics cover local cinema programmes, the industry organ remarked ironically that it did eventually "expect to see the lay press take up the work of criticizing the films and in that way relieve us of a very monotonous and thankless job."[22] Nevertheless, such reporters, untrained in the mechanics of the photoplay, would deliver criticism "of very little value to the exhibitor who is asking for the innovation."[23] The editor cited as an example a notice from the Albany *Evening Journal*: filled with "mock heroics," the write-up's dumbed-down style reflected the mainstream press's ill fit to the purpose of criticism. Such local press, *Moving Picture World* claimed, would have little resonance beyond the circumscribed limitations of parochial print circulations: "The film critic's powers will be, so far as the exhibitor is concerned, limited to his own locality."[24] This is a prediction that, we shall see in

Chapters 5 and 6, finally came undone in the days of Roger Ebert, national syndication, IMDB, and Rotten Tomatoes.

"We shall be glad when the day arrives when we can copy directly what the *New York World* critic says, or the *Times* or the *Herald*, and pass it on to our readers in States far away," the piece continued.[25] The poor quality of the mainstream press's criticism surely pertained to the medium's poor exemplars hitherto. "When the films are uniformly better and finally attract the attention of the metropolitan press," the article prognosticated, "those great newspapers with a subscription list near the million mark may do something in the line of criticism that will be of service."[26] Even then, however, mainstream critics would never have the authority of their colleagues on the arts and theatre pages: "the film critic of a metropolitan paper will never be able to work as much havoc in the picture trade as he has done before in the theatrical line," where "the dramatic critic has done, or undone in the past, many productions costing thousands of dollars."[27] Until that day, the trade press would remain the most important and most influential source of writing on film: "There must still be an authoritative paper that goes everywhere, in order that the exhibitor may know what is coming to him, and that paper we expect will be, as it has been in the past, the *Moving Picture World*."[28]

The trade papers, once venues for proto-criticism, epitomized the uneasy balance that early film writers struck between catering to the industry, their ultimate paymasters, and pampering the delicate, infant art. These conflicting roles saw the authors both promoting and evaluating in equal measure and assuming the perspectives of both the producers and consumers. Such double-positions were becoming all-inclusive (if not schizophrenic) by the time that film was more widely accepted as a popular art. This was all too evident in the hybrid publications being founded. The 1919 programme of *Film-Kurier* declared that "the main task of this new daily newspaper will be to inform audiences about all trends in cinematography, and to convert wider circles to the young art form." Nevertheless, it also claimed to do double duty: "In addition it will serve as the main newspaper for the entire film industry, reporting on a daily basis about everything that might be of interest to the professional."[29] *Film-Kurier*'s attempt to maximize its readership proved successful commercially; by the end of the 1920s, it had one of the highest circulations among European film magazines.[30]

Internationally, other new publications followed *Film-Kurier*'s mixed model, balancing the recognition of film as an art with canny business sense. In the United States, *Film Spectator* was founded on such principles in 1926. In its first issue an editorial declared independence from studios' concerns and influence and foregrounded intentions to deliver an autonomous criticism. "No art has flourished except on criticism," editor Welford Beaton wrote, asking "What publication in America today is carrying intelligent constructive criticism of the art of picture making?"[31] Nevertheless, in the very same article, Beaton described the magazine's "basely commercial" purposes. Although *Film Spectator* would pursue a close analysis of cinema's emo-

tional, popular appeal with insights into aesthetic features and "has not the remotest interest in the private lives of motion picture people" and other such gossip, the trade paper ultimately hoped to instruct industry leaders on how to profit from such insights.[32]

Such business-friendly stances would come under increasing attack, however. The rivalry between the trade and mainstream press only intensified in the 1920s with the blossoming of film criticism at national newspapers and arts and political weeklies. For Willy Haas, screenwriter for films such as G.W. Pabst's *Die freudlose Gasse* (*The Joyless Street*, 1925) and reporter for *Film-Kurier*, mainstream critics in 1922 were inexperienced novices, interlopers who lacked "practical empiricism, the sophisticated-mild look for clean entertainment; even the best among them are hard, abstract Robespierres, blood-thirsty-innocent advocates of a transcendental artistic ideology of virtue."[33] Pointedly aiming at aesthetes and moralists alike, Haas shot at colleagues such as Ihering, Arnheim, or Balázs, who urged a critique of the finished product rather than, in the words of Ihering, judging with a calculus of the production costs in mind. Haas pursued a criticism that took technical craft and effects into account. Reviewers who lacked professional experience in the industry – "highbrow-literary colleagues who file their consummate film ignorance as arrogantly as possible in some weekly" – might as well step aside; such a critic focuses "only on the facts, never on the possibilities: because he does not know them, cannot know them."[34] Hans Siemsen, once a vigorous opponent of Haas, concluded in 1925 that there was indeed a problem with critics writing too many "thick volumes about theory and philosophy, about the aims and aesthetic laws of film."[35] Professional, rigorous criticism had to engage with the industry in order to perform its most important function, influencing production: "Real criticism only concerns the work and addresses those who created it and should continue to create."[36]

In a late British example of this phenomenon, Alistair Cooke retrospectively examined the role of the critic and, similar to Haas, bemoaned the pretentious aesthetic and ideological criticism that was divorced from the realities of the industry: "We cannot say at the moment where film criticism ends and literary or political criticism begins because ideas come at us in the movies with all the beautiful confusion of life itself."[37] Implicitly chiding writers such as Hugo Münsterberg as well as the neo-Arnoldians, Cooke maintained that if "a critic is an assessor of something that is presented to him, then we shall have no film critics until the psychologists and the eye specialists get together and tell us when and why we react to such things as double-exposure," movement, dissolves, and other cinematic techniques.[38] "For these are the mechanised units with which the movies attack your nervous system," Cooke remarked ironically, "and leave you a willing sucker for a piece that as a literary product, or an example of the best that is known and thought, is pathetic."[39] Such pontifications, submitted by those without knowledge of "the vital processes of film construction, about the actual moments in a film that give it speed, fluency or what else," contradicted the actual experience of cinema and remained worthless as criti-

cism; "a man may write good philosophy without knowing when to take his meals."[40] As a special, visceral, and emotional form, film demands a close, rather than distanced form of criticism, performed by those with practical experience. Such attacks against critics' authority would become perennial and persistent.[41]

Pace Haas and Cooke, in the 1920s many critics sought to erect a foundation for their authority by creating distance from the filmmaking business and marking a break with the cosy early relationship to the industry. In the mid-1920s, Claude Beylie submits, French magazines negotiated a delicate balancing act between mass and niche-cinephile audiences and between industrial and artistic concerns.[42] A 1925 article by Lucien Wahl, outlining the profession of the film critic, thematized the dangers of industry influence and called for colleagues to remain independent from the business and its discourses.[43] Maligned as "agents of the studios," German reviewers also attempted to engender a sense of integrity apart from the industry.[44] One concrete manifestation of this will for independence and recognition was the establishment of the Munich Film Critics Association in 1922, followed by the Association of Berlin Film Critics in 1923. Guidelines for film critics issued by the national press association that year forbade critics from profiting from or working for producers or exhibitors.[45]

In Britain, C.A. Lejeune responded to charges of incompetence from the local trade press and asserted the need for a separation between critics and the industry. Her 1922 *Manchester Guardian* article on the "Qualities of the Good Lay Critic" both symptomatically betrayed the trade papers' anxieties about the competition from the mainstream press and contemplated the necessity of the critic's practical knowledge and relationship to the industry. Detecting widespread "indignation" in the trades' attitudes towards critics working for general-interest dailies and weeklies, Lejeune noted that the latter have "been labelled ignorant, malicious, prejudiced."[46] She admitted that there remained a lack of practical expertise among the lay press; some pundits even hold the cinema in contempt. "Against the half-dozen film critics who are specialists in their work," she allowed, "one must set the dozens who, their only qualification being a facile pen, are proving themselves the worst enemies of art in service of which they are nominally employed."[47] These dozens, "the men against whom showman and producer alike bear a righteous grudge,"[48] included "the critic who has not troubled to study the technical side of his job."[49] Nevertheless, she submitted, the "good lay critic" is "a very different proposition, and the day is coming when the trade may well find him a friend in need."[50] Similar to Iris Barry, Lejeune saw the function of the critic as one of an intermediary between the industry and the audience, rather than a spokesperson for the studios. "This is where the lay critic can be of immense service," Lejeune concluded, "acting as interpreter between producer and public, guiding the taste of the impartial, and bringing to the notice of the cynic beauties of acting and production which left to himself, he would wilfully ignore."[51] In later years Lejeune would be less diplomatic about the critic's relationship to the industry and the need for critical independence. In an ironic 1939 self-dialogue called

"Me to Myself," she treated the question of "what could be done to improve the standard of pictures." In her answers she attempted to assert her (and other critics') authority against film producers, who "have one major obsession," that they "think they know what the public wants in pictures" but, in fact, "haven't the vestige of a notion."[52]

Aesthetic Criticism as Assertion of Authority vis-à-vis Industry

In light of a growing consensus that film criticism must deploy an idiom distinct from industrial business language, aesthetic criticism became a key method. As discussed, a formalist, aesthetic criticism represented one efficient way to distinguish film criticism from theatre criticism. Unlike programmatic statements, simply performing aesthetic criticism, (i.e. describing or evaluating a work based on film's unique formal properties such as editing), both fulfilled the review's evaluative function and implicitly argued for the medium's unique status. By the early 1920s in France, several prominent critics – including Louis Delluc, Émile Vuillermoz, Léon Moussinac, and René Clair – were writing in proto-auteurist veins; the aesthetic concerns of the work's unity, coherence, and creative innovation became chief principles of evaluation in their reviews of individual films.[53] Although they would proliferate quickly in the 1920s and contribute to a perhaps unparalleled rich Parisian cinephile culture, these efforts came later than the German formal-aesthetic treatises initially formulated by Hermann Häfker, Herbert Tannenbaum, and others in the early 1910s in response to the theatre-cinema quarrel.[54]

In self-reflexive articles throughout the 1920s, critics actively reckoned with industry interference; many, such as Herbert Ihering, agitated seriously for the autonomy of film criticism, both as a discourse and as a profession, and for aesthetic criticism as a means to indicate this autonomy. Ihering was critic for the national daily *Berliner Börsen-Courier*; together with (but perhaps at the time more so than) Siegfried Kracauer, he was the most esteemed German film critic in the 1920s, an authority that he achieved perhaps from his background in theatre criticism.[55] One of Ihering's most important themes was his proposal of aesthetic ways of seeing as an antidote to the industry's commercial visions; he defined criticism, let us remember, as "the inner drive to grapple with the principles of an art."[56] "Every time someone pans a film, the cinema people say: film is an industry, not literature [...] film should be understood in the light of audiences' needs, not via theatre aesthetics," Ihering wrote in 1923, remarking ironically that the local industry only complained about negative critiques, when in fact film critics did praise – albeit the competition, i.e. American cinema.[57]

Anticipating Arnheim and Balázs, Ihering countered claims that critics should adopt industrial discourses. Although film is "of course connected to business," the commercial angle is a factor "before the work on the film, not afterwards." According to Ihering – explicitly rejecting procedures deployed by contemporaneous colleagues such as *Film-Kurier*'s Willy Haas and "the lion's share" of film critics, who "mentally

calculate the production costs into their opinions," releases should be judged on their artistic merits as products, not processes: "Afterwards the film is finished and subjects itself to independent evaluation as to whether the effort for this object, for this subject, for this performance was worth it."[58] In addition, part of his motivation in founding the Association of Berlin Film Critics was precisely to demarcate colleagues' activity from "obliging ad copy writers."[59] It and the Imperial German Press Association's 1923 guidelines were "created for film criticism so that it is not pushed aside by impure elements."[60] The Association embodied and formalized the general sentiment that the profession should operate distinctly from the industry; it signalled the disapproval of studios' attempts to punish recalcitrant, outspoken, other otherwise uncooperative critics.[61]

Ihering's case reveals critics' sensitivities to industry opinions and perceived doubts of their lack of authority to speak as an expert about film. Balázs's 1924 deliberation on "Industry and Art: A Justification of the Film Critic" reveals similar anxieties. There Balázs responded to both the studios and commentators such as Haas, defending aesthetic criticism and defying calls to treat film solely as a technical object and commodity. Specifically, he answered charges from "someone" named Pollack, in "some newspaper," who, "in the name of the 'industry'," claimed that Balázs "knows nothing about film" and that film critics were "superfluous and damaging and have no right to exist."[62] For Balázs, such interlocutors spoke not in the name of the filmmakers, the cast or crew; they represented the interests of the cinema lobby, the distributors, and the exhibitors. "And if these gentlemen are of the opinion that I have no idea about *their* business, they are absolutely right," he wrote. "Their industry interests me just as little as it interests the public. We judge only the *production*, the film itself, and are entitled to that opinion," he continued, giving as evidence for his understanding of production and right to form an educated opinion "the articles that via my film dramaturgy 'Der sichtbare Mench' have been published in the German, Swedish, Dutch, French, and English *film trade press*."[63] In this passage we see Balázs asserting his authority against – but also via – the industry: he is autonomous of its needs and pressures but nonetheless argues for the relevance of his knowledge and pronouncements based on his usefulness to the trade press.

Above all, however, Balázs appealed to *audiences'* preferences: "The public does not tend to recognize the distributor and cinema owners as the ultimate instance in questions of film art, just as little as it would recognize the decisive competence of the book store owner in questions of literary taste."[64] Complaining that his Viennese complainant's views would have never merited discussion in Germany, France, Scandinavia, England, and America, in which countries "the most reputable authors work in service of film criticism," he remarked that the "future of film art" depends on the "critical formation of taste."[65]

In film theory circles today, with few and recent exceptions, Rudolf Arnheim is understood as a quintessential formalist.[66] Nevertheless (and to whatever extent this picture is actually much more complex), it is important to understand that Arnheim's

first self-reflexive formulations of a formalist take on cinema came in the context about debates about *criticism* and, in particular, aimed to dispute competing claims that critics should dwell on production histories and technical knowledge. His 1929 piece "Professional Film Criticism," originally published in *Die Weltbühne*, pled for an aesthetic criticism that assumes the authority of the critic's judgement, rather than a forensic report or reconstruction of the production process.

The article asserted the critic's autonomy from the production process and his or her authority over the interpretation and evaluation of film vis-à-vis industry insiders. "Film professionals – actors, directors, producers, and manuscript authors – assume," Arnheim lamented, "the same attitude of amused resignation toward remarks by film critics that people adopt when children, the sick, or the elderly – people who don't know any better – talk nonsense."[67] Arnheim rejected the industry's condescending treatment of critics and its territorialism in regard to the technical tools of the trade as "unjustified insofar as the professionals believe that the average film critic, who works behind a desk and not in a studio, lacks the necessary basic technical knowledge," yet, Arnheim claimed, "there are few film critics who lack this most basic knowledge."[68] Filmmakers' more serious charge was that critics evaluate films as aesthetic products without taking into account the economic and biographical vagaries in play during production. "The question," Arnheim summarized, "is whether a work should be accepted purely as a finished end product and evaluated accordingly, or whether one should take into consideration the process of its production, and whether the artist was in full, unencumbered possession of his means."[69] In this, Arnheim treated a problem that had "only become acute with film," that is, a dilemma for the new branch of film criticism; painting, music, or poetry observed significantly different laws of production, exhibition, and consumption.[70]

According to Arnheim, there are epistemological problems with "studio criticism." The reviewer would have to ascertain insider knowledge about which individual was responsible for which portions of the finished product, "have intimate contact with the producer," and be "constantly informed about the internal-political relationships."[71] Perhaps the greater dilemma, however, would be that such investigations would force the critic into speculating about the authorship of films in a way that would compromise his ability to assess the object without influence from the studios: "one should remember that the critic's main task is to evaluate the finished work without prejudice – and if someone is too closely involved with the making of something, he cannot respond to it objectively."[72] In his boldest statement of critical authority in the silent film period, Arnheim proposed an aesthetic, formalist criticism as the only way to preserve the autonomy, and thus status, of the film critic: "The film critic is meant to function here as an impartial authority. If he, too, is forced into the production process, there is no real authority left to differentiate good from evil."[73]

Although "Professional Film Criticism" implied that aesthetic criticism was necessary because of epistemological and ethical dilemmas and the ways in which "studio criticism" undermines the authority of the critic vis-à-vis the industry, it did not

relinquish early film criticism's implied function to assist the industry in delivering better product. Thus, Arnheim recommended that whether the faults lie in a poor screenplay, blurry cinematography, or miscast actors, the "film critic sticks to the results, and the producers know amongst themselves who the scapegoat was."[74] Rather than treating a film as an "individual achievement," the critic should both look at micro-level subtleties to measure progress and "ought to find out where the error lies and how it could be avoided in the future," differentiating between the coincidental and the typical.

> The film critic sees the film production of the entire world as a unified work in which each individual piece has its place; it is the critic's task to identify that place. He may leave hundreds of films unmentioned, since they are industrial mass products; where, however, there is an instructive example or an instructive error, he must intervene. For the critic should not give grades. Grades are immaterial. He should help navigate.[75]

Part II: The Audience

Early Didactic Imperatives

In France, Britain, Germany, and the United States, education and morality informed discourses on the cinema from its beginnings.[76] Expressed in cinema reform movements and battles over censorship, such debates also led to the establishment of film-specific magazines. In the United States, for example, the National Board of Review and their organ *Exceptional Photoplays* were established to circumvent state censorship by bureaucrats and instead create a basis for constructive film criticism developed and disseminated by "enlightened men of taste."[77] Previewing the impetus and strategy of other 1920s social critics such as Siegfried Kracauer, Alfred Kuttner claimed in *Exceptional Photoplays* that film is "first and foremost the expression of a particular culture from which it derives its deepest significance."[78] The public was a key stakeholder in evaluating the dimensions and standards of cinema.

Crucially, such discussions about the purpose of criticism dovetailed into deliberations over the proper relationship between critic and audience. One major stream of thought in this debate – and the current that dominated the earliest proper film criticism in the first years of the 1910s – largely borrowed the ideas and tropes of eighteenth and nineteenth-century arts criticism, from Lessing to Arnold. According to these commentators, such as Alfred Mann in 1913, the film review had an essential "pedagogical function: to help audiences to find the standards of taste by which to judge the quality of films and recognize artistic value."[79] For Roland Schacht, to cite another German example of the early didactic impulse, the critic should ideally act as mediator between great works and the uneducated mass public.[80] Louis Reeves Harrison, the American writer for *Moving Picture World*, saw in film a similar Arnoldian

possibility in 1911; the medium might uplift the tastes of the masses and fulfil a function that fine art had for "the selfish class."[81] For some, this task was most urgent in the field of cinema, which often indulged realms of invention and fancy. In the face of such romanticism, Adolf Sellmann claimed in his 1912 monograph *Der Kinematograph als Volkserzieher?* that "we need people with bright and clear eyes and a practical sense for reality [...] not careless people who in their thoughts and desires live in a fantasy world."[82] For Sellmann, the "undiscriminating audience" should be guided to have better taste. Through laws of supply and demand, he and other commentators argued, critics training audiences would lead to studios' production of improved films in the long term.[83]

Such positions recall the historical image of the critic in the bourgeois public sphere as articulated by Jürgen Habermas. Marked by their expertise and specialist knowledge, critics functioned as both members and leaders of the public sphere's opinion formation; critics were simultaneously representatives and teachers of the public.

> In the institution of art criticism, including literary, theater, and music criticism, the lay judgment of a public that had come of age, or at least thought it had, became organized. Correspondingly, there arose a new occupation that in the jargon of the time was called *Kunstrichter* (art critic). The latter assumed a particularly dialectical task: he viewed himself at the same time as the public's mandatary and as its educator. The art critics could see themselves as spokesmen for the public [...] because they knew of no authority beside that of the better argument and because they felt themselves at one with all who were willing to let themselves be convinced by arguments.[84]

This identity contains serious internal tensions. Already in this chapter we have seen examples of the tenuous and contradictory positionings of critics, such as Iris Barry's triangular model. These tensions are particularly pronounced in film criticism and betray fundamental paradoxes in the establishment of the field. Film was understood as an art with specific formal properties to be learned and applied, but nonetheless as a popular medium of universal comprehensibility. Cinema was supposedly addressed to a wide public and, furthermore, in its earliest forms was primarily consumed by the working classes. Yet, criticism – as Barry intuited – was (and is) largely consumed by middle-class audiences.[85] How to balance these contradictory imperatives and negotiate a proper relationship to the audience that takes into account film's special "democratic" status – while nevertheless maintaining authority? This question shaped early film criticism's crisis.

Democratic Positionings for the Authoritative Critic

In the comments of Arnheim, Balázs, Barry, Lejeune, and others above, we see how early film critics attempted to establish critical authority and enumerate its proper-

52

ties vis-à-vis the industry. These efforts, as we have seen, were often triangulated with a third entity: the public. Moreover, the question of the critic's relationship to audiences became more exigent for many early commentators because of film's status as a "democratic art."

Although the acolytes of the Lessing-Arnold traditions would nervously claim that film's popular nature demanded an influential, pedagogical criticism, others saw utopian possibilities for the mediation of the new "folk culture."[86] For the early American film trade columnist W. Stephen Bush, writing in 1913, "film has practically abolished the numerous and envious distinctions of price and class in all the playhouses where it holds exclusive sway."[87] Nothing "in our modern civilization has done more to emphasize the brotherhood of man than the motion picture," Bush continued, suggesting that cinema's triumph in America and the hostility it encountered abroad, in "autocratic countries like Russia" and "backward" nations such as Austria, "is due to its enlightening and leveling influence."[88] Such comments, that "the motion picture has emancipated the gallery," were typical, in America and elsewhere.[89] Some scholars have even pointed to Hugo Münsterberg's 1916 seminal treatise on the cinema, *The Photoplay*, as a symptomatic step in this vein; its emphasis on perception and how the spectator's brain pieces together visual cues might be seen to give power to the audience over genius authors or taste-making critics.[90] Furthermore, if contemporaneous utopian polemicists such as Vachel Lindsay would have had their way, in the future film would have its own democratic systems of distribution and critique. In *The Art of the Moving Picture*, Lindsay asked exhibitors to make their cinemas into a "Conversational Theatre" and hand out feedback forms that would require movie-goers to evaluate the film. Citizens could pronounce their opinions on the film in "approved or disapproved" ballot boxes at the door.[91] Lindsay's ballot-box system would at best translate later into studio focus groups and sneak-preview screenings; for professional critics, such methods undermined their authority to speak and be heard. Nevertheless, significant figures would experiment with textual positions that at least appeared more democratic in spirit.

Louis Delluc, the most prominent French film critic of the late 1910s and early 1920s, represents a key example of a positioning between the fronts: courting the audience on their terms in order to establish his right to speak on their behalf. Compatriots such as Émile Vuillermoz established their critical authority via the "high road," that is, by comparing cinema to the fine arts; Vuillermoz used his background as a music critic in order to demonstrate his right to educate the public.[92] In contrast, Delluc celebrated cinema as an art of the common people; his mode of address used the pretence of speaking of the people, for the people, suggesting rhetorically that he was an anti-critic: "I have learned long ago not to want to do the work of a critic; I am neither heedless nor shrewd enough to assert the faults and failure of the spectacle," Delluc wrote in 1917. "It is from the crowd actually that I gather my best impressions and the clearest judgments."[93] In the manner of Gilbert Seldes and Pauline Kael, Delluc sought to differentiate himself from elitist, didactic critics – even as he himself

derived from this populist stance the right to speak in those authoritative terms. Delluc's gambit is explicitly anti-Arnoldian. He does not want to educate the masses; rather, he receives his ability to discern *from* them. Furthermore, and again in anticipation of Kael (see Chapter 5), in practical terms this meant a reviewing practice that registered and recorded an engagement with real audiences and their reactions to film. "The source of Delluc's authority," Richard Abel notes, "lay not so much in an aesthetic or moral standard but in the audience, the crowd."[94]

Delluc's "democratic" establishment of critical authority is expressed programmatically in "The Crowd," first published in a 1918 *Paris-Midi* column and then expanded in 1920 for his book *Photogénie*.[95] In the piece Delluc protocolled the diverse groups and classes of audiences at screenings in various Parisian districts, including "barkeepers, charcoal sellers, cinema proprietors [...] mechanics, pimps, laborers, and women warehouse packers."[96] Delluc's strategy compared the reactions of middle-class and working-class audiences, implying a greater authenticity and truth to the latter. After listing the preferences of the "cinema managers present at the Pathé preview" of Abel Gance's *La Dixiéme Symphonie* (*The Tenth Symphony*, 1918) and revealing that he himself prefers "Séverin-Mars's hands on the piano [...] and his pensive and passionate sobriety," he contrasted these views with the public: "But what I like is not what they like."[97] Important here is Delluc's implied stance as middle-class and not directly of the crowd, but nonetheless especially able to understand and appreciate their tastes. This – and Delluc's experiences of "slumming it" – enabled him to speak to and for a wide range of ostensibly working-class but, more likely, middle-class readers. "In a frightfully little cinema in Clermont-Ferrand," Delluc wrote, "I have seen what is called the popular sensibility." Applauding cinema's ability to expand "the taste of the masses who have been so resistant to letting themselves be cultivated by any of the other arts," Delluc suggested that, by comparison, the working-class audience was able to follow, understand, and appreciate *Alien Souls* (1916) better than the middle-class elite: "The same film which I had seen in an elegant cinema in Paris had caused people to smile. And it is the elegant cinema that got it wrong."[98] Although Delluc's rhetoric gives voice to lay audiences' reactions and thus suggests an alliance with the masses, we must be realistic about how his partially self-deprecating reviewing practices nevertheless endeavoured to inscribe films with a single, true meaning, to praise (in a condescending, pedagogical way) cinema's effect on the masses, and to reassert his own legitimacy to act as the audience's ultimate mediator.

Gilbert Seldes's attitude towards the public evinced similar contradictions. In the United States in the 1920s, Seldes, who wrote widely for arts and political magazines such as *The Dial*, *Vanity Fair*, and *The New Republic*, came to embody the possibility of an influential, "democratic" critic, programmatically presented in *The 7 Lively Arts*, originally published in 1924.[99] That book maintained, in part, that film and the other "lively arts" are at least as important as the traditional "major" arts and that they move more lives. This fact means that they deserve criticism, but also require a dif-

ferent critical stance towards the public. The "lively arts have never had criticism," Seldes claimed, arguing that there are "good professional critics in journals like *Variety*, *The Billboard*, and the moving-picture magazines – some of them. But the lively arts can bear the same continuous criticism which we give to the major."[100] Recollecting his aims in 1957, Seldes explained that "the critics had been snobbish about these things, and it was my point precisely that everyone's taste was, in these matters, surer than the critics' judgment. I thought of myself as *un*- not *dis*-covering merits in what was, by definition, popular, hence well-known."[101]

According to historian and biographer Michael Kammen, Seldes "came of age at a time when aspiring critics confronted a decline of traditional cultural authority" and a "major portion" of his "success and prominence, in fact, resulted from the diverse way in which [he] responded to that waning of cultural authority – exemplified by the dissipated genteel tradition – as an opportunity to reformulate the nature and thrust of expository criticism."[102] Indeed, Seldes's response to the perceived decay of authority in the 1920s was ambivalent at best. At times he called for the public to respect pundits; at others he scolded commentators who tended to whine excessively and express opprobrium unfairly. At still others he opined, anticipating today's death of a critic discourse, that the greats were all gone: "critics of a generation ago who, working largely through newspapers, broke down certain barriers which had hampered the artist, or proclaimed the advent of new creative forces [...] have almost all ceased to write criticism."[103] In a much later article, entitled "Are Critics Necessary?," Seldes's position between the fronts presented an almost unsolvable riddle. In that piece he simultaneously argued for critical authority but also for democratization, claiming that "the critic is the only true believer in democracy" and wanting to participate in establishing "a nation of critics."[104]

Seldes's belief that pop culture could be "democratic *and* distinguished"[105] reflected this perhaps untenable ambivalence in his concept of critical mediation: his programmatic statements that everyone could be a critic were contradicted in practice by his reviewing. This tension, as well as his indictments of "arty conglomerations of middle-high seriousness and bourgeois beauty"[106] and "the shift of all entertainment into the area of big business,"[107] previewed Pauline Kael's stance, a subject of Chapter 5: the creation of critical authority by implying a democratic equality between the critic and the reader, a conspiracy often bonded at the expense of "the industry" or "the elite," which the critic paints as their common enemy.

Star Critics, Subjective Modes, and Sociological Criticism

Louis Delluc and Gilbert Seldes point ahead to Pauline Kael in a further, significant way: both were recognizable critics. Indeed, in the late 1910s in France and by the early 1920s in Britain, Germany, and the United States, the first "star" reviewers emerged in the respective national mainstream press, a phenomenon which complicated critic-reader relations. In the early days, few writers on film were known outside of small trade coteries; this was compounded by the fact that reviews went

unsigned or were published with fictitious bylines. The establishment of regular re-
viewing in the national dailies, however, changed the situation and by the early
1920s, some journalists were able to more or less sustain an independent status as
film reviewers or editors of film sections.[108] Such prominent reviewers included Del-
luc (*Paris-Midi*), René Jeanne (*Le Petit Journal*), Lucian Wahl (*L'Oeuvre*), Léon Mous-
sinac (*L'Humanité*), and J.-L. Croze (*Le Petit Parisien*) in France; Kurt Pinthus (*8-Uhr-
Abendblatt*), Herbert Ihering (*Berliner Börsen-Courier*), Hans Siemsen, Kurt Tuchols-
ky, Rudolf Arnheim (all three contributed to dailies and *Die Weltbühne*), Siegfried
Kracauer (*Frankfurter Zeitung*) in Germany and Béla Balázs (*Der Tag*) in Austria;
C.A. Lejeune (*Manchester Guardian*, later the *Observer*) and Iris Barry (*Daily Mail*,
The Spectator, Vogue) in Britain; and Robert Sherwood (*Life*), John Farrar (*Bookman*),
Clayton Hamilton (*Theatre*), Alexander Bakshy (*Theatre Arts Monthly*), Seymour
Stern (*Quill*), and Gilbert Seldes (*Vanity Fair, The New Republic*) in the United States.

As film criticism established itself in the dailies and in the middlebrow weeklies
and monthlies, editors allowed, and in some cases actively encouraged, critics to
develop subjective modes or distinctive personalities. Apart from enabling empa-
thetic connections between pundit and reader and an authoritative basis for that
writer's pronouncements, editors also hoped to engender a loyalty that might trans-
late into improved circulations and sales in an increasingly crowded and competitive
publishing sector.[109] The star critic had long been a trope in theatre criticism (as
evidenced above in the early *Moving Picture World* editorial on "Film Criticism in the
Lay Press"). In the context of the artistic ambitions of 1920s cinema, both critics and
editors wanted to realize the drama critic's pretensions to "make or break" produc-
tions with more idiosyncratic and "artistic" criticism.

One such subjective mode was socially attuned criticism, which put paid to earlier
attempts (such as Delluc's) to bind the audience into the critic's fundamental work
and thereby reconfigure didactic and triangular models. To be sure, moral criticism
had long been a feature of cinema discourse; in all cultures under examination here
there is a tradition of claims, such as those by the French Catholic *Le Fascinateur*,
that the impressionable "will find it difficult to resist the temptations" presented by
cinema.[110] Furthermore, the organs of church, trade unions, and political parties
tended to see film as a reflection of society tinted through their respective ideological
lenses. This led, for example, a Communist Party of Germany pundit to claim that
"arts criticism is important foremost as the critique of society and only secondarily as
aesthetic critique," taking the polemical "democratic" position that "the criticism of a
'dilettante' from a sociological perspective can be less dilettantish and more profes-
sional than the criticism of a sociologically clueless professional critic."[111]

Such views justified authority via methods of criticism that purported to under-
stand readers, their experiences, and their desires. Formulated more forcefully in the
middle to late 1920s and early 1930s by Siegfried Kracauer, Béla Balázs, Jean Galtier-
Boissière, Harry Alan Potamkin, Rudolf Arnheim, and others, these modes sought to
replace or rebalance the attention to aesthetics that had been an essential step in

56

professionalizing film criticism only years before. Referring to films as "the mirror of the prevailing society,"[112] Kracauer charged the "adequate film critic" with the task of "extrapolating from mainstream films other social intentions that often assert themselves very inconspicuously" and pointing out "the image of society that innumerable films promote."[113]

Whereas a few years before it had been necessary for critics to identify elements of cultivation and sophistication, by 1932 Kracauer readily admitted what the old enemies of film and its criticism had always maintained, i.e. that film was a capitalist commodity: "With the exception of a small number of outsiders, producers make films neither in the interest of art nor to enlighten the masses but for the sake of the profits they promise to yield. This observation applies, in any case, to the great majority of films that the critic reviews."[114] This fact, argued Kracauer – the author of some two thousand articles on film and other subjects for the influential left-liberal daily *Frankfurter Zeitung* from 1921 to 1933[115] – calls for a different approach to mainstream films but also to the constellation of critic, industry, and public. "The film critic of note is conceivable only as a social critic," Kracauer wrote in a formulation that would have a decisive bearing on film criticism for decades to come, as we shall see explicitly in Chapter 4. "His mission is to unveil the social images and ideologies hidden in mainstream films and through this unveiling to undermine the influence of the films themselves wherever necessary."[116] Taking leave of early criticism's promotional and didactic imperatives, Kracauer's prescription for the critique of mainstream film implies a critic's role of speaking – via the dissection of film and its industry – to the audience about itself. This constitutes a significant realignment of Iris Barry's "vicious triangle."

Conclusion

By way of conclusion to this period in film criticism, I would like to emphasize two points. First, Chapters 1 and 2, in their examination of early film criticism and the crises attending the establishment of the activity and profession, have challenged the view proposed by Haberski and others that early film writing represented a smooth birth of critical authority that would be steadily undermined. Instead, I have argued that this period, the origins of film criticism, presented scenes of crisis that previewed subsequent concerns. Establishing film as a worthy object of critique; comparing or contrasting film to other arts in order to justify its cultural import or aesthetic value; invoking authoritative critics from the past; broaching questions of objectivity and critical distance; defining and policing the profession; negotiating the relationship to the industry; grappling with the ability to influence and lead opinion; functioning as both an avatar of and mediator for the public: these themes recur again and again in the history of film criticism right up to the present debate. In the postwar period examined in Chapters 3 and 4, for example, such crises returned. The next generation struggled to define and practice proper criticism and used the early

critics and preferences as authoritative (or demonized) figures and canons on which to base or distinguish their own assertions of legitimacy. In both of these case studies, we shall see how the imagined vanguard position of French film culture – to some extent already visible in this chapter – functioned as a point of departure for these deliberations.

Second, it will no doubt strike readers that this chapter dwells on some figures now canonized as seminal theorists, including Arnheim, Balázs, and Kracauer, who all began their professional careers as reviewers. On the one hand, this demonstrates the degree to which these writers were prone to self-reflection – not only on film as a medium, i.e. composing film theory – but also on their day-to-day practice as culture journalists.[117] On the other hand, their position in this narrative works to show how the discourses of film criticism and film theory have criss-crossed since their beginnings. This fact represents a further challenge to the many commentators, including McDonald, who posit a historical caesura in the 1960s on this issue. Canonical "theorists" have evaluated film within the institutional context of journalistic practice at the same time that they were setting out the basic principles and parameters of the medium. In addition, it should be noted that a number of these early critics were also deeply involved in practical filmmaking and the moving image industry, a fact that certainly contributed to the ambivalent attitudes to the industry. These figures included Balázs, Bryher and the *Close-Up* group, Delluc, Jean Epstein, Haas, Seldes, and Woods – not to mention Sergei Eisenstein, Dziga Vertov, and filmmaker-theorists from outside the immediate geographical parameters of this study.

Several scholars have highlighted the need for approaches to figures such as Kracauer and Arnheim that take account of where and how their writings were initially composed and disseminated. "The respective structural conditions, for example the daily film critic's constant time constraints or the publisher's economic interests in cinema advertisements," Helmut Diederichs reminds us, "influence the form and quality of criticism."[118] The film theory of this era, Gertrud Koch has written, "has a particularly delicate status: it was almost exclusively written by authors who had worked as film critics, who [...] developed their theories from actual viewing and reviewing practice"; these are film theories "based on the moviegoer's notebooks and diaries."[119] In general, Helmut Stadler notes, studies on Kracauer suffer from methodological errors: authorially and textually fixated, they ignore that Kracauer was bound to institutional limits and specific production and reception conditions, which also affected content, form, and style.[120] Even those seeking to understand Arnheim in the context of a history of ideas, Eric Rentschler maintains, would be best served to pay attention to his reviews: "Arnheim's early criticism both enriches and complicates our reading of his subsequent film theory."[121] Elsewhere, I have made this point about Balázs and how even his formalized books of "theory" came recycled and paraphrased through reviews written for daily newspapers in the course of a freelance existence.[122]

The scope of this chapter has not allowed me to elaborate on such concerns to any great depth; although subsequent chapters will more forensically dwell on these matters, here I have only had the space to gesture to these facts. Nevertheless, this book's very act of contextualizing Arnheim, Balázs, and Kracauer within a profession and activity that includes Lucian Wahl, W. Stephen Bush, Herbert Ihering, Penelope Houston, Pauline Kael, Rex Reed, and Armond White – rather than, for instance, Christian Metz or Peter Wollen – represents in itself an intervention. It is hardly controversial to suggest that early writings on film are concerned with asserting film as an art (indeed, it is the conventional wisdom from venerable experts such as Noël Carroll). Nevertheless, in a film studies context – where such texts are routinely anthologized in readers and primers – the point does need to be made that such pronouncements were not being made primarily in ivory towers, but rather in mass-media practice. These were daily, weekly, or monthly repeated performances of the assertion to speak legitimately and authoritatively to the public about the young medium.

In this sense, I will end this chapter with a mention of André Bazin, who represented both a film critic-theorist in the tradition of Arnheim, Balázs, and Kracauer, but also served as a bridging figure between the first generation and the postwar generation that will feature in Chapters 3 and 4. Bazin partook of the rich interwar French film culture, which linked him to Louis Delluc; his 23 March 1949 column for *Le Parisien libéré* on Delluc, whom he called the "patron saint of film criticism," also attests to the way in which film critics quickly constructed and used the *history* of their profession – once it existed – and their father and mother figures as a way to define themselves, in comparison or contrast. In turn, postwar French critics would use Bazin and his contemporaries but also his generation's film directors as role models to be venerated or Oedipal demons to be exorcized.

Bazin had much to say about the purpose of the critic and his or her role vis-à-vis the reader. He deliberated on the "liberal" and "authoritarian" approaches to audiences, their potential risks (including "intellectual disorder"), and advocated a compromise of an "open authority" that provides the audience with the "illusion of critical freedom."[123] He also addressed the essential balance between aesthetic and industrial concerns in reviews, the critic's need to have at least "a minimal technical competence," and the necessity to critique film in formal terms.[124] Many of his comments echo quite closely the positions taken in the 1920s and 1930s, such as those found in Arnheim's 1935 essay on "The Film Critic of Tomorrow."[125]

One of his most direct approaches to the topic, however, which will lead naturally to the concerns of the next chapters, came in a 1943 article, entitled "Toward a Cinematic Criticism." Remarking that film criticism is only read by a sophisticated urban minority, Bazin nevertheless argued that it remains "indispensible to the development and future of the cinema."[126] Although the influence of critics is "weak and without proportion to its object," it is steadily increasing: "Certain film columns are attracting increased readership, and their authority is becoming established."[127] The

side effect of these authoritative critics' efforts is, Bazin maintained, the creation of an "elite of film-lovers capable of judging what is offered them."[128] The crystallization of knowledge and taste in this cinephile coterie who were wresting sole control from the industry's "few knowledgeable technicians" was vital to Bazin; "the crisis of cinema is less of an esthetic than an intellectual order" and "no art, not even a popular one can do without an elite."[129] The column closed with a call for the "establishment of a certain specialization of criticism," a type of writing "in journals no longer aimed at the average man but at the knowledgeable film-lover; addressing itself to connoisseurs, it would by definition no longer have to sacrifice to snobbism."[130]

That "snobbish" journal, of course, would be *Cahiers du cinéma*. Its tone and style, its mode of communication with its readers, and its blithe assertions of authority – as we shall see in the following two chapters – would both influence the course of film criticism and produce extreme reactions, the next flare-up in the permanent crisis of criticism.

3. The Institutional Assertion of Authority: *Sight and Sound* and the Postwar Cinephile Challenge

The first chapters have chronicled the early crises of criticism and critics' responses: attempts to assert authority with discourses of promotion and distinction, and by defining the critic's proper relationship and proximity to the industry and to audiences. Indicative of contemporary trends, most critics were writing for the trade press or for the arts pages of dailies and weeklies. In the 1930s and certainly by the end of the Second World War, however, government institutions, museums, and other arts bodies had joined the earliest film critics in recognizing the potentials of film in a variety of social activities, including communication, education, the consumption and appreciation of art, and the "democratization" of the vanquished nations. These moves initiated, on the one hand, a broader cultural legitimacy for film and its critical practitioners; on the other hand, it produced competing definitions and imperatives for the critic. At the same time, the "snobbish" film magazines that Bazin had mooted in 1943 were being founded. In turn, as these grassroots movements proliferated and government organizations increasingly funded institutions designed to produce, disseminate, interpret, censor, or evaluate moving images, a more mature film culture developed. A younger generation of critics began posing fundamental questions about the purpose of their profession and film's role in national and international culture. A more educated and confident readership challenged the authority of critics and agitated for its own specific interests and approaches towards film.

With these two phenomena – institutional film cultures and niche cinephile audiences – increasingly at odds, the former needed to re-evaluate their modes of critique and how they addressed their readers. This was, for such institutions and their critics, a new crisis: Once film criticism was established as a recognized organ of national-cultural importance, how could an authority be articulated that nonetheless negotiated a proper relationship to an increasingly sophisticated audience?

The case of postwar British film culture and, specifically, a late 1950s, early 1960s debate on the role of the critic conducted in *Sight and Sound*, but proliferating nationally and internationally, is particularly illuminating in this regard. It was brought to the fore by the challenge of *Cahiers du cinéma* and related cinephile film cultural developments on the domestic scene. At the latest by the release of François Truf-

faut's *Les 400 coups* (1959), the French *nouvelle vague* enjoyed widespread acclaim in international publications devoted to cinema. Even those critics who disagreed over the aesthetic value of the French upstarts wrote in unison about their cultural importance. The filmmakers' *writings*, however, produced a much different response in these very arenas. In the late 1950s and early 1960s, the taste and style of *Cahiers du cinéma* precipitated an international crisis about the function and itinerary of "serious" film criticism and the role of the critic therein. Perhaps nowhere was the critical battle as protracted and vicious as in Britain.

Examining *Sight and Sound*'s "Critical Question," a 1960 reaction to *Cahiers du cinéma* and domestic cinephiles and a self-reflexive programme of institutional criticism, instructs us about the construction of a particular kind of liberal taste that would come to define *Sight and Sound*'s role in the establishment of a broad-church national film culture. Aiming to accommodate the new diverse (or "fragmented") postwar niche audiences, *Sight and Sound* sought a dialogue that would nevertheless define its role as the ultimate arbiter of the conversation and, via canon-building and other means, assert long-term authority.

The Radcliffe Report, *Sequence* and 1950s *Sight and Sound*

In order to approach the crisis that *Sight and Sound* had to resolve around 1960, I need to telegraph key earlier developments that illuminate and anticipate the remit, position, and later reaction of the magazine and its critics. *Sight and Sound* was founded in 1932 by a group of educators as a way to agitate for a more serious film culture. Many of the initial articles advocated a national body to represent and promote film; in 1933, the British Film Institute was established and took over the publication of the magazine.[1] Supported by advertising from the manufacturers of audiovisual equipment, early notices informed readers about BFI activities and promoted its policies; some space was devoted to columns (e.g. written by C.A. Lejeune, Alistair Cooke, or John Grierson) that recommended films.[2] The founding principles of the BFI were to create, between the film-as-entertainment and film-as-art fronts, a third-way film culture based on the medium's potential for communication and instruction.[3]

After a troubled start with heavy interference from the domestic film industry, wartime standstill, a series of debilitating staff departures, and government recommendations in the mid-1940s that the BFI disband, the so-called Radcliffe Report (1948) built momentum for a rebirth and redirection of the BFI – and concomitantly, its publications *Sight and Sound* and *Monthly Film Bulletin*. The report recommended a refocus "on the development of public appreciation of film as an *art form*."[4] The turn towards film as art (rather than mere propaganda or pedagogical tool) and towards film appreciation (rather than instrumentalizing the medium as a visual prop to aid education) entailed direct funding from the government to invest in the National Film Library and its archive collection and loan programme; a new repertory

cinema in London, the National Film Theatre; education outreach and assistance to film societies; and a new film critical culture.[5]

The reinvigoration of film criticism began with the BFI's publications, *Sight and Sound* and *Monthly Film Bulletin*. In 1949, the young editors of the Oxford undergraduate magazine *Sequence* – which had considerable following in the nascent London cinephile scene as the "exciting magazine at the time"[6] and in its thirteen issues between December 1946 and 1952 also attracted contributions from luminaries such as Lotte Eisner, John Huston, and Satyajit Ray – approached BFI director Denis Forman for a grant. He responded by inviting them to take over the editorship of *Sight and Sound*, revitalize the magazine, and make it appeal to a wider middle-class audience.[7] These transplanted figures included Gavin Lambert, who became editor-in-chief of *Sight and Sound*, and Lindsay Anderson, a regular contributor. Penelope Houston was Lambert's assistant and in 1956, when Lambert headed for a career in America, Houston took over his position. Under their stewardship, *Sight and Sound* escaped from the lingering influence of Paul Rotha and John Grierson and had pretensions to be a more sophisticated and accessible journal that kept up with new developments in world cinema.

In one sense, the editors did import the concerns of *Sequence*, which had aimed to radically correct the documentary-heavy traditions of British film culture and promoted the feature film as art, whether in the guise of Italian neo-realism or John Ford westerns; part of *Sequence*'s revolt included an emphasis on aesthetics over sociological content, the traditional domain of official government channels. In addition, the first *Sight and Sound* issues under Lambert and Houston's leadership evince a more youthful, irreverent approach designed to appeal to cinephiles, including a film quiz and coverage of André Bazin's Festival du Film Maudit in Biarritz. Positive reviews of Max Ophüls's *Letter from an Unknown Woman* (1948) and Vittorio de Sica's *Ladri di biciclette* (*Bicycle Thieves*, 1948) set the revamped journal's tastes, which resounded with the editors' favourites at *Sequence* and were in keeping with the Radcliffe Report's recommendations to move away from educational films and towards a broader consideration of narrative feature filmmaking. In turn (but also for institutional reasons that I will address later), *Sight and Sound*'s readership increased dramatically; between 1950 and 1959, circulation rose from 5500 to 15,000.[8] Nevertheless, not all readers were enthusiastic about the new leadership, or convinced that the young critics even represented a new editorial direction. Indeed, subscribers felt that *Sight and Sound* had not even made the changes in their relationship to their audience that Arnheim, Seldes, or Kracauer had negotiated fifteen years prior.

Among readers, the consensus spoke that – despite advances in film culture and greater appreciation and awareness by the lay public – *Sight and Sound* remained old-fashioned and stuck in an Arnoldian mode. In a letter to the editor in the autumn 1956 issue, John Russell Taylor (later lead critic for *The Times*) complained about the politics of *Sight and Sound*'s taste, which in his opinion was symptomatic of British film criticism. In Taylor's estimation, contemporary critics assumed a "despairing"

attitude to filmmaking, one that demanded "the warm and human" or "hard-hitting but unsensational social criticism" and privileged the film's subject matter over its aesthetics. In practice, Taylor asserted, *Sight and Sound* maintained "a weakness for the unpolished and just-competent in direction." In the way that the magazine's critics pronounced their "moral judgments" without any regard of form and style, their conclusions "could often be reached just as well through reading a plot summary of the film without seeing it."[9] Taylor's letter singled out contributors Lindsay Anderson and Walter Lassally as particularly guilty in this regard.

In some ways, Taylor's lament – and further critical letters to the editor – was a symptom of the successful implementation of the Radcliffe Report's prescriptions for greater appreciation of film as an art. The film society movement – a cornerstone in the late 1940s policy developments (so much so that the British were fervently setting up film societies in occupied Germany in support of "re-democratization")[10] and in the BFI's strategies to bring sophisticated film culture to the regions in the 1950s – grew from twenty (in 1944) to 213 in 1950.[11] The diversification of national film culture would also be evidenced in a new assortment of cinephile magazines, to which I will return later.

Within the ranks of *Sight and Sound*, Lindsay Anderson first responded directly to Taylor's cinephile challenge; his lengthy statement, "Stand Up! Stand Up!," represents a (partial) movement towards a subjective, Kracauerean-style social criticism, and a possible route for *Sight and Sound* to have taken – although, as we shall see, it would eventually chart another path. In the article, Anderson dismissed Taylor in order to take up even larger issues: defining the purpose of film criticism by appealing to the critic's "commitment." In so doing Anderson dissented from the mainstream views of the day. English newspaper critics doubted film's status as art and repudiated their responsibility to treat the moral or social issues brought up by movies in their purview. Such opinions, Anderson submitted, were endemic in UK criticism and evidenced by figures such as Alistair Cooke, a prominent critic for the BBC and in the mid-1930s a regular columnist for *Sight and Sound* and whose pronouncements against film theorists we have already encountered. In a "Critic's Testament," Cooke claimed that:

> [as] a critic I am without politics and without class [...]. However much I want in private to rage or protest or moralise, these actions [...] have nothing to do with critics [...]. I am merely a critic and I have to decide whether Miss Harlow's smiles and pouts were performed expertly enough to entice Mr. Gable away.[12]

Cooke's claims to "objectivity" and his articulation of the profession as a protocol of star performances were inimical to Anderson's formulation of a subjective, political criticism. For Anderson, Cooke represented the epitome of the bland English bourgeoisie: "the holding of liberal, or humane values; the proviso that these must not be taken too far; the adoption of a tone which enables the writer to evade through

64

humour."[13] Write-ups must attend to social implications; in Anderson's idiom, re-viewing must be committed: "criticism (film criticism included) cannot exist in a vacuum [...] writers who insist that their functions are so restricted are merely indulging in a voluntary self-emasculation."[14] Since film is an art connected intimately to society, film criticism "cannot escape its wider commitments": "there is no such thing as uncommitted criticism, any more than there is such a thing as insignificant art."[15] According to Anderson, the critic must acknowledge and make clear his or her vision of the medium, politics, and the world. Anderson's notion takes inspiration from Sartre's *littérature engagée*, socially engaged writing that accepts an intellectual responsibility to maintain an unequivocal stance in contemporary political debates. In his *What is Literature?* Sartre hoped that minority voices might find a forum through such channels. Sartre's polemic is predicated on the idea that, as it is impossible to be politically neutral, the writer's only ethical course is to admit openly his or her beliefs: one is responsible equally for omissions as for commissions.[16] Following Sartre's writer, Anderson proposed that the film critic could perform an irritating function, liberating the reader by stimulating his or her creative and critical faculties.

Anderson's article received much support (but also further critique) in follow-up letters to several subsequent issues of *Sight and Sound*.[17] Nevertheless, he was certainly not a solitary voice at the journal. Although "Stand Up! Stand Up!" is the most famous programmatic statement of "commitment," recently departed editor Gavin Lambert was certainly sympathetic to its aims. (Lambert even wrote a letter in support of Anderson to the magazine from Hollywood.)[18] Witness how Lambert, in a review of *The Cobweb* (1955), cuts down the film in the very first line: "The problem [with the film] is to discover the makers' attitude towards their subject." Later in the notice, he faults Vincente Minnelli's picture for the way that it "remains tentative, uncommitted."[19] For the "committed" wing of *Sight and Sound*, the fronts should be clear: films should take an unambiguous position towards their subject and critics should be transparent about their motives and politics.

Nevertheless, although Lambert and Anderson advocated a moralistic, yes political criticism, it clearly did not take aesthetic shapes into account, nor did it adopt a true Kracauerean symptomatic procedure. Indeed, beyond its evocation of "commitment," Lambert's review of *The Cobweb* betrays the tensions at work at this point in the history of *Sight and Sound* – and not only in relation to readers who wanted less moralism and more attention to cinematic form. Lambert's write-up is more or less an elaborate plot summary that deciphers themes and speculates on symbolism: e.g. "There are two central situations here: the idea of the 'drapes' intensifying antagonisms and creating unexpected alliances in the clinic, the study of a disturbed young artist who, to his danger, becomes trapped in an intrigue beyond his grasp."[20] The notice's last paragraph glosses over the performances, but beyond this "the film" appears to signify in a vacuum; there are mere mentions of humans being involved in the production: source-text author John Paxton, producer John Houseman and director Minnelli. This approach to "the film" – the attention to the plot, political message,

and potential symbolism – contrasts markedly to how at this very moment writers in Paris were dealing with Minnelli and other Hollywood directors: *la politique des auteurs.*

Talking "to" or "with" the Audience: The Threat of Cinephilia

Lambert's almost total reticence about a human creative force speaks to British critics' dismissive, irritated, but also increasingly anxious attitude towards their Parisian counterparts in the middle to late 1950s. The approach reveals serious tensions, not only regarding the proper content and style of criticism; at issue was a significant difference in the mode of addressing the audience.

Well before the inception of the *nouvelle vague*, a number of sceptical *Sight and Sound* articles assessed the *Cahiers du cinéma* set. Already in 1954, Lindsay Anderson surveyed contemporary "French Critical Writing" and recommended two periodicals: *Cahiers du cinéma* and *Positif*. Immediately after writing about these "discoveries," however, he issued a warning: "I have stressed in this note the enlivening qualities of French writing on the cinema; I have not emphasised its more irritating aspects. These certainly exist."[21] Among these annoyances were poor style and an absence of logic and lucidity. "Anxious to establish themselves as *littérateurs*," the critics delivered a "dithyrambic" prose that remained "short on analytical capacity."[22] *Cahiers du cinéma*, in particular, was prone to "a perverse cultivation of the meretricious." Their fawning flattery of Hawks, Preminger and Hitchcock "seriously vitiates much of the writing in *Cahiers*; an examination of the attitude behind it would be worth attempting."[23] One year later, Anderson had even less patience for *Cahiers*, which, he declared, had been "almost completely taken over by the convoy of bright young things whose eccentric enthusiasms, paraded so generously in recent issues, have already sadly impaired its reputation."[24] Anderson expressed his disgust for the "preposterous" Young Turks, their cultish attachment to inferior directors, and their lack of practical filmmaking knowledge. Witness the following passage from Anderson, one of several that applies metaphors of illness and sin:

> The French again. Each of these issues makes a special effort, *Positif* in the name of the American cinema generally, *Cahiers du Cinéma* in particular homage to Alfred Hitchcock; it is rather disappointing to have to record that they are respectively rather inadequate and inexcusably bad. For the light they throw on certain vices endemic in French criticism, however, they merit attention.[25]

In this review, Anderson ridicules the writers' knowledge of literary historiography, is outraged at the "absurdity" of comparisons that the authors employ to describe their privileged directors (Hitchcock to Nietzsche, Faulkner, or Poe), and cannot fathom why – if they insist on discussing Hitchcock – these self-interested critics neglect his British films. Taking aim at what he perceives to be the *Positif* writers' lack of techni-

cal knowledge, Anderson claims that the "basic weakness in most French writing on the cinema of this kind seems to be this extraordinary unawareness of the fact that films have to be written before they can be directed."[26]

In general, *Sight and Sound* registered the French tastes, styles, and attitudes towards Hollywood and the audience with suspicion. There were regular barbs against the French school during Houston's editorship: e.g. an unsigned spring 1957 review of recent film periodicals that took issue with *Cahiers du cinéma*'s write-ups, whose "*politique d'auteur* [*sic*] [...] is now losing its power to amuse. This malady has also begun to infect another French publication, *Cinéma 57*."[27] The problem – from the perspective of both the Anderson-Lambert "committed" faction as well as Houston – was that by the late 1950s, the *Cahiers* line was no longer confined to Parisian cinephile journals and coffee houses. The seeds of auteurism – planted in Jacques Rivette's celebratory Hitchcocko-Hawksianism, François Truffaut's agitation, "A Certain Tendency in the French Cinema," and elsewhere[28] – had begun to bear real fruit. After Claude Chabrol's *Le beau Serge* (1958) and the modest visibility of other projects, the furious international reception of Truffaut's *Les 400 coups* meant that the Young Turks had to be taken seriously.[29] Their filmmaking could no longer be ignored and their film criticism needed to be engaged with as well. Even worse for the established *Sight and Sound* editors, however, the new popularity of French film culture meant that the *Cahiers du cinéma*'s radical approach was being transposed into Anglophone writing among British critics. The challenge to *Sight and Sound*'s hegemony was taking place on two fronts: both young domestic and Parisian.

This perceived defiance precipitated self-reflection about the role of *Sight and Sound* within film culture and how critics might relate to audiences depending on the status and aims of their medium. The autumn 1958 issue featured a transcript of a conversation between Paul Rotha, Basil Wright, Lindsay Anderson, and Penelope Houston, entitled "The Critical Issue." Marking the twenty-fifth anniversary of the BFI and the twenty-sixth anniversary of *Sight and Sound*, it took stock of the course and present state of British film magazine journalism. In the discussion, the status of the journal within national film culture became a concern: it, former *Sequence* rebel Anderson admitted, "is a magazine of the Establishment, while the other papers are magazines of independence [...] *Sight and Sound* does not – all right, cannot – do the same thing [as *Sequence*], because it is not an independent publication."[30] Houston agreed: "It seems to me that this may be the right moment for an anti-*Sight and Sound* paper, that there's a job a non-official, non-subsidised, magazine could do, which we can't quite do ourselves and which is a necessary job at any time."[31] Houston's statement seems unimaginable today both in the frank assessment of the editor's own publication and in light of her real reaction to the challenge of such an "anti-*Sight and Sound*" magazine just a few months later. The conversation also became a forum to compare British criticism to international trends. According to Anderson, "[in France] you have a magazine like *Cahiers du Cinéma*, terribly erratic and over-personal in its criticism, which has been enraging us all for the last five years."[32]

In essence, "The Critical Issue" argued for the status quo: *Sight and Sound* could hardly embrace a subjective style and more conspiratorial mode of addressing the audience because of the magazine's function as organ for the BFI. It is therefore perhaps unsurprising that the article sparked a series of strongly worded letters from young mavericks who believed that the journal was now seriously misjudging and underestimating its readers; critical authority could no longer be gained or sustained by appealing to high-minded moral values. In the winter 1958-1959 issue, for example, Ian Jarvie wrote that he agreed with Houston's assessment that there was no anti-*Sight and Sound* magazine in Britain – but insisted that there is most certainly an anti-*Sight and Sound* movement, consisting of young cinephiles "who would rather read *Films and Filming* and shoot college newsreels than read *Sight and Sound*, which is allied in their minds with the pieties of *The Observer*" and represents a "middle-brow" sophistication. If it had been avant-garde in the 1930s and 1940s to advocate Soviet silent cinema and Italian neo-realism, these traditions were now "established, conventional, pious, middle-brow things to like." This was also the reason, according to Jarvie, that the young generation – following *Cahiers* – had so radically intervened with a new taste: "instead of all this the young take odd, isolated, almost idiosyncratic likes like: preferring later Hitchcock to the pre-war vintage, enjoying the fast, tough (perhaps sadistic?) gangster film, rhapsodising over Nazi films, being bored with neo-realism and free cinema: revolting in fact, against the OK or the 'nice', gentle taste in films."[33] In the spring issue, Jarvie's letter itself received responses, with readers complaining that the "A.Y.M. [Angry Young Man]" was "irresponsible and defeatist." His praise for Nazi cinema and Hitchcock "seems merely a desire for 'kicks,' perhaps an attempt to forget a boring life, depressingly represented in neo-realism." Nevertheless, one reader did agree that there was a need for an "anti-*Sight and Sound* approach." Taking the journal's style and overall approach to task, he wrote that "[a]rticles are too tame, too wrapped up in technique or general surveys. A director is analysed like a Royal Commission, and conclusions are remote, buried under a welter of conditional clauses. Judgements are too sober and refined. Unpretentious films are cynically dismissed."[34]

The shift in readers' sentiment – towards cinephile tastes, purposes, and modes of address – is demonstrated in the unrelenting casual and often vitriolic level of discourse on the correspondence page. Jarvie responded to his critics with another letter, in which he sought to demystify *Sight and Sound*'s "commitment," which amounted to "unpardonably" conflating aesthetics and politics: "any anti-*Sight and Sound* journal would be out to fill in the gaps or do it better, if it is really a *film* magazine."[35] More importantly, this discussion continued in other publications and venues. From June 1959 to June 1960, the magazine *Films and Filming* invited a number of the country's leading reviewers to state programmatically their thoughts on the purpose of film criticism. *Film*, the organ of the British film society movement followed suit. Jarvie was invited to write a piece for the September-October 1960 issue, in which he broadened his attack on all domestic criticism: "Film criticism in Britain

today is awful. So awful that I propose not to talk about it, but to say what it should be."[36] Ian Cameron, who together with Mark Shivas and Victor Perkins had taken over the film section of the student journal *Oxford Opinion* in April 1960, launched his own invective. Quoting almost identical passages from two *Sight and Sound* reviews published five years apart, Cameron concluded that in Britain, the film critic "works like a machine. Just feed in the plot synopsis and out comes a shattering revelation like 'truly, a film that speaks up for life.'" Since mainstream critics were only interested in story and political message, no knowledge of cinema's aesthetic properties, stylistic features, and formal shapes was necessary: "Criticism is thought of as a job for the unskilled or at best semi-skilled, a refuge for failed film directors and superannuated law court reporters, a relaxation for literary critics and lady novelists, or an extra source of income for the 'I can criticise anything' boys."[37] Responses to these provocations came in various publications including the *Spectator*, the *Sunday Times*, and the *Observer*. In *Film*, mainstream critics such as Peter John Dyer (editor of the BFI's listings magazine *Monthly Film Bulletin* and associate editor of *Sight and Sound*) defended themselves and the publication was placed in an awkward position of keeping the peace between the various factions (besides *Oxford Opinion* there was at this time *Definition*, a short-lived journal that aspired to "committed" political criticism) on its pages and in a number of public debates, such as at the London Film Society.[38]

The Reassertion of Authority I: National Tradition

After Penelope Houston had more or less aroused the discussion about the proper role of institutional criticism in broader film culture by entertaining the need for an "anti-*Sight and Sound*" organ in the 1958 "Critical Issue," she attempted to reassert *Sight and Sound*'s role as ultimate authority in an autumn 1960 article. "The Critical Question" replied to her young domestic critics as well as *Cahiers du cinéma*'s challenge by disregarding her opponents' legitimacy to speak about film to a broad audience and with an appeal to *Sight and Sound*'s authority based on "English" traditions and a new broad-church liberalism.

"The Critical Question" begins by responding to Anderson's squib from four years before, "Stand Up! Stand Up!" Houston pays little more than lip service to Anderson's theses, however, before pursuing a different agenda. Like Anderson's objection to Cooke's professed "objectivity," Houston agrees that there is "no such thing as entirely objective, unbiased criticism."[39] She then couches her disagreement in an ironic jab based on Anderson's heritage. Anderson, Scottish by descent, was born in colonial India to an Army officer and, after boarding school in West Sussex and studies at Oxford, served as cryptographer for the Intelligence Corps in Delhi during the final year of the war.[40] According to Houston, therefore, "Lindsay Anderson is not an Englishman, and he has none of the English respect for words like 'fair' and 'balanced' and 'impartial'. With all a Scot's distrust of compromise, he took the critical

writing of four years ago to task for its undefined liberalism and asked it to declare its principles: he wanted values to be openly admitted."[41] Houston further reminds her readers that Anderson is clearly representing the left, even more so than most critics, who, although mostly progressive, "did not relish being told that they ought to be radical."[42] Indeed, Houston moves to the centre herself in her comments. She tempers the calls from Anderson and others that cinema should be "related to life as we are currently experiencing it" by countering that "the idea that art cannot also afford to be difficult, esoteric, private, would take us into the sphere of the cultural *gauleiters* [sic]." The committed critic, in Houston's eyes, too often judges art by a recognizable relation to "*his* politics."[43]

If her disagreements with Anderson are polite, Houston's subsequent dismissals of other colleagues and "democratic" (in her mind populist) upstarts are less restrained. Under the subheading "Living in the Dark," Houston turns her attention to "the new generation" of English film criticism, epitomized in *Oxford Opinion*. (Almost inconceivable today, this student publication had made waves with its inaugural issue.) Houston's objection to these young critics is not simply that their taste is "directly opposed to the one that preceded it,"[44] i.e. Houston's own Oxford class, about twelve years prior. The new generation's "allegiance is solely to the cinema; its heroes are directors also greatly admired by the younger generation of French critics (Nicholas Ray, Samuel Fuller, Douglas Sirk, Frank Tashlin); its concern is essentially with the cinema as a director's medium."[45] Worse still, in the new critical school, "[t]here are no good or bad subjects; affirmation is a word for boy scouts; social significance is a bore [...]. Cinema, by its definition means first and foremost the visual image; and the critic's response is to the excitement it can communicate."[46] Again, Houston repeats, these attitudes derive largely from the French: that is, from *Cahiers du cinéma*, whose reviews eschew analysis in favour of "slightly breathless statements."[47] This, Houston surmises, is the fundamental difference between the English critics and the French (and their young British disciples). While the French school, with its close analysis of a "half a dozen striking shots" and their technical significance and emotional impact offers criticism "like walking in a fog without a torch," the English deal with the subject matter: "Cinema is about the human situation," Houston concludes, "not about 'spatial relationships.'"[48]

In this piece, Houston stakes out an authoritative critical position based on tradition and seniority; not unlike today's squibs by Armond White and others about bloggers' supposedly "dumbed-down" faux-criticism, Houston disputes the tyros' taste and professionalism. For the young, art should not be judged by its seriousness, but merely evaluated for its "kicks" and "stabs at nerves and the emotions." Sounding well beyond her years (33), Houston discounts a new generation that wants jazz, method acting, and violence and yet disregards sophistication; the rogue cinephiles maintain a "disinterest in art which does not work on one's own terms, and an inevitable belief that those terms are the only valid ones."[49]

The weakness of the *Cahiers du Cinéma* school, both in its own country and among its exponents here, seems to be that it barely admits of experience which does not take place in the cinema. Its criticism too easily becomes shop talk for the initiated; its enthusiasms are self-limiting; it turns inward upon itself, so that a film's validity is assessed not in relation to the society from which it draws its material but in relation to other cinematic experiences. It is all a bit hermetic, as though its practitioners had chosen to live in the dark, emerging to blink, mole-like, at the cruel light, to sniff the chilly air, before ducking back into the darkness of another cinema.[50]

Notice how Houston argues here against cinephile criticism and its claims to be more representative of contemporary audiences. Indeed, she points out its fundamentally *exclusive* – rather than democratic – approach: "shop talk for the initiated." Further-more, Houston posits, cinephile criticism ignores films' real ramifications for the audience: "it barely admits of experience which does not take place in the cinema [...] a film's validity is assessed not in relation to the society from which it draws its material."

In her critique of *Cahiers du cinéma* and *Oxford Opinion*, Houston appeals to (na-tional) tradition as a source of authority and guiding principle. "English critical writ-ing" should adhere to essential English traits: empiricism, an "innate" distrust of the-ory, and a "reluctance to draw demarcation lines." These typical qualities mean that it would be strange for a domestic critic to consider whether the film should have even been made. This is difficult for the English critic because it asks him or her to judge a work "not 'on its own merits' (that favourite, elusive English phrase) but according to some system of values; that, in fact, he has a theory."[51] For Houston and *Sight and Sound*, the challenge of *Cahiers du cinéma* and its followers has to do with the proper functions and visions of criticism in its national contexts. The French must occupy themselves with theory and form, just as the English are naturally in-clined to empiricism and human relationships. In the same way that Houston under-stands cinema as a collection of national industries,[52] so too film criticism should be divided into national schools.

Richard Roud's companion piece, "The French Line," furthers Houston's national-critical distinctions to the cinephile approach. The "greatest difference" between *Cah-iers du cinéma* and *Sight and Sound* is one of object: form (French) and content (English). According to Roud, the French have always preferred form to content in their aesthetic deliberations; the young French cinephiles extend this principle by claiming that Hollywood B-directors display a mastery of form precisely because – on account of industrial practices – they are not allowed to deal with "important" issues of content. More pernicious, in Roud's opinion, is the fact that "American life in all its forms exercises a very strong hold over present-day young French intellec-tuals."[53] In the end, according to the American-born Roud, the question is not one of "commitment" (Anderson's code word for politics), but rather a disputed definition

of the film critic's purpose. The French prefer Westerns and *films noirs* because they define their task as attempting to "extract [...] meaning" and to concentrate "entirely on the beauties of a work of art," rather than, as the English do, "attempting impartially to point out both the good and bad elements."[54] Roud complains that their focus on mise en scène and the *politique des auteurs* made it "only a question of time before their system of rationalising personal quirks and fancies should produce such a crypto-fascist and slightly nutty approach to cinema."[55]

Ultimately, the *Sight and Sound* response evinces broad fears of democratization and specific anxieties about relinquishing the cultural authority of a canon based largely on the superiority of certain genres (drama), styles (realism, "restraint"), moral attitudes (indictment of poverty, war), and national origins (European). Above all, the implosion of reigning middle-class standards and the mix of high and low culture disturbed *Sight and Sound* critics. That Fuller or Hawks could coexist with Shakespeare and Molière confused Roud and irritated Houston; even Anderson was appalled at comparisons of Hitchcock and Nietzsche. Although *Sight and Sound* was clearly invested in the idea that film is art – and had fought that first battle since early on – this mixing of media was detrimental to the prescriptive, forward-looking, liberal mode of historiography and aesthetic to which *Sight and Sound* subscribed. The veneration of America that *Cahiers du cinéma* and the domestic challengers put forward threatened to undermine the authority that *Sight and Sound* and the BFI had painstakingly built since their inception and in the early days of promotion and distinction.

The Reassertion of Authority II: Lionel Trilling and a New Liberalism

In addition to invocations of national tradition, Houston reasserted *Sight and Sound's* legitimacy by appealing to an established critical mode and to an authoritative figure. "The Critical Question" put forward "liberalism" as a responsible and serious alternative to the "slightly nutty" approach of the French and their young British followers. At first glance, this might seem to offer a retreat to the liberal criticism with which Anderson had taken issue in "Stand Up! Stand Up!" and other pieces,[56] and to his parody of the liberal critic, who determines the intentions of the artist, measures the success of his or her attempt, and then "relates the whole thing loosely to the commonplace assumptions of contemporary 'liberal' feeling."[57] Houston's move might seem to represent the traditional, "Establishment" criticism and return to the journal's traditional preoccupation with humanism and an outmoded, top-down Arnoldian didacticism.[58] Upon closer inspection, however, the shift was more nuanced and strategic. Houston articulated not an unthinking liberalism à la Cooke, but one that attempted to be more democratic and inclusive, a type of criticism that tried to engage readers with a lighter-touch pedagogy and to reaffirm an art-film canon.

Significantly, Houston appealed to the liberal tradition via the American literary critic Lionel Trilling, whose writings she would have encountered during her studies at Oxford. Indeed, "The Critical Question" refers to him, quotes him, and even paraphrases (unacknowledged) sections from his book *The Liberal Imagination*. Trilling's approach functioned as a blueprint for the liberal criticism that Houston would promote as *Sight and Sound*'s editorial line. Her strategy invoked an authoritative critic in order to combat *Cahiers du cinéma*'s prolificacy but also position *Sight and Sound* as a broad church.

At the end of "The Critical Question," after discounting Anderson's "committed" approach and much derision of the *Cahiers du cinéma/Oxford Opinion* style, Houston details a positive example of a way forward. The "main duty of criticism," Houston formulates, "is to examine the cinema in terms of its ideas, to submit these to the test of comment and discussion."[59] Houston continues: "liberalism, which ought to mean allegiance to principles but a certain flexibility of mind about assumptions, a readiness to subject them to the pressure of thought, is more valuable here than the rigidity of mind which believes that once the end is agreed on the means must be predetermined."[60] This spirit of liberalism means that we should look to the cinema to "extend our range of ideas rather than to confirm pre-conceived assumptions."[61] Alluding to, among other associations, the tainted tradition of appeasement and Britain's last Liberal Prime Minister David Lloyd George, Houston hopes to rescue the word "liberal" from its "present implications of indecision and inertia."[62]

In her essay, Houston redeems a type of liberal criticism with substantial, almost slavish affinities to Trilling. Compare Houston's definition of liberalism, an "allegiance to principles but a certain flexibility of mind about assumptions" and "a readiness to subject them to the pressure of thought,"[63] with Trilling's words from *The Liberal Imagination*. He suggests that liberal criticism "might find its most useful work not in confirming liberalism in its sense of general rightness, but rather in putting under some degree of pressure the liberal ideas and assumptions of the present time."[64] Houston's desire to position *Sight and Sound* between the fronts of *Definition*/Anderson's "commitment" and *Cahiers*/*Oxford Opinion* resembles strongly Trilling's approach towards literature and literary criticism. Trilling was a man of the left – but disapproved of literature that was transparently ideological, and in this vein he preferred Henry James' bourgeois novels over the "social realism" of Theodore Dreiser. According to scholar Mark Krupnick, "Trilling appears as the liberal critic of liberalism, the critic of the left from within its ranks"; Trilling's stance is revealed "in his praise of Hawthorne's 'dissent from the orthodoxies of dissent.'"[65] Trilling's disdain for "ideological thinking" anticipates the manner by which Houston distances herself from Anderson. She finds "much contemporary 'committed' writing needlessly didactic, too readily prepared to lay down the law and to accept, unconsidered, such Brechtian dicta as the one that the only questions which can usefully be asked are those which can be answered."[66]

Crucially, Houston appropriated Trilling's critical concept of a liberalism that transcends political factions and squabbles, a supposedly non-ideological and non-doctrinaire approach. "Liberalism is," Trilling writes in *The Liberal Imagination*, "a large tendency rather than a concise body of doctrine."[67] Although Trilling allows for the word "liberal" to be used in political discourses, he maintains that it represents an attitude or even emotion – referring thus to "political" in its original, "wider" sense as pertaining to "the organization of human life," rather than a doctrine or "narrow" prescription: "The word liberal is a word primarily of political import, but its political meaning defines itself by the quality of life it envisages, by the sentiments it desires to affirm." In sum, "there is no such thing as a liberal idea," as Trilling paraphrases Goethe; "there are only liberal sentiments."[68]

Houston's concept of film criticism follows from Trilling's ideas, but also other contemporary instances and discourses of liberalism, such as the Liberal leader Jo Grimond's programme of internationalist cooperation, colonial self-determination, and suspicion of socialism and ideology.[69] According to Grimond, "liberals should accept the Kantian rule of 'always acting in such a way that I can also will that my maxim should become Universal Law'."[70] Indeed, Houston presents a concept of film criticism that embraces humanism, internationalism, tolerance and stylistic restraint and that subscribes to a loose neo-Kantian, pre-Rawlsian ethics. Much in the manner that Daniel T. O'Hara describes Trilling's ideas about the purpose of criticism, Houston's method values the "ability to imagine amidst the least fortuitous of circumstances as noble a motive for the Other as one can imagine for oneself."[71] It is beyond the purview of this book to probe deeply into political events. Nevertheless, it should be explicitly noted that the postwar critical debates surrounding commitment vs. form and cinephilia vs. authority must also be understood in the context of the Cold War and the international positionings of third-way leftist movements across Europe. It is clear that calls for "commitment" as well as the anxieties over the celebration of Hollywood had to do with political attitudes towards the United States but also the desire – as we shall see explicitly in the following chapter – to resist appropriation by the conformist forces of real, existing Warsaw Pact socialism.

Houston's liberalism entails a taste for a humanistic, internationalist moral realism that also respects the aesthetic principles set out by Victor Freeburg years before: "directness, ease, emphasis, unity."[72] Just as Trilling claimed that the best writers of last 150 years "have in one way or another turned their passions, their adverse, critical, and very intense passions, upon the condition of the polity,"[73] Houston praises films that focus on the "human situation" and on "the difficulty of loving and the problem of communication."[74] Ideally, such narratives should deal not only with social problems, but also challenge "pre-conceived ideas."[75] This is the logical consequence of Trilling's calls for "an awareness of complexity and difficulty."[76] "All novelists deal with morality" the literary critic opined, "but not all novelists, or even all good novelists, are concerned with moral realism, which is not the awareness of

morality itself but of the contradictions, paradoxes and dangers of living the moral life."[77]

If Trilling privileged literature as having a "special relevance to criticize the liberal imagination [...] because literature is the human activity that takes the fullest and most precise account of variousness, possibility, complexity, and difficulty,"[78] Houston transfers a similar argument to cinema. For Houston, cinema is an art form, but more an interface of human experience and possibility than a machine of aesthetic shapes and sounds. Within this framework, Nicholas Ray vs. Satyajit Ray becomes the central taste axis of the debate, made graphic on the first pages of "The Critical Question," which features stills from the two directors' films, accompanied by the captions: "Nicholas Ray's cinema: 'The Savage Innocents' ... or Satyajit Ray's cinema: 'The World of Apu.'" Houston sides with the latter – together with Italian neo-realism, *Tokyo Story* (1953), and the puzzles of Alain Resnais (*Hiroshima mon amour*, 1959) and Michelangelo Antonioni (*L'Avventura*, 1960). "The critical duty," according to Houston, "is to examine the cinema in terms of its ideas, to submit these to the test of comment and discussion."[79]

The Broad Church and the Canon

Houston's proposal that critics should submit ideas about cinema "to the test of comment and discussion" implies a commitment – at least programmatically – to an active public sphere and a more democratic style of mediation. In addition, it recognizes that the BFI organ required another mode of authority, another way of addressing the audience. The liberal film criticism put forward in "The Critical Question" serves – ultimately – the institutional tasks and economic realities of *Sight and Sound* and its parent organization: to erect a national, but therefore polyvocal, film culture. A Trilling-style liberalism – this tolerant "attitude" beyond ideology or fashion and celebration of an internationalist moral realism – becomes a key to an inclusive, broad-church approach to film culture. This is a constellation, more complex than Iris Barry's prewar model of triangulation, in which *Sight and Sound* acts as the ultimate arbiter and authority, remaining above petty divisions, disagreements, and "subjectivity."

Let us recall the remit set out in the 1948 Radcliffe Report: a new estimation of film that considered it as an art to be appreciated rather than as an instrument to impart other lessons. Accompanying this stance was the drive to build up a permanent collection at the National Film Library and endeavours to bring more sophisticated film appreciation to the regions under the auspices of film societies. These initiatives were largely successful. Film culture in the United Kingdom was thriving and in many ways close to its zenith. As already stated, Britain witnessed a dramatic growth in the number of film societies in the 1940s and early 1950s; between 1950 and 1959, *Sight and Sound* tripled its readership from 5500 to 15,000.[80] BFI membership numbers were peaking in 1960 at just over 40,000.[81] This growth was achieved no doubt by

the increasing quality of *Sight and Sound*, a general thirst for the postwar quality cinema, and a blossoming of arthouse culture, but also because of director Denis Forman's canny strategies to link the membership structures and payment models for the BFI with *Sight and Sound* and the National Film Theatre.[82]

In many ways, then, the often fiery debates over film criticism seen in the late 1950s and early 1960s in Britain were symptoms of success: the BFI's encouraged growth in film culture and more widespread film literacy and appreciation. The regular auto-critique found in the often scathing letters to the editor in *Sight and Sound* was part of an "orchestra principle" by which a certain measure of radical criticism would and even must be present in the BFI publication in order to be able to function as an overarching liberal instance. As long as such voices and contrapuntal tones were contained within the publication (rather than submerging into an invisible underground cinephile subculture), the magazine could still fulfil its prescribed function to reach out to a larger audience with divergent tastes.

Houston's Trilling-influenced liberal critique might be profitably regarded as part of a larger attempt to centralize a polyvocal national taste culture. Part of this effort included continuing to promote film as an art and establishing a critical framework for cinema "quality." In the "Critical Question" debate, a remarkable amount of attention was devoted to placing cinema on the same level as literature and theatre; in part, Trilling appealed because his model imported the seriousness afforded to literature. In "looking for a theory" in "The Critical Question," Houston states explicitly that cinema should be "entitled to the kind of critical analysis that has been traditionally devoted to the theatre and the novel."[83]

The entitlement to critical analysis also entailed the erection and maintenance of a canon against which future films might be judged. This included, first of all, the invention of the "classics" and became a chief task for Houston's re-energized liberal criticism: *Sight and Sound*'s decennial Top Ten became just one prominent example during her long tenure. The intellectual forefather of this sense of canon-building was again Trilling, who, in this respect, very much followed in the tradition of Matthew Arnold, whose works he edited. Mark Krupnick calls Trilling's project the creation of "a sane and steady overview," and, much in the vein of Arnold, to achieve a "totalizing vision and thereby provide readers with an 'intellectual deliverance.'"[84] Through the increased readership, *Sight and Sound*'s "good-taste" editorial line, and the BFI's development of film education for teachers and youth leaders (including an annual film appreciation summer school),[85] the organization was fulfilling the Arnoldian ideals "to learn and propagate the best that is known and thought in the world" in order to raise class-cultural aspirations. Yet, this system still allowed for a broader, slightly more democratic conversation to transpire, albeit in a controlled way.[86]

Beyond the tutelage taking place in film appreciation training and on the pages of *Sight and Sound* and *Monthly Film Bulletin*, the BFI was simultaneously asserting its cultural authority in other ways. One such material manifestation of the canon was being compiled in the form of the National Film Library. Following the Parisian Ciné-

mathèque and the Museum of Modern Art in New York, the film collections of the National Film Library and, later, the exhibitions of the National Film Theatre were essential to what Richard MacDonald has called the BFI's "gradual construction of authority over the art of film."[87] Whereas the National Film Library had been initially established to collect and disseminate educational and instructional films for classroom use, in 1941 the body reorganized its loan section to emphasize films meant to "illustrate the 'core' history of cinema."[88] Anticipating Houston's later efforts at *Sight and Sound*, the National Film Library's policy was "rooted in the notion that the commercial film could be improved by cultivating the taste of an increasingly demanding public"; the tactics in this strategy included activities "from the presentation of films that were outstanding, unusual or artistic, to the study of film technique, in order to construct a sound basis for criticism and discrimination."[89] Scholars have shown how similar developments were taking place – at slightly different speeds and with slightly different objectives – in France, the United States, and West Germany, among other countries.[90] Haidee Wasson's study of New York's Museum of Modern Art, for instance, details how the institution strategically created an audience for their extant collection, simultaneously educating and even disciplining the public in how to attend and respond to an arthouse screening.[91]

The BFI – including the National Film Library, the National Film Theatre and *Sight and Sound* – contributed to a similar process in Britain, to be continued into the 1960s, at which point Houston's post-Rotha generation worked to consolidate taste around a set of quality directors and world cinema movements. The programming at the National Film Theatre and the birth and growth of the London Film Festival were also very much in keeping with this promotion of Houston's liberal, internationalist taste.[92] With an Arnoldian task to expose Britons to the best of world cinema (by culling selections from first-run festivals), the programming in its early years (including films by Satyajit Ray, Akira Kurosawa, Yasujiro Ozu, Luchino Visconti, and Andrzej Wajda) revolved around the very directors who featured prominently in the text of and accompanying photos to Houston's "Critical Question" as arbiters of the liberal taste. Richard Roud, director of the festival from 1960 to 1969, embodied the very close link between the BFI's various promotional arms of this canon.[93]

A Decisive, International Crisis

There was a substantial response, both nationally and internationally, to "The Critical Question."[94] In Britain, the Houston and Roud articles earned critique from predictable quarters, including the editors of *Definition* and *Oxford Opinion*.[95] Furthermore, the internationally inspired domestic challenge to *Sight and Sound* – and Houston's and others' dismissive reactions[96] – resulted in a permanent diversification of film publications. *Sight and Sound* and *Monthly Film Bulletin* continued into the 1970s as the traditional bulwarks of national film culture, offering a functional critique (and promotion) of British cinema with a liberal humanist attitude towards world cinema,

with some increased attention to formal shapes. The "committed" genealogy of Anderson and *Definition* would become increasingly attracted to structuralist, Marxist, and psychoanalytic theoretical frameworks and be taken up again in *Screen*. Groups of mavericks, including Raymond Durgnat, shifted alliances or remained on the fringes.[97] Once the *Oxford Opinion* critics graduated, they founded *Movie*, which adopted *Cahiers du cinéma*'s auteurism and aestheticism in order to elaborate a more "precise" analysis of Hollywood pictures and other non-middlebrow cinemas: the privileged filmmakers were Otto Preminger, Joseph Losey, Alfred Hitchcock, Jerry Lewis, Vincente Minnelli, and Nicholas Ray.

The international responses to the "Critical Question" crisis became decisive for the future of film criticism. The San Francisco-based *Film Quarterly*, for example, was very sympathetic to the *Sight & Sound* position. In particular, Ernest Callenbach's editorial cited Houston's magazine as the "finest journal of film criticism in the world" for its humanistic concern. Moreover, Callenbach shared deep reservations about the "work of the *Cahiers du Cinéma* gang." The French and their followers in America have a "wildly inaccurate" and slightly fascist approach that amounts to "juvenile-delinquent" punditry: "the cult of the worthless story, the jazzed-up gangster film, and sometimes Leni Riefenstahl" as an alternative to the dominant school of film writing represents "change but certainly not progress."[98] Despite the flattering treatment of Houston's essay, *Film Quarterly* offered a resolution to the crisis of postwar criticism that resembled the *Oxford Opinion* programme. "What is needed to enable us to push through the present impasses," Callenbach wrote, "is a kind of 'textual' criticism: criticism which sticks much closer to the actual work itself than is usual."[99] In practice, then, film criticism should not follow Houston's liberal vision, nor should it become a more radical commentary of social and political issues and implications in the Anderson vein. Rather, Callenbach called for close formal analysis and for "critics willing to look over and over again at the films which *are* available for patient study," i.e. the sustained and repeated viewings of 16mm prints available for rental and able to be viewed frame by frame on flatbed editing equipment.[100]

In the Federal Republic of Germany, as we will see in detail in Chapter 4, the editors of the leading cinephile journal *Filmkritik* took up Houston's "Critical Question" (and a similar contemporary challenge from *Positif*) to produce a programmatic statement on the purpose of their work, "Is There a Leftist Criticism?"[101] The West German critics, deeply influenced by Siegfried Kracauer, proposed a synthetic position that married Anderson's commitment with a thorough attention to formal questions. This inspection of form, the writers warned, must never devolve into the "impressionism" and auteurism of *Cahiers du cinéma*, whose slippery formalism allowed them to honour Riefenstahl by ignoring manifest content. Finally, another alternative route available at precisely this historical moment was taken by Lawrence Alloway. Peter Stanfield has elaborated on Alloway's pop art appraisal of film, a "descriptive criticism of film that would account for popular cinema's 'specific kind of communication (high impact, strong participation, hard to remember), or in the technology

and organization through which the movies reach us.'"[102] At a moment when most critics – whether *Sight and Sound, Film Quarterly, Filmkritik,* or *Cahiers du cinéma* – were attending to films as individual works, Alloway was concerned with "collective endeavours of filmmaking operating within an industrial context. Mapping these shifting alliances becomes a key activity for the critic."[103]

Such reactions represented other solutions to the postwar crisis of the cinephile challenge – including close textual analysis, ideological-symptomatic criticism, and industrial-generic observation – available to the course of *Sight and Sound* and mainstream British film criticism, routes that coexisted with the more widely known auteurist iterations and intersections from the period: Andrew Sarris's importation and transformation of an "auteur theory" as an alternative to what he considered to be the fusty moralism of Bosley Crowther; Pauline Kael's scathing ripostes to Sarris and the widening fronts of the "Sarristes" and "Paulettes" in Anglophone journalistic film reviewing, which we will examine in Chapter 5; the rise of an academic film criticism and analysis.[104]

The late 1950s, early 1960s was surely a decisive moment in the history of film criticism and film culture in general. It represented a vital crisis: a moment of ontological deliberation in which interlocutors were pulling in different, often diametrical directions and many alternatives were available. Indeed, far from being an isolated footnote to the history of British film criticism, the discursive issues of reception surrounding "The Critical Question" help us understand the basic shape of contemporary film criticism. These debates and the diversification of film culture that developed from them would create a lasting framework for the profession. The episode also exemplifies an institutional response that can be made against perceptions of "dumbing-down" and "fragmentation," key buzzwords in today's "death of the critic" discourse.

In general, this case study curiously anticipates the "democratization" that is supposedly a new feature of digital-age criticism: in many ways, the crisis at *Sight and Sound* was as much a response to *readers' reactions* to the *nouvelle vague* and *Cahiers* as to the French themselves. Certainly, the interactivity of the "new media" provides new opportunities for bottom-up distribution of film writing unmediated by the correspondence pages of *Sight and Sound* or the economic or geographical obstacles to upstart print fanzines. Nevertheless, in many ways, new media merely compensate for declining civic and cultural participation, rather than necessarily representing any net increase or uniform anarchy of information.[105] Likewise, this example suggests that the discourses of crisis inherent in today's debates about the purpose and trajectory of the profession were also a feature of late 1950s and early 1960s institutional film writing. A typical comment from this period by Houston, that there "is plenty of reviewing and not nearly enough criticism,"[106] is common also among today's "dumbing-down" rhetoric and Chapters 5 and 6 will return to this theme in depth. First, however, the next section, Chapter 4, examines *Filmkritik*'s much different response to the crisis of postwar film culture.

4. From "I" to "We": *Filmkritik* and the Limits of Kracauerism in Postwar German Film Criticism

For the young *Sight and Sound* editors, the postwar perceptions of crisis in film criticism, precipitated by the *nouvelle vague* and French critical writing, came to a head in Houston's article on "The Critical Question." Citing "English" traditions, it attempted to diffuse the cinephile challenge to critical authority with a broad-church liberalism that could contain and lead a diversified national film culture. A few hundred kilometres to the east, in the Federal Republic of Germany, the reception of French film culture was also producing a crisis. This episode, however, would lead to a very different course and conclusion, one which was mortgaged to past traditions and methods of subjective criticism as detailed in Chapter 2 and one which – despite the role of Lindsay Anderson in the British debates outlined in Chapter 3 and his subsequent success as a director – was even more related to new domestic filmmaking.

The subject of this chapter is the position and role of *Filmkritik*, the most important postwar German film periodical. Founded as an attempt to create "legitimate" criticism in a country where "tradition" was tainted in the aftermath of the Nazi dictatorship, the magazine initially used Siegfried Kracauer as a guiding figure before events in international film culture led to a crisis that required a new basis of authority. Closely examining *Filmkritik*'s founding principles and its ambivalent encounter with *Cahiers du cinéma*, this chapter analyzes the subsequent attempts to relocate their authority in an internationalist, alternative national subculture and subjective style after the initial Kracaueran approach no longer functioned. The outcome was a dramatic shift in the journal's approach to the domestic industry and to its readers.

Establishing a Postwar German Criticism: Elucidation, *Ideologiekritik*, and the Disavowal of Impressionism

The origins of *Filmkritik* took place in the context of a society having undergone "re-education" and hungry for legitimate international culture. The magazine was founded under the editorship of Enno Patalas in 1957, but its pre-history lies in the postwar German film society movement, initiated by the Allied occupiers and taken over by domestic figures such as Johannes Eckhardt and the University of Münster

sociologist Walter Hagemann.[1] At the time, German film writing was published in film-society journals such as *Der Film-Club* and *Film-Forum*, trade papers and advertising brochures such as *Film-Revue* or the *Illustrierte Film-Bühne*, as well as the religious-oriented *Film-Dienst* (Catholic) and *Filmbeobachter* (Protestant). Patalas, at the time Hagemann's doctoral student, was dissatisfied with the lacklustre state of domestic criticism and sought to start his own journal. The first attempt was the short-lived *film 56*. The moniker betrays the debt that the Germans had to French film culture: it pays homage to the publication of the Fédération français des ciné-clubs, *Cinéma*, which also appended the last two digits of the year to its title.[2] The German journal's subtitle (translation: "International Magazine for Film Art and Society") anticipates the authors' implied conception of cinema as a sophisticated aesthetic and mass-social medium. As the journal's financial problems increased and the relationship with Hagemann deteriorated, Patalas moved to Munich, where he founded *Filmkritik*. The inaugural issue was published in January 1957.

Patalas and the early *Filmkritik* sought to practice film criticism as a brand of broader cultural and social critique. This programme, anticipated already in the first issue of *film 56*, intended to "make the elucidation [*Aufhellung*] of film production's ideological character the main task" of the journal, since "films are not mirrors of life as it is": their representations are channelled through collective desires and fears and are not always immediately perceptible.[3] This was a conscious attempt to evoke the tradition of legitimate Weimar Republic criticism, and, above all, the authoritative criticism of Siegfried Kracauer, who emigrated after the Nazis seized power. "The film critic of note is conceivable only as a social critic," Kracauer's 1932 dictum on the purpose of film criticism, became the young practitioners' motto and his untranslated English-language *From Caligari to Hitler* their historiographical prototype.[4] Indicative of the editorial line, the second issue of *film 56* reprinted Patalas's speech, "From Caligari to Canaris: Authority and Revolt in German Film," which he delivered to the 1955 film society meeting at Bad Ems.[5] The ideological approach persisted in the first issues of *Filmkritik* and concurrently in the last issue of *film 58* and included the serial reprinting of Max Horkheimer and Theodor W. Adorno's chapter on the culture industry from *Dialectic of Enlightenment*.

The first-ever *Filmkritik* article, "Instead of a Programme," began with a reference to another thinker associated with the so-called Frankfurt School:

We agree with Walter Benjamin: The public is constantly judged incorrectly and yet feels itself to be represented correctly by the critics. Typical film criticism, insofar as it is not an appendix to the advertising section or practiced by volunteers, turns this sentence on its head: it says to the public what it already knows but can't formulate so elegantly. Oscar Wilde's observation applies to their best representatives: They have nothing to say, but they say it delightfully.[6]

The editorial continues with an assault on the "old-fashioned" belletristic art criticism, "which notes impressions and fancies instead of identifying structures, which describes instead of interpreting, which 'celebrates' and 'pans' instead of leading the reader to the proper understanding." Rather than position the film within social discourses this disparaged criticism "prefers to see the film 'only as a film.'" These critics are not interested in a normative, committed criticism; instead, they "place their trust in the preexisting taste and reserve intellect for the discovery of stylish bons mots."[7] This style of criticism, "impressionism," became the target of derision for the German critics in the periodical's early years.

For Patalas and the other *Filmkritik* writers, the purpose of their practice entailed – rather than self-indulgent flowery prose – a clear pedagogical function: "Film criticism should try to sharpen the gaze of the responsive [*ansprechbaren*] cinemagoer." These spectators should be directed to "aesthetic structures and configurations" produced by "the genius of the artist," but also to "social and political approaches, in which, consciously or unconsciously, the spirit of the age is articulated and confirmed." Ultimately, criticism "should illuminate the societal mechanisms in the films' production and effect, determine the possible positive cases in which films contribute to social self-awareness, and denounce the negative [cases] in which political narrow-mindedness is fostered and perpetuated."[8]

The *Filmkritik* programme's understanding of a criticism that "sharpen[s] the gaze of the responsive cinemagoer" is suggestive for at least two reasons. First, "sharpening" readers' perceptual (or sensual or intellectual) skills gestures towards an Arnoldian-style, top-down didacticism by which the educated, enlightened critic reveals the work "as it really is."[9] In this hierarchical model of communication the critic serves as the necessary medium through which the subordinate reader can understand implicit meanings. Second, *Filmkritik*'s invocation of a "responsive cinemagoer" disavows a remit to speak to all potential viewers and instead restricts its addressees. The term *ansprechbar* is never defined as such, but it implies that the editors see their audience to be cinephiles, the politically left-of-centre, or simply the open-minded; the notion of the "responsive cinemagoer" will prove vital later on in the magazine's history. This call for a committed, explicitly political criticism founded on the ideological-symptomatic model was unique in Germany for being independent of institutional affiliation such as party, church, trade union, university, club, or the industry; it resounded with early critics' struggles for autonomy, as seen in Chapter 2. The journal's subtitle in the early days ("Up-to-date Information for Cinephiles") betrayed this independence.

In practice, *Filmkritik*'s first years saw regular reports from European film festivals, overviews of genres and national cinemas, frequent diatribes about the "failure" of the German film societies, invectives against censorship and dubbing practices, and suspicious diagnoses of the domestic industry's health. The reviews themselves more or less followed the editorial programme of a party-neutral leftist perspective. Witness the unsigned notice of Georges Sadoul's newly translated *Histoire d'un Art: Le*

Cinéma. The venerable French Marxist film historian is taken to task for his aesthetic interpretation, "which never transcends the level of newspaper criticism." According to the Germans, Sadoul's sociological commentary is clouded by his political bias. In general, a true history of film must dedicate much more attention to the "symptomatic and the truly meaningful."[10]

Film reviews pointed out, in true Kracauerean style, continuities between Nazi features and contemporary productions. In this vein, for instance, Reinhold Thiel deconstructs *... und nichts als die Wahrheit* (*Nothing But the Truth*, 1958) by juxtaposing a plot summary, line-for-line, with the action of *Ich klage an* (*I Accuse*, 1941).[11] Patalas, in a review of the homophobic *Anders als du und ich* (*§ 175*) (*Different from You and Me*, 1957), takes the opportunity to highlight the links between the film and the director Veit Harlan's earlier *Jud Süß* (*Jew Süss*, 1940), the infamous anti-Semitic account of a Jewish financial advisor who brings Swabia to ruin. For Patalas, "Veit Harlan's opus is closed and indivisible." It is a "straight line" that leads from *Jud Süß* to *Anders als du und ich*: "the line of pre-fascist hatred towards intellect."[12] So committed were the young editors to the historiographical trajectories and thematic emphases of *From Caligari to Hitler* that Kracauer himself wondered, in a letter to *film 56*, whether the singular focus on political messages foreclosed aesthetic analysis: "I only wish that you would attempt in the future more systematically to discern what is socially and politically wrong or right also in the aesthetic domain. Generally speaking, it seems to me that you overemphasize *manifest content* at the expense of other considerations."[13]

New Waves and a New Internationalism: Towards a Third-Way, "Leftist" Criticism

Kracauer initially provided a figure and method with which the young *Filmkritik* editors could establish critical authority and link themselves to a legitimate cultural history. At the turn of the decade, however, *Filmkritik*'s Kracauerism[14] came up for revision. A number of factors forced the editors to balance a "German" symptomatic didacticism with an emergent international cinephilia. A rise in circulation in Germany but also the necessity to engage with dramatic new developments in French film culture led to a considerable shift of *Filmkritik*'s stance on the function of criticism and on the proper way to relate to readers.

Filmkritik enjoyed increases in readership in its early years and was able to expand its coverage year after year. The magazine transformed from a thin collection of reviews with a single editorial into a vehicle for bold commentary on national and international film culture that suggested an increasingly outward-looking perspective. In 1960, *Filmkritik* replaced its usual leader-editorial with a section called "New Films Abroad," which included translated excerpts from foreign reviews of premieres in those countries. The March 1960 issue of *Filmkritik*, for instance, begins with Marcel Martin's and Pierre Billard's reviews of *Pickpocket* (1959) from *Cinéma 60* and

includes seven other reviews from that magazine, from the BFI's organ of reviews, *Monthly Film Bulletin*, as well as *Films and Filming*, a British magazine self-described as addressing the public "that finds *Picturegoer* unsatisfying and *Sight and Sound* unintelligible."[15] In subsequent issues, *Filmkritik* published scores of translated write-ups from foreign periodicals. Save a few exceptions (e.g. the *Schermi* take on *La dolce vita* [1960] in the April 1960 issue), these publications were British or French and included, in addition to the above, *Sight and Sound, Positif, téléciné, Le Figaro,* and *Combat.*

These notices from overseas are significant not least because they take up a prominent part and considerable portion of the content – about one-third, until 1961, when the magazine expanded and much of the foreign reporting could be done by the in-house staff. They evince a thirst for the opinions of a sophisticated cinema culture beyond the confines of what the editors referred to as the "cultural provincialism" of the Federal Republic.[16] Moreover, the expanded coverage also shows a desire to position *Filmkritik* in a serious pantheon; the magazine sought legitimacy via such international associations.[17]

This positioning came at a crucial moment in world cinema: the emergence of the *nouvelle vague* and flowering of international (and especially European) art cinema. Initially, *Filmkritik* cautiously regarded the developments in France. In 1959 and 1960 the new French filmmakers received a few sneers and backhanded compliments from the magazine. In the "New Abroad" rubric on *À bout de souffle* (*Breathless,* 1960) from the May 1960 issue, Patalas sees the film as an important depiction of youth culture with refreshingly elliptical montage, albeit third in a ranking of the *jeune cinéma* hitherto, behind Alain Resnais's *Hiroshima mon amour* (1959) and François Truffaut's *Les 400 coups* (1959). Patalas bristles, however, at *Cahiers du cinéma's* and Jean-Luc Godard's veneration of the United States and the fact that – like Truffaut and Claude Chabrol – he "fails to comment on the reality he depicts."[18] Nevertheless, the scepticism towards the French cannot be equated with a wholesale rejection of the New Wave. In weary prose, Patalas admits that "the 'New Wave,' it is clear now, was not a cursory sensation that would be forgotten again the next day."[19] Indeed, even unacknowledged, the intellectual dialogue with *Cahiers du cinéma* is unmistakable. In 1959, *Filmkritik* began to furnish all its issues with a table of films on release, including individual editors' ratings, in the style of the French magazine's "Conseil des dix" section. This seeming indulgence was tempered in the initial issues with the pedagogical warning "for the filmgoer with mature judgement": "the [initial] notices are merely supposed to serve factual information before the cinema visit, the [subsequent] critiques are for the later testing of your own judgement. The critiques reflect the opinions of the author." The choice of films also overlaps with those discussed by their Parisian counterparts: German rediscoveries from the Weimar Republic, Italian neo-realism (a favourite topic of Ulrich Gregor), and the realism of a Jean Renoir or Robert Bresson.

If the first issues of 1961 featured an ambivalent take on the *nouvelle vague*, the March edition finally addressed the underlying subject of *Cahiers du cinéma*, ontological issues of criticism, and *Filmkritik*'s place in an international genealogy of postwar cultural-political agitation. The result, "Is There a Leftist Criticism?," was provoked, Patalas and the new co-editor-in-chief Wilfried Berghahn claim, by a question in *Positif*.[20] This challenge, as we have seen, was only one part in an international debate over the purpose of film criticism in such publications as the English *Definition* and the American *Film Quarterly*, and especially Penelope Houston's "Critical Question" in *Sight & Sound*.[21] Patalas and Berghahn locate the roots of postwar progressive criticism in Gavin Lambert and Lindsay Anderson's *Sequence* and their subsequent tenure at *Sight and Sound*, Bernard Chardère and *Positif*, and the radical critics – of mostly European birth, they remind – of the New York journal *Film Culture*.

What unites these forward-looking critics, according to Patalas and Berghahn, is their rejection of impressionistic writing. Indeed, following Lindsay Anderson (presumably from his programmatic article on "engaged" criticism, "Stand Up! Stand Up!"),[22] the pair stresses the need to analyze films' messages and attitudes rather than retreat to "vague universal-humanistic and aestheticizing statements of personal sympathies or antipathies." Quoting Brecht, they reaffirm their belief that film's social function must be interrogated.[23]

The Germans' comments on the possibility of leftist criticism and their foreign colleagues represent a milestone. The editors articulate their own vision of criticism against two distinct positions that they detect in the foreign press.

First, Patalas and Berghahn define *Filmkritik* against what they call "aesthetic" criticism, which privileges form and style at the expense of content and, in particular, that content's political implications. Although cultivating a serious interest in film, the aesthetic critic attends to the work only as an "isolated phenomenon without social foundations and conditions"; the film is merely considered for what appears on the screen; audience desires and the film's conditions of production are ignored. This form of criticism is "opportunistic," because it demands only formal evaluation and thus conveniently obviates difficult political stances; it is "schizophrenic," because it is usually practiced by sophisticated thinkers who "know theoretically that film cannot be satisfactorily defined in aesthetic [terms], but do so anyway."[24]

Using André Bazin and *Cahiers du cinéma* as an example of how such a "schizophrenic programme" can arise, the authors recognize Bazin's role in transcending belletristic criticism and teaching the young *Cahiers* critics such as Eric Rohmer, Truffaut, and Chabrol to uncover and interpret specifically filmic structures; this type of analysis, on the connections between form and meaning, provided the basis for the new wave. Nevertheless, quoting Marcel Martin, Bazin was a "man of the left and critic of the right."[25] Bazin's method seduced many critics – including German practitioners – into superimposing their own intentions onto films of varying quality, thus producing an "uncontrolled engagement." Such a procedure could only develop

into a single critical programme, the *politique des auteurs*. For the *Filmkritik* editors, the singular focus on form and style, typical of auteurism and "aesthetic" criticism in general, blinded the critic to obvious ideological problems that must be accounted for. This glaring methodological deficiency, according to Patalas and Berghahn, was epitomized in *Cahiers du cinéma* critics' admiration for Leni Riefenstahl.[26]

This attitude towards Riefenstahl, which time and again served as a shibboleth to differentiate *Filmkritik* from *Cahiers du cinéma*'s pure "aesthetic" criticism, deserves a short excursion. In these years, the French magazine featured glowing appraisals of the German director, commending her command of montage, bemoaning her unjust forced "quarantine" from the national industry, and ranking her along Fritz Lang and the up-and-coming Jean-Marie Straub and Rudolf Thome as one of the national cinema's greats.[27] This treatment culminated in Michel Delahaye's reverential interview, "Leni and the Wolf," which focused on her formal innovation, placed her in the Romantic tradition of Novalis's *Heinrich von Ofterdingen*, and allowed her sufficient discursive space to position herself as a sort of resistance fighter whose films were "documents," and thus "unpolitical."[28] The interview's accompanying photos – Riefenstahl on dangerous location shoots on mountains, production stills from her turn in *Das blaue Licht* (*The Blue Light*, 1931), and so on – depict the director of *Triumph des Willens* (*Triumph of the Will*, 1935) as a pin-up. This contrasts clearly with the treatment in *Filmkritik*, which in this period persistently agitated against the "aesthetic" rehabilitation of Riefenstahl. According to the editors, Nazi cinema "cannot be mastered, but must be understood," and articles such as Helmut Regel's "On the Topography of the National Socialist Film" belonged to this imperative.[29] When the French magazine did break this convention with its fawning treatment of Riefenstahl, *Filmkritik* published a small part of Delahaye's interview as a sidebar to an article by Patalas,[30] who highlighted *Cahiers du cinéma*'s inability to spell Riefenstahl's name correctly as in keeping with a general misunderstanding of her. Already in 1964 Dietrich Kuhlbrodt wrote a leader entitled "And Tomorrow Veit Harlan?," in which he took the Bremen *studio für filmkunst* to task for dedicating a retrospective to Riefenstahl and presenting her body of work in uncritical, formalist terms.[31] Although, according to Kuhlbrodt, the director's "technical skill and photographic finesse" cannot be denied, her films reveal "not only the 'soul of National Socialism' (*Völkischer Beobachter*, 1935) but, above all, false pathos and monumental kitsch." Kuhlbrodt wonders why there has not been an outcry from the government, press, or other institutions against the repertory cinema – which in recent years had twice won a national award for best programming.[32]

Besides pointing out the dangers of "aesthetic" criticism with the example of Riefenstahl, Patalas and Berghahn's "Is There a Leftist Criticism?" seeks to define *Filmkritik*'s approach in opposition to a second, flawed method: "pseudo-leftist" criticism. This type of criticism is concerned purely with "political messages" immanent on the level of character and plot. Referring presumably to *Positif*, Patalas and Berghahn emphasize that the misguided pseudo-leftist approach can be illustrated by develop-

ments in France as well.[33] This type of reviewing praises a film for the political position it takes and disregards its quality or form; the mode degrades cinema to mere propaganda and overlooks the fact that "political affects are not identical with social insights."[34] Such critics laud subjects or attitudes towards subjects; they forget that motion pictures are more than scripts. Pseudo-leftist criticism fails the requirements of the demanded new criticism, and – because it is similarly one-sided – it resounds with naïve, aesthetic criticism. Indeed, for Patalas and Berghahn, *Positif* is a negative example of a socially engaged brand of criticism that transformed into a dogmatic mouthpiece for the Communist Party in the Cold War. Film criticism must be independent of vested interests, the editors argue, echoing the Weimar-era positions of Ihering, Balázs, Arnheim, and Kracauer.

Against the "dangers" of these two methods, Patalas and Berghahn sketch a third-way leftist criticism; this task is an especially pertinent question in Germany since, "apart from [*Filmkritik*]," a leftist criticism did not exist in the country.[35] Their articulation of the "new, required criticism" is perhaps mostly directed against the fallacies of "naïve, aesthetic criticism." Patalas and Berghahn are insistent that they are more interested in "message" than "form" and attend not only to "artistic" films as autonomous "works." It is intended as an "engaged" criticism – that takes a (leftist) stance on films' politics. Nevertheless, the authors understand politics not only as (in the manner of the "pseudo-leftists") "manifest messages" but also as the "search for implicit 'latent'" meanings. In addition, they see films as symptoms "of historical trends" and claim to be "vitally interested in the desires of the audiences." Rather than hope to decipher the director's intentions, they seek to uncover his "mental habits." Crucially, they see "form as an aspect of the message."[36]

In essence, "Is There a Leftist Criticism?" represents an affirmation of Kracauerism in the face of international fashions in the purpose, form, and style of criticism. The last opposition in their list – between the "naïve" critique of "only the film" and the "required" critique of "the society from which the film emerges" – is especially telling. It clearly reiterates Kracauer's prescription of the film critic as social critic. The articulation of a critical, Western Marxism stakes out a political position between the "official" Marxism of the Communist Party of Germany or the German Democratic Republic (or *Positif*) and militates against innuendo that *Filmkritik* was a red bastion. In the context of this international debate, *Filmkritik* claims a position between the fronts of *Cahiers du cinéma* and *Positif* in which form should harmonize with content; the political evaluation of the balance between these two factors is, according to the editors, the basis of the critic's task.

The Limits of Kracauerism: The Auteurist Turn and the Rise of the "Aesthetic Left"

Seen in retrospect, "Is There a Leftist Criticism?" sought to define the purpose of criticism in two spheres. First, as discussed, it positioned *Filmkritik* among leading

serious film-specialist publications, asserting authority via its coexistence on an international stage. Second, it anticipated an internal struggle over the editorial direction of *Filmkritik* between the so-called political leftists and aesthetic leftists in the mid-1960s. This episode in the history of the journal has been documented by no less than two scholarly articles and thus should not be rehearsed in detail here.[37] Nevertheless, the purposes of this chapter certainly behove one to expand on those studies by highlighting how these debates functioned within an international politics of taste and how this battle changed the positioning of the magazine's critics vis-à-vis their readers and German filmmakers. In the months after the publication of "Is There a Leftist Criticism?," both readers and contributors intervened in the debate over critical methodology and purpose,[38] a development that eventually led to the demise of the "political left" (i.e. the magazine's traditionalists who subscribed to Kracauerism) and the victory of the "aesthetic left," an approach to film criticism that combined a broadly formalist auteurism with a new subjective, esoteric, and inward-looking style.

In the mid-1960s, *Filmkritik* continued to grow in editorial confidence and redirect its perspective towards an international arena. What had begun as a small pamphlet of text with a Spartan layout transformed into a professional operation with colour covers, a host of photos, special offers, and cross-over deals with clubs and other institutions for subscribers. Advertising increased and issues bulged to 72 pages; in addition, the editors and their correspondents across the Federal Republic and overseas were producing various books (on stars, genres, directors) and accompanying periodicals (*Filmreport*) with commercial ties to the publication.

At the same time, articles increased dramatically in length and became more theoretical, especially with the introduction of the rubric "Theory and Practice" in the first issue of 1966. This transformation, Patalas claimed in a revisionist editorial, had always been a goal: a move away from the evaluative and a partial return to the academic thrust of *film 56* and *film 58*. The constant growth in size and readership and, temporarily, the position as the Federal Republic's only "non-commercial" film magazine and even "the film magazine with the Western world's second largest number of subscribers" were both causes and symptoms of an enlarged self-esteem.[39]

They also index a new developing relationship with French film culture in general and a move towards auteurism as a critical methodology in particular. Since the regular articles on the *nouvelle vague* from 1959 to 1961, there was continued and prominent interest in new French productions; by the mid-1960s this had coalesced into more and deeper treatment of a triumvirate of directors: Resnais, Truffaut, and Godard.[40] Along with Swedish, Italian, American, and German film, French cinema continued to hold a central place in the magazine's coverage. Most remarkably, the estimation of *Cahiers du cinéma* began to change. Where once the writings of the Young Turks[41] had been ignored in the surveys of international peers, *Filmkritik* began reporting on and reprinting excerpts from *Cahiers du cinéma*. This included a feature on Renoir (1/1965) and, more strikingly, a reprint of Jacques Rivette's (in)famous panegyric to the genius of Howard Hawks, which begins: "The evidence on the

screen is the proof of Hawks's genius: you only have to watch *Monkey Business* to know that it is a brilliant film."[42] The inclusion of the latter is particularly surprising because Rivette's piece epitomizes the impressionistic, breezy style so inimical to Patalas and Berghahn in their 1961 treatise on leftist criticism. By way of partial explanation, Patalas accompanied the reprint with an introduction, "How Can One Be a Hawksian?"[43] In his text he chronicled the change in taste by the *Filmkritik* editors in a revealing way. The journal's early attempts to assess Hawks were lukewarm at best, according to Patalas; his films seemed only to provide fodder "for ideological criticism." In the meantime, *Filmkritik* recalibrated its regard for the director, whose works could now be viewed only via "the critically and artistically productive Hawks reception of *Cahiers* and the New Wave which emerged from it." Patalas's rationale for the reprint and for the reappraisal of Hawks in general hides behind a layer of scholarly respectability, one that obscures evaluation to deem Hawks an important artefact because he inspired the critic-filmmakers who formed the *nouvelle vague* – a movement that is, in fact, "good." Nevertheless, even to acknowledge *Cahiers du cinéma* as "critically productive" represents a significant about-face for *Filmkritik*.

Moreover, *Filmkritik* started to assume the look and feel of the French journal. It began to have cover photos, often in colour and often of the scantily clad heroines of contemporary European art cinema (Claudia Cardinale, Catherine Deneuve, Swedish beauties, and Godard's muses); in some instances, the cover images of the two magazines featured the identical publicity still.[44] In addition to this arthouse titillation,[45] the Germans borrowed some of their French counterparts' cult of personality. This came in the form of an array of self-composed short biographies of the contributors, "Resumés," an attempt to enhance and personalize the relationship to their readers and one that had been intermittently requested in letters to the editor.[46] Whereas previously *Filmkritik* had sought legitimacy by contrasting itself to *Cahiers du cinéma*, by 1965 and 1966, it seems, a comparison with the hip French journal was more effective to achieve this goal.

Perhaps most strikingly, *Filmkritik* made a belated turn to auteurism. In a new, irregularly appearing rubric called "On the Self-Understanding of Film," directors spoke for themselves through interview excerpts collected from various publications. In the first installment, a short introduction provided a rationale. Beginning with a quotation from Godard's *Le petit soldat* (*The Little Soldier*, 1963) – "The time for action is over; a time of reflection is beginning" – the piece asserts that "the era of naïve filmmakers is over" and therefore "it is no longer uninteresting what the authors say about themselves and their films."[47] The use of the philosophically charged word *Autoren*, a parallel formulation of *auteur*, is key, alongside the claim that "while writers compose essays and painters issue programmatic statements in exhibition catalogues, cineastes' feelings remain provisional and fleeting."[48]

The directors afforded these dossiers included Resnais (10/1964), Luis Buñuel (11/1965), Lang (12/1965), and Bresson (9/1966). In addition, interviews with directors became a regular feature, and a number of *Filmkritik* contributors began to write

prolix, sophisticated essays on filmmakers' oeuvre. In July 1964 *Filmkritik* published an extended treatise on Frank Tashlin by the young *Movie* editor Ian Cameron – in those years a polemical auteurist and devotee of *Cahiers du cinéma*. In the August 1966 issue Helmut Färber delivered an "Essay about Hitchcock" that, despite its stated intention – "not to try to recuperate Hitchcock as a film artist" – is a fawning hagiography of "the fantastical director who uniquely has made very personal films for decades and in uninterrupted succession – within the established film industry, not against it."[49] Indeed, Färber emulates *Cahiers de cinéma* so slavishly that on several occasions he footnotes or otherwise references which Young Turk's interpretation he follows. Färber, Herbert Linder, and above all Frieda Grafe (since 1962 also Patalas's wife) wrote most frequently in this vein, whether on Resnais's "practical films" (6/1966), Truffaut (4/1965, 4/1966), or Godard (5/1965, 3/1966). This veneration of the French did not go unnoticed by readers. One Armin Magerkuth of Bochum complained that "*Filmkritik*, one-eyed since 1965, is now in the process of becoming blind: the star is Jean-Luc Godard"; with a bit of "scholastic sophistry" Linder is trying to recuperate Godard as a "humanist."[50] The new pieces became more abstract and impressionistic in style, a development that irritated some subscribers. Singling out Färber, Linder, and Grafe, one letter to the editor appealed for "comprehensible" criticism. The new style created the danger of an "unintentional" return "to the disadvantages and errors of the belletristic film criticism that you rightly reject"; "*Cahiers du cinéma* shouldn't be a model for *Filmkritik*."[51]

How shall we account for *Filmkritik*'s dramatic shift towards auteurism? After all, in some ways, this break in editorial policy was ironic in its timing: the move away from politics, history, and society as creators of artistic meaning took place just as the West German student politicization was approaching its 1968 climax, re-examining national history critically, and rejecting the desires of the individual for the needs of the collective. In addition, the adoption of auteurism transpired at the very moment that *Cahiers du cinéma* was relinquishing this method and moving on to more radical ideological positions. The French review dropped the "Conseil des dix" rubric in 1966; already in the November 1965 issue, Jean-Louis Comolli, having recently taken over editorial duties from Rivette, declared the death of the *politique des auteurs*, which had become, to his mind, a slippery and unrigorous programme.[52] This made manifest a process under way since the early 1960s: the "discovery" of Brecht; the recognition of the Algerian War; the disappointment in the later works of Hitchcock, Hawks, and Ford; and the abandonment of the singular fixation on mise en scène and form at the expense of narrative and ideology.[53]

There are surely a number of explanatory factors for the new direction. They might include, for example, a complex shuffle of personnel that began at the latest with the premature death of Berghahn (the most passionate and intelligent defender of the Kracauerean political left) in September 1964 and the subsequent ascendance of (especially younger) contributors associated with the aesthetic left.

Nevertheless, I want to advance two additional explanations for the demise of the Kracauerism associated with the journal's early years. First, the editors' use of ideological critique as an educational tool could be sustained only as a *temporary* methodology. In other words, *Filmkritik*'s first-generation authors were victims of their own success. If uncovering hidden meanings and messages was the central tactic in the broader strategy of "elucidation," what does the intrepid critic do when the readers – after all, intelligent, "responsive cinemagoers" – have been "enlightened" and have internalized the critical procedures and learned to unveil and demystify on their own? This constitutes a crisis of authority, the threat of critical democratization. In this sense, the shift away from Kracauerism can be understood not as a seasonal swing of fashion but in light of the purpose of the approach itself: a historically circumscribed, pedagogical method to be employed only under certain social conditions and whose function could be fulfilled but thereby exhausted by its own reception in the social consciousness. Its success contributed to its obsolescence.

This explanation was, in a sense, the one that both Berghahn and Patalas implied in two opposing programmatic statements in the mid-1960s. Nine months before his death, Berghahn published "On the Purpose of 'Filmkritik,'" a meditation on the history, possibilities, and responsibilities of *Filmkritik*, "with [and] without [italics]."[54] It responds to readers' and rival publications' conclusions that the journal's editorial position was too sociological – or even socialist. For Berghahn, criticism – just like film – maintains a dialectical relationship with historical processes. This belief explains the attraction of Kracauer to the *Filmkritik* editors in the early days and accounts for their relationship to contemporaneous productions. "Almost all German films of those years [...] most American films and some French and Italian too": "The critique of these films could be confined to analysing their pseudo-realism and naming their ideological client, for whom they worked consciously and, even more often, unconsciously."[55] In times like the 1950s, "an intellectual interregnum," criticism had to pay attention to "the fundamentally transitory nature of its object" and militate "against the supposed intentions of [the object's] author." In such periods, Berghahn wrote, "the works themselves are more telling than the consciousness of their creators."[56] The *nouvelle vague* posed a real challenge to criticism because those films were the products of a "time of speculative planners and theorists."[57] Berghahn ridiculed the *politique des auteurs* as pseudo-critical "directorial complicity" and attacked the French, whose "intentions and manifestos weighed more than their works" in the early years and whose directors – whether Chabrol, Godard, or Resnais – were "grossly overestimated" and would be in "need of revision" by future critics.[58] The piece ends with a rebuff aimed at other contributors at *Filmkritik* (much of the middle section takes Gregor and Patalas to task over their assessments of Federico Fellini): "I think that *Filmkritik* has let itself be corrupted by formal inventions [...] and that the consideration of content has come up too short."[59]

Berghahn's death foreclosed a thorough response to his polemic in 1964; the discussion picked up again in July 1966 with Patalas's "Plea for the Aesthetic Left: On the

Purpose of *Filmkritik* II."[60] The article in many ways revises the history of the magazine that Berghahn outlined in his text: "the criticism of 'aesthetic structures and shapes'" had in fact always been the intention of the magazine's founders. This task had, Patalas writes self-critically, simply been "delayed" in the face of the ideological criticism necessary in the context of the decrepit mid-1950s film culture.[61] At the time and in practice, the methodology "understood form only as a means and not as part of the purpose." This led, Patalas maintains, to reviews that "found nothing else in the films than what had been anticipated from the beginning."[62] Like Berghahn, Patalas seeks a historically dialectical criticism. A routine ideological film criticism that "makes the revelation of the already-revealed its perpetual task" becomes reactionary itself: "The purely sociologically oriented film criticism is no longer able to take stock of the important films today."[63] Just as in Berghahn's position paper, for Patalas the *nouvelle vague* represents a caesura in criticism. Nevertheless, Patalas disagrees with Berghahn's interpretation of this transition: the best films of the New Wave "make the demand for an aesthetic method of film criticism unavoidable."[64] He proposes a vague model of synthesizing aesthetic and ideological criticism by "liberating the gaze of the beholder from conventional beliefs," "enlivening the [reader's] process of cognitive creation," and "provoking [him or her] to independent reflection on the work."[65]

These principles – meant to rebalance the critic's relationship to the audience – gesture to a loosening of the magazine's original didactic approach. Of course, in some ways Patalas's formulations of this "new aesthetic criticism" are as nebulous as they are familiar: they resound with and to some extent rehash the catalogue of the "new, required criticism" that he and Berghahn had compiled for "Is There a Leftist Criticism?" in 1961. Nevertheless, the article does point ahead – while still trying to find common ground and continue the project of Berghahn, Patalas's erstwhile friend and a figure still very much remembered and revered by *Filmkritik* readers[66] – to the criticism already taking space in the magazine in the form of Grafe's, Linder's, and Färber's long, abstract musings on French and other *auteurs*.

In addition, the exchange is useful for the retrospective assessment of *Filmkritik* and the implication that the Kracaurean methodology – far from being "wrong" – had run its course and was no longer necessary. In this sense, it is perhaps *not* ironic that *Filmkritik* retreated from ideological-symptomatic analysis precisely as the West German student movement had begun to internalize this in their readings of Horkheimer and Adorno. After all, the spirit of the Socialist German Student Union's national historiography – the "continuity thesis" by which 1945 was not a "zero hour" and the Federal Republic was essentially fascist – was itself somehow Kracaurean.[67] Because *Filmkritik* considered itself part of a cultural vanguard, the contributors reacted against the appropriation of their method by presumably "middlebrow" students by reasserting and redirecting their authoritative position. This is a common theme in international postwar cinephile criticism.[68]

Positive Hermeneutics and Functional Domestic Criticism

Besides the temporality of Kracauerism as a hermeneutic, the second major, and perhaps more complex explanation for the transition to auteurism was the basic limitations of *Filmkritik*'s symptomatic approach to new developments in filmmaking and in particular the national cinema. The editors needed procedures and vocabularies to respond to the Young German Film and renegotiate their relationship to domestic film culture.

The Kracauerean method that Patalas and Berghahn had appropriated was essentially negative. As an instruction manual, *From Caligari to Hitler* aptly prepared the young critics to uncover threatening traits in – as Berghahn readily admits in his retrospection – "almost all German films" and "most American films," and thus practice a social critique of these most disfavoured countries. However, in the political left's understanding, Kracauer did not provide an example to deal with positive evaluations. In these cases, *Filmkritik* fell back on the default option that had been exercised in much classical film criticism since the 1920s and before: celebrating film as an art or, at best, showing how "quality films (mostly of French origin) [...] continued or complicated the traditions" of the legitimate pre-war cinema.[69] Thus, faced with the perceived methodological dead-end of Kracauer, *Filmkritik* had to contrive a "positive" hermeneutic. This became urgent from 1962 on as the magazine needed to serve a larger purpose: a prescriptive, functional critique and promotion of the domestic cinema. In this respect, the French critical developments from *Cahiers du cinéma* presented an opportunity. For: not only did the *nouvelle vague* provide a model for the filmmakers of the Young German Film. *Cahiers du cinéma* became the – belated and partly reluctant in the case of *Filmkritik* – model for German film criticism to conceive of an autonomous, yet *influential* relationship to the emerging domestic cinema: as a categorizable collection (i.e. "movement") of visionary artists with visible signatures, a band of *Autoren* battling against the restrictive industrial and political structures of the Federal Republic.

Certainly, *Filmkritik* had always regularly reported on the industry, if usually in a distanced, pejorative manner. In the late 1950s and very early 1960s it devoted many notices to the pitiful state of German production and the incompetence of the Spitzenorganisation der Filmwirtschaft (SPIO), the lack of "realism" and treatment of the past in domestic features, the "failure" of German film societies. The journal delivered scores of articles condemning censorship practices, the state's subsidy policies, and the detrimental activities of the domestic industry's self-regulation, censorship, and certification bodies.[70] There were also regular jeremiads on the lack of intelligence in rival German film criticism.[71] Contributors were even prone to exporting doomsday pronouncements to the foreign press. These included Patalas's castigation of local productions, "The German Waste Land," in *Sight and Sound*, and Gregor's complaint, "German Films in 1964: Stuck at Zero," in *Film Quarterly*.[72] *Filmkritik*'s treatment of German fare attracted international notice. In a letter to *Film Quarterly*, David Stew-

art Hull, the historian who later wrote a monograph on Nazi propaganda films,[73] rued *Filmkritik's* "gleefully masochistic attitude" towards the domestic cinema: "When the current generation of German critics gets over its breast-beating, sorrows-of-Werther period, it might get together and suggest some solutions to the current dilemma instead of merely deploring it in such self-righteous and uniformed terms."[74] Hull implied that *Filmkritik* maintained a wholly antagonistic attitude towards domestic filmmaking. "One has only to thumb through recent issues," Hull claimed, "to get a strong whiff of their self-debasement; reading of their loathing of German films in general is almost asphyxiating."[75]

Hull's queasiness was unwarranted. There was a significant divergence between how Patalas and especially Gregor were writing about German cinema for foreign periodicals and how *Filmkritik* was actually commenting on the domestic cinema and, in particular, the nascent art cinema movement beginning in the early 1960s. At least since the 1961 Oberhausen Film Festival, and certainly by the 1962 incarnation and the Oberhausen Manifesto, there were serious hopes for and real promotion of the Young German Film.

For example, the manifesto inspired an article by Patalas called "The Chance."[76] According to Patalas, the time was ripe for a new beginning of quality German film production: "the situation in the Federal Republic today resembles that of France in 1958 – the year before the blossoming of the 'New Wave.'"[77] Reprinting a host of excerpts from the German press reactions, the issue made an event out of the Oberhauseners' stunt. After the festival and into the mid-1960s, *Filmkritik* offered extensive and increasingly optimistic reportage on German film culture. There were regular reports on the Kuratorium junger deutscher Film (2/1965, 6/1965, 11/1965, 12/1965) and calls for a national film academy (4/1964, 6/1964) and a German cinémathèque along the lines of the Young Turks' Parisian playground. As editorial favour turned towards auteurism, there were "rediscoveries" of German directors such as Lang (12/1965) – not coincidentally only a few months after *Cahiers du cinéma* produced a major dossier on him in its August issue – and regular and extensive consideration of young German filmmakers, such as Peter Schamoni, Ulrich Schamoni, Klaus Lemke, and, above all in these years, Jean-Marie Straub, Volker Schlöndorff, and Alexander Kluge. This coverage included notes on films in preproduction, excerpts from screenplays, interviews with the filmmakers (and their letters to the editor), in-house notices, and write-ups of these films from abroad.

The positive reception of the Young German Film allied the movement with *Filmkritik* as joint participants in an internationalist national subculture; the journal asserted the capacity and authority to influence the domestic art cinema's development. When Kluge's *Abschied von gestern* (*Yesterday Girl*, 1966) garnered a Silver Lion and various special jury prizes, for example, Patalas led the October 1966 issue with "Dr. K. Conquers Venice." The article gushes – with uncharacteristic exclamation marks and ellipses – as if *Filmkritik* itself had won the festival; Kluge is referred to by a nickname.

Axel Kluge missed getting the Grand Prize of the Mostra by a hair! It came down – it is said – to one vote. The one vote that was against him – it is said – was Joris Ivens's vote. Ivens joined the jury at the beginning of the festival, taking the place of Erwin Leiser, who is ill. Leiser would have voted for Kluge's film, clearly, because he would have been able to understand the dialogue without the French subtitles. If only Leiser hadn't been sick[78]

Patalas specifies that Kluge's awards are a "victory for the Young German Film, but not for the Federal Republic." To support this claim he relates a critical anecdote about cultural functionaries from the Foreign Office, who initially tried to distance themselves from *Abschied von gestern*, which premiered at the invitation of the festival, rather than as the official German contribution. When the film received positive attention from foreign critics, the officials attempted to take credit for the success. In a sidebar, the eight special jury prizes that *Abschied von gestern* received – bestowed by Italian, Spanish, and French critics – are listed and explained.[79]

This decoupling of the German state and German culture and the high regard of foreign opinion and taste are key to the self-definition of *Filmkritik* and its relationship to the Young German Film, both of which, in the minds of the editors, existed as part of a "legitimate" alternative culture (even though *Abschied von gestern*, for example, received government funding). It should be emphasized, however, that the connection was not – as in the case of *Cahiers du cinéma* – merely an artistic manifestation or extension of the criticism. Unlike the Young Turks or even contemporary *Sight and Sound* writers such as Gavin Lambert and Lindsay Anderson, most of the early *Filmkritik* editors did not have production in their personal purview. (Critics with serious filmmaking experiences or aspirations joined the ranks much later: most notably Wim Wenders, Harun Farocki, and Hartmut Bitomsky.)[80] Nevertheless, the editors posited that the Young German Film maintained a symbiotic relationship with the journal. Witness Patalas's leader from 1966:

> No doubt: the "German Wave" is rolling. The mere fact that the Schamonis, Straub, Schlöndorff, Kluge, and the others can shoot their films and that they will play in the cinemas has a special meaning for us. With the premiere of these films, for the first time screens will articulate – no matter how well or poorly – this country's generation to which the contributors of this magazine also belong.[81]

According to Patalas, *Filmkritik* had a leading role to play in this movement. Although the critics were ready to advocate the filmmakers, the latter could not expect only "jovial pats on the shoulder"; the writers would be their most attentive, "most patient but also most intolerant" critics. "That may not make them happy," Patalas concluded, "but perhaps it will be useful to them."[82]

In this formulation, *Filmkritik* should function as the conscience of the movement. Relinquishing their previously ironic (if not cynical) distance to the industry, *Filmkri-*

tik appropriated the mode of "influence" that we examined as a fault line among early critics such as Willy Haas and Hans Siemsen. There is also the implication that, rather than the criticism simply responding to genius directors, the young filmmakers were continuing the critics' pioneering work; the *critics* had paved the way for the Young German Film, it was the fulfilment of their prophecy. Indeed, an odd messianic, utopian flavour had prevailed at the early *Filmkritik*: these were critics in search of a work, "film friends" without an amiable cinema to call their own, agitating and heralding the way for such productions to arise. This too recalls old patterns and purposes of the critic since the early days of cinema.

In this context, the special attention lavished on Kluge, Schlöndorff, and Straub in 1964 and 1965 is significant. Certainly, *Der junge Törleß* (*Young Törless*, 1966) and *Nicht versöhnt* (*Not Reconciled*, 1965) were important films in their own right and their status as literary adaptations had cultural cachet for the aesthetes of *Filmkritik*. Even more, however, these productions appealed to important aspects of *Filmkritik*'s identity. Their treatment of the national past and allegorical modes were particularly attuned to the magazine's politics. But precisely for this very reason, *Ideologiekritik* was inappropriate. *Abschied von gestern* and *Nicht versöhnt* already subscribed to the "continuity thesis," suggesting that the Federal Republic remained firmly in the shadow of National Socialism. They performed the function of theoretical Kracauerism themselves, making an auteurist appraisal more apt than an against-the-grain symptomatic approach. These were the sorts of films that had been hoped for in the early years. Elucidation and demystification were superfluous procedures to account for projects that – as Linder described Godard's films – "contain their own analysis, they contain as spectacle the reflection on spectacle, performance, and looking; the position of the spectator is no longer that of the subject towards the object."[83]

Although there was clearly a transformation of the journal and a new editorial direction, this process cannot be simply described as a matter of *Filmkritik* becoming "the German version" of *Cahiers du cinéma*, as has sometimes been implied in the history of postwar film culture.[84] *Filmkritik* did not merely emulate the French in order to gain cultural respectability. Of course, *Filmkritik* was, like the Young Turks-era *Cahiers du cinéma*, a European film journal written (almost exclusively) by young men who sought to challenge the hegemonic film culture in their respective countries and who advocated emerging art cinemas. Yet, the shift in methodology and style in the mid-1960s produced less an "aesthetic" criticism – in the terms of Berghahn and Patalas from "Is There a Leftist Criticism?" – than an "aesthetic left," an increasingly theoretical auteurism inflected by commitment on specific, and specifically political, subjects.

In many ways, the journal's transformation was less a question of ideology – after all, the writers were all somehow on the left – than an important shift in the stance, mode of communication, and ethical responsibility that the critic should maintain vis-à-vis the reader.[85] Much of the *Cahiers du cinéma*'s writings was (like the *nouvelle vague*) unashamedly subjective, biased, and emotional; it allowed and even cele-

brated individual opinions, idiosyncratic prejudices, and inexplicable predilections of taste; it often embraced the film as text – at the expense of context. These democratic lessons informed *Filmkritik*'s much more earnest aesthetic left, which was openly personal yet theoretical; it aimed to "provoke [the reader] to independent reflection on the work."[86] The understanding of film criticism as a dialogical rather than purely didactic pursuit was anticipated already in the many letters to the editor that allowed for a measure of reflexivity.

The journal's development required a re-division of critical duties and a movement towards an implied first-person plural, "we," form of address. This departed from the magazine's founding principles, the political left's aura of "objectivity" and commitment to the function of the educated, enlightened critic as the medium that allowed the reader to see through the illusions presented by the filmmakers and their commercial agents. This early conception of the critic's task had responded to the postwar German film culture's fundamental distrust of film because of its wartime potential as propaganda and a suspicion surrounding the profession because of Joseph Goebbels's *Gleichschaltung* of critics in November 1936. The film criticism against which *Filmkritik* rebelled was, if not belletristic, then largely moral, narrative-based, and appropriated by the church, the state, or other institutions. The alternative tradition available was a turn to an internationalist national culture: the "legitimate" German culture of exiles, such as Brecht, Benjamin, and above all Kracauer. Initially, in the context of the postwar desire for legitimacy and in keeping with discourses of re-education, Kracauer availed the young editors of an untainted authority and subject position that allowed them to fulfil another function (coming to terms with the national past) in a way that other possible approaches, whether belletristic impressionism or auteurism, could less effectively, if at all.

Nevertheless, as the new waves and, in particular, the Young German Film emerged, this stance became unsustainable. Although in the founding year of *Filmkritik* cinema was still a chief leisure activity for West German consumers, the course of the magazine coincided with the demise of film as dominant mass medium in the face of television, and the rise of art cinema and cinephilia as institutional and subcultural reactions to this process. This exclusivity contributed in turn to cinema's status as an aesthetic (rather than primarily commercial) phenomenon. When Kracauer had formulated his treatise on the film critic's task, he was concerned with "unveiling hidden social ideas and ideologies." By the mid-1960s, developments in distribution and the establishment of a niche market for the "responsive cinemagoer" had rendered much of this superfluous. With the explicitly artistic aspirations of the new waves and the films' interrogations of Hollywood, film criticism could gain little purchase by demystifying consumer product. Indeed, with the host of positive examples of filmmaking on offer, the cinephile could be directed towards these works, rather than simply warned to stay away from others.

Just as art cinema conceived of itself as personal expression, the writing on the phenomenon became more subjective in the late 1960s and into the 1970s. This de-

velopment echoed the 1930s responses of Arnheim and Kracauer to the new confidence of cinema as an important cultural phenomenon and the rise of star critics. Political re-education yielded to agencies of aesthetic theory, advocating on behalf of a young generation, locating film's ontology among other forms, but also, via auteurism and a new more personal address and style, exploring subjective psychologies through film and through writing and reading about film. In the absence of pressing didactic imperatives and with the self-assurance of a niche cinephile demographic, criticism could engage with camp sensibilities, and function partly as a literary end, rather than merely a pedagogical means. The "sensibilists" who increasingly influenced *Filmkritik* throughout the 1970s and until the magazine's demise in 1984, Eric Rentschler has convincingly argued, expressed a "unique mode of cinephilia" partly derived from their idiosyncratic reading of Kracauer's later work, *Theory of Film.*[87] They privileged "single moments and a selective attention, aiming to escape theoretical cubbyholes that for them remained abstract constructions devoid of experiential immediacy."[88]

The aesthetic left's subjective mode of associative auteurism represented a potentially more democratic way of relating to sophisticated readers. Unfettered by appeals to tradition or indeed any universal standards external to the critic, evaluations and interpretations had a low threshold for validity: they had to be true only for the critic and, as such, could accommodate a potentially limitless array of perspectives. In the United States, at the same time that *Filmkritik* was firmly in the hands of the aesthetic leftists, an American film critic was also flirting with a more democratic mode. Even if her project and style differed significantly from Grafe's and Linder's esoteric abstractions – notoriously, her favoured pronoun was "you"[89] – Pauline Kael indulged convivial modes of addressing readers, yet retained a respected authority. Indeed, as we shall see in the following chapter, in the minds of many commentators Kael was the most influential film critic ever.

5. The Anxiety of Influence: The "Golden Age" of Criticism, the Rise of the TV Pundit, and the Memory of Pauline Kael

The previous two chapters have revealed the processes by which critical authority was asserted vis-à-vis ascendant French film culture, the new waves, and sophisticated, less deferential cinephile audiences. Chapter 4, in particular, demonstrated how *Filmkritik* adopted a new methodology, style, and mode of address so that the journal could position itself in this global order and in relation to domestic filmmaking, as well as stay ahead of its readers, who increasingly had internalized the procedures of ideological-symptomatic critique.

The present chapter, which moves from Europe of the 1940s, 1950s, and 1960s to the United States in the 1960s, 1970s, and 1980s, picks up on some overlapping themes: for example, the way in which American critics approached and exploited New Hollywood to stake out fronts in ontological matters of criticism and taste and how these writers negotiated an informal, personal, and colloquial relationship with readers. Nevertheless, in this chapter the perspective changes. Rather than looking at US film criticism from the mid-1960s through the late 1980s purely on its own historical terms, this chapter analyzes the period through the mediated memory of the era and thereby recontextualizes it within the current crisis of criticism, which will be the focus of Chapter 6. This is necessary for two reasons. First, unlike Houston-era *Sight and Sound* and *Filmkritik*, which have elicited a smattering of academic treatises and journalistic recollections, American film criticism of the 1960s and 1970s has inspired a huge proliferation of memory, a meta-level that must be considered. Second, following from this, the memory has been deployed as a contrasting example in the contemporary crisis discourse: it serves an argument about a halcyon era of influential, public critics that once existed.

This chapter examines the role of the film critic during the so-called "age of criticism" (and concomitant zenith of cinephilia) from the mid-1960s through the 1970s, and the aftermath of this period, which witnessed the birth of the modern blockbuster and a crisis of authority precipitated by the rise of television criticism. In retrospective assessments – not only of film criticism, but also broader narratives – this transition is seen as the last stand of the public critic and the beginning of an anar-

chic, populist, and ultimately useless explosion of opinion. Names such as Pauline Kael and Andrew Sarris are nostalgically invoked – by critics and scholars such as Richard Corliss, James Wolcott, Craig Seligman, Raymond J. Haberski, Rónán McDonald, and others – to suggest a pure age of criticism before the "sell-out" and "dumbing-down" of the profession and its status, symbolized by the likes of Gene Siskel and Roger Ebert. Although some commentators derive the present crisis of authority in film criticism purely from technological developments such as Twitter and blogs, the demise of print, or platforms such as Rotten Tomatoes (the focus of the Chapter 6), others deem it a longer and larger crisis of authority that stems from the lack of "public critics" such as Pauline Kael.

Examining chiefly US film criticism (although one that was surely engaged in a debate and over the importation of French auteur theory and the international new waves), this chapter critically evaluates the prevailing history of the "authoritative" critics of the 1960s and 1970s and their demise in the 1980s with the triumph of broadcast punditry. Introducing a body of empirical findings that disputes the claims of these commemorators, I proceed to focus on the memory, myths, and realities of Pauline Kael, critic for the *New Yorker* between 1968 and 1991, who is regularly cited as the archetypal "public critic" and as perhaps the most authoritative film critic ever. Closely analyzing the history surrounding what is said to be her most influential essay, on *Bonnie and Clyde* (1967), I challenge the widespread claims about its decisive significance in the critical and popular reception. Indeed, I contest the very idea of critical influence.

The "Golden Age" of Film Criticism and its Demise: Conventional Wisdom

The history of 1960s and 1970s US film criticism conventionally revolves around three major principles. First, in strongly personalized accounts it is asserted that critics from this era enjoyed widespread respect and made determinant mediations between films and readers, thus shaping both the tastes of the public as well as influencing filmmakers and the industry. Second, these narratives often make direct parallels between the strength of critical authority and the quality of film production output and cinema culture. Third, these testimonials imply that this authority has been lost or, at best, diluted because of the aforementioned lack of quality filmmaking and canny studio strategies, but above all on account of the prominence of superficial criticism on television and (in a preview of Chapter 6) other new media. The sections that follow survey and anatomize these discourses, before turning to empirical evidence about critics' ability to influence audiences and offering detailed consideration of Pauline Kael in order to scrutinize these accounts of putative authority and its loss.

Anne Thompson's *Variety* piece, "Crix' Cachet Losing Critical Mass," is symptomatic of the contemporary crisis discourses telegraphed in the Introduction. It sums

up the perceived loss of critical authority in the age of Twitter as a phenomenon that began much earlier. A generation of film lovers "can't name a working critic" besides Roger Ebert, Thompson claims, and "that's thanks to his TV fame."[1] This phenomenon is largely attributable to the lack of critics with public persona and cultural power. Unlike in the glory days of Andrew Sarris and Pauline Kael, Thompson submits, today young people "don't read newspapers and never will." Preferring to be spoon-fed information from studios' marketing departments, they "check out film rankings at Rotten Tomatoes or Metacritic and dip into some reviews, but they haven't found a particular film critic they trust to steer them straight."[2] Critics no longer dominate discourse and have lost their function as opinion leaders and authority figures. Film critics have been outpaced by studio marketing information; only baby "boomer parents" still appreciate movie critics and "follow their guidance."[3]

Anne Thompson's squib – to which I will return again in Chapter 6 – is an unexceptional view, not only among industry insiders; its tone and scope resound with the general consensus among journalists and critics. In Neal Gabler's analysis, for example, the role of the critic in this unique period was responsible for raising and mediating the role of popular culture, a procedure by which "high" and "low" gradually lost their force. "In time," Gabler writes, "popular music, the movies and particular television shows would all have critical champions in the most influential, highbrow media organs, and a few powerful ones, such as the old *New Yorker* movie critic Pauline Kael, would even make their reputations by insisting that 'official' art was dull and desiccated and that the real vibrancy was with the subversive trash of popular culture."[4] The timing of Kael's career was vital: hers "was a time in America, some 40 years ago, when the balance of power was shifting from the elites to the populists – a last ditch fight that turned criticism into a blood sport with all sorts of warriors." In those days, critics were influential and omnipresent. "One could actually find critics on nightly talk shows then – something that almost never happens now – and many were practically household names," such as the "proud elitists" à la "John Simon of *New York Magazine*, populists such as moustachioed Gene Shalit of *The Today Show*, professional eviscerators such as Rex Reed and Judith Crist." To be sure, there was a measure of self-promotion involved, but also a real belief in the role of the critic in the mediation of culture: "This was a criticism as entertainment but it also demonstrated a genuine dispute over cultural hierarchy – over the claims of informed taste over popular taste."

Furthermore, like Gabler's observations of an activity between entertainment and vigorous intellectual debate, the many accounts of this period posit not only strong and influential film critics, but also an overall heightened respect for film culture, which became both a spectatorial and participatory activity. In critic Richard Schickel's memory, Pauline Kael and Andrew Sarris "raised the musty level of film criticism to a volcanic, love-hate art."[5] The passion of their arguments on the auteur theory[6] and on the merits of new releases "lured people to see new films [...] opened eyes, awakened curiosity, aroused intelligence."[7] In those days, the profession was trans-

formed and, if we believe Schickel, Kael and Sarris were at least partly responsible for a general invigoration of the intellectual debate over popular culture. "They made film criticism sexy. Pictures were things that mattered; ideas were worth fighting over. Forget Tracy-Hepburn. Sarris and Kael were more like Ali-Frazier. Film criticism was the main event, and these two were the champs."[8]

Remembering reading the *New Yorker* in the 1970s, writer and critic Daniel Mendelsohn recalls "always sav[ing] Pauline Kael for last, because I loved that she wrote the way most people talked; her now famous second-person-singular address made me feel included in her fierce and lengthy encomia or diatribes – made me want to be smart enough to deserve that inclusion."[9] The bond that these critics sought out and formed with the reader via the mediated object appealed to Mendelsohn; so too did the basis for their authority, which amounted to an informed cinephilia and an engaging writing style. "It wasn't that these people were Ph.D.s, that the expertise and authority evident on every page of their writing derived from a diploma hanging on an office wall," Mendelsohn writes. He never knew "while reading Kael, whether she had a degree in Film Studies. [...] If anything, you felt that their immense knowledge derived above all from their great love for the subject." The confidence of Kael's opinions back then, "the sheer extremity of her enthusiasm, the ornery stylistic over-seasoning, the grandiose sweeping pronouncements, made it clear that there was something enormous at stake when you went to the local movie theatre."

These were heady, fortunate, and bygone times for American film critics and film criticism, according to many including Phillip Lopate, who dubs the era "The 'Heroic' Age of Moviegoing."[10] In this epoch, according to director, screenwriter, and critic Paul Schrader, it "mattered which movies were made, which movies audiences saw, and what they thought of the movies they did see."[11] "Movies were no longer just a great common pastime," maintains Kael's biographer Brian Kellow, "like Saturday afternoon baseball games."[12] They played a "significant role in the culture as people became interested in exploring the connections between cinema and contemporary life."[13] Not only were average filmgoers more active and engaged, Kellow submits; film critics were omnipresent, leading the charge when "hit films [...] were dissected in national magazine cover stories, on television and radio talk shows."[14] "Those were the days," James Wolcott reminiscences. "Film critics had the oral swagger of gunslingers. Quick on the draw and easy to rile, they had the power to kill individual films and kneecap entire careers."[15] In the 1970s, "the feudal age of criticism, when criticism retained the ability to make readers made in both senses of the word,"[16] the studios "would sometimes slip a spy into the screening room to monitor Kael's responses, her sighs and whispers," so powerful was the *New Yorker* critic.[17] Today, in contrast, critics shuffle in and out of screenings like "a prison work detail or refugees from the Russian front."[18] Because of "the shrinkage of prestige and clout in the field," film criticism "has become a cultural malady, a group case of chronic depression and low self-esteem."[19]

MATTIAS FREY

Historians' investigations into 1960s and 1970s American film criticism differ little from journalists' rose-tinted memories. In fact, in Raymond J. Haberski's monograph on American film criticism, history stops after Pauline Kael and Andrew Sarris. It proposes that this was the "golden age of criticism" and that, beginning in the 1970s, the "lively debates over the place of movies in America" waned, because of "the critics' loss of cultural authority and the increasing irrelevance of the meaning of art."[20] Haberski quotes Pauline Kael, who recalled the 1960s and 1970s as a time "when movies were hot, when *we* [film critics] were hot," when "movies seemed to matter."[21] The historian uses this anecdote to make the claim that, "for a relatively brief moment, movies did matter to a population that read movie critics and believed discussing movies was significant."[22] According to the many who write in this manner, film critics *used* to have a privileged position to direct readers towards important works; those days, however, are over. Because this is no longer the case and the "meaning of culture has fractured into parts that no longer need to be defined within a common culture" – let us recall Haberski's argument outlined in the Introduction – there should be a renewed role for public criticism.[23]

Haberski's rise-and-fall trajectory is more or less de rigueur. From the few dedicated scholarly histories of film criticism to the many memoirs, most if not all subscribe to this historiography. In Jerry Roberts's survey, after "The Film Generation: The 1960s" and "The Golden Age: The 1970s" came "The Television Age" and concurrently "The Malaise: The 1980s and 1990s."[24] The collected writings of Pauline Kael, compiled and released in 2011, bear the title *The Age of Movies*; the compendium of Dave Kehr's film criticism maintains a similar eschatology: he presents a collection of reviews from a "transformative decade," the mid-1970s to the mid-1980s, entitled *When Movies Mattered*.[25] As elaborated in the Introduction, these periodizations are likewise not out of keeping with histories of criticism involving other media, such as literature. Contemporary academic studies, such as those advanced by Terry Eagleton, Maurice Berger, and Rónán McDonald maintain a decidedly uniform arc and strike similarly elegiac chords.[26] Let us recall how McDonald advocates new "public critics" along the lines of Pauline Kael or Susan Sontag, who, he opines, do not currently exist in contemporary media and society. Charting a historical trajectory that includes the "age of criticism" and prominent professionals such as F.R. Leavis and Lionel Trilling, McDonald asserts that the early 1970s marked the beginning of the end of a period in which critical writing flourished nearly indistinguishably between broadsheets and academic journals and critics made authoritative, evaluative pronouncements to a broad public.[27] The "death of the critic" entailed an end to a communicative mediation between a learned expert and a willing, engaged reader. Since then, scholarly and journalistic criticism have increasingly diverged and the vacuum of authority has been replaced by a host of blogging tyros and a dispersive field of reviewing that fails to capture the public imagination.[28] McDonald calls for the critic as strong authority figure, a type – he asserts – that once existed. According to McDo-

nald, the role "has diminished since the heyday of Kenneth Tynan, Clement Greenberg or Pauline Kael."[29]

Critical Decline, Film Cultural Decline: The Rise of the Television Critic

If chroniclers of film criticism maintain a similar regard of the craft to historians of literary criticism, many of the former posit an additional, particular claim: one that yokes the decline of the public, influential film critic to the decline of filmmaking as an aesthetic form and filmgoing as a culturally important activity. Such a link, between the fate of filmmaking and film criticism, is a recurring trope in the history of film culture. Let us recall, for example, early critics such as Clayton Hamilton and Willy Haas or how the *Filmkritik* authors retrospectively justified their move away from Kracauerism as a symptom of the increasing quality of filmmaking in the late 1950s and early 1960s. This is also how Dave Kehr narrates the descent in the 1970s and 1980s, what he calls the "inevitable reaction" to the golden age of European art cinema and New Hollywood: "In 1975, Steven Spielberg's *Jaws* pointed the way to a brutal new commercialism, based on saturation advertising on television and wide release patterns that bypassed the old downtown, first-run theaters in favour of suburban shopping malls."[30] This situation only intensified with *Star Wars* (1977). "The wayward auteur was replaced with an almost fanatical adherence to the rules and regulations of juvenile genre filmmaking," while formulaic horror, science-fiction, and action-adventure flicks "were reproduced as simply as possible [...] in the hope of providing visceral thrills for young filmgoers and nostalgic reveries for their parents."[31] This left little room for serious art and contemplative film criticism. According to Kehr, the "adult dramas of the early 70s were banished from the multiplexes, as the Hollywood establishment concentrated on pleasing the taste of the average American fourteen-year-old boy."[32] Indicative of this development, both Pauline Kael's supporters and detractors attribute her eventual loss of influence to the poor fare she was required to review, week after week. This was formulaic filmmaking, which – unlike the dazzling and daring New Hollywood – needed no interpreter and certainly no defender. By the 1980s, the "conglomerates were tightening their grip on the studios," David Denby writes, and Kael "was reduced to looking for subversion in more and more trivial movies."[33] Brian Kellow's biography supports this thesis. "By the mid-1980s the nature of movie criticism itself had begun to change dramatically" and Kael struggled to remain current. "In keeping with the tone in recent Hollywood films," Kellow reports, "reviewing had become lighter and more 'entertainment' driven."[34] This only became worse and "Kael's biggest professional disappointment," Kellow adds as a postscript, was "the infantilization of the great moviegoing audience." Kael would have "been shattered," Kellow speculates, "to witness the way in which the role of the film critic has been eclipsed – not only by studio marketing

practices but even more by the Internet, with its system of validating the critical opinion of anyone who owns a computer."[35]

In Jerry Roberts's "biography of the profession," to date the only survey of the entire twentieth century of US-American film criticism, the summary is similarly neat: "The arrival of the great age of film criticism in the 1960s included the meteoric rise of Pauline Kael as well as the advent of Judith Crist, Roger Ebert, Stanley Kaufmann, and Richard Schickel."[36] "The proliferation of outstanding critics occurred in the 1970s," Roberts notes, "as Hollywood's product also experienced a renaissance from such protean talents as Francis Ford Coppola, Steven Spielberg, and other filmmakers."[37] Once again, according to Roberts, a crisis in filmmaking yielded a crisis in criticism: "Hollywood's attention to the blockbuster syndrome after *Jaws* (1975) produced the critical malaise of the 1980s and 1990s. Sequels, teen films, and copycat films led into the doldrums of the 1990s."[38] Weak Hollywood fare and pernicious distribution tactics in turn undermined critics' authority: "The depression over consistently poor movies that found big audiences through saturation marketing – despite critical drubbings – proved time and again that critics had little influence." Hollywood triumphed in its putative battle with the critical establishment. "The studio marketing departments invented and nurtured the 'Blurb Mill' – reviewers in marketing departments' pockets. Depression among film critics was expressed by David Denby, Richard Corliss, Peter Rainer, J. Hoberman, Jonathan Rosenbaum, and others."[39] In Roberts's and many others' narratives of film criticism, the maxim obtains: the dearth of (quality) films, the demise of cinephilia, the death of the critic.[40]

In these chronicles, the rise in prominence of the "television critic" above all signalled the decline of the serious, authoritative critic in the United States. Jerry Roberts characterizes the eccentricities and antics of NBC opinionator Gene Shalit: bushy-haired, moustachioed, and always wearing a bow tie, Shalit was prone to alliteration, exclamations, and other self-conscious stylistics and regularly appeared on game shows such as *What's My Line?* and *To Tell the Truth*.[41] For Richard Corliss, television critics such as Jeffrey Lyons and Gary Franklin, who take "the minute-manager approach to an art form," do not earn their titles: "Lyons isn't a film critic, but he plays one on TV. The resident movie sage on PBS' *Sneak Previews* and superstation WPIX, Lyons has no thoughts, no perspective worth sharing with his audience."[42] Rex Reed is another television critic sent up with disdain. Gallivanting from one talk show appearance to another offering "catty snipes, priggish assessments, and juicy tidbits," Reed and his "pervasive TV exposure" lead Roberts to describe him as the "'hatchet man' of show business journalism [...] even as he was introduced, each time, as 'film critic Rex Reed.'"[43]

For many commentators, this television punditry – and, above all, Gene Siskel and Roger Ebert's syndicated programme – epitomized the dissolution of the profession and the informed public critic into a subgenre of light entertainment. "On *Siskel and Ebert and the Movies*," Richard Corliss writes in an infamous 1990 squib in *Film Comment*, "the critics play Roman emperors and award a thumbs-down condemnation or

a thumbs-up reprieve."[44] Unlike in the days of Sarris and Kael, Siskel and Ebert do not attempt to elucidate films or educate audiences. Rather, their programme functions as "a sitcom (with its own noodling, toodling theme song) starring two guys who live in a movie theater and argue all the time. Oscar Ebert and Felix Siskel. 'The fat guy and the bald guy.' *S&E&TH* is every kind of TV and no kind of film criticism."[45] In contrast:

> the elevated sort, as practiced over the past half-century by James Agee and Manny Farber, Andrew Sarris and Pauline Kael, J. Hoberman and Dave Kehr – in the mainstream press and in magazines like *Film Comment* – is an endangered species. Once it flourished; soon it may perish, to be replaced by a consumer service that is no brains and all thumbs.[46]

For Corliss, "'real' critics," i.e. print critics, deem television critics to "have no more in common with serious writing than belly dancers do with the Ballet Russe."[47]

Corliss's doomsday rhetoric about broadcast criticism was endemic in the late 1980s and early 1990s, in other words, before the internet became the new threat to critics' perceived authority. In another jeremiad that uncannily previews the crisis discourse around Twitter and other new media film reviewing, Patrick Goldstein's 1988 *Los Angeles Times* article elegizes the moribund state of the profession and bemoans the influence of television critics, who may be "killing film criticism."[48] For Goldstein, Hollywood owns a large part of the guilt for this deterioration: "Movie marketeers go far afield these days to find critical boosters for their pictures – and top billing often goes to TV film critics." As evidence, Goldstein singles out contemporaneous or recent advertisements for *Overboard* (1987), *La Bamba* (1987), *Surrender* (1987), *Someone to Watch Over Me* (1987), *Three Men and a Baby* (1987), *Fatal Attraction* (1987), and *Running Man* (1987), which all quote exclusively from TV film critics. The Barbra Streisand star vehicle *Nuts* (1987) "has an ad running in [the *Los Angeles Times*] with eight raves – *all* from TV film reviewers." According to Goldstein, the hegemony of the television-based film critic has "changed the rules of the reviewing game." Critics – both "print essayists and the glib tastemakers who populate the airwaves – have been absorbed into Hollywood's star-making machinery." Film clips, used as "descriptive weapons," simply function as free advertisements for studios. The "key to TV critics' influence isn't what they say so much as what they show," which is why "marketing execs love them," Goldstein asserts. "Pauline Kael may be a dazzling stylist, but would her richly descriptive criticism play on TV? Probably not." The new television critics – including Siskel and Ebert, who are in Goldstein's idiom "critic-celebrities" but above all "a brand-name commodity" – have ushered in the "Age of Glitz Criticism."

Another claim anticipates the rhetoric about the supposed "democratization" or "anarchy" of criticism in the age of Twitter that will be picked up in Chapter 6. Goldstein maintains that "as long as they can cut it as TV performers, anyone can be a

film critic today. And we mean *anyone*," including baseball legend Yogi Berra and New York mayor Ed Koch, who, Goldstein reports, would soon begin reviewing films on local television stations or in syndication. "Remember when critics used to write scholarly texts and lecture about the *auteur* theory?," Goldstein asks, evoking the notion of a "statusful past," as in Gans's formulation of the "dumbing-down" thesis; with "critics today, what counts is Armani, not *auteur*." This is in contrast to today's "print critic, who finds himself with less space – and less clout – than ever before." The problem, Goldstein sums up, "is that many critics find it hard to differentiate recognition from influence." The end result is that there are no "important film critics left in America," according to Goldstein's anonymous studio executive source. "Once you get past Siskel and Ebert, it's a short list. And if there are any others, you can bet they're on TV."

Writing with the benefit of twenty years' hindsight, Frank Rich appraises the role of television with less of Goldstein's apocalyptic tone, even if his assessment is similarly nostalgic. "Though there are still some fine film critics at work," he summarizes, "few readers wait for their verdicts on the new Almodóvar or Scorsese the way so many once waited for Kael's. Print movie critics declined in influence with the rise of Siskel and Ebert's thumbs up-thumbs down appraisals on television."[49] For Jonathan Rosenbaum, Gene Siskel, whose "main beat was real estate" when he first began his career in media for the *Chicago Tribune*, was the epitome of everything wrong in film criticism: "most 'film experts' are hired not on the basis of their knowledge about film but because of their capacity to reflect the existing tastes of the public."[50] Television punditry pre-packages "criticism" into sound bites, according to Rosenbaum; it forecloses discussion of "foreign and independent" productions.[51] The format of Siskel and Ebert's show "made it virtually impossible to recognize informed opinion or expertise; matters of film history and aesthetics were virtually beside the point."[52] The show "may well have represented one of the many points in our film culture where reviewing shades off into promotion and coverage becomes more important than evaluation."[53] To wit, in 2010 *New York Times* stalwart A.O. Scott found the many eulogies around the end of *At the Movies*, the television programme that Roger Ebert and Gene Siskel began, to be ironic. The cancellation was seen in the context of the general crisis of criticism and "death of the critic" discourse: "it is worth remembering that the program, now inscribed on the honor roll of the dead, was once implicated in the murder."[54]

The rhetoric of the many detractors of television criticism are in crucial ways predictable. Media historians have shown how, time and again, the appearance of new media has been feared and loathed, whether these innovations were the telegraph, radio, or mobile phones.[55] Chapter 6 will detail how today's new media – the internet, blogging, Twitter, IMDB, Rotten Tomatoes, and so on – are being seen as the villains of the current crisis of criticism. In addition, we can partly understand this history via the perceived position of television among media professionals and especially the print media. In Kimberly Meltzer's qualitative study of American journal-

ists, she shows that within internal media hierarchies, newspaper journalists are regarded as the "legitimate craftsmen."[56] Television journalists, in contrast, are more highly revered by the public on account of their wider recognition (and, sometimes, "fame") and by virtue of their larger salaries; nevertheless, within the industry itself, they suffer from a lower regard. This discrepancy between colleagues' esteem and the public's perception of status for journalists according to medium means, for Meltzer, that "television journalism and its accompanying celebrity have made the traditional guidelines for cultural authority messy."[57] But, *pace* Meltzer, perhaps the shifting matrices of technology and exposure vis-à-vis cultural esteem and authority are less ambiguous than straightforward. In the Introduction and throughout this book we have repeatedly encountered iterations of this argument about the degradation of authority: the "dumbing-down" thesis. Let us again recall Gans's formulation of the concept, which suggests "that the culture being supplied is less sophisticated or complicated, or tasteful, or thoughtful, or statusful than a past one."[58] This narrative paradigm is the template for the arguments of Corliss, Goldstein, Rich, and Rosenbaum: in fact, for more or less all of the writers and academics surveyed here.

The Case for Kael: Assertions of Pauline Kael's Cultural Authority

Up to this point I have outlined the conventional historiography and discursive patterns about the perceived heyday of authority and the public role of film critics in the 1960s and 1970s and its end, which has been ascribed to the lack of quality filmmaking, a change in Hollywood genre preferences and marketing tactics, and the proliferation of "dumbed-down" television criticism. Nevertheless, whether or not the "demise" of public critics such as Pauline Kael occurred because of the parallel decline of film art or whether it came about because of the rise of Siskel and Ebert misses the point. Only anecdotal evidence has asserted that this period of increased cultural authority actually existed. We need to evaluate the extent to which the past was a "golden age" at all and reckon with the idea that the crisis of criticism began with the demise of the "public critics" and, most notably and famously in the case of film criticism, Pauline Kael. In the present and following sections I will rehearse the claims made for Kael as an influential – indeed, the archetypal and *most* influential – film critic before introducing a body of empirical evidence that severely complicates, if not outright refutes, these claims. The memory of Pauline Kael and the so-called golden age overstates and mischaracterizes the authority of critics in this period and, indeed, in any period. Scrutinizing these claims helps us place the "crisis" of authority ascribed to the downfall of Kael and other public critics into context.

Although accounts may differ on the authority of film critics as a group, all seem to agree: Pauline Kael was the most powerful sort of film critic and, if we accept the theses of Haberski and McDonald, her level and type of influence are what critics should wield or should aspire to wield. According to the venerable British film re-

viewer Derek Malcolm, "Pauline Kael could make or break reputations at will."[59] This was not just a matter of leading a willing readership with her write-ups; she had a tremendous power within the industry and with other critics as well: "Hollywood took note of what she wrote [...]. If a director was praised by Kael, he or she was generally allowed to work, since the money-men knew there would be similar approbation across a wide field of publications." Malcolm – the chief film critic for the *Guardian* and later the *London Evening Standard* – describes her "profound effect" on him and other colleagues: "The rest of us tagged behind. At the height of her career, it was difficult to raise one's voice sufficiently to mask hers."

For Paul Schrader, Kael's enemies and the invective she suffered during her career were ultimately indicators of her authority. The attacks "were not so much the result of her specific opinions, but of her enormous impact on film (and cultural) criticism."[60] For Schrader, this influence included personalizing and sexualizing criticism, wresting criticism away from the "Eastern Establishment," and taking it to "the average filmgoer." As the "pied piper of reviewers, who made readers believe that movies, even disreputable movies, were important," Kael rendered both films and film criticism culturally significant.

According to such nostalgic exercises, in the "golden age of criticism" Kael possessed a "higher power," an authoritative, yet "liberating force" to create and lead discourse on films.[61] James Wolcott recounts a press screening of Bob Fosse's *Lenny* (1974) in which Kael's presence marked the cue to dim the lights; "there was the collective awareness" that "of all the movie critics, her notes mattered most, and whatever she was scribbling might be added to the bill of indictment or provide the embroidery of a fantastic rave."[62] Kael's verdict, according to Wolcott, was decisive and ultimate. "Each note could be a nail in Fosse's coffin or a diamond stud for his vest. [...] Melodramatic as it might sound, Kael's review of *Lenny* proved to be such a devastator that Fosse, carrying a grudge until he stooped, immortalized its aftershocks in *All that Jazz*" (1979), where his alter-ego "has a heart attack after *his* Lenny Bruce opus is coolly panned by a local-news critic."[63]

If we believe these testimonies, Kael possessed an almost divine ability to change the course of film history. Writers ascribe Kael with inspiring them into the profession, pulling the strings to get them a job, or with convincing Paul Schrader – over a night of drinking at her flat – to give up his goal of becoming a minister in the Christian Reformed Church to become a pundit and win a place at film school.[64] Kael is credited with David Lynch landing directorial duties on *The Elephant Man* (1980); these reports strongly imply a crucial part of his career is indebted to her reviews or other networking machinations.[65]

Following from this episode, perhaps the most significant indication of her status as a "public critic" and of her authority – which is in turn often used to exemplify the potential of any public critic – is the claim that she transformed projects that would have been commercial failures into successes. In the many journalistic and the few academic accounts of Pauline Kael's career, this notion recurs habitually. In James

Wolcott's homages to Pauline Kael and in Brian Kellow's biography of the famous *New Yorker* critic, for example, Kael's career is structured around moments in which she "rescued" a film or "saved" a director, such as Frederick Wiseman or Robert Altman, from obscurity.[66] In the case of *M.A.S.H.* (1970), Kael's pronouncements not only fostered the success of the film and Altman's career. Kellow suggests that the performance of *M.A.S.H.* rejuvenated Fox; the implication is that Pauline Kael's review in the *New Yorker* had a determining influence over the fate of a major Hollywood studio.[67] According to Wolcott's protocol of an advance preview of *Diner* (1982), Kael exercised the pivotal sway in the film's reception and in the decision to release it at all: "Pauline wouldn't be the only critic to praise *Diner*, but her going to bat for it before anyone else had seen it kept it from being bottom-drawered as just another coming-of-age film, a nice try." For Wolcott, "absent that screening, *Diner* would have died an obscure death, rediscovered for its qualities only after its rediscovery was too late to do anybody any good."[68]

There is no shortage of anecdotal evidence about studios executives, distributors, and even directors deferring to Kael in her presence because of her perceived clout. Indeed, for self-professed "Paulette" David Denby, one "of the minor highs of hanging out with her was to see publicists, directors, and other critics quail before such an unprepossessing-looking person."[69] Kael "loved her power to influence, and she wanted people in the movie business to listen to her."[70] Another commentator, Frank Rich, provides a similar assessment: "There may never have been an American movie critic with a more voracious desire to work her will on the world."[71] This ability to influence made her – in a sentiment echoed throughout the literature – transform "the sensibility and standards of mainstream pop culture criticism in America."[72] The rhetoric of "intervention" is a hallmark of the writings on Kael; although it echoes the role that *Filmkritik* understood itself to have in relation to the New German Cinema, here the prism of memory magnifies considerably. According to Denby, "in the seventies, Pauline and her group were not the only ones pushing Scorsese, Coppola, Altman, Spielberg, and the rest, but we did it early, and we helped a group of directors make their way."[73] That is why for Denby – just like for McDonald or Haberski – the case is clear: "In movie criticism, Pauline is unlikely to have a successor."[74] The idea that Kael's influence was immense, of a certain time, and *sui generis* resounds with the memory of another erstwhile acolyte, James Wolcott. What Pauline Kael achieved during her stint at the *New Yorker*, Wolcott opined in 2001, "can't be done now."[75] Kael's import to culture was massive, according to Sanford Schwartz; her retirement from regular reviewing in 1991 was a "national news story." During her more than two-decade tenure at the *New Yorker*, "she was undoubtedly the most fervently read American critic of any art."[76]

The aggrandizing claims about Kael – or any other individual film critic for that matter – and her authority are based on anecdotes or are merely asserted. As detailed in the above section, there is no lack of critics and other opinion leaders who cite her as an influence on public taste and critical practice. The few academic stud-

ies of criticism, such as those written by Haberski, Roberts, and McDonald, all list her as the epitome of the "public critic." The so-called evidence about the authority of critics – which Haberski, McDonald, Eagleton, Berger, and many others maintain is now lost – must be put under scrutiny.

The Influence of the Critic: Empirical Findings

Researchers working with rigorous methods have investigated the claims that critics can function as "tastemakers" or "gatekeepers" and significantly exert influence on the success or failure of a film. The gatekeeper thesis has traditionally contended that the critic shapes the reader's reception of the film – or at least provides the preconditions or point of departure for the latter's later viewing. In empirical studies performed over decades, however, sociologists, economists, and psychologists have doubted the extent to which pundits have the ability to perform this function. In Wesley Shrum's empirical analysis of the Edinburgh Fringe Festival, for example, he concludes that, despite anecdotal claims to the contrary,[77] critics "do not have the power to 'make or break' shows." Indeed, much more significant than a critic's positive evaluation or scathing opprobrium is the "visibility provided by reviews."[78] According to Shrum's research, which is also useful for film, the reviewer only has an effect on certain type of productions ("legitimate" genres such as arthouse) or certain types of readers/viewers (those who seek to refine a discriminating sensibility for art).[79]

Morris B. Holbrook has made further inroads into this field by questioning the implicit assumptions made about the divergence of critical judgement and popular appeal of films.[80] Many ontologies of criticism presuppose a significant difference between the tastes of critics and general audiences. Matthew Arnold's seminal understanding of criticism, for instance, famously sought to "to learn and propagate the best that is known and thought in the world" in order to raise the taste and class-cultural aspirations of what we would now call the critic's "audience."[81] To cite another, seemingly very different example, Pierre Bourdieu's studies of distinction and critical agency arrive at strikingly similar results: connoisseurs' possession of significant "cultural capital" provides legitimacy to their claims to provide value to art in the form of expert judgements; this is a power that lay audiences do not have. Even in the contemporary field of aesthetics, which often differentiates in neo-Humean terms between "ideal" or "professional" critics versus "amateurs," "connoisseurs," and "épiciers," similar presumptions are widespread.[82] Despite their vastly different enterprises and historical contexts, Arnold, Bourdieu, and contemporary philosophy of art come to similar conclusions on this question. In each there is an abiding understanding of the professional critic as one whose knowledge about a certain area of art gives him or her the right to speak about it. In Holbrook's idiom, there is a set of binaries at stake: between "professional critics" and "ordinary consumers," "expert judgments" and "popular appeal," "extensive training" and "naïve appreciation."[83]

In contrast to the theoretical assumptions, the outcomes of Holbrook's quantitative study of a sample of one thousand films released before 1986 shows a "significant tendency for popular appeal and expert judgments to reflect shared tastes between consumers and critics."[84] Based on these findings, many understandings of criticism that posit a divergence between critical and popular judgement and many "cultural critiques that denigrate popular appeal to ordinary consumers while extolling the expert judgments of professional critics [...] are just plain wrong."[85] These findings have profound implications for the present discussion. Although it might be argued that popular audiences responded to the one thousand films in Holbrook's study *only* *because* they were following the judgements of critics (referred to as an "influence effect" in the discussion below), Shrum's (and, below, others') research would seem to discount this probability. Indeed, the more likely explanation is that critics' taste acts less as a magnet for popular opinion than as a reflection of it. Similar to Shrum's findings, Holbrook's work indicates that critics' authority might not be as strong as apocryphal testimonies suggest.

Study after study shows weak – if any – influence that critics exert in the reception of a film. Although it is widely reported anecdotally that critics' opening weekend pronouncements may help (or hinder) the length of its run and robustness of its financial return, Jehoshua Eliashberg and Steven M. Shugan's study of critics' impact on films' market performance suggests that the "aggregate impact of critical reviews on actual box office revenues, at the beginning of the movie's life, is statistically insignificant."[86] Their findings confirm that critics are less decisive in motivating cinema attendance than other factors (trailers, television advertisements, release timing, word of mouth) and that, rather than *influencing* attendance, critics' evaluations are more useful in predicting the ultimate potential of a film: they "act more as leading indicators than as opinion leaders."[87] Robert O. Wyatt and David P. Badger's controlled laboratory experiment into the effect of positive, mixed, and negative critical evaluations on subjects' interest in seeing a film similarly disputes the anecdotal claims that critics can "make or break" a release. Negative reviews do not "decrease interest significantly over no review or a mixed review"; positive reviews do not "increase interest significantly over a mixed review or no review."[88]

The evidence is overwhelming: critics, as a group, do not significantly determine the popular reception of film. Measured in this way – and this is indeed one of the main indicators of cultural esteem that the many writers quoted above in this chapter are claiming – film critics do not possess significant authority. As powerful as these findings are, however, they do not address what McDonald or Haberski might argue is essential to their notions of authority: the personality of the *individual*, "public" critic and his or her mediation of the cultural object with the audience via a quasi-personal relationship. Shrum, Holbrook, Eliashberg and Shugan, et al. use large sample sizes, of films (or in the case of Shrum, theatrical productions) but also of critical judgements, which are only somewhat weighted in terms of supposed authority. Thus, Shrum gives additional weighting to the four major Fringe review organs

which write up 82 per cent of shows and to select broadcast media; Holbrook uses American Film Institute and British Film Institute critics' polls, among other indicators of critical judgement. Nevertheless, none attempts to account for the added value that a "name" critic's evaluation might bring to a production. After all – and in spite of studies which show that there is "good or acceptable" agreement between critics' film reviews 93.7 per cent of the time[89] – this is the main claim that Kael's journalistic celebrators and detractors make. It is also the one advanced by the academic analysts of the "public critic," i.e. that a few "influential" critics do indeed exert tremendous power.

If many studies have not accounted for this fact, David A. Reinstein and Christopher M. Snyder's recent article, "The Influence of Expert Reviews on Consumer Demand for Experience Goods: A Case Study of Movie Critics," makes this very subject its object of inquiry.[90] Specifically, the economists measure the influence that the reviews of Roger Ebert and Gene Siskel – at the time widely revered (or reviled) as the most influential American film critics and whose nationally syndicated television show maintained 95 per cent market penetration and between eight and eleven million weekly viewers – had on American filmgoing.[91] By using a mathematical model of the timing of reviews aimed to distil the "influence effect" (from the "prediction effect") of their reviews, Reinstein and Snyder find overall only a weak, marginally statistically significant outcome of Siskel and Ebert's reviews. The results are more conclusive when broken down by genre of film. There is no influence effect for "widely-released movies, or for genres such as action movies or comedies." The authors do find, however, "an economically and statistically significant influence effect on opening weekend box office revenue for narrowly-released movies and for dramas."[92] In contrast to aggregate studies of critics such as the one undertaken by Eliashberg and Shugan, Reinstein and Snyder's work suggests that the very top critics may exert some authority – but only in select cases. This is an important exception to which I will return later in this chapter.

The Influence of Pauline Kael: Myths, Realities, and *Bonnie and Clyde*

Faced with reams of testimonies that portray Pauline Kael as decisively influential but also with a whole body of scientific research concluding that critics do not exert a statistically significant ability to change the reception of most if not all films, let us return to the case of Kael's influence. In this section, I scrutinize perhaps the most famous and oft-repeated example of Kael's capacity to influence: her review of *Bonnie and Clyde*, published in the *New Yorker* on 21 October 1967.[93]

To the mind of Jerry Roberts, this "glowing watershed review" is "certainly one of the single most important film assessments in history."[94] The piece transformed not only the fortunes of the Arthur Penn production, but those of film criticism itself: "A new era of film criticism found 6,000 words to stand on, an essay that remains one of

the most important pieces of film writing."[95] "In 1967," according to James Wolcott, "everything changed." The release of *Bonnie and Clyde* was "a momentous event in both movie history and movie criticism."[96] Initially controversial, especially on account of initial reviews, the film "is now recognized as the beginning of the American New Wave."[97] The reason for this development is clear, Wolcott claims: "It was Pauline Kael's bravura championing of *Bonnie and Clyde* in *The New Yorker*."[98] Scholar Lester D. Friedman concurs: "The turning point in the critical battle of *Bonnie and Clyde* came with Kael's 9,000-word review which, in turn, galvanised her own career as the most influential movie critic of her generation."[99] (A symptomatic measure of the mythic and perhaps inflated claims made for this piece include the fact that, in various accounts, it contains 6000, 7000, or 9000 words.)[100]

Furthermore, the film went on to a significant gross, "served as the galvanizing point for the [next decade's] generation of young, outsider filmmakers," was the pinnacle of Penn's career, and made Warren Beatty and Faye Dunaway stars.[101] Even scholarly advocates of Kael's influence are keen to reproduce sound bites from Peter Biskind's nostalgic reckoning with New Hollywood, *Easy Riders, Raging Bulls*, in which screenwriter David Newman and (uncredited) script doctor Robert Towne assert, respectively, that Kael's review "put us on the map" and that without it, the film "would have died the death of a fucking dog."[102] Many commentators mention in this context Bosley Crowther's negative reviews and his sacking in December 1967, casually or explicitly suggesting that the venerable *New York Times* purveyor of moral criticism was usurped by Kael's essay.[103] As a measure of importance, Roberts and others emphasize the review's critical influence: it caused *Newsweek*'s Joe Morgenstern to revise his opinion. "Rumor had it," Peter Biskind dishes, "that she persuaded Morgenstern to see the picture over again. A week later, he published an unprecedented recantation."[104] Scholars, such as Haberski, routinely repeat this legend as fact, even stating that it was Kael's review – published nearly two months after Morgenstern's – that caused the *Newsweek* turnaround.[105]

These opinions are widely held and recycled in the literature on Kael: were it not for Kael's essay, these commentators imply, *Bonnie and Clyde* and Warren Beatty would be insignificant to film history and New Hollywood might have been stillborn.[106] Furthermore, her essay launched a new generation of film critics and provided "the essential values and aesthetic sensibilities for a new breed of American film critics" in a "holy war to determine the future direction of American film criticism."[107]

Nevertheless, there is no rigorous, substantial evidence to support these views. In fact, the film had been a success since it premiered at a sold-out two-thousand-seat Expo Theater on 4 August 1967 as the opening film at the A-list Montreal Film Festival, where it was "wildly received" with "gales of laughter and applause."[108] According to one report, the film received a standing ovation and fourteen curtain calls for Beatty and Dunaway.[109] *Variety*'s Robert J. Landry protocolled the "glamor opening": "The film gave the festival a powerful first-night lift and also delivered the persons of

Warren Beatty, Faye Dunaway and director Arthur Penn. It was an occasion, a coup, and a success."[110]

Indeed, despite claims that the film suffered from a poor reception upon its initial US release in August 1967, the critical response that summer was resoundingly positive. Important approbations – which preceded Kael's by about two months – included those by Andrew Sarris in the *Village Voice*, Judith Crist for *Vogue*, Kathleen Carroll (*Daily News*), and Penelope Gilliatt for the *New Yorker*.[111] Of course, there were some negative reviews, including the *Variety* write-up and, most notably, Crowther's decidedly scathing notices.[112] These opinions notwithstanding, praise was more or less widespread. Warners went so far as to run a double-page advertisement in *Variety* that featured one small publicity still and the title of the film: the main attraction was the seven full or excerpted glowing reviews, including those of Crist (*Vogue*), Gene Shalit (*Ladies' Home Journal*), William Wolf (*Cue Magazine*), and Liz Smith (*Cosmopolitan*).[113] The *New York Times* printed a host of reader letters that rejected Crowther's dismissal and even *Catholic Film Newsletter* endorsed Arthur Penn's latest as the "Best of the Month."[114] On 23 August, the National Society of Film Critics honoured it as one of eight films members had jointly recommended that year.[115] Almost a month before Kael's *New Yorker* piece appeared, *Variety* announced that the film's success was building in New York; the trade paper registered implications among Warner executives that Crowther's screeds had actually helped at the box office.[116] This fact would seem to support Shrum's findings that any publicity is good publicity.

Many commentators recycle the idea that *Bonnie and Clyde* suffered from a poor initial popular reception and meagre box-office returns; this scenario services their contention about Kael's decisive influence. According to Peter Biskind, "*Bonnie and Clyde* did no better than fair business in New York."[117] Scholar Lester D. Friedman contends that the film "opened in New York (on 13 August)" only to be "quickly withdrawn from circulation by Warner Bros."[118] These assertions cannot be substantiated.

During *Bonnie and Clyde*'s limited US release beginning in New York in mid-August 1967 and then fanning out to Los Angeles and finally regional markets, the film broke one record after the other. On the first day of its run at the New York cinema Forum, it hit a new all-time high of $8000;[119] the next week the "great grosser" earned "a wham $59,000" at the Forum and Murray Hill cinemas.[120] In the 30 August issue, *Variety* termed *Bonnie and Clyde* "a highly promising newcomer," which "hit a new house record in L.A." at the 810-seat Vogue cinema and "continues smash in N.Y.," where it improved earnings to $70,000 while still limited to two theatres.[121] Week on week, this success continued, so that on 13 September, with *Bonnie and Clyde* ranking ninth in the country at the box office in spite of only screening in a handful of cinemas, *Variety* published an article about its remarkable fortunes.[122] The piece reports that Warners, which had planned a distribution strategy based on word of mouth, was pleased with the film's run: "its hopes have been realized."[123] Six weeks after the New York premiere, *Bonnie and Clyde* opened at the Woods cinema in Chicago, with a test saturation in the Midwest planned for 4 October.[124] On that day,

Variety was already reporting that *Bonnie and Clyde* ranked third in its national box-office survey.[125] A good two weeks before Kael's piece, the *Observer* issued an article about the release's resounding fortunes in London, where *Bonnie and Clyde* had broken "every record"[126] at Leicester Square's Warner Theatre, an episode that Warners duly advertised in *Variety*.[127] By 11 October, ten days before Kael's article appeared, *Bonnie and Clyde*'s initial run was peaking with a second-place ranking on the box-office list.[128] Even on the basis of 1967 returns for its first release, $2.5 million, the film would have made a very healthy 20 per cent profit.

That *Bonnie and Clyde* did not immediately qualify as a blockbuster is surely, when one examines the evidence, unsurprising. This is not – as often asserted – because of critics or even the public, but because of the poor regard for the film on the part of studio leaders, such as Jack Warner and Ben Kalmenson, and the concomitant initial distribution strategy, which was limited and relied on word of mouth rather than a saturation release with a large publicity push.[129] The gross figures for the re-release ($16.5 million) – after it received ten Academy Award nominations and was rolled out on 21 February 1968 in 340 theatres nationwide – are extraordinary and reportedly put it in the top twenty films of all time, a pantheon that is perhaps beyond the expectations of all but the most ambitious projects.[130]

Bonnie and Clyde was initially a "narrowly released film," i.e. the type of film whose reception Reinstein and Snyder allow some exceptional critics to exert some control over. Nevertheless, even if one limits the question of influence to critics and their praise, Kael's contribution was not singular. As stated, her essay appeared in the *New Yorker* two months after a whole raft of critics registered their approval and the National Society of Film Critics awarded the film with its distinction. Although in some chroniclers' estimation Kael deserves the credit for *Bonnie and Clyde*, there is no shortage of evidence that suggests other critics were just as, if not more, important. Joe Morella, Edward Z. Epstein, and Steven Alan Carr contend that it was *Time*'s and *Newsweek*'s recanting of their initially negative assessments that led to the film's wider release.[131] The reversal by Morgenstern was much more valuable than an initial rave would have been; the studio could exploit the controversy and, in fact, it was highlighted in the new advertising campaign for the film.[132] In addition, whereas *Variety* reported on the flak that Crowther took for his negative reviews and Morgenstern's self-critique in *Newsweek*, [133] Kael's essay passed without fanfare among the industry insiders. Although Morgenstern's recantation is attributed to Kael's influence, the evidence is sketchy at best. He reports that his change of mind resulted from a second viewing with his wife at a public screening, i.e. not solely among the filmmakers and the press.[134] In any event, he published his second piece months before Kael's essay appeared.

If any single journalistic piece is to be deemed decisive, the 8 December 1967 *Time* feature story on "The Shock of Freedom of Films," which deals extensively with *Bonnie and Clyde* (and reproduces Robert Rauschenberg's psychedelic rendering of Beatty and Dunaway as the title characters) is the much more logical direct cause for

the subsequent wider release that Beatty "strong-armed" Warners into in early 1968 and not – as is implied in some chronicles – the effect of Kael's "revolution."[135] The *Time* story does devote sixteen words to Kael's notice; it also describes nine other reviews, however, in its detail of the film's critical reception. The article speaks of "cinematic perfection," a "watershed picture, the kind that signals a new style, a new trend," and compares the film with *Birth of a Nation* (1915) and *Citizen Kane* (1941). The publication of this hyperbolic praise and Beatty's subsequent move for a re-release seems more than serendipitous. In fact, it has been reported that Beatty went to Warners in December 1967, after "*Time* hit the newsstands," to demand that *Bonnie and Clyde* be given a full, wide release in early 1968.[136] The timing of the respective pieces (21 October and 8 December) and the relative power of the publications in terms of circulation – *New Yorker*'s modest readership of less than 475,000 in 1967 was dwarfed by *Time*'s circulation of almost 3.5 million[137] – would strongly suggest that Kael's piece might not have had the singular paradigm-shifting power that it is commonly ascribed. Indeed, with the exception of Andrew Sarris's piece for the *Village Voice*, which at the time had only a little over 50,000 readers, all of the publications with positive reviews mentioned above had substantially larger circulations than the *New Yorker* in 1967.[138] To cite one example, nearly two million readers could have seen Joe Morgenstern's initial review and reversal in *Newsweek*.[139]

Even the evidence that some have recycled about Newman and Towne's retrospective recollections of Kael's role pales when put under scrutiny. In fact, the full quote in Biskind has Newman claiming that the Kael review "was the best thing that ever happened *to Benton and myself* [...]. She put *us* on the map."[140] In this context, Newman's retrospective assessment makes sense. Kael's essay aided Newman's career because it gives the screenwriters the accolades – at the expense of both Beatty and Penn – for the film's achievement.

But perhaps the most convincing case can be built by examining the timing of Kael's review against *Bonnie and Clyde*'s box-office results. Looking concretely at these figures demonstrates that her essay did not significantly sway the popular reception of the film in the ways that Eliashberg and Shugan and especially Reinstein and Snyder have explicitly examined (for example, in the case of Siskel and Ebert). If Kael were to have had such clout we should find an increase in box office following the publication of her 21 October essay. In fact, the opposite is true. After *Bonnie and Clyde* ranked fifth in terms of box office in mid-October and then fourth the subsequent week, the 1 November and 8 November issues of *Variety* (which measure the weeks that should have recorded any direct influence of the essay), report earnings, respectively, that rank seventh and then fall out of the top ten altogether.[141] At best, we can say that Kael's glowing review was *indicative* of the later cumulative box office and the retrospective critical regard. This is neither novel, nor special, however. Indeed, it is what Eliashberg and Shugan predict should be true of the majority of film critics.

In sum, if historians of film criticism speculate on Kael's contribution to *Bonnie and Clyde*'s success, film historians must attribute the production's increasing fortunes to the new marketing campaign and wider release that Beatty negotiated with Warner Bros., word of mouth, and "its release to great fanfare and acclaim in the United Kingdom," just as much as the critical reception in general and Kael's essay in particular.[142] The most lucid commentators on the subject – incidentally those few who actually examine the reviews, release patterns, and box-office returns in detail – conclude, as Mark Harris does, that "her rave did not, as has often been claimed, turn *Bonnie and Clyde*'s fortunes around."[143] Even Kael's biographer, Brian Kellow, echoes this idea: "Pauline's review did not, as was often claimed, turn around *Bonnie and Clyde*'s fortunes single-handedly."[144]

The case for Kael's influence is circumstantial at best. A far more precise analysis of the episode might follow Kellow, who maintains (with my emphasis added): "In terms of the impact it would have on her *career*, it was the most important essay Pauline would ever write."[145] Or as David Sterritt puts it: "No article did more to establish Kael's semideserved reputation as the most tuned-in movie pundit of her time."[146] For the select cases where Kael – who, by all accounts, was the most influential American film critic until deep into the television era of Roger Ebert – might have succeeded in leading opinions, perhaps to the modest extent that Reinstein and Snyder allow for in their empirical study of Siskel and Ebert, there are many more cases where her fervent championing or complaining made no difference, whether gauged in contemporary box-office attendance figures, retrospective critical or aesthetic appraisal, or any other conceivable measure. Her lengthy effusions about the acting talents of Barbra Streisand or the self-reflexive, discursive merits of *Fiddler on the Roof* (1971), for instance, were largely ignored; Brian De Palma and James Toback, two of Kael's against-the-grain favourites, have had middling to moderately successful careers but have not stood the test of time.[147] Her vicious condemnations of Meryl Streep have hardly had any lasting impact on the actress's career.[148] Similarly, Kael's pans of Luchino Visconti's *La caduta degli dei* (*The Damned*, 1969),[149] *The Graduate* (1967),[150] and all of Michelangelo Antonioni's work,[151] her description of Ingmar Bergman as "a tiresome thinker of second-rate thoughts [...] the Billy Graham of the post-analytic set,"[152] or the fact that she ignored the significant works of Chantal Akerman, Rainer Werner Fassbinder, Jim Jarmusch, Spike Lee, Sally Potter, and many others during her time at the *New Yorker*,[153] have not detracted from retrospective assessments of these films and filmmakers, nor removed them from university syllabi, repertory cinema programmes, nor otherwise prevented them from taking or maintaining a significant place in the canon of film history.

From Sarris to Siskel, Television to Twitter

In the preceding sections I have argued that the retrospection of Pauline Kael and the "heroic" or "golden" era of film criticism is exaggerated and nostalgic. There is

little evidence – other than anecdotal – and certainly no scientifically rigorous data to suggest that Pauline Kael, or any other single critic, wielded the power ascribed to her and which, perhaps, some fellow critics and filmmakers believed she exercised in her heyday.

This chapter has not sought to demonstrate that Kael and the other heralded American critics from the 1960s and 1970s were inconsequential. Instead, I maintain that, rather than operating with broad and romantic terms such as the "golden age of criticism" or recycling anecdotes, we need to be very specific about *precisely what influence that might be.* Surely, the very fact that Kael, Sarris, and others loom so large in the memory of writers and scholars is significant in and of itself: the sheer number of citations and mentions constitutes one form of impact. Even if Kael's effect on the earnings and status of individual films was not nearly as large as has been remembered, she indisputably remains an inspiration for these many writers who have since made the long march through the institutions. Her influence can also be measured in the women, including Carrie Rickey and Manohla Dargis, who followed in her wake; in the many imitators of her rhetorical habits and brash opinions; and as a trickle-down economics of writers, teachers, and academics who espouse some element of her taste or style. According to David Denby, Kael's "protest against classy surfaces and formalism was enormously influential on an entire generation of critics who have celebrated every vestige of energy in American pop for the past thirty-five years."[154] Nevertheless, even Denby had this to say about her "authority" in retrospect: "the effect was alternately to flatter and terrorize the reader into agreement."[155] Denby's "imitation" of Kael's rhetorical tools such as the "thumping-finger-in-the-chest use of 'you,'" he writes, "was not conscious; I was reaching for the security of an authoritative voice [...]. The hectoring second person was an attempt to hog-tie an elusive emotion."[156]

The measure of influence that Kael and others may have had is best described as legacy. One element of their legacy was the innovation of the "name" critic. Indeed, rather than a "public" critic in the utopian formulations of McDonald and Haberski, Kael was certainly a pioneering "celebrity" critic, a figure whose name came before the title of the publication in the minds of readers such as Daniel Mendelsohn, a status that can be easily compared to the auteurism of contemporaneous art-film marketing. In the case of Kael – but also in the battles surrounding *Cahiers du cinéma* and *Positif, Sight and Sound* and *Movie*, and *Filmkritik* regarding, for example, constellations of critic-audience relations – the memory has become a soap opera. Especially in the American case, these recollections revolve around a cast of leading stars, e.g. Kael, Sarris, Simon, Crist, more than, necessarily, the important magazines and newspapers they wrote for, including the *New Yorker*, the *Village Voice, New York*, and others.

There is a clear irony to this celebrity legacy, and not only because Kael publicly abhorred auteurism (although she practiced it devotedly in her reviews): Kael foreshadowed the type of film culture she supposedly detested. Her and others' cine-

populism and self-promotion paved the way for the cults of personality that formed under television cameras (Ebert and Siskel) and the much derided "entertainers" such as Jeffrey Lyons, Rex Reed, and Gary Franklin. In contradistinction to Haberski and McDonald, who see these critics as the utopian ideal, I submit that it was, in fact, these supposedly authoritative, "golden-age" critics who anticipated the proliferation of "dumbed-down" criticism in the 1980s and 1990s. Rather than a break or revolution, the "television age" and "malaise" were logical results. Certainly, in a very literal sense, that kind of public film critic – *public* in the sense of someone with wide exposure and recognition – only increased with Siskel and Ebert.

In this way, *pace* McDonald and Haberski, Kael did more to dismantle their idea of an authoritative critic than any other film commentator in the twentieth century. Indeed, even as she pressed her tastes upon her readership, she was assaulting the airs of gentlemanly respectability that critics were supposed to possess. This was a major thrust of her arguments against Sarris's interpretation of the auteur theory – which attempted to codify and institutionalize the Young Turks' anarchy of personal taste into an authoritative canon. It was her argument against the "Sarristes" such as Dave Kehr, who recalls Sarris as a "god" for him and his university classmates; *The American Cinema* was their bible: "This dedication to a sacred text was something we shared with some of the other cultists then proliferating on the proudly radical campus – the humorless Maoists, with their Little Red Books."[157] Kael and the others, through their agitation for the trashy and popular in their culture war against the Establishment, were partially complicit in the rise of the youth-oriented *Jaws*-style film culture that they went on to criticize.[158] Similarly, their reviewing practices, and particularly Kael's increasing impatience with "foreign films," had a hand in killing the "age of cinephilia." "The overall neglect," Jonathan Rosenbaum has written, "was spearheaded by Pauline Kael during her last years as a critic [at the *New Yorker*] but has become commonplace in virtually all magazines since then."[159]

This sober analysis should not, however, be construed as an attack on Kael as a critic or an argument about the obsolescence of film critics or film criticism. Rather, I propose that we use these findings to consider why it is so beneficial to have (or believe we have) public critics of such cultural authority in the first place. To what end *should* our culture have critics who, with the flick of their pen, can affect cinema attendance, filmmakers' careers, and the moviegoers' tastes and habits? This is a serious question, to which I will return in the Conclusion.

Film criticism of the late 1960s and 1970s, the subject of this chapter, was a decisive period. The career of Pauline Kael touched upon almost all of the individual instances of crisis broached in this book. It stretched from the earliest permutations of crisis – regarding the respectability of the medium and the status and role of the critic – through the defining stances towards French film culture (of which Kael herself famously took part via her polemics against Andrew Sarris);[160] negotiating a cosy, yet authoritative relationship to readers and a close, influential, but sometimes antagonistic one with the industry; to the challenge presented by broadcast media. In

addition to existing on the threshold of historical periods, Kael also had a role in the fragmentation of film criticism between academic film studies and journalistic reviewing. Whereas, up to this point, film journalists and the few scholars lecturing and writing about film shared similar concerns, this was the moment when, to the minds of many, scholars began speaking in incomprehensible jargon. Critics, according to many academics, began a solitary pursuit of mindless punditry. The separation and mistrust between film critics and academics was and never has been as absolute as Haberski and McDonald maintain; nevertheless, we must remark upon how, why, and when this occurred. It was certainly a part of Kael's agenda, such as we see in her screed against Siegfried Kracauer's *Theory of Film*, published in *Sight and Sound* in 1962 and reprinted three years later in her collection *I Lost It at the Movies*.[161] Although Kael's plea for what we would now call cinephilia is well taken, there is a sense in which both sides – the *Screen* theorists and the anti-intellectuals among reviewers – suffered from the decreased volume and quality of exchange. Annette Michelson remarked, on the occasion of Kael's death, that "Kael's intransigent resistance" to film theory "progressively inhibited her ability to account for film's impact in terms other than those of taste and distaste, expressed with increasing vehemence."[162] Kael "ceased to renew her intellectual capital, to acknowledge and profit by the achievements of a huge collective effort."[163]

The theme of fragmentation once again intrudes into the history of film criticism. Surely, part of this perceived atomization was actually a plurality caused by expanded interest in film culture from wide sections of society. Although we have surely come a long way from when the British Film Institute simply transplanted Oxford undergraduates to run *Sight and Sound*, this chapter has charted the beginnings of the contemporary crisis of criticism: the rejection of "dumbed-down," populist television criticism considered too close to advertisement and the industry and too chummy and informal with audiences. Nevertheless, it was still one practiced (and gatekept) by professional media personnel, even if some of these were dismissed as "social climbers," such as Rex Reed, Jeffrey Lyons, and Gene Siskel. Television pundits represented a challenge to good taste and to the function of the profession (promotion rather than evaluation), but film criticism nonetheless remained an activity practiced by the few. In the next chapter we see critical authority being put under further pressure – not just by hacks or followers of Kael or self-promoters who infiltrated the ranks of newspapers and television networks – but by *anyone* with a blog and a Twitter account.

6. The Spectre of "Democratization" in the Digital Age

In January 2013, film critics reacted with apoplexy to *The Impossible* (2012), the disaster movie starring Naomi Watts and Ewan McGregor. The reviewers' outrage was not directed at the script, performances, or aesthetic. Indeed, the write-ups of the film itself were generally good. The critique focused pointedly on the marketing campaign and, above all, the poster. The latter featured twenty four- or five-star recommendations and seven excerpts from positive notices; rather than reviews exclusively from broadsheet, tabloid, television, or radio critics, however, the longest and most prominent quotations came from "@browning_33," "@katie_m_kelley," and "@lisamegan4" – in other words, Twitter users, not professional critics.

In the *Daily Telegraph*, chief film critic Robbie Collin demanded, "Who needs film critics? Not the advertising agency promoting *The Impossible*. The latest print advertisement for Juan Antonio Bayona's visceral tsunami drama features no approving quotes from well-known reviewers."[1] This disturbed Collin because the film had garnered many glowing notices in quality publications, including the *Daily Telegraph* itself. For Collin, the advertising campaign represented the "plausible next step after street teams, brand ambassadors and undercover marketing"; it functioned as part of an "insidious, long-term agenda" hatched by producers.[2] "The people behind *The Impossible*'s campaign have probably reasoned that normal cinema-goers would be very amenable to the idea of their opinions appearing in print," Collin opined. "If an online recommendation could be plucked from the ether and propelled to national stardom, both the volume and gusto of such recommendations might well increase."[3] Writing for the *Guardian* about the same topic, top UK critic Peter Bradshaw worried that this case forced film critics to "have just endured another blow to their fragile self-esteem," even worse than distributors' common practice to "slather their posters with adoring quotes from reviewers, along with the traditional migraine-rash of stars."[4]

The passionate reactions to *The Impossible*'s poster disclose the contemporary anxiety about critical authority. In addition, they uncannily reprise Patrick Goldstein's 1988 lament about television pundits explored in the previous chapter.[5] Once again, the division of labour and the relations between industry, audience, and press cause critics concern. As broached in the Introduction and demonstrated throughout this book, the supposed democratization of criticism is perhaps the most heated topic in the debates surrounding arts and culture writing. Proponents praise the way in which

blogs, internet forums, and other new forms potentially allow anyone to become a film critic. Professional critics have often complained about the way that this has eroded their gatekeeper function and dumbed-down writing about film and sometimes even compared the new democracy to a critical anarchy.

Let us recall the arguments of *Variety*'s Anne Thompson in her programmatic statement, "Crix' Cachet Losing Critical Mass," presented in the last chapter. According to Thompson, young cinephiles these days "don't read newspapers and never will."[6] Instead, they "check out film rankings at Rotten Tomatoes or Metacritic and dip into some reviews, but they haven't found a particular film critic they trust to steer them straight."[7] Thompson quotes *Newsweek* reviewer David Ansen, who sums up the consensus: "It is scary [...]. It's a lot like a return to the hard old days when I was growing up when anyone could be a critic and they'd take somebody off the sports desk. It's a profound diss to the knowledge and expertise of a lot of good critics out there."[8]

Ansen's claim – that, unlike in the past, today "anyone [can] be a critic" – is stipulated as fact both by the defenders of traditional critics and by the new tweeters and internet anarchists. Despite the widespread agreement, however, the present chapter will call this claim into question. Critically assessing leading new portals of digital criticism, the following appraises their assertions of "democracy" and parses their discursive origins. Using Rotten Tomatoes as a case study, I outline the site's claims to produce a more democratic experience of criticism and evaluate the extent to which it and similar sites represent challenges to, or simply perpetuate, traditional notions of critical authority. Ultimately, I will conclude, the fears of the old guard – which sees these sites as radical attacks on their cultural esteem – are misplaced. Although some democratization is achieved in terms of access and broader participation in critical discourse, in crucial ways sites such as Rotten Tomatoes venerate traditional criticism and its gatekeeping hierarchies and erect new barriers for potential citizen critics to enter the profession.[9]

"Democracy" Discourses

In order to understand the democratic discourses – which inform both the new digital portals for film criticism as well as the often passionate reactions against these platforms – we need to examine their constituent parts: (1) critics' traditional anxiety about authority and the relationship between critic and reader and (2) widespread rhetoric about the capacity of the internet to provide democratic access to information and to promote freedom, community, and an expanded and inclusive public sphere. I will describe each in turn.

As outlined in the Introduction and evinced by statements such as Ansen's, today's critics feel undermined by bloggers and other "citizen journalists" because of the way in which the practice of criticism by "anyone" degrades the professional distinction of working critics.[10] Nevertheless, as demonstrated in this book, this sentiment is hardly

MATTIAS FREY

novel and did not begin with the introduction of new media or the World Wide Web. The anxiety about the status and cultural authority of the critic is as old as the profession itself.[11]

If one half of the current crisis of criticism is a chronic complaint, then the other half is acute and derives from recent innovations. We might call this the medium-specificity or technological deterministic thesis or simply the digital democracy discourse. In short, this type of thinking claims that the internet, as a technology and platform, is in itself fundamentally democratic.[12] Online criticism is by extension more democratic than previous print and other "old media" forms.

Lincoln Dahlberg identifies three basic types of arguments about the possibility of the internet to enhance democracy. The "communitarian" argument stresses the potential of the internet to enhance "communal spirit and values," provide avenues for participation in virtual communities, and build connections between people who share similar values, interests, or concerns.[13] The second type of claim, the "liberal individualist," emphasizes how the web can assist "the expression of individual interests" and enable people to access political information and to be able to "express views directly to elected representatives."[14] Finally, the third "deliberative" camp argues, along neo-Habermasian lines, that in contrast to the communitarian and liberal individualist models, which are based upon pre-discursive expressions of shared values or private interests, "decentralized communications enabled through Web publishing, electronic bulletin boards, e-mail lists and chat rooms does seem to provide public spaces for rational-critical discourse," in other words, a potentially democratic public sphere.[15]

I will return to Dahlberg's terminology and others' research into the digital democracy discourse later. I introduce it here in order to outline the terms of debate but also in order to begin to dispute the a priori argument that the internet is – as a technology and platform – necessarily democratic. The initial enthusiasm for the internet, and now its various exponents – whether Twitter, Facebook, blogging, and so on – may simply be the newest iteration of a perennial phenomenon in the history of communication: the history of discourse about previous communication technologies reveals similar claims to democratization.[16] With the invention and introduction of "every new distribution medium, be it the telegraph, radio, television or now the internet and mobile phones," Janet Jones and Lee Salter remind us, "there are always those who say that things will never be the same again; but the change is rarely quite as radical as pundits first prophesise."[17]

Major Trends

The previous section characterized the two components of today's claims to (and fears about) the increased democratization of criticism. This section surveys the new digital criticism's major outlets before proceeding to a case study of one of these sites in order to scrutinize its democratic capacity and claims in detail.

I propose to categorize the outlets into four broad categories. The first type encompasses online film reviews of traditional print news media but also online-only film reviews produced in the institutional context of a "magazine" or "journal." Reviews under this rubric would range from A.O. Scott's online notices for the *New York Times* and Peter Bradshaw's for the *Guardian*, but also include many sites, such as Everyonesacritic and Frontrowreviews, which have no print edition and feature solicited or unsolicited reviews by unpaid critics in a magazine-like format. Even without evaluating the quality of the sites' criticism (which may vary widely), we must conclude that the format itself is hardly novel. Indeed, it can be classified under what journalism scholars call "shovelware." This means the "reproduction of offline material online," delivered without a "real attempt to consider the development of specifically online" forms.[18] Perhaps less pejoratively, the phenomenon might be classified under the concept of "remediation": the form "remains the same, but the platform upon which it is delivered is constantly re-defined by historically sensitive technical developments, including paper, print, online news portal, blog, and other formats."[19]

The second category encompasses sites, which, although primarily designed to communicate information about films, also provide forums for users to comment on them. The most important and prominent of these is the Internet Movie Database (IMDB). It details films' technical specifications, production and reception history; lists memorable quotations from the dialogue; and provides links to trailers, production stills, and traditional (online) reviews. In addition to this information, compiled by the site or contributed by registered members, there is also space for users to assign a star rating (which are then aggregated into lists), post reviews of the film, access message boards to debate and contextualize the film in lists. Other important examples of this type – with more strongly editorial slants – include Ain't It Cool News, Deadline Hollywood, and CHUD, which are perhaps more focused on "news," (including production history and gossip regarding forthcoming films, celebrity news, and trivia), but which fundamentally rely on user contributions including reviews or evaluations.[20] Similar to the first category above, many blogs may be also put under this rubric.

A third avenue for the new film criticism includes platforms not intended to be film sites at all, but rather "social media," which are nevertheless used (by critics "professional" or otherwise) as a means to evaluate films. This includes, for example, the late Roger Ebert's use of Facebook, but above all the many critics who are on Twitter as well as "trending" discussions/commentaries of (usually) contemporary films. The actual content of 140-character tweets (and the equivalent) may range from capsule reviews to notices about upcoming films or projects, tips about what films to see at the upcoming weekend, personal-confessional messages about the critic's mood or state of mind, or notes on popcorn quality. The identity of these sites relies on the "feed" interface, which – as a tweet, Facebook post, or RSS feed – is easily and immediately accessible to smartphone, tablet, and computer users.

Finally, there are the so-called aggregate sites. These include Rotten Tomatoes, Metacritic, Movie Intelligence Review, and the Movie Review Query Engine. Although the selection criteria and demographic varies slightly between these sites, all have the same basic function: (1) the aggregation and collation of a broad range of critics' reviews and (2) an algorithm that yields a single quotient – that is, a single score of a film that supposedly serves to provide a more objective overview of the critical reception and the "true value" of a film, unimpeded by local or personal prejudices.

All four of these platforms make key claims to a more democratic spirit and function of criticism. Twitter, for example, democratizes in the way it allows only 140-character tweets, or by the very fact that anyone with internet access may tweet, "follow," and be "followed" by thousands or even millions of Twitter users. For many years, Hollywood claimed that the democratic element of internet sites such as Ain't It Cool News "threatened the Hollywood system of film marketing because individual users could post reactions to early test screenings."[21] Even remediated shovelware is also potentially more democratic in the sense that – unlike a paper copy of the *Guardian* or the *Boston Globe* – it can be accessed for free.

However, I want to focus in depth on the aggregate sites and, in particular, on Rotten Tomatoes. With 55 million page views and 11.6 million unique visitors monthly it is the most popular such site. Its 6.1 million US users per month make it the 203rd most visited website in that country, a popularity that sees it on par with major airlines such as Southwest and retailers such as Macys.[22] Furthermore, these sites make a particular and special claim to "democracy." In the following section I closely analyze the site, its functions, as well as its utopian assertions to offer a more perfect, democratic criticism – a major source of anxiety for today's critics.

Rotten Tomatoes

Rotten Tomatoes maintains a homepage (www.rottentomatoes.com) that features news, trailers, and photo galleries of films on release or in development. Nevertheless, the main focus of the site is the individual pages of films. In many ways this parallels IMDB, and in recent years Rotten Tomatoes has moved consistently in this direction. The individual film sites now feature a short plot description, information about the cast, photos, and trailers, and so on; the subtitle of the homepage has changed to "Movies Trailers Reviews," which bespeaks the new branding as a one-stop location for film information. Nevertheless, the statistical side of Rotten Tomatoes is still much less detailed and comprehensive than IMDB. The clear priority is the criticism, in contrast to the latter site, where reviews are collected as an archive of hyperlinks to external sites. According to Rotten Tomatoes founder Seth Duong, the page layouts were designed to recall "movie ads in newspapers"[23] – the very sort of promotional materials we examined in the case of *The Impossible*. Reviews (they vary in number, but roughly 26) appear as approximately 30-word quotations (usual-

ly zingers that encapsulate the critic's opinion in a pithy way), an embedded hyper-link to the original review, the critic's name and affiliation, and an icon of either a red "fresh" tomato or a green "rotten" one. Many more such write-ups can be ac-cessed with a click and users may also sort and filter reviews by whether they are positive or negative or written by a "Top Critic" or by one of the users' favourite critics, so-called My Critics.

One of the key features of Rotten Tomatoes and its marketing is the so-called Tomatometer. It measures aggregate evaluation by calculating the percentage of "Ap-proved Tomatometer Critics" who recommend the film. A red tomato indicates that the film is "fresh" and has achieved at least 60 per cent positive reviews; a green tomato denotes a "rotten" film that has failed to achieve above 60 per cent. Films with a Tomatometer ranking of above 75 per cent (and which meet certain other criteria) receive the superior distinction of "Certified Fresh." These metrics are dis-played prominently on all of the individual film pages. Even in the various "news" stories and other lists, the Tomatometer rating appears beside the film title. Toma-toes, fresh and rotten, are key metaphors and symbols throughout the site. The site allows app developers to imbed Rotten Tomatoes content into their programmes; the logo and "Certified Fresh" icons are also available for export under certain condi-tions.[24] According to the website, Approved Tomatometer Critics are reviewers who:

> fit within a set of standards – mostly from accredited media outlets and online film societies. [...] We use the same list of critics to evaluate each movie. This way, we can insure that the Tomatometer is consistent and unbiased. This also pre-vents studios or fans from affecting the Tomatometer by submitting only positive reviews to us from sources not on our approved Tomatometer list.[25]

The "set of standards" that approved publications must meet include ranking as – in terms of circulation measured by the Audit Bureau of Circulations, the Magazine Publishers of America, and the Association of Alternative Weeklies – a top 100 daily US newspaper, top 100 weekly US newspaper, top 100 magazine, or top ten entertain-ment-based publication. According to the site, applications for "international publi-cations will be made on a case-by-case basis, with input from local Rotten Tomatoes editors when applicable."[26] Television, radio, and exclusively online venues for criti-cism must satisfy similar requirements in terms of broadcast reach or number of hits per month.[27] In addition, approval for individual critics depends on another set of hurdles, such as working for a Tomatometer-approved publication for at least two years or being a member of an approved society of film critics.[28]

In addition to the qualifications necessary to become an Approved Tomatometer Critic, Rotten Tomatoes makes further distinctions among its approved critics: these were earlier referred to as the "Cream of the Crop," or now simply as "Top Critics." The evaluations of this elite inner circle of reviewers carry a heavier weighting in the Tomatometer algorithms and in the Certified Fresh designation; films may only be

rated as such when the release receives at least 75 per cent on the Tomatometer and has been reviewed by 40 or more critics, including five Top Critics.[29] Who is a Top Critic and by which formula is this determined? According to the website,

> Top Critic is a title awarded to the most significant contributors of cinematic and critical discourse. To be considered for Top Critics designation, a critic must be published at a print publication in the top 10% of circulation, employed as a film critic at a national broadcast outlet for no less than five years, or employed as a film critic for an editorial-based website with over 1.5 million monthly unique visitors for a minimum of three years. A Top Critic may also be recognized as such based on their influence, reach, reputation, and/or quality of writing, as determined by Rotten Tomatoes staff.[30]

The metrics behind the Tomatometer, the various accreditation hurdles to participate in this metrics, the Certified Fresh label, the concept of the Top Critic, but also the ability of registered members to mark their favourite critics (My Critics), illustrate the core function of Rotten Tomatoes and also speak to its claims to a more rigorous approach to cinemagoing and film criticism. Indeed, the Rotten Tomatoes statement of purpose sums up these issues succinctly:

> Life before RT and our Tomatometer was fairly tough when it came to organizing weekends of movie watching at the local Cineplex. Sure, we could rely on our local critics or word of mouth, but where was the consensus? Why should we rely on a single critic who may have a particular taste in film different from ours? Couldn't we organize and collect all of the reviews from various sources (newspaper, online, magazines) and average them into a single score? We could and did.[31]

This statement reveals the site's self-understanding and contains claims to democratize film viewership and film criticism – but also previews the major contradictions to these claims. In the following subsections I critically analyze the three interlocking claims to more democracy. Rotten Tomatoes aims to overturn traditional media hierarchies and promote a more democratic experience of film culture by offering (1) a more *objective* experience of criticism; (2) greater *access* to a more diversified selection of criticism; and (3) an increased degree of *participation and community*.

Objectivity

In the above quotation – and, furthermore, in the copious regulations regarding the accreditation of critics and news media in the Tomatometer that precede it – the emphasis is on consensus. The novelty of Rotten Tomatoes is to deliver not the subjective musings of an arbitrary local critic, but rather the "consistant and unbiased" quotient of opinions about any given film. The technical procedures that feed into

the Tomatometer bespeak a scientific "objectivity" to the algorithm. Unlike the days when only local newspapers and a handful of national news media or specialty entertainment magazines might have been available to any given potential film viewer (particularly if he or she did not live in a major metropolitan area), Rotten Tomatoes promises to overturn hierarchies by providing an "objective" survey. Aggregation – and this is a key tenet of broader rhetoric on new media,[32] not just of film criticism sites or Rotten Tomatoes – allows readers a more democratic experience of culture.

Tamara Shepherd has written critically about this development. She notes that the site's "database tends to flatten out some of the hierarchical distinctions."[33] Shepherd's assertions are based on concepts of hierarchy and distinction as understood through the sociological studies of Pierre Bourdieu. She suggests that the coexistence of national, prominent critics (such as the *New York Times'* Manohla Dargis) with reviewers from local press (*Bangor Daily News*) or online spheres (Film Freak Central; eFilmCritic) means that, "for the casual RT user, the differences between these sources may not be readily apparent."[34] Indeed, not only does Rotten Tomatoes provide a "scientific" survey of opinions that disregards cultural distinctions between media; it thereby unhinges the traditional hierarchies of the authoritative critic and the passive "follower."

Here we see how the site is indeed explicitly pitched against the ideas of *Variety* critic Anne Thompson presented in Chapter 5 and outlined at the beginning of this chapter. To rehearse briefly her complaint, Thompson maintains that her film students no longer consult Kael and Sarris or other public, authoritative critics who might "steer them straight,"[35] i.e. inform them about what they ought to be watching and why – an idea about the purpose of criticism that dates back to Arnold. Instead, they "dip" into Rotten Tomatoes and form ad hoc alliances with any critic, regardless of his or her background, training, or publication's status.

A recent feature on the site would seem to confirm the thesis that Rotten Tomatoes intends a significant democratization of the relationship between professional critic and lay audience. In March 2013, Rotten Tomatoes heavily advertised an app. Supported by popcorn manufacturer Pop Secret, the programme interfaced with Rotten Tomatoes and enabled users to determine which critics most consistently share their taste in film. The tagline – "Are You Like These Critics? Or Are They Like You?" – plays on and upends traditional notions of authority and democratization.

Nevertheless – in contrast to the rhetoric and self-positioning of Rotten Tomatoes, but also to Thompson's jeremiad and the spirit of Shepherd's analysis – I would submit that, in many ways, the site is neither objective, nor does it truly democratically flatten hierarchies. Indeed, I would argue that in a supposed age in which critics are dead and opinions are meaningless (to paraphrase two doomsayers coming from otherwise opposing perspectives, Rónán McDonald and John Carey),[36] Rotten Tomatoes remains entirely anachronistic in terms of its *veneration* of critics and criticism. Unlike IMDB or even *Variety*, Rotten Tomatoes celebrates criticism and validates a

basic tenet of critical authority: that critics' judgements can and should matter to the reception and consumption of film and other cultural products.

Although much of the site's rhetoric and the concept of the Tomatometer subscribe to ideas about objectivity, the rules to *become* a critic featured on the site and, following from this, the ability to influence the outcome of the ultimate Tomatometer rating, is hardly a free for all. The "strict criteria" – and the detailed information and language used by Rotten Tomatoes to explain these criteria – suggest an old-fashioned attention to authority.[37] Far from putting the *New York Times* and *Bangor Daily News* on the same level, the concept of Top Critics and the fact that a number of them must confirm a film's positive rating in order for the film to be distinguished as Certified Fresh, imply – rather than an anarchy of opinion where hierarchies are suspended – a sacralization of the traditional gatekeeper function of certain, authoritative (and, in practice, usually print) critics. This is a distinction that would not be made on the external review sites of IMDB, nor would be readily apparent to someone performing an internet search to find reviews of any given film. Looking closely at the explanation of which critics are accredited to become Tomatometer critics and especially Top Critics, we see a final sentence that defies the general rhetoric of democracy: "A Top Critic may also be recognized as such based on their influence, reach, reputation, and/or quality of writing, *as determined by Rotten Tomatoes staff.*"[38] This methodology represents a major inscription of traditional, arbitrary gatekeeping.[39] The Tomatometer is certainly not a scientific algorithm – and precisely that fact reinforces traditional ideas about the authority of critics and criticism.

Furthermore, through the My Critic function and the Pop Secret app, the site provides the means to find a critic to "steer you straight" à la Thompson. With a few clicks of the mouse the reader can instantly access and "follow" the critic or critics whom he or she feels most corresponds to his or her taste; the user is provided with an instant archive of their writings. Research suggests that, rather than creating the feared fragmentation of information, the algorithms of search engines and aggregators actually narrow and consolidate the number of news outlets that users consult.[40] Based on this winners-take-all logic it would not be far-fetched to predict that – *pace* Thompson, McDonald, et al. – Rotten Tomatoes might actually create new public, authoritative critics.

Access

The second broad democratic claim that Rotten Tomatoes makes regards its ability to provide greater access to a more diverse selection of criticism. Indeed, in the broader rhetoric of digital democracy associated with the internet, the question of access has been primary. As theorist Zizi Papacharissi summarizes, "by enabling greater access to more information, net-related technologies would at least provide citizens with the tools with which to develop informed viewpoints."[41]

In other words, rather than "rely[ing] on a single critic who may have a particular taste in film different from ours," Rotten Tomatoes promises easy access to a wide spectrum of information and critical viewpoints. The logic – again, one that is typical of digital democracy rhetoric[42] – is that, if readers are given access to a wide range of criticism, they themselves are better able to form their own opinions and make decisions. This once again points to how Rotten Tomatoes purports to liberate the user from the influence of the authoritative, single critic. Rather than pedagogical insights or the search for an evaluative "truth," Rotten Tomatoes wants to provide a "consumer guide." According to Stephen Wang, a primary Rotten Tomatoes designer, "there's a mistaken impression that the Tomatometer is a quality rating telling you how good a movie is. Actually, I like to think of it as a *confidence* meter – the percentage likelihood that you'll enjoy a movie."[43]

Tamara Shepherd argues that the site's provision of easy access merely represents an example of what Henry Jenkins calls "convergence culture." It is, in her opinion, a major way that "film criticism is being repackaged under the terms of a new media economy."[44] Shepherd criticizes "the rhetoric of newness and obvious promotional elements of RT,"[45] which she says makes it conflatable with industry discourse. Ignoring the concept of Top Critic, she notes how the selection of reviews is organized according to the default criterion of publication date, bemoans the reduction of entire reviews to taglines, and takes issue with the Tomatometer's foregrounding of "numbers" over quality.[46] She suggests that Rotten Tomatoes minimizes criticism to "marketing instruments and consumer advice."[47]

I disagree with many of Shepherd's suggestions, which rehearse the dumbing-down discourse. In particular, I dispute that the site's "promotional elements" represent any fundamentally novel development. As we have seen throughout this book, there is a long history of promotion in film criticism; it has been a means for critics to assert authority. Moreover, there is a strong tradition of promotional discourse in the most highly regarded and distinguished critics, from Siegfried Kracauer and André Bazin, to Manny Farber and Jonathan Rosenbaum. What makes these critics' motives palatable in the minds of many, however, is their advocacy of Roberto Rossellini, Rainer Werner Fassbinder, Michael Snow, or Abbas Kiarostami: in other words, film-makers and films with artistic intensions – not *The Avengers* (2012) or *Scary Movie 5* (2013) or other productions of primarily commercial or entertainment value.

Nevertheless, I agree with Shepherd that, in light of some commercial realities, we need to parse Rotten Tomatoes' claims that access is a priori democratic. Even putting aside the significant question of who even has access to the internet[48] or the fact that the site provides access almost exclusively to North American English-language criticism, we must recognize the research findings that indicate how commercialization is a major obstacle to digital democracy.[49] Rotten Tomatoes is a for-profit company, not a public service, and its ownership history has no doubt inflected its ultimate priorities. In 2004, Rotten Tomatoes was bought by IGN Entertainment, a conglomerate of (especially male-oriented) websites, including TeamXBox, GameSpy,

and AskMen; it, in turn, was subsequently acquired by News Corporation, i.e. Rupert Murdoch and 20th Century Fox, for $650 million.[50] In 2010, Rotten Tomatoes was sold to Flixster, an online movie discovery service, which in 2011 was then acquired by Warner Bros.[51] Via these processes of integration, Rotten Tomatoes can now focus its news section on tie-ins to Warner Bros. films. Indeed, business analysts interpreted the Warner Bros. acquisition as a symptom of studios' efforts to "encourage people to buy movies."[52]

In this context, we need to consider carefully the democratic access that Rotten Tomatoes purports to achieve and how it is mitigated by the commercial roles that Rotten Tomatoes, as a subsidiary of Flixster and of Warner Bros, has in promoting cinemagoing and film consumption. Although the site can be used as a reference tool for historical releases, examining the homepage shows that it functions primarily to acquaint viewers with new releases in cinemas and on DVD; it briefly branched out into a television programme à la *Siskel & Ebert*.[53] Furthermore, although the layout of reviews is the prime novelty and draw, Rotten Tomatoes functions as a "one-stop shop." Users can place films in rental queues on Netflix; check showtime listings and buy cinema tickets; watch trailers or look at publicity images; read news on celebrities, the industry, and the latest information about upcoming projects. In so doing it competes not only with Metacritic and Movie Intelligence Review; it is also profiling itself against IMDB, individual RSS and Twitter feeds, Deadline Hollywood, *Variety*, and so on. In many ways the logic is connecting people who want information – rather than necessarily explicitly seeking "criticism" – about a certain film. According to one of its founders, "Rotten Tomatoes occupied a position of being the decision-making point for many moviegoers when figuring out what they wanted to watch in theaters."[54]

Participation and Community

The final democratic claim that demands scrutiny is that of community participation. The celebratory rhetoric of digital democracy asserts that the internet broadens the public sphere and encourages participation, which once again "challeng[es] the monopoly of traditional elites."[55] Rather than the old top-down model of authoritative critic teaching the passive consumer, champions of the internet argue that it can provide egalitarian two-way communication and "afford online conversations a degree of *reciprocity*, which can truly help connect citizens of democracies."[56] Rotten Tomatoes subscribes to this digital democracy rhetoric: because the potential film viewer is not being bulldozed by the subjective opinions of arbitrary local critics or hegemonic national authorities, he or she can potentially enjoy a more communal experience of film culture. Rotten Tomatoes represents another iteration of how virtual communities renegotiate physical, cultural, and geographical forms of proximity, and overturn tyrannies of the local in order to encourage social interaction.

One important instance of this claim is a feature on the pages of individual films where readers' (in other words, not "accredited Tomatometer critics") own evalua-

tions can be read. They share the same format as the critics' write-ups (short capsule review tagline with full review accessible by click). What counts against these "Audience Reviews" as supporting the site's assertions to any radical increase in community participation, however, is their position. They are subordinated to the critics' – both in literal position in the layout of the page and quantitatively (only two are provided after the two dozen or so critics' notices). Furthermore, the distinction in name – "Audience Reviews" – defines these commentators precisely *not* as citizen journalists but rather primarily as spectators. Once again, professional critics – as determined by Rotten Tomatoes' "strict criteria" and "staff" – clearly remain at the top of the hierarchy.

The most important manifestation of this claim is the site's user forums. They allow users to comment on individual films as well as trends in film culture; Shepherd cites these as major examples of the democratization thesis.[57] In general, online forums have been lauded for the way in which they cultivate "a participatory culture among media audiences, thus inserting a bottom-up consumer-driven element to the traditionally top-down process of creating media content."[58] On some level, such discussion forums – not unlike the similar ones to be found on IMDB and other sites – do provide a measure of user interaction and community. But it is clear that these exchanges, which deliberate (as one thread is entitled) on the "Awful Green Screen" CGI technology in *Oz the Great and Powerful* (2013),[59] do not live up to the utopian hopes of digital democracy proponents. Although they might "draw attention to particular issues" and "spark deliberation at local national and global levels," and have in a literal sense "stimulated debate and protests," as deliberative democrats such as Dahlberg would advocate, the quality of debate often fails to maintain "respectful and reflexive deliberation."[60] The case of *The Dark Knight Rises* (2012) is symptomatic. Rotten Tomatoes suspended user comments on the film after a number of threatening, misogynistic, and otherwise derogatory remarks were made towards critics who delivered negative notices. The incident led the site to consider removing the function altogether.[61]

Rotten Tomatoes' role as a virtual community must be considered to offer at best what Dahlberg terms "a 'weak' form of democratic participation" rather than the "strong" model of rational-critical discourse.[62] The lack of reflexivity and respectful listening leads Shepherd to see the "democratized" forum and other user-derived content on the site less as a true "community" in the utopian sense, but rather as a form of what Henry Jenkins calls "participation," in other words, "open-ended consumption practices shaped by 'cultural and social protocols.'"[63] Another way to see the communitarian function of Rotten Tomatoes – rather than any sort of deliberative democracy – is as a homogenous "community of interest" where "members' interests, values, and prejudices are reinforced rather than challenged," or simply as a more-or-less ad hoc social network.[64] The association with Flixster, a social networking site for "discovering new movies" and "meeting others with similar tastes in movies" would seem to confirm this.[65] Indeed, rather than a "democratic" or "delibera-

tive" public sphere, Rotten Tomatoes provides a platform – almost in the vein of a dating site – to find "consensus" and seek the "like-minded." For all Shepherd's (and others') talk of "heterogeneity" and "fragmentation,"[66] in many ways Rotten Tomatoes magnetizes the homogenous (people who like what you like) in order to find more appropriate cultural products to consume. The task aligns preferences. It connects users with critics who have similar tastes (through the Pop Secret app and the My Critics function) and of course encourages user-user interaction via the forum. It is in many ways a niche form of Facebook, and, like that company, both Rotten Tomatoes and parent company Flixster deploy users' registration information to sell advertising.

Examining advertisers' data on Rotten Tomatoes reveals that the site attracts a very homogenous – and very lucrative – demographic. Users are largely male, generally middle-class (they have attended university and sometimes graduate school), predominantly in the 18-34 bracket, and mostly childless.[67] This high-consuming profile group reveals why the IGN consortium of male-heavy websites found Rotten Tomatoes to be attractive. Although Shepherd's claim to race may be overstated – empirical data suggests that there is a larger than proportional share of Hispanic and Asian-American users – based on this demographic, it is difficult to disagree with the spirit of her assessment that the "glimmer of 'democratization' provided by RT ultimately serves to paper over its presumable maintenance of traditional hierarchies of gender, race and class."[68] This is a serious question, and one that I would like to ponder beyond the confines of Rotten Tomatoes, by way of conclusion.

Conclusion

In sum, Rotten Tomatoes lessens some hierarchies. Its perhaps greatest contribution is to reduce the geographic boundaries that local media have traditionally encountered.[69] Before Rotten Tomatoes and the other new portals of criticism, it would have been difficult to imagine someone from California or Nigeria reading a *Bangor Daily News* critic. Furthermore, it surely provides – with some not inconsiderable exceptions mentioned above – superior ease of access to a greater diversity of film criticism. This does indeed signal an advance from the days of the *Moving Picture World* 1911 editorial, which insisted that the mainstream press's film reviews would never have weight or reach beyond the local geographical community.[70]

Rather than anarchize criticism or usurp professional status, however, Rotten Tomatoes reasserts the authority and worth of the traditional critic. The democratic prospect of community can only be understood along the lines of a social network of like-minded consumers, rather than the utopian model of a "deliberative democracy" or "public sphere" in Dahlberg's sense. The site actually reinforces the top-down authority of critics: in form, layout, and functionality, it subscribes to the idea that viewers should base their consumption decisions on *critical* discourse, rather than on advertisement or word of mouth.[71] Far from denigrating film criticism, Rotten Toma-

toes promotes it, exposing potential film spectators to this mode of writing; the site supports it in the competition it has always faced from informational discourses, including official marketing, news stories on films, and so on.

Criticism as defined by Rotten Tomatoes must be understood as part of a promotional-informational discourse, a key mode of criticism since its beginnings and one that is presently producing considerable anxiety among commentators. I submit that – rather than any real democratization – the problem and source of the apparent horror on the part of Thompson, McDonald, et al. has to do with a disagreement over the ontology of criticism, that is, that Rotten Tomatoes implies a different *purpose* for film criticism. Even Shepherd laments the fact – following the research of others such as Shyon Baumann – that "professional film reviews may have begun as artistic criticism, but today primarily serve as a kind of *Consumer Report*."[72] The claim is that Rotten Tomatoes is dumbing-down criticism by moving from critical analysis or informed evaluation to simple promotion.

Rotten Tomatoes and other related sites such as Twitter or IMDB provide a training in traditional critical discourses and forms and thus somewhat democratize criticism as an activity that may potentially be practiced by a broader public. Nevertheless, it merely changes, rather than eradicates the barriers to entry required to practice criticism as a *profession*. Briefly, "barriers to entry" is the phrase that economists use to describe obstacles that impede or prevent entry into a market; they use the concept to explain why some markets might be prone to monopolies or other inefficiencies.[73] The barriers to enter into diamond manufacturing might include the high start-up costs of equipment purchase and advertising, the expenses and risks to access scarce materials, and the economies of scale or customer loyalty that established companies such as DeBeers enjoy. In other industries and businesses, the barriers to entry may take a different form. To become a taxi driver in New York, for example, one needs an official medallion; these are regulated in number and expensive to obtain. Many countries require practitioners of law or medicine to pass exams and/or acquire licences.[74]

There have been utopian ideas about the ways in which the internet has lowered the barriers to entry for the citizen critic.[75] "Anyone" with a keyboard and internet connection can set up a blog within minutes and become a critic. Indeed, the costs of disseminating criticism have dramatically decreased in the digital age.[76] Nevertheless, the barriers to entry have shifted from production to filtering: speaking has become easier but being heard is more difficult than ever.[77] It is true that there are now millions of blogs. Commentators are theoretically correct to claim that any one of these *could* be accessed for free by billions of internet users. But, as scholar Matthew Hindman reminds us, these assumptions – after all, the basis of professional critics' fears – are misleading: "The Internet does provide any citizen a *potential* audience of billions, in the same way that *potentially* anyone can win the lottery."[78] In reality, however, web traffic to blogs is miniscule. For every one million bloggers, only a few dozen "have more readers than does a small-town newspaper."[79] For every

citizen critic who achieves a measure of success, ten thousand will toil in obscurity as voices in the wilderness, critics speaking but not being heard.

In many ways the potential and problems of the new film criticism resemble the development of digital film production in the 1990s: the initial exhileration surrounding the availability of digital cameras and the ability to edit a film on a PC, and the ultimate challenges regarding generating an audience in a market flooded with amateur filmmaking. Even if some traditional barriers to entry have been overcome, Twitter users and other online critics – without access to traditional, dwindling jobs – have to self-advertise and self-promote. This poses a new barrier to entry. Economists have shown how, because of "brand loyalty" (in this case to A.O. Scott, Peter Bradshaw, one's local newspaper, and so on), "new rivals, seeking to sell as much as existing firms, may need to advertise more than existing firms (or offer some other compensating advantage)."[80] In turn, this gestures towards the conclusions of Matthew Hindman in his studies of political blogs; in spite of the rhetoric of digital democracy, when based on readership (rather than the actual number of outlets/blogs), thus far the internet has actually reduced plurality and made the dominant players even more important.[81] This fact might comfort the critics who reacted with such indignation to *The Impossible* and its poster. "Digital technologies create a public space," according to Zizi Papacharissi, "but do not inevitably enable a public sphere."[82]

Conclusion. What is the Good of Authoritative Critics?

This book has shown how the current "crisis of criticism" is neither new, nor unique. Film criticism has been permanently marked by the rhetoric of crisis; anxiety over authority and the democratic liberation of critical practice has been present and a source of debate since the very beginnings of the activity and profession. It may be true that the exact designs of the current crisis's precipitating factors (certain online technologies and business models) are novel. Nevertheless, as we have seen in the case of television criticism in Chapter 5, crises based on changes in the medium of dissemination are hardly unprecedented. They too inspired similar doomsday rhetoric about the dumbing-down of the profession and the fragmentation of film culture because of diminished authority.

How Public is "Public"?

Chapters 5 and 6 re-approached the contemporary crisis and reckoned with the "death of the critic" commentators' utopian (past "public critics" such as Pauline Kael) and dystopian (putative "democratic" free-for-alls like Rotten Tomatoes) ideas. By way of conclusion, I would like to pose the question that gets to the heart of the crises and anxieties: Why does our society need "public critics" who can dramatically readjust box-office figures; decide the fates of films, filmmakers, and studios; or determine cinemagoers' leisure hours? In other words: What is the good of authoritative critics?

Haberski, for example, answers this question by claiming that without authoritative critics, there is no public debate about cinema.[1] This belies the reality that, in fact, film culture has never been richer. In the digital age, with limitless user forums, an assortment of blogs and specialty magazines, niche social networking, and easier access to both comment and consume reviews, Haberski's argument seems to suggest a special concept of "public debate." This implication needs to be addressed in detail.

To this end, I would like to return briefly to the discussion in Chapter 5 and Reinstein and Snyder's, Shrum's, and others' findings regarding the sorts of productions upon which critics have a small effect.[2] Significantly, Reinstein and Snyder conclude that the influence of critics is "strongest for movies with a narrower release and for dramas, virtually nonexistent for movies with a wider release and for action movies and comedies."[3] This correlates with Shrum's notion that in theatre reviews, the role

of critical evaluation is only significant in "legitimate genres,"[4] and resounds with the intuitions of very early critics such as Iris Barry. Simply stated, the likes of Pauline Kael might have had a modest effect on some small art films.

We should by no means downplay this exception to the rule; indeed, this finding helps us understand what is actually meant by "authority" among those such as Haberski and McDonald who fear its loss and seek to reclaim it in the age of television and Twitter. Their desire for "authority" is nostalgia for a pre-pluralistic, middle-class world, for the *New Yorker* and the *Village Voice*, for a cultural realm in which the coterie of trendsetters could fit into a private room at the Algonquin.[5] This critical authority was and is, at best, a circumscribed one whose force field revolves around a small constellation of privileged neighbourhoods in cosmopolitan cities and university towns.

It should be noted that – with the exception of Pauline Kael, whose origins were working-class until she gradually made her way up to the echelons of the New York Establishment – the vast majority of the critics discussed in this book (and the vast majority of film critics and film scholars generally), are of the middle classes. Even Jerry Roberts admits that film criticism "has traditionally been looked upon as an exotic and privileged occupation," estimating that in 2009 about one hundred Americans made their living as a film critic.[6]

The range of influence, then, that Kael and others may have exerted – and which Haberski, McDonald, Berger, Eagleton, and many others nostalgically mourn – was undeniably limited to a small elite of middle-class sophisticates. Although the subscription base and circulation of the *New Yorker* (about 450,000 in the 1970s) was no competition for *McCall's* (about eight million) or *Time* (over four million),[7] it commanded the readership of – and this is, I suspect, the true measure of authority that Haberski and McDonald intimate – other film critics and the cultural middlebrow and haut monde.

The desire for a tightly unified culture is as old as the rhetoric of "fragmentation" and "atomization." Already in the time of Matthew Arnold, Daniel G. Williams notes, "there was an awareness among writers that any major historical, literary or political work was likely to reach 'a very large portion of the governing elite.'"[8] This cosy arrangement meant that insights could be quickly and efficiently disseminated and debated among a homogenized patriciate. The perception of the end of this era was seen to have been followed by the gradual atomization of that intellectual sphere into discrete and compartmentalized institutional units, with the fruits of research appearing in increasingly specialized journals. The general role of cultural leadership and moral authority performed by the likes of Arnold or William Dean Howells was being rapidly overtaken towards the end of the century by the coterie magazine and the specialist journal and by the formation of professional disciplines within the universities, on the one hand, and the rise of the popular press, on the other.[9]

It is remarkable how familiar such – Victorian – crisis rhetoric seems to the current debate. The similarities to Haberski's contention, that these days the role of the

MATTIAS FREY

critic has become "polarized into the twin camps of academia and irrelevance," are striking.[10] Furthermore, it also resounds with McDonald's claims about the atomization of culture and the supposed benefits of the authoritative critics. Echoing the Victorians about the pernicious fragmentation created by the "universities" and the "popular press," *The Death of the Critic* advances the thesis that "the public critic has been dismembered by two opposing forces: the tendency of academic criticism to become increasingly inward-looking and non-evaluative, and the momentum for journalistic and popular criticism to become a much more democratic, dispersive affair, no longer left in the hands of experts."[11]

The Backlash against Cultural Studies

McDonald's answer to the underlying question about the necessity of authoritative critics is that without such opinion leaders, audiences will not be able to measure aesthetic value. They will not be able to separate good from bad. Without evaluation, McDonald argues, we lose our sense of absolute value; everything is relative. And if a lack of evaluation in criticism explains the devaluation of criticism and the "death of the critic," McDonald attributes the demise of evaluation to the rise of cultural studies in academic thought.[12] The "key factor in separating academic from non-academic criticism," McDonald submits, "is the turn from evaluative and aesthetic concerns in the university humanities' departments."[13]

Although, in McDonald's opinion, cultural studies resolved the traditional disputes over how to measure artistic value in a scientific, rigorous way, it did so by driving "a steamroller over hierarchies, flattening all into indifferent practices."[14] By forsaking evaluation, the procedures and focus of cultural studies implied that all cultural production was equally worthy of attention – but therefore equally worthy of being ignored. "If we do not attend to the value *in* the arts," McDonald wonders, "then how can we attend to the value *of* the arts?"[15]

McDonald's comments are in many ways typical; they resound with other recent works, such as Noël Carroll's *On Criticism*, which argues for (a return to) evaluation. The principal function of arts criticism is neither description, nor to demystify hidden meanings or latent ideologies: "criticism," according to Carroll, "is essentially evaluation grounded in reasons."[16] Historically, "criticism has been generally aligned with evaluation," Carroll submits.[17] It is only recently that critics have renounced their task to judge objects according to their aesthetic value. "Throughout the twentieth century, there have been numerous arguments designed to sever criticism from evaluation." As evidence for this view and to motivate his study, Carroll cites a recent poll of critics, by which 75 per cent maintained that their primary function is not evaluation.[18]

The arguments of Haberski, McDonald, and Carroll betray an anxiety over authority; all explicitly or implicitly represent a backlash against cultural studies. Moreover, their comments are indebted to familiar rhetoric about cultural studies' pernicious

effects on intellectual life. Michael Denning's recent monograph on *Culture in the Age of Three Worlds*, which examines the origins of cultural studies and the field's legacy on institutional academia and scholarly discourse, clarifies what is at stake.

Denning argues for the historical specificity of what he calls the "cultural turn" and suggests that "the moment of cultural studies is a moment which has in some sense passed [...] the academic triumph of cultural studies in the 1990s came as the age that generated it was disappearing."[19] For Denning, cultural studies represents a critique of traditional disciplines such as English literature or art history, but also functions as an alternative to discipline. It is not "yet another" new field in the humanities, but rather an alternative to the humanities.[20] The emergence of cultural studies constitutes "a fundamental break with the notion of the humanities" and "with the assumptions that the study of art and letters is separate from the study of society."[21] Detractors of cultural studies have come to lament the decline of a public culture in the United States (see Haberski) and the magazines associated with the turn as full of jargon, high theory, and low culture; these are publications that supposedly forsake the general reader and address an incestuous circle of insiders.[22]

Nevertheless, what commentators such as Carroll simply foreclose and others like McDonald do not acknowledge – and this is Denning's key contribution – is "the fact that these cultural studies or postmodern magazines are remarkably similar to *Partisan Review*, *Modern Quarterly*, *Politics* and the other legendary magazines that supported an oppositional public discourse for an earlier generation."[23] These journals were, of course, the intellectual marketplaces where the likes of Lionel Trilling and F.R. Leavis – the very public critics whom McDonald resurrects – traded ideas. Rather than the unexpected dagger in the critic's back, cultural studies is, in Denning's historical analysis, a descendent of the liberal cultural pluralism of the 1940s, the logical continuation of the work of Trilling, Leslie Fiedler, Robert Warshow, or Dwight Macdonald. Some "contemporary journals" associated with cultural studies, Denning shows, "do constitute an oppositional public sphere not unlike those remembered so fondly."[24] In this light, we might question to what extent Penelope Houston's appeal to "tradition," Trilling, and a broad-church liberalism, actually represented a proto-cultural studies through the back door? Certainly, the role of Siegfried Kracauer, to cite another "authoritative" critic, has long been acknowledged in paving the way for cultural studies.

Clearly, this book has not argued for a utopian anarchy of opinion. In Chapter 6, I showed the serious flaws in the theses of the internet's supposed absolute democracy; so too do I reject the scholarly assertions of John Carey, who argues that criticism is an irrational free for all, a set of publicly recorded personal opinions that may or may not be as good as others.[25] For me and many others who have engaged with films in real or imagined dialogue with critics' writings and earned money by reviewing, these opinions are not in fact interchangeable. This cultural role must be taken seriously.

Nevertheless, the neo-Arnoldianism on offer from Haberski, McDonald, and others seems unnecessarily anxious, conservative, prescriptive, and elitist. Why can academic secondary literature, middlebrow criticism, and "mindless punditry" not productively commingle and coexist – indeed, as they always have? The "death of the critic" proposals seem especially problematic in the domain of film, which, we have seen, has always struggled with its status between art, entertainment, communication, and other roles. Film has always had many functions and purposes. Why can the same not be true of its criticism?

The Permanent Crisis of Film Criticism

That today's debate seems particularly existential no doubt has to do with the concomitant discussions of job losses. Overlapping concerns are at stake: i.e. not only a change in the *medium* of criticism and in the nature of democratic competition, there is also film criticism as a *profession* on the line. At the same time, as we learn from Reinhart Koselleck, a current crisis always seems more threatening than those of the past whose outcomes are certain. The discourse of crisis implies "the claim to interpret the entire course of history from a particular point in time," meaning that it is "one's point in time that is experienced as critical."[26] Historical analysis, of the kind this book provides, serves to correct the near-sightedness of the crisis rhetoric. We have seen how just one hundred years ago, the notion of a resident film critic at a daily newspaper was still fanciful; except for a handful of fortunate souls, it rarely has been a fulltime job. Despite widespread reports of past authoritative critics and a presently dumbed-down anarchy of opinion, film critics have never actually had the powerful authority or wide influence some have believed to exert or feared to have lost.

In the cyclical and often intoxicated discourses of the crisis of criticism, some have begun to concede this sobering fact. In the words of long-time (and recently sacked) *Village Voice* critic J. Hoberman, "whatever stature and authority film critics have exists mainly in their own minds – and those of other critics, academics, and cinephiles, as well as a few overly sensitive or underappreciated filmmakers."[27] Writing in the *New York Times*, author Katie Roiphe has also acknowledged the repetitive nature of critics' rhetoric on the crisis of the profession and the dumbing-down of their object of inquiry and culture in general. "Critics have always been a grandstanding, depressive and histrionic bunch," Roiphe maintains. "They – and by 'they' I mean 'we' – have always decried the decline of standards, the end of reading, the seductions of mediocrity, the abysmal shallowness and distractibility of the general public, the virtually apocalyptic state of literature and culture."[28]

In fact, the rhetoric of crisis can actually service assertions of authority by appealing to the need for timely intervention. It suggests, Koselleck maintains, a "sense of compelling sound judgement and prompt action under the commanding presence of some urgent necessity." Crisis "indicates an increasingly urgent set of circumstances,

the meaning of which mankind seems unable to escape."[29] Except, that is, by virtue of the critic's heroic mediation. In this way crisis also reinforces the "outsider" identity that practitioners have maintained at least since the Victorian period and through the course of film history. For the critic, Roiphe claims, there is "a certain romance in describing oneself as standing in the midst of a grave intellectual crisis, solitary, imperilled, in the vast desert of our cultural landscape. There is, in this stance of the underdog defender of all that matters, a certain pleasing drama, an attractive nobility."[30]

The rhetoric of crisis will surely persist in criticism. This will happen despite the reality that, first, it has been a permanent feature of the field; second, critics have never been as influential as they believe; and, third, developments – including new media – are not as "democratic" as many fear. There are several reasons for this, including the fact that for all critics, there are institutional incentives to use such rhetoric: it motivates articles, it provides urgency to writing, it attracts readers, it intimates impact. Academics are ideally bound (but often fail) to produce insights based on the advancement or challenge of previous knowledge, in an effort to solve "earnest" problems. Journalists work on shorter-term horizons: repetition – of the crisis rhetoric or any other news or analysis – must only be justified in the immediate timeframe of writing and initial publication, without the necessity to stand the test of time. Crisis is permanent, in film criticism but surely in other domains. "Crisis doesn't come at us like a rent, a great rip, in the otherwise very solid fabric of the present," John Phillips remarks, "but it dogs at us like some tenacious ghostly embodiment of something long dead but who refuses to go away. There never seems to have been a time without crisis or at least the threat of crisis."[31]

Notes

Introduction

1. See, for example, Goldstein, "Are They Still Relevant?"; Rossmeier, "Where Have All the Film Critics Gone?"; Hess, Kleinhans, and Lesage, "The Last Word: Fretting about Film Criticism"; McDonald, *The Death of the Critic*; Berger, ed., *The Crisis of Criticism.*

2. Such as the one organized by *Sight and Sound* editor Nick James on 8 October 2008 at the British Film Institute or Mark Kermode's symposium on "Who Needs the Professionals Now That Everyone's a Critic?" at London's Institute of Contemporary Art on 13 June 2014. According to Mark Cousins's column on "Situation Critical," every "film festival, every film magazine, every university is asking, 'What's the future of film criticism in the age of the internet?'" See Cousins, "Situation Critical," 13.

3. Means, "The Departed – No. 55, Phil Villareal."

4. "Are Film Critics Really Needed Anymore ... Or Is It a Washed-Up Profession?"

5. For a small sample of the many articles in this vein, see James, "Rip It Up: Revitalizing Film Criticism," 14-15; Nowell-Smith, "The Rise and Fall of Film Criticism," 10-11; Rizov, "Death to the Death of Film Criticism"; Doherty, "The Death of Film Criticism"; Kurtz, "Media Notes: Are Newspaper Critics Old Hat Amid the Flood of Online Critics?"; Berger, "The Film Critic Is Dead. Long Live the Film Critic." For celebrations of online criticism that symptomatically confirm the rule, see, for example, Ebert, "Film Criticism is Dying? Not Online," or Scott, "A Critic's Place, Thumb and All."

6. Haberski, *It's Only a Movie!*, 1, 5.

7. James, "Who Needs Critics?," 16.

8. James, "Who Needs Critics?," 16.

9. James, "Who Needs Critics?," 16.

10. James, "Who Needs Critics?," 16.

11. "Film Criticism in the Age of the Internet: A Critical Symposium," 30-46.

12. "Editorial," 1.

13. See Frey, "Critical Questions."

14. Kallay, "The Critic is Dead ... ," 26-7. For an example of the influence of Kallay's piece, see "Film Criticism in the Age of the Internet," 30.

15. Kallay, "The Critic is Dead ... ," 26.

16. Kallay, "The Critic is Dead ... ," 26. See Dery, ed., *Flame Wars.*

17. Kallay, "The Critic is Dead ... ," 27.

18. Kallay, "The Critic is Dead ... ," 27.

19. McDonald, *The Death of the Critic*, 3, 7.
20. Eagleton, *The Function of Criticism*, 103.
21. Berger, "Introduction: The Crisis of Criticism," 4.
22. McDonald, *The Death of the Critic*, 1, 77. See also Haberski, *It's Only A Movie!*, which deploys the term "golden age of criticism."
23. McDonald, *The Death of the Critic*, 113.
24. McDonald, *The Death of the Critic*, 7, 15.
25. Haberski, *It's Only a Movie!*, 8.
26. See, for example, Haberski, *It's Only a Movie!*, 188, 190.
27. Haberski, *It's Only a Movie!*, 9, 190, 8.
28. Haberski, *It's Only a Movie!*, 7.
29. Haberski, *It's Only a Movie!*, 5, 2-3.
30. Haberski, *It's Only a Movie!*, 191.
31. Haberski, *It's Only a Movie!*, 189.
32. McKee, *The Public Sphere*, 2.
33. Gans, *Popular Culture and High Culture*, 80.
34. Eagleton, *The Function of Criticism*, 7; James, "Who Needs Critics?," 16; White, "What We Don't Talk About When We Talk About Movies."
35. McDonald, *The Death of the Critic*, 3.
36. See Eagleton, *The Function of Criticism*, 7, 113; McDonald, *The Death of the Critic*, 7, 15, 34, 86-7.
37. See Ross, *No Respect*, 2-3.
38. McKee, *The Public Sphere*, 140.
39. McKee, *The Public Sphere*, 141.
40. See Denning, *Culture in the Age of Three Worlds*, 140ff.
41. McKee, *The Public Sphere*, 142.
42. Habermas, "Further Reflections on the Public Sphere," 425. There is a whole wealth of scholarship that elaborates on this assertion, much of which is quoted, along with Habermas's reflection, in McKee, *The Public Sphere*, 142.
43. McKee, *The Public Sphere*, 142-3.
44. See, for example, Clayton and Klevan, eds., *The Language and Style of Film Criticism*; Carroll, *On Criticism*.
45. The fifth is Japan. See Acland, "Theatrical Exhibition," 91.
46. Williams, *Ethnicity and Cultural Authority*, 5.
47. Arnold, *Culture and Anarchy and Other Writings*, 186.
48. Arnold, *Culture and Anarchy and Other Writings*, 89.
49. Arnold, *Culture and Anarchy and Other Writings*, 190.
50. Arnold, *Culture and Anarchy and Other Writings*, 89.
51. See Koselleck, "Some Questions Concerning the Conceptual History of 'Crisis,'" 13.
52. See West, *Crisis and Criticism*; Hasan, *Criticism in Crisis*; Crosthwaite, ed., *Criticism, Crisis, and Contemporary Narrative*. See also, for example, Kompridis, "Crisis and Critique," 3-8; Boenisch, *Krise der Kritik?*; and Zenthner, *Krise und Kritik*.
53. See Wizisla, *Walter Benjamin and Bertolt Brecht*, 66-97.
54. See De Man, "Criticism and Crisis," 8.
55. Crosthwaite, "Introduction," 2.

56. See Sorokin, *The Crisis of Our Age*; Sorokin, *Social Philosophies of an Age of Crisis*.
57. See Koselleck, *Critique and Crisis*.
58. Koselleck, "Some Questions Concerning the Conceptual History of 'Crisis,'" 13.
59. Koselleck, "Some Questions Concerning the Conceptual History of 'Crisis,'" 14.
60. Koselleck, "Some Questions Concerning the Conceptual History of 'Crisis,'" 12.
61. Koselleck, "Some Questions Concerning the Conceptual History of 'Crisis,'" 15.
62. Koselleck, "Some Questions Concerning the Conceptual History of 'Crisis,'" 16-17.
63. Quoted in Witoszek and Trägårdh, "Introduction," 3.
64. Koselleck, "Some Questions Concerning the Conceptual History of 'Crisis,'" 18.
65. Koselleck, "Some Questions Concerning the Conceptual History of 'Crisis,'" 16.
66. Koselleck, "Some Questions Concerning the Conceptual History of 'Crisis,'" 19.
67. Koselleck, "Some Questions Concerning the Conceptual History of 'Crisis,'" 16.
68. Crosthwaite, "Introduction," 4.
69. Witoszek and Trägårdh, "Introduction," 4.
70. Koselleck, "Some Questions Concerning the Conceptual History of 'Crisis,'" 20.
71. Koselleck, "Some Questions Concerning the Conceptual History of 'Crisis,'" 20.

1. The Birthing Pains of the First Professionals

1. Haberski, *It's Only a Movie!*, 11.
2. Haberski, *It's Only a Movie!*, 1, 5, 6.
3. Haberski, *It's Only a Movie!*, 9, 59.
4. McDonald, *The Death of the Critic*, ix.
5. Haberski, *It's Only a Movie!*, 14.
6. See Frey, "Cultural Problems of Classical Film Theory," 324-40. See also Hake, *The Cinema's Third Machine*, xiii.
7. For examples of this approach, see Carroll, *Philosophical Problems of Classical Film Theory*, or Turvey, *Doubting Vision*.
8. See Lenk, *Théâtre contre Cinéma*. Cf. Hake, *The Cinema's Third Machine*, xvii; Abel, *French Film Theory and Criticism*, 11, 18.
9. See Frey, "Cultural Problems of Classical Film Theory"; Wasson, *Museum Movies*; Donald, Friedberg, and Marcus, eds., *Close-Up, 1927-1933*.
10. Beylie, "1895-1930," 13.
11. Low and Manvell, *The History of the British Film, Volume 1 1896-1906*, 120.
12. Beylie, "1895-1930," 13; Lenk, *Théâtre contre Cinéma*, 8; Abel, *French Film Theory and Criticism*, 5; Lounsbury, *The Origins of American Film Criticism*, 3; Diederichs, *Anfänge deutscher Filmkritik*, 36; Hake, *The Cinema's Third Machine*, 6-8; Marcus, *The Tenth Muse*, 237.
13. Abel, *French Film Theory and Criticism*, 5.
14. Lounsbury, *The Origins of American Film Criticism*, 3.
15. Lounsbury, *The Origins of American Film Criticism*, 3.
16. Beylie, "1895-1930," 14; Lenk, *Théâtre contre Cinéma*, 8; Abel, *French Film Theory and Criticism*, 6.
17. Lenk, *Théâtre contre Cinéma*, 209, 229; Abel, *French Film Theory and Criticism*, xv; Beylie, "1895-1930," 14-15.

18. Lounsbury, *The Origins of American Film Criticism*, 478-9, xvi-xviii; Abel, *French Film Theory and Criticism*, 7.

19. Diederichs, *Anfänge deutscher Filmkritik*, 84; Abel, *French Cinema*, 241; Beylie, "1895-1930," 16-17; Abel, *French Film Theory and Criticism*, 7.

20. Lounsbury, *The Origins of American Film Criticism*, xvii; Abel, *French Cinema*, 246; Beylie, "1895-1930," 19.

21. "Kinematographische Bilder I," n.p.

22. Lenz-Levy, "Die Eröffnung des neuen großen 'Union-Theaters' in Berlin," 752.

23. Hardekopf, "Die Karriere des Kinematographen," 2.

24. "Soll das Filmdrama kritisiert werden?," 24.

25. Beylie, "1895-1930," 14.

26. See Abel, *French Film Theory and Criticism*, 18; cf. Diederichs, *Anfänge deutscher Filmkritik*, 23 ("precisely film criticism owes its existence in the first instance to the artistic claims of cinema and to the model of art criticism") and Diederichs, "Über Kinotheater-Kritik, Kino-Theaterkritik, ästhetische und soziologische Filmkritik," 22 ("it was only a small step from cinema's pretension to art to art criticism").

27. Tannenbaum, "Kunst im Kino," 47. Emphasis in original.

28. See Lounsbury, *The Origins of American Film Criticism*, 12.

29. Woods, "Spectator's Comments," *Dramatic Mirror*, 23 October 1909, 14.

30. Woods, "Spectator's Comments," *Dramatic Mirror*, 24 January 1912, 32.

31. Lindsay, *The Art of the Moving Picture*; Freeburg, *The Art of Photoplay Making*; Diamant-Berger, *Le Cinéma*.

32. See Abel, *French Cinema*, 241; Beylie, "1895-1930," 16-17, 19; Diederichs, *Anfänge deutscher Filmkritik*, 84-100; Lounsbury, *The Origins of American Film Criticism*, 94.

33. See Lounsbury, *The Origins of American Film Criticism*, 115-16.

34. Haas, "Sprechbühne und Lichtbildbühne," 153-5.

35. Sherwood, "The Silent Drama: The Tenth Muse," 142.

36. Hamilton, "The Screen," 34, 54.

37. Hamilton, "The Screen," 54.

38. Heller, "Massenkultur und ästhetische Urteilskraft," 28.

39. See Stam, *Film Theory: An Introduction*, 27-8, 33-7; Canudo, "The Birth of the Sixth Art," 58-66. See also Häfker, *Kino und Kunst*.

40. See, for example, the introduction and texts collected in Kaes, ed., *Kino-Debatte* and Kaes, "Einführung," esp. 1, 11. See also the many pertinent texts reprinted in Schweinitz, ed., *Prolog vor dem Film*. Furthermore, see Lenk, *Théâtre contre Cinéma*, esp. 13, 96, 253-4.

41. See Diederichs, "Herbert Tannenbaum – der erste deutsche Filmtheoretiker," 7.

42. Viertel, "Das Kino," 70-1. Eric de Kuyper has examined the long tradition – beginning in early film criticism but inflecting film theories to this day – of treating "theatrical" elements of films as poor style and particularly "unfilmic." There was a need to differentiate film from the theatre because, of all the arts, it was the closest to cinema, and yet the "theatrical" was always interpreted as bourgeois, despite the fact that nineteenth-century developments in mise en scène in many ways paved the way for cinema and anticipated its form. See De Kuyper, "Le théâtre comme 'mauvais objet,'" 60-72; esp. 62.

43. See the many texts collected in Kaes, ed., *Kino-Debatte* and Schweinitz, ed., *Prolog vor dem Film*. See also Tannenbaum, "Kino und Theater," 33-46; Abel, *French Film Theory and*

Criticism, 99. These debates were carried out in a variety of publications, from daily newspapers to specialized journals; the interlocutors ranged from industry personnel to the intelligentsia. In the *Frankfurter Zeitung*, for instance, Georg Lukács outlined in 1913 his thoughts on the aesthetics of cinema. He wrote that those dramatists who fear cinema could replace theatre overlook the unique formal properties and attractions of the new medium. See Lukács, "Gedanken zu einer Ästhetik des Kinos," 12-18.

44. See, for example, Balázs, *Béla Balázs*; Arnheim, *Film as Art*, 164-89; Marcus, *The Tenth Muse*, 253. In her autobiography C.A. Lejeune reprints her *Manchester Guardian* piece from the early 1920s, in which she writes that the "instruments of the scenario-maker are borrowed on the one hand from drama and the other from painting [...] thereby confusing, more completely than the rhythmic school in painting or the descriptive school in music, Lessing's famous distinctions of the arts." See Lejeune, *Thank You For Having Me*, 69.

45. See Diederichs, "Über Kinotheater-Kritik," 29-30.

46. "Zur Uraufführung des Lindau-Bassermann-Films 'Der Andere,'" 24-5.

47. Tannenbaum, "Kino und Theater," 46.

48. See Duquesnel, "La Quinzaine théâtrale," 2. See also Lenk, *Théâtre contre Cinéma*, 254-5.

49. See Abel, *French Film Theory and Criticism*, 18-19.

50. See Lenk, *Théâtre contre Cinéma*, 300.

51. See Beylie, "1895-1930," 15.

52. See Dureau, "Le Film national," 3-4; see also Lenk, *Théâtre contre Cinéma*, 302, 326.

53. See Yhcam, "La Cinématographie," 11, 14. See also Lenk, *Théâtre contre Cinéma*, 303.

54. Diederichs, *Anfänge deutscher Filmkritik*, 46.

55. Abel, *French Film Theory and Criticism*, 19.

56. Pinthus, "Quo vadis – Kino? Zur Eröffnung des Königspavillon-Theaters," 72.

57. See Hauptmann, "Film und Theater," 124.

58. See Lichtenstein, "Retter des Theaters," 82.

59. See Hake, *The Cinema's Third Machine*, 14.

60. "Soll das Filmdrama kritisiert werden?," 24.

61. Quoted in Abel, *French Cinema*, 243.

62. Quoted in Marcus, *The Tenth Muse*, 250.

63. Abel, *French Film Theory and Criticism*, 102.

64. Kürschner, "Zur Kritik und Aesthetik des Films," 40. See also Diederichs, *Anfänge deutscher Filmkritik*, 75, 168.

65. Freeburg, *The Art of Photoplay Making*, 1.

66. Balfour, "The Art of the Cinema," 390, 388.

67. Bryher, *Film Problems of Soviet Russia*, 131.

68. Arnheim, "The Film Critic of Tomorrow," 105.

69. See, for example, Abel, *French Film Theory and Criticism*, 340; Heller, "Massenkultur und ästhetische Urteilskraft," 40; Diederichs, *Anfänge deutscher Filmkritik*, 75.

70. Hamburger, "Zur Frage: 'Filmkritik,'" 14.

71. Lejeune, *Cinema*, 20-1.

72. Barry, *Let's Go to the Pictures*, ix.

73. Harrison, "The Art of Criticism," 74.

74. Freeburg, *Pictorial Beauty on the Screen*, 68. See also Freeburg, *The Art of Photoplay Making*, 70.
75. Ihering, "Filme und Filmkritik," 77.
76. Ihering, "Filme und Filmkritik," 77.
77. Ihering, "Filme und Filmkritik," 77.
78. Arnheim, "Professional Film Criticism," 105.
79. Arnheim, "Professional Film Criticism," 104.
80. "The Press and the Moving Picture," 24.
81. "The Press and the Moving Picture," 24.
82. "The Press and the Moving Picture," 25.
83. See Lenk, *Théâtre contre Cinéma*, 321-2.
84. Laroche, "Die Kinokritik," 9-10. Quoted in Hake, *The Cinema's Third Machine*, 121.
85. Arnheim, "Note," 101.
86. Quoted in Marcus, *The Tenth Muse*, 242.
87. See Abel, *French Cinema*, 243; Rudolf Arnheim, "Old Chaplin Films," 147.
88. Arthur Mellini's 1911 *Lichtbild-Bühne* article quoted in Lenk, *Théâtre contre Cinéma*, 325. See also Dureau, "Le Cinéma et l'aviation – Écho de Béthuny," 2.
89. See Abel, *French Cinema*, 243. See also Lenk, *Théâtre contre Cinéma*, 305-7; Beylie, "1895-1930," 14.
90. Lejeune, *Thank You for Having Me*, 69, 73.
91. Potamkin, "The Plight of the European Movie," 278. As we will see also in the succeeding chapters, France often played an – at least imagined – vanguard role. Already by 1913, specialized journals – although surely the majority of these were still more or less trade papers advising the industry – had become numerous enough to form their own professional organization. See Abel, *French Film Theory and Criticism*, 6.
92. Quoted in Marcus, *The Tenth Muse*, 261.
93. Abel, *French Cinema*, 263.
94. See Heller, "Massenkultur und ästhetische Urteilskraft," 35.
95. See Bourdieu, "Intellectual Field and Creative Project," especially 162-3; Baumann, *Hollywood Highbrow*.
96. Balázs, "Film Criticism!," 55-6.
97. Balázs, "Film Criticism!," 55.
98. Balázs, "Film Criticism!," 56.
99. Balázs, "Film Criticism!," 55.
100. Balázs, "Film Criticism!," 56.

2. Second-Wave Crises of Proximity and Distance

1. See Wasson, "Writing the Cinema into Daily Life," 321. See also Sitton, *Lady in the Dark*.
2. Barry, *Let's Go to the Pictures*, 181.
3. Barry, *Let's Go to the Pictures*, 188-9.
4. Barry, *Let's Go to the Pictures*, 189.
5. Barry, *Let's Go to the Pictures*, 189.
6. Barry, *Let's Go to the Pictures*, 189.
7. Barry, *Let's Go to the Pictures*, 190.

8. Barry, *Let's Go to the Pictures*, 189.
9. Barry, *Let's Go to the Pictures*, 190.
10. Barry, *Let's Go to the Pictures*, 190.
11. Barry, *Let's Go to the Pictures*, 192.
12. Barry, *Let's Go to the Pictures*, 193.
13. Hake, *The Cinema's Third Machine*, 3.
14. See Yhcam, "La Cinématographie," 11, 14; Harrison, "The Art of Criticism," 74. See also Abel, *French Film Theory and Criticism*, 24; Lenk, *Théâtre contre Cinéma*, 303; Beylie, "1895-1930," 13.
15. "Soll das Filmdrama kritisiert werden?," 24.
16. Ihering, "Zwischen Plüsch und Kelchesrand," 90.
17. Hake, *The Cinema's Third Machine*, 9.
18. Elster, "Zur Frage einer Kinokritik," 261.
19. See Diederichs, *Anfänge deutscher Filmkritik*, 165; Heller, "Massenkultur und ästhetische Urteilskraft," 36.
20. See Hake, *The Cinema's Third Machine*, 122.
21. "Film Criticism in the Lay Press," 50-2.
22. "Film Criticism in the Lay Press," 51.
23. "Film Criticism in the Lay Press," 51.
24. "Film Criticism in the Lay Press," 51-2.
25. "Film Criticism in the Lay Press," 52.
26. "Film Criticism in the Lay Press," 51.
27. "Film Criticism in the Lay Press," 51.
28. "Film Criticism in the Lay Press," 52.
29. Quoted and translated in Hake, *The Cinema's Third Machine*, 115.
30. See Hake, *The Cinema's Third Machine*, 116.
31. Beaton, "We Salute You," 2.
32. Beaton, "We Salute You," 2. See also Lounsbury, *The Origins of American Film Criticism*, 188-9.
33. Haas, "Film Resümee 1922/23," 449.
34. Quoted, respectively, in Ungern-Sternberg, *Willy Haas 1891-1973*, 71; and Hake, *The Cinema's Third Machine*, 123 (Hake's translation).
35. Siemsen, "Kino. Kritik. Und Kinokritik," 37. Translation follows Hake, *The Cinema's Third Machine*, 124.
36. Siemsen, "Die Kritik," 712. Translation follows Hake, *The Cinema's Third Machine*, 124.
37. Cooke, "The Critic in Film History," 252.
38. Cooke, "The Critic in Film History," 252.
39. Cooke, "The Critic in Film History," 252-3.
40. Cooke, "The Critic in Film History," 261.
41. Even Gilbert Seldes would make such claims, admonishing "the 'amateur' critic who proposed, without sufficient knowledge of the entertainment industry, to condemn the escapism of Hollywood." See Lounsbury, *The Origins of American Film Criticism*, 410-11.
42. Beylie, "1895-1930," 19.
43. See Abel, *French Film Theory and Criticism*, 323.
44. See Hake, *The Cinema's Third Machine*, 14.

45. See Heller, "Massenkultur und ästhetische Urteilskraft," 35.

46. Lejeune, "The Week on the Screen," 7.

47. Lejeune, "The Week on the Screen," 7.

48. Lejeune, "The Week on the Screen," 7.

49. Lejeune, "The Week on the Screen," 7.

50. Lejeune, "The Week on the Screen," 7.

51. Lejeune, "The Week on the Screen," 7.

52. Lejeune, "Me to Myself," 82-3.

53. See Abel, *French Film Theory and Criticism*, 199-200, 213; Beylie, "1895-1930," 17.

54. See, for example, Tannenbaum, "Kino und Theater," 33-46; Häfker, *Kino und Kunst*; Lukács, "Gedanken zu einer Ästhetik des Kinos," 112-18. See also Lenk, *Théâtre contre Cinéma*, 12.

55. See Herbst-Meßlinger, "Der Kritiker als Intellektueller," 13-67; Hake, *The Cinema's Third Machine*, 116.

56. Ihering, "Filme und Filmkritik," 77.

57. Ihering, "Filme und Filmkritik," 77.

58. Ihering, "Der Volksverband für Filmkunst," 79.

59. Ihering, "Filme und Filmkritik," 78.

60. Ihering, "Filme und Filmkritik," 78.

61. See also Hake, *The Cinema's Third Machine*, 126.

62. Balázs, "Die Branche und ihre Kunst," 316.

63. Balázs, "Die Branche und ihre Kunst," 317.

64. Balázs, "Die Branche und ihre Kunst," 317-18.

65. Balázs, "Die Branche und ihre Kunst," 318.

66. Eric Rentschler argues that, in spite of the writers who seek to erect a clear divide between the aesthetician Arnheim and the sociologist Kracauer, "there are curious and intriguing affinities between these two seminal thinkers." See Rentschler, "Rudolf Arnheim's Early Passage between Social and Aesthetic Film Criticism," 52.

67. Arnheim, "Professional Film Criticism," 101.

68. Arnheim, "Professional Film Criticism," 101.

69. Arnheim, "Professional Film Criticism," 102.

70. Arnheim, "Professional Film Criticism," 102.

71. Arnheim, "Professional Film Criticism," 103.

72. Arnheim, "Professional Film Criticism," 103.

73. Arnheim, "Professional Film Criticism," 103.

74. Arnheim, "Professional Film Criticism," 104.

75. Arnheim, "Professional Film Criticism," 105.

76. See, for example, Abel, *French Film Theory and Criticism*, 10.

77. See Lounsbury, *The Origins of American Film Criticism*, 95-98.

78. Kuttner, "A Question of Faith," 6.

79. Mann, "Kino-Rezensionen in der Tages-Presse," 109-10.

80. See Hake, *The Cinema's Third Machine*, 122.

81. Harrison, "Mr. Lowbrow," 21.

82. Quoted in Heller, "Massenkultur und ästhetische Urteilskraft," 33.

83. Quoted in Diederichs, *Anfänge deutscher Filmkritik*, 48, 105. For French examples in this vein, see Lenk, *Théâtre contre Cinéma*, 233.

84. Habermas, *The Structural Transformation of the Public Sphere*, 41.

85. See my discussion of this topic in Chapter 5, the Conclusion, and, additionally, Diederichs, *Anfänge deutscher Filmkritik*, 175-6.

86. Alfred Mann was one such proponent. See Diederichs, *Anfänge deutscher Filmkritik*, 51.

87. Bush, "The Triumph of the Gallery," 67.

88. Bush, "The Triumph of the Gallery," 68.

89. See, for example, the writings of Balázs; Lounsbury, *The Origins of American Film Criticism*, 13; Quirk, "Art and Democracy," 19.

90. For example, see Haberski, *It's Only a Movie!*, 27.

91. Lindsay, *The Art of the Moving Picture*, 225. According to Lindsay, the present American film critics "should take the business of guidance in this new world as a sacred trust, knowing they have the power to influence an enormous democracy" (228).

92. See Abel, *French Film Theory and Criticism*, 100.

93. Delluc, "Abel Gance après *La Zone de la mort*," 7. Translated and quoted in Abel, *French Film Theory and Criticism*, 101.

94. Abel, *French Film Theory and Criticism*, 101.

95. See Delluc, *Photogénie*.

96. Delluc, "The Crowd," 160, 163.

97. Delluc, "The Crowd," 160-1.

98. Delluc, "The Crowd," 162.

99. Seldes, *The 7 Lively Arts*.

100. Seldes, *The 7 Lively Arts*, 303.

101. Seldes, *The 7 Lively Arts*, 4.

102. Kammen, *The Lively Arts*, 5.

103. See Seldes, "New York Chronicle," 733-4; Seldes, "Complaint Against Critics," 18. The quotation comes from "New York Chronicle," 734.

104. Quoted in Kammen, *The Lively Arts*, 8.

105. Kammen, *The Lively Arts*, 10. Emphasis in original.

106. Seldes, *The 7 Lively Arts*, 270.

107. Seldes, *The 7 Lively Arts*, 304.

108. See Abel, *French Film Theory and Criticism*, 195; Beylie, "1895-1930," 17; Hake, *The Cinema's Third Machine*, 15; Diederichs, "Über Kinotheater-Kritik," 33-4.

109. See Hake, *The Cinema's Third Machine*, 116.

110. Quoted in Beylie, "1895-1930," 14.

111. Durus, "Notizen zur Frage 'Fachmännische Kritik,'" 6.

112. Kracauer, "The Little Shopgirls Go to the Movies," 91.

113. Kracauer, "The Task of the Film Critic," 634.

114. Kracauer, "The Task of the Film Critic," 634.

115. Stalder, *Siegfried Kracauer*, 12.

116. Kracauer, "The Task of the Film Critic," 635.

117. For more on this subject, see Diederichs, *Anfänge deutscher Filmkritik*, 13.

118. Diederichs, *Anfänge deutscher Filmkritik*, 19.

119. Koch, "Rudolf Arnheim," 165.

120. Stalder, *Siegfried Kracauer*, 14.

121. Rentschler, "Rudolf Arnheim's Early Passage between Social and Aesthetic Film Criticism," 64.

122. Frey, "Cultural Problems of Classical Film Theory," 339.

123. Bazin, "Comment présenter et discuter un film," 70. See also the discussion in Watts, "The Eloquent Image," 220.

124. Bazin, "Toward a Cinematic Criticism," 58.

125. Arnheim, "The Film Critic of Tomorrow," esp. 107-8.

126. Bazin, "Toward a Cinematic Criticism," 54.

127. Bazin, "Toward a Cinematic Criticism," 55.

128. Bazin, "Toward a Cinematic Criticism," 55.

129. Bazin, "Toward a Cinematic Criticism," 57, 56.

130. Bazin, "Toward a Cinematic Criticism," 63, 65.

3. The Institutional Assertion of Authority

1. Nowell-Smith and Dupin, eds., *The British Film Institute*, 1.

2. Nowell-Smith and Dupin, eds., *The British Film Institute*, 237-8.

3. Nowell-Smith and Dupin, eds., *The British Film Institute*, 14.

4. See Nowell-Smith and Dupin, eds., *The British Film Institute*, 30-1; Radcliffe, *Report of the Committee on the British Film Institute*. The quotation comes from Dupin, "The Postwar Transformation of the British Film Institute," 446. Italics in original.

5. Dupin, "The Postwar Transformation of the British Film Institute," 446.

6. Nowell-Smith and Dupin, eds., *The British Film Institute*, 238.

7. Nowell-Smith and Dupin, eds., *The British Film Institute*, 33-4, 239.

8. Dupin, "The Postwar Transformation of the British Film Institute," 448.

9. "Correspondence," *Sight and Sound* 26.2 (1956): 110.

10. See Fehrenbach, *Cinema in Democratizing Germany*, 174f.

11. MacDonald, "Screening Classics," 218-19.

12. Quoted in Anderson, "Stand Up! Stand Up!," 66.

13. Anderson, "Stand Up! Stand Up!," 67.

14. Anderson, "Stand Up! Stand Up!," 68-9.

15. Anderson, "Stand Up! Stand Up!," 69.

16. See Sartre, *What Is Literature?*

17. See "Correspondence," *Sight and Sound* 26.3 (1956-1957): 163-5 as well as "Correspondence," *Sight and Sound* 26.4 (1957): 220.

18. "Correspondence," *Sight and Sound* 26.3 (1956-1957): 165.

19. Lambert, "The Cobweb," 197.

20. Lambert, "The Cobweb," 197.

21. Anderson, "French Critical Writing," 105.

22. Anderson, "French Critical Writing," 105.

23. Anderson, "French Critical Writing," 105.

24. Anderson, "*Positif*, September-October 1954," 161.

25. Anderson, "*Positif*, September-October 1954," 161.

26. Anderson, "*Positif*, September-October 1954," 161.

27. "Periodicals," 220.
28. See Rivette, "The Genius of Howard Hawks," 126-31 and Truffaut, "A Certain Tendency of the French Cinema," 224-37. For more on the history of *Cahiers du cinéma* from this period, see Bickerton, *A Short History of Cahiers du Cinéma*.
29. See, for the beginnings of this reception, Marcorelles, "Paris nous Appartient," 34; Sadoul, "Notes on a New Generation," 111-17; and Houston, "The Festivals," 142.
30. Rotha et al., "The Critical Issue," 272, 274.
31. Rotha et al., "The Critical Issue," 274.
32. Rotha et al., "The Critical Issue," 275.
33. "Correspondence," *Sight and Sound* 28.1 (1958-1959): 48.
34. "Correspondence," *Sight and Sound* 28.2 (1959): 101.
35. "Correspondence," *Sight and Sound* 28.3-4 (1959): 190.
36. Jarvie, "Preface to Film Criticism," 13.
37. Cameron, "All Together Now," 12-13. Cf. Cameron, "Editorial," 36.
38. See Armitage, "The Current Picture," *Film* 26 (1960): 4-6; Dyer, "Counter Attack," 8-9; Armitage, "The Current Picture," *Film* 27 (1961): 6-7; Vaughan and Riley, "Letters from the Trenches," 9-11; Armitage, "The Current Picture," *Film* 28 (1961): 4-5; Armitage, "Free Criticism," 8-10; Cameron, "What's the Use?," 10-11; and Jarvie, "Comeback," 18. See also Nowell-Smith and Dupin, eds., *The British Film Institute*, 136-7.
39. Houston, "The Critical Question," 160.
40. See Ryan, "Introduction: A Revolutionary Soldier," 3ff.
41. Houston, "The Critical Question," 160-1.
42. Houston, "The Critical Question," 161.
43. Houston, "The Critical Question," 165.
44. Houston, "The Critical Question," 162.
45. Houston, "The Critical Question," 162.
46. Houston, "The Critical Question," 163.
47. Houston, "The Critical Question," 163.
48. Houston, "The Critical Question," 163.
49. Houston, "The Critical Question," 163-4.
50. Houston, "The Critical Question," 164.
51. Houston, "The Critical Question," 160.
52. See Houston's *The Contemporary Cinema*, which divides postwar film history into national movements.
53. Roud, "The French Line," 167.
54. Roud, "The French Line," 168-9.
55. Roud, "The French Line," 171.
56. See also Anderson's early *Sequence* notice, "Angles of Approach," a squib against "middle-brow" criticism that draws on Virginia Woolf and anticipates the 1960s Anglophone critical reactions from Manny Farber to Parker Tyler.
57. Anderson, "Stand Up! Stand Up!," 63.
58. According to David Wilson, the concerns of postwar *Sight and Sound* might be best summed up under the banners of the "humanism," "realism" and the "hesitant but growing recognition of the cinema as a director's medium." See Wilson, "Introduction," 16.
59. Houston, "The Critical Question," 164.

60. Houston, "The Critical Question," 165.
61. Houston, "The Critical Question," 165.
62. Houston, "The Critical Question," 165.
63. Houston, "The Critical Question," 165.
64. Trilling, *The Liberal Imagination*, x.
65. Krupnick, *Lionel Trilling and the Fate of Cultural Criticism*, 57.
66. Houston, "The Critical Question," 165.
67. Trilling, *The Liberal Imagination*, x-xi.
68. Trilling, *The Liberal Imagination*, xi.
69. See, for example, Grimond, *The Liberal Challenge*, 266-7.
70. Grimond, *The Liberal Challenge*, 273.
71. O'Hara, *Lionel Trilling*, 12.
72. See Freeburg, *Pictorial Beauty on the Screen*, 68.
73. Trilling, *The Liberal Imagination*, xii.
74. Houston, "The Critical Question," 163, 165.
75. Houston, "The Critical Question," 165.
76. Trilling, *The Liberal Imagination*, xv.
77. Trilling, *E.M. Forster*, 11-12. Quoted in Krupnick, *Lionel Trilling and the Fate of Cultural Criticism*, 64.
78. Trilling, *The Liberal Imagination*, xv.
79. Houston, "The Critical Question," 164.
80. Dupin, "The Postwar Transformation of the British Film Institute," 448.
81. Dupin, "The Postwar Transformation of the British Film Institute," 450.
82. See Nowell-Smith and Dupin, eds., *The British Film Institute*, 35-6.
83. Houston, "The Critical Question," 164-5.
84. Krupnick, *Lionel Trilling and the Fate of Cultural Criticism*, 59.
85. See Dupin, "The Postwar Transformation of the British Film Institute," 448.
86. Arnold, "The Function of Criticism at the Present Time," 265; see also Arnold, "Culture and Anarchy," 499.
87. MacDonald, "Screening Classics," 214.
88. MacDonald, "Screening Classics," 215.
89. MacDonald, "Screening Classics," 215.
90. See Wasson, *Museum Movies*; Roud, *A Passion for Films*; see the pages of *Filmkritik* in the late 1950s and early 1960s for regular calls for a cinémathèque along the French model.
91. See Wasson, *Museum Movies*, esp. 1-2 and 16-18.
92. For examples of programming schedules, see Nowell-Smith and Dupin, eds., *The British Film Institute*, 78-83.
93. See Temple and Smolens, eds., *Decades Never Start on Time*.
94. See, for example, Callenbach, "Editor's Notebook," 2-3; and Patalas and Berghahn, "Gibt es eine linke Kritik?," 131-5.
95. See, for instance, "Correspondence," *Sight and Sound* 30.1 (1960-1961): 48 and "Correspondence," *Sight and Sound* 30.2 (1961): 101-2.
96. *Monthly Film Bulletin* editor Peter John Dyer's hysterics against *Oxford Opinion* included the line "I wouldn't trust [the *Oxford Opinion* editors] with an inch of space in any magazine of mine." Dyer, "Counter Attack," 8.

97. See Miller, ed., *The Essential Raymond Durgnat*.

98. Callenbach, "Editor's Notebook," 2.

99. Callenbach, "Editor's Notebook," 3.

100. Callenbach, "Editor's Notebook," 4.

101. Patalas and Berghahn, "Gibt es eine linke Kritik?," 131-5.

102. Stanfield, "Maximum Movies," 183.

103. Stanfield, "Maximum Movies," 187.

104. For more on this strand of the international reaction to *Cahiers du cinéma*, see Stam, *Film Theory: An Introduction*, 89-92.

105. See Putnam, *Bowling Alone*.

106. Houston, "The Critical Question," 164.

4. From "I" to "We"

1. For more on the postwar German film society movement and the early days of *film 56* and *Filmkritik*, see Fehrenbach, *Cinema in Democratizing Germany*, 169-210.

2. The British Federation of Film Societies produced a magazine called *Film*, which also began appearing shortly after *Cinéma 55*.

3. Patalas, Kotulla, and Ungureit, "Panorama 1955," 2.

4. Kracauer, "The Task of the Film Critic," 635. The English-language *From Caligari to Hitler* appeared in 1947. The first German translation was published in 1958 (in a truncated form). A complete German version was not available until over twenty years later.

5. Patalas, "Von Caligari bis Canaris," 56-66.

6. "Anstelle eines Programms." The English follows from Heide Fehrenbach's translation (*Cinema in Democratizing Germany*, 191).

7. "Anstelle eines Programms."

8. "Anstelle eines Programms."

9. Arnold, "The Function of Criticism at the Present Time," 236; see also Arnold, *Culture and Anarchy and Other Writings*, 190.

10. "Geschichte der Filmkunst."

11. Thiel, "... und nichts als die Wahrheit."

12. Patalas, "Anders als du und ich (§ 175)."

13. Reprinted and translated as Kracauer, "Letter to the Editors of *film 56*," 226.

14. It is important to differentiate between Kracauer's method and the appropriation of a method that invokes Kracauer. Eric Rentschler refers to the "watered-down" versions of Kracauer on offer in the postwar German arts pages. See Rentschler, "American Friends and New German Cinema," 11.

15. Quoted in Morgan, "Books and Magazines," 161.

16. Patalas, "*Ugetsu*," 22.

17. The perennial complaints about differences between the original version and the synchronized German copy (e.g., 2/1960) similarly reveal the editors' international pretensions.

18. Patalas, "A Bout de Souffle [*sic*]," 129-30.

19. Patalas, "A Bout de Souffle [*sic*]," 129-30.

20. Patalas and Berghahn, "Gibt es eine linke Kritik?," 131. *Cahiers du cinéma* would respond with its own issue on "La Critique" in December 1961.

21. Houston, "The Critical Question," 160-5.
22. Anderson, "Stand Up! Stand Up!," 63-9.
23. Patalas and Berghahn, "Gibt es eine linke Kritik?," 131.
24. Patalas and Berghahn, "Gibt es eine linke Kritik?," 132.
25. Patalas and Berghahn, "Gibt es eine linke Kritik?," 133.
26. Patalas and Berghahn, "Gibt es eine linke Kritik?," 133.
27. Delahaye, "Allemagne ciné zéro," esp. 63-4.
28. Delahaye, "Leni et le loup," 42-51, 62-3.
29. Regel, "Zur Topographie des NS-Films," 5.
30. Patalas, "Reise in die Vergangenheit," 649.
31. Kuhlbrodt, "Und morgen Veit Harlan?," 395.
32. This absolute stance tempered with the years; see, for example, Herman Weigel's very polite "Interview mit Leni Riefenstahl," 395-410. This interview refers to the "errors" in the *Cahiers* interview (405, 432-3) and is accompanied by a text (Weigel, "Randbemerkungen zum Thema," 426-33) that responds ironically to some of Riefenstahl's interview statements. Nevertheless, it is reverential, largely concerned with stylistic or production-history concerns, and auteurist. Weigel wants to assert Riefenstahl's authorship for *Das blaue Licht* at the expense of Béla Balázs ("Randbemerkungen zum Thema," 427).
33. Patalas and Berghahn, "Gibt es eine linke Kritik?," 135.
34. Patalas and Berghahn, "Gibt es eine linke Kritik?," 135.
35. Patalas and Berghahn, "Gibt es eine linke Kritik?," 134.
36. Patalas and Berghahn, "Gibt es eine linke Kritik?," 133-4.
37. See Schenk, "'Politische Linke' versus 'Ästhetische Linke,'" 43-73; and Lenssen, "Der Streit um die politische und die ästhetische Linke in der Zeitschift *Filmkritik*," 63-79.
38. See the October and December 1966 issues in particular.
39. Patalas, "Brief der Redaktion," 178; Patalas, "Perspektiven," 705.
40. For a small sampling, see the reports about censorship in France (6/1965 and 3/1964), a write-up of Godard's war films (5/1965), and notes and reviews on Godard and French film culture in 6/1965, 10/1965, and 11/1965.
41. "Young Turks," the term that Bazin appropriated to describe the younger writers at *Cahiers du cinéma*, has since entered the critical discourse to describe the "Hitchcocko-Hawksians" at the magazine. See Bickerton, *A Short History of Cahiers du Cinéma*, x, 12, 21ff.
42. Rivette, "Jacques Rivette über Howard Hawks," 291-4. Rivette's essay, published in the May 1953 issue of *Cahiers du cinéma*, appears in English as Rivette, "The Genius of Howard Hawks," 126-31.
43. Patalas, "Wie kann man Hawksianer sein?," 290. All further quotations come from this page.
44. For instance, the same saucy image of Claudia Cardinale from *Vaghe stelle dell'Orsa ...* (*Sandra*, 1965) graces the title page of both *Cahiers du cinéma*'s and *Filmkritik*'s December 1965 issues.
45. In 1964 Daniel Filipacchi bought *Cahiers du cinéma*'s publisher; Filipacchi also published a number of soft-core titles such as the French *Playboy* and *Penthouse* and had a role in pressing for the proliferation of flashy stills in the cinema review. See Bickerton, *A Short History of the Cahiers du Cinéma*, 47.
46. "Lebensläufe," 236-9.

47. See the introduction to "Zum Selbstverständnis des Films I. Alain Resnais," 508.

48. "Zum Selbstverständnis des Films I. Alain Resnais," 508.

49. Färber, "Versuch über Hitchcock," 463.

50. "Leserzuschriften," *Filmkritik* 10.6 (1966): 354.

51. "Leserzuschriften," *Filmkritik* 9.5 (1965): 296.

52. See the editorial forum of Comolli et al., "Vingt ans après," 18-31.

53. See, for example, Dort, "Pour une critique brechtienne du cinéma," 33-42; and Marcorelles, "Interview with Roger Leenhardt and Jacques Rivette," 168-81. For a narrative of this process, see Bickerton, *A Short History of Cahiers du Cinéma*, esp. 35, 45, and 51ff.

54. Berghahn, "Zum Selbstverständnis der *Filmkritik*," 4-8.

55. Berghahn, "Zum Selbstverständnis der *Filmkritik*," 6.

56. Berghahn, "Zum Selbstverständnis der *Filmkritik*," 7.

57. Berghahn, "Zum Selbstverständnis der *Filmkritik*," 8.

58. Berghahn, "Zum Selbstverständnis der *Filmkritik*," 8.

59. Berghahn, "Zum Selbstverständnis der *Filmkritik*," 8.

60. Patalas, "Plädoyer für die Ästhetische Linke," 403-7.

61. Patalas, "Plädoyer für die Ästhetische Linke," 404.

62. Patalas, "Plädoyer für die Ästhetische Linke," 405.

63. Patalas, "Plädoyer für die Ästhetische Linke," 406.

64. Patalas, "Plädoyer für die Ästhetische Linke," 406.

65. Patalas, "Plädoyer für die Ästhetische Linke," 407.

66. In May 1965, for instance, *Filmkritik* reader Werner Schubert mourned the previously comprehensible writing: "An unfortunately unreachable model in this regard are Wilfried Berghahn's reviews." See "Leserzuschriften," *Filmkritik* 9.5 (1965): 296.

67. Hans Kundnani explores the "continuity thesis" in *Utopia or Auschwitz*.

68. For examples of this from Anglophone film criticism, see Greg Taylor's comments on the traditions of "camp" criticism in *Artists in the Audience*.

69. See Berghahn, "Zum Selbstverständnis der *Filmkritik*," 6; see also Grafe, "Diskussion: Zum Selbstverständnis der *Filmkritik*," 588.

70. These were perennial features in the early years; it is exceptional to find an issue that does not indulge in these prescriptive critiques.

71. See, for example, Hembus, "Der Film und die deutschen Illustrierten," 158-60.

72. Patalas, "The German Waste Land," 24-7; Gregor, "The German Film in 1964: Stuck at Zero," 7-21. Nevertheless, these journals' actual understanding of German film culture is perhaps betrayed by the decennial *Sight and Sound* Top Ten list in 1962, which misidentifies Patalas as an East German critic. See "Top/Ten," 13.

73. Hull, *Film in the Third Reich*.

74. Hull, "Correspondence & Controversy: German Cinema," 64

75. Hull, "Correspondence & Controversy: German Cinema," 63.

76. Patalas, "Die Chance," 146-50.

77. Patalas, "Die Chance," 146.

78. Patalas, "Dr. K. erobert Venedig," 547.

79. Patalas, "Dr. K. erobert Venedig," 547.

80. This is again a delay of a French development: *Cahiers* had rid itself of its critic-cineastes and welcomed the influx of professional critics. See Bickerton, *A Short History of Cahiers du Cinéma*, 45.
81. Patalas, "Liebe Filmkritik-Leser!"
82. Patalas, "Liebe Filmkritik-Leser!"
83. Linder, "Godard – Instinkt und Reflexion," 125.
84. Schenk describes the "oft-made comparison with *Cahiers du cinéma*" in "'Politische Linke' versus 'Ästhetische Linke,'" 67.
85. Lenssen makes a similar point in "Der Streit um die politische und die ästhetische Linke in der Zeitschrift *Filmkritik*," 73.
86. Patalas, "Plädoyer für die Ästhetische Linke," 407.
87. Rentschler, "Kracauer, Spectatorship and the Seventies," 65.
88. Rentschler, "Kracauer, Spectatorship and the Seventies," 66.
89. See Adler, "The Perils of Pauline."

5. The Anxiety of Influence

1. Thompson, "Crix' Cachet Losing Critical Mass," 12.
2. Thompson, "Crix' Cachet Losing Critical Mass," 12.
3. Thompson, "Crix' Cachet Losing Critical Mass," 12.
4. All quotations from this paragraph come from Gabler, "Everyone's a Critic Now."
5. Corliss, "All Thumbs," 16.
6. See Kael, "Circles and Squares," 12-26; Sarris, "The Auteur Theory and the Perils of Pauline," 26-33.
7. Corliss, "All Thumbs," 16.
8. Corliss, "All Thumbs," 16.
9. Mendelsohn, "A Critic's Manifesto." All further quotations in this paragraph come from the same source.
10. Lopate, *Totally, Tenderly, Tragically*, 3.
11. Schrader, "Fruitful Pursuits," 129.
12. Kellow, *Pauline Kael*, 80. Kellow largely recycles his views from Gitlin, *The Sixties*, 16.
13. Kellow, *Pauline Kael*, 80.
14. Kellow, *Pauline Kael*, 80.
15. Wolcott, "Waiting for Godard," 46.
16. Wolcott, *Lucking Out*, 66.
17. Wolcott, "Waiting for Godard," 46.
18. Wolcott, "Waiting for Godard," 48.
19. Wolcott, "Waiting for Godard," 48.
20. See the dust jacket of Haberski, *It's Only a Movie!*
21. Haberski, *It's Only a Movie!*, 188. Italics in original.
22. Haberski, *It's Only a Movie!*, 188.
23. Haberski, *It's Only a Movie!*, 191.
24. Roberts, *The Complete History of American Film Criticism*, 147, 197, 249, 314.
25. Kael, *The Age of Movies*; Kehr, *When Movies Mattered*.

26. See, for example, Eagleton, *The Function of Criticism*, 103; Berger, "Introduction: The Crisis of Criticism," 4; McDonald, *The Death of the Critic*, 3, 7.

27. McDonald, *The Death of the Critic*, 1, 77. See also Haberski, *It's Only A Movie!*, which deploys the term "golden age of criticism."

28. McDonald, *The Death of the Critic*, ix.

29. McDonald, *The Death of the Critic*, viii.

30. Kehr, *When Movies Mattered*, 7.

31. Kehr, *When Movies Mattered*, 7.

32. Kehr, *When Movies Mattered*, 7.

33. Denby, "My Life as a Paulette," 170.

34. Kellow, *Pauline Kael*, 311. See also 245ff., 281, and 312ff.

35. Kellow, *Pauline Kael*, 359.

36. Roberts, *The Complete History of American Film Criticism*, 15.

37. Roberts, *The Complete History of American Film Criticism*, 15.

38. Roberts, *The Complete History of American Film Criticism*, 15.

39. Roberts, *The Complete History of American Film Criticism*, 15.

40. Cf. Wolcott, "Waiting for Godard," 46-53, which lists, outlines, and criticizes these perennial journalistic pronouncements.

41. Roberts, *The Complete History of American Film Criticism*, 255-6.

42. Corliss, "All Thumbs," 15, 14.

43. Roberts, *The Complete History of American Film Criticism*, 259-60.

44. Corliss, "All Thumbs," 14.

45. Corliss, "All Thumbs," 18.

46. Corliss, "All Thumbs," 15.

47. Corliss, "All Thumbs," 14.

48. All quotations in this paragraph come from Goldstein, "Commentary: TV Film Critics Go for the Glitz."

49. Rich, "Roaring at the Screen With Pauline Kael."

50. Rosenbaum, *Movie Wars*, 57.

51. Rosenbaum, *Movie Wars*, 54-5.

52. Rosenbaum, *Movie Wars*, 58.

53. Rosenbaum, *Movie Wars*, 59.

54. Scott, "A Critic's Place, Thumb and All."

55. See Jones and Salter, *Digital Journalism*, vii, 4, 15.

56. Meltzer, "The Hierarchy of Journalistic Cultural Authority," 59-74.

57. Meltzer, "The Hierarchy of Journalistic Cultural Authority," 62. Lyons makes such claims about print colleagues being jealous of his earnings and fame; see Corliss, "All Thumbs," 15.

58. Gans, *Popular Culture and High Culture*, 80.

59. All quotations from Derek Malcolm come from his afterword to Houston, "Pauline Kael."

60. All quotations come from Schrader, "Fruitful Pursuits," 129.

61. Wolcott, *Lucking Out*, 74.

62. Wolcott, *Lucking Out*, 54.

63. Wolcott, *Lucking Out*, 54. Italics in original.

64. See Denby, "My Life as a Paulette," 170.

65. See Wolcott, *Lucking Out*, 91-2; Kellow, *Pauline Kael*, 274, 286, 324.

66. Wolcott, *Lucking Out*, 66, 74, 90; Kellow, *Pauline Kael*, 130, 135, 169.

67. See Kellow, *Pauline Kael*, 132-6.

68. Wolcott, *Lucking Out*, 90.

69. Denby, "My Life as a Paulette," 170.

70. Denby, "My Life as a Paulette," 170.

71. Rich, "Roaring at the Screen With Pauline Kael."

72. Rich, "Roaring at the Screen With Pauline Kael."

73. Denby, "My Life as a Paulette," 170.

74. Denby, "My Life as a Paulette," 170.

75. Smith and Strausbaugh, "James Wolcott: A Q&A."

76. Schwartz, "Introduction," xi.

77. Cf., for example, Levy, "Art Critics and Art Publics," 137.

78. Shrum, "Critics and Publics," 347.

79. Shrum, "Critics and Publics," 369.

80. Holbrook, "Popular Appeal versus Expert Judgments of Motion Pictures," 144-55.

81. Arnold, "The Function of Criticism at the Present Time," 265; see also Arnold, "Culture and Anarchy," 499.

82. See, for example, Stern, "Voices of Critical Discourse," 313-23; Levinson, "Artistic Worth and Personal Taste," 225-33; and Ross, "Comparing and Sharing Advice: Reflections on Critical Advice," 363-71.

83. Holbrook, "Popular Appeal versus Expert Judgments of Motion Pictures," 146.

84. Holbrook, "Popular Appeal versus Expert Judgments of Motion Pictures," 153.

85. Holbrook, "Popular Appeal versus Expert Judgments of Motion Pictures," 153-4.

86. Eliashberg and Shugan, "Film Critics: Influencers or Predictors?," 68. Cf. Burzynski and Bayer, "The Effect of Positive and Negative Prior Information on Motion Picture Appreciation," which predicts critics' pronouncements have greatest effect on the early stages of the run.

87. Eliashberg and Shugan, "Film Critics," 68. See also Faber and O'Guinn, "Effect of Media Advertising and Other Sources on Movie Selection," for a study that shows how critics' reviews ranked low in terms of importance in the decision of whether or not to see a film.

88. Wyatt and Badger, "How Reviews Affect Interest in and Evaluation of Films," 878.

89. Buor, "Reliability of Ratings of Movies by Professional Movie Critics," 243-57.

90. Reinstein and Snyder, "The Influence of Expert Reviews on Consumer Demand for Experience Goods," 27-51.

91. See Reinstein and Snyder, "The Influence of Expert Reviews on Consumer Demand for Experience Goods," 34. See also Smith, *The Film 100,* and Roberts, *The Complete History of American Film Criticism,* 274.

92. Reinstein and Snyder, "The Influence of Expert Reviews on Consumer Demand for Experience Goods," 29.

93. Kael, "Bonnie and Clyde," 147-71.

94. Roberts, *The Complete History of American Film Criticism,* 158.

95. Roberts, *The Complete History of American Film Criticism,* 164.

96. Wolcott, "Waiting for Godard," 50.

97. Wolcott, "Waiting for Godard," 50.

98. Wolcott, "Waiting for Godard," 50. See also Wolcott, *Lucking Out*, 250.

99. Friedman, *Bonnie and Clyde*, 24.

100. For just a few examples: Houston, "Pauline Kael," maintains the essay contains 6000 words, as does Wolcott, "Waiting for Godard," 50; 7000 words is the length attested in Rich, "Roaring at the Screen With Pauline Kael" and in Harris, *Pictures at a Revolution*, 345. Biskind (*Easy Riders, Raging Bulls*, 40) reports 9000, as does Sterritt, "Bonnie and Clyde," 64.

101. Roberts, *The Complete History of American Film Criticism*, 165.

102. Biskind, *Easy Riders, Raging Bulls*, 40-1.

103. See, for example, Kellow, *Pauline Kael*, 101, 103; Sterritt, "Bonnie and Clyde," 63-4; Friedman, *Bonnie and Clyde*, 26; Beaver, *Bosley Crowther*, 187; or Gerald Peary's documentary, *For the Love of Movies: The Story of American Film Criticism* (2009).

104. Biskind, *Easy Riders, Raging Bulls*, 40.

105. See Haberski, *It's Only a Movie!*, 178.

106. In addition to Friedman, *Bonnie and Clyde*, and other academic accounts, see Peter Bradshaw's recent reckoning with the episode. Ignoring the Hollywood actor's previous roles and celebrity, Peter Bradshaw writes that Kael's "passionate support" for *Bonnie and Clyde* "put Beatty on the map." See Bradshaw, "Why Warren Beatty's Attack on Pauline Kael Failed."

107. Friedman, *Bonnie and Clyde*, 25, 22.

108. See Harris, *Pictures at a Revolution*, 337; Crowther, "Shoot-Em-Up Film Opens World Fet [*sic*]," 32.

109. Biskind, *Easy Riders, Raging Bulls*, 39.

110. Landry, "Montreal Discovers H'Wood: Glamor Opening, Next Day Blah," 5.

111. Sarris, "Films," 21; Crist, "Movies: Bonnie and Clyde, 'Triumph,'" 68; Carroll, "Bonnie and Clyde Brutal and Brilliant," 44; Gilliatt, "The Party," 77-9.

112. "Bonnie and Clyde," 6; Crowther, "Shoot-Em-Up Film Opens World Fet [*sic*]," 32; Crowther, "Screen: Bonnie and Clyde Arrives," 36.

113. See the advertisement in *Variety*, 16 August 1967, 18-19.

114. "'Bonnie and Clyde' Building in N.Y.," 4. For examples of reader letters that the *New York Times* printed, see Carr, "From 'Fucking Cops!' to 'Fucking Media!,'" 83-4; and Harris, *Pictures at a Revolution*, 344.

115. "Critics Honor 3 Pix," 11.

116. "Bonnie and Clyde Building in N.Y.," 4.

117. Biskind, *Easy Riders, Raging Bulls*, 41.

118. Friedman, *Bonnie and Clyde*, 24.

119. "'Heat' Mighty 127G on Big B'way," 13.

120. "B'way Soars; 'Staircase' Huge 245G, 'Clyde' Sock 59G," 9.

121. "National Boxoffice Survey," *Variety*, 30 August 1967, 5; "L.A. Trade Soars; 'Heat' Sockeroo $39,000, 'Clyde' Record 28G," 11; "N.Y. Biz Still Strong," 11.

122. See "B'way Labor Day Boom: 'Heat of Night' Torrid $98,000, 2d; 'Staircase' 225G, 3d; 'Clyde' 74½G, 2d," 9; "Holiday Hypos L.A.; 'Twice' Smash 285G in 23 Sites, 'Clyde' Wow 29G, 2d," 9; "National Boxoffice Survey," *Variety*, 13 September 1967, 4; "'Bonnie and Clyde' Building in N.Y.," 4.

123. "'Bonnie and Clyde' Building in N.Y.," 4.

124. See "Chi Uneven; 'Clyde' Wham $42,000," 8; "W7's 'Bonnie & Clyde' 'Movie Month' Special," 22.
125. See "National Boxoffice Survey," *Variety*, 4 October 1967, 5; "International Sound Track," 26.
126. "Smash-Hit Killers," 23.
127. See "National Boxoffice Survey," *Variety*, 4 October 1967, 5; the advertisement in the same issue (19); "International Sound Track," 26.
128. See "National Boxoffice Survey," *Variety*, 11 October 2013, 7.
129. See "'Bonnie and Clyde' Building in N.Y.," 4; see also Harris, *Pictures at a Revolution*, 340, 347. See also Biskind, *Easy Riders, Raging Bulls*, 38: Warners vice president Dick "Lederer knew they were going to bury" *Bonnie and Clyde*.
130. Biskind, *Easy Riders, Raging Bulls*, 46.
131. See Morella and Epstein, *Rebels*, 162-4; Carr, "From 'Fucking Cops!' to 'Fucking Media!,'" 85.
132. Harris, *Pictures at a Revolution*, 342.
133. Gold, "Crowther's 'Bonnie'-Brook Rap at Violence Stirs Brouhaha," 5, 28; "Bosley's 'Bonnie'-Brook Adding New Chapters; Times Interviews Penn," 22; "Newsweek Reverses 'Bonnie' Stand: Calls First Review 'Grossly Unfair,'" 5, 24.
134. See Harris, *Pictures at a Revolution*, 341-2.
135. "The Shock of Freedom in Films." Cf. Kellow, *Pauline Kael*, 103.
136. Biskind, *Easy Riders, Raging Bulls*, 46.
137. See *N. W. Ayer and Son's Directory Newspapers and Periodicals 1967*, 760, 774.
138. See *N. W. Ayer and Son's Directory Newspapers and Periodicals 1967*, esp. 778.
139. See *N. W. Ayer and Son's Directory Newspapers and Periodicals 1967*, 759.
140. Biskind, *Easy Riders, Raging Bulls*, 40. My emphasis.
141. See "National Boxoffice Survey," *Variety*, 18 October 1967, 7; "National Boxoffice Survey," *Variety*, 25 October 1967, 7; "National Boxoffice Survey," *Variety*, 1 November 1967, 4; "National Boxoffice Survey," *Variety*, 8 November 1967, 10.
142. See Lennon, "Riding the New Wave."
143. Harris, *Pictures at a Revolution*, 347.
144. Kellow, *Pauline Kael*, 103.
145. Kellow, *Pauline Kael*, 101.
146. Sterritt, "Bonnie and Clyde," 64.
147. Cf. Denby, "My Life as a Paulette," 170.
148. See Seligman, *Sontag & Kael*, 50-1.
149. Kellow, *Pauline Kael*, 132.
150. Denby, "My Life as a Paulette," 170.
151. Kael, *The Age of Movies*, 127-34.
152. Kael, *The Age of Movies*, 196.
153. See Indiana, "Critical Condition," 126.
154. Denby, "My Life as a Paulette," 170.
155. Denby, "My Life as a Paulette," 170.
156. Denby, "My Life as a Paulette," 170.
157. Kehr, *When Movies Mattered*, 4-5.
158. See Carr, "From 'Fucking Cops!' to 'Fucking Media!,'" 86.

159. Rosenbaum, *Movie Wars*, 55.

160. Kael, "Circles and Squares," 12-26.

161. See Kael, "Is There a Cure for Film Criticism?," 56–64. See also Kael, *I Lost It at the Movies*.

162. Michelson, "Eco and Narcissus," 165.

163. Michelson, "Eco and Narcissus," 165.

6. The Spectre of "Democratization" in the Digital Age

1. Collin, "Who Cares What Twitter Critics Think?"

2. Collin, "Who Cares What Twitter Critics Think?"

3. Collin, "Who Cares What Twitter Critics Think?" Ironically, this article was opened up for debate, both inviting readers to tweet their views "using the hashtag #twittercritic" and by voting in an online poll, which asked "Whose verdict on a film do you value the most?" and comprised the multiple choice of "professional critic," "friend of family member," or "random tweeter."

4. Bradshaw, "How Twitter Users Became the Industry's Favourite Critics." Bradshaw also refers to the "David Manning" affair from 2001; Sony Columbia invented Manning as a way to spout praise of its films. For more commentary on the *Impossible* poster, see also Orr, "Movie Posters: 'Great Film!' – Dave from the Internet."

5. Goldstein, "Commentary: TV Critics Go for the Glitz."

6. Thompson, "Crix' Cachet Losing Critical Mass," 12.

7. Thompson, "Crix' Cachet Losing Critical Mass," 12.

8. Thompson, "Crix' Cachet Losing Critical Mass," 23.

9. Rosa A. Eberly uses the term "citizen critic" to refer to non-experts who intervene into public discourse on literature in her pre-internet *Citizen Critics*.

10. See also Crompton, "Critics Are Important – Even in the Blogosphere." This sentiment is widespread and oft-repeated. For another squib in this vein, see Kallay, "The Critic Is Dead ... ," 26-7.

11. See also Michael, *Anxious Intellectuals*.

12. See, for example, Hague and Loader, eds., *Digital Democracy*; Papacharissi, *A Private Sphere*; and Hindberg, *The Myth of Digital Democracy*.

13. Dahlberg, "The Internet and Democratic Discourse" 616-18.

14. Dahlberg, "The Internet and Democratic Discourse," 618.

15. Dahlberg, "The Internet and Democratic Discourse," 616. See also Papacharissi, *A Private Sphere*, 113.

16. Hindman, *The Myth of Digital Democracy*, 5.

17. Jones and Salter, *Digital Journalism*, vii. See also Mosco, *The Digital Sublime*: it shows that the claims to democracy and equality made by advocates of the internet were also made by proponents of older "new media," such as the telephone, radio, and television.

18. Jones and Salter, *Digital Journalism*, 7.

19. Papacharissi, *A Private Sphere*, 64. See also Bolter and Grusin, *Remediation*.

20. For more on Ain't It Cool News, see Owczarski, "From Austin's Basement to Hollywood's Back Door," 3-20.

21. Owczarski, "From Austin's Basement to Hollywood's Back Door," 4.

22. See "Rottentomatoes.com Traffic and Demographic Statistics by Quantcast."

23. Ryan, "An Oral History of RT, Part One."

24. See "Rotten Tomatoes: Licensing."

25. "Who Are the Approved Tomatometer Critics?"

26. "About Critics."

27. For example: "Online publications must achieve and maintain a minimum 500,000 unique monthly visitors according to comScore, Inc or Nielsen Net Ratings and reviews must have an average length of at least 300 words. Publications must also show a consistent standard of professionalism, writing quality, and editorial integrity across all reviews and articles. Lastly, site design and layout should also reflect a reasonable level of quality and must have a domain name specific to the property." See "About Critics."

28. See "About Critics."

29. See "Rotten Tomatoes: Certified Fresh." According to the page, "Reserved for the best-reviewed films, the Certified Fresh accolade constitutes a seal of approval, synonymous with quality."

30. See "About Critics."

31. See the Rotten Tomatoes Facebook page: "Rotten Tomatoes – Info: Facebook."

32. See Papacharissi, *A Private Sphere*, 153-4.

33. Shepherd, "Rotten Tomatoes in the Field of Popular Cultural Production," 34.

34. Shepherd, "Rotten Tomatoes in the Field of Popular Cultural Production," 34.

35. Thompson, "Crix' Cachet Losing Critical Mass," 12.

36. Shepherd does cede this point ("Rotten Tomatoes in the Field of Popular Cultural Production," 37): "RT paradoxically offers both an alternative to, and reinforcement of, traditional movie criticism through its exploitation of the Internet's participatory potential." See McDonald, *The Death of the Critic*; Carey, *What Good Are the Arts?*

37. Even Shepherd admits that the "site determines to establish aesthetic credibility through alternate means" ("Rotten Tomatoes in the Field of Popular Cultural Production," 35).

38. See "About Critics." My italics added here for emphasis.

39. For more on how gatekeeping remains a critical part of the dissemination of information in the digital age, see Hindman, *The Myth of Digital Democracy*, 12-13.

40. See Hindman, *The Myth of Digital Democracy*, 38-57, especially 56.

41. Papacharissi, *A Private Sphere*, 120.

42. See, for example, Hindman, *The Myth of Digital Democracy*, 2-3, 6.

43. Italics in original. See Ryan, "An Oral History of RT, Part Three."

44. Shepherd, "Rotten Tomatoes in the Field of Popular Cultural Production," 34.

45. Shepherd, "Rotten Tomatoes in the Field of Popular Cultural Production," 29.

46. Shepherd, "Rotten Tomatoes in the Field of Popular Cultural Production," 35.

47. Shepherd, "Rotten Tomatoes in the Field of Popular Cultural Production," 35.

48. See Hague and Loader, *Digital Democracy*, 9; Hindman, *The Myth of Digital Democracy*, 9; Papacharissi, *A Private Sphere*, 120.

49. See Papacharissi, *A Private Sphere*, 123.

50. "News Corp. Acquires IGN for $650 million."

51. Sweney, "Warner Bros Buys Rotten Tomatoes Owner Flixster."

52. Chmielewski, "Warner Bros. Buys Social Network Flixster, Parent of Rotten Tomatoes."

53. See "The Rotten Tomatoes Show."

54. Ryan, "An Oral History of RT, Part Two."

55. Hindman, *The Myth of Digital Democracy*, 6.
56. Papacharissi, *A Private Sphere*, 122. Italics in original.
57. Shepherd, "Rotten Tomatoes in the Field of Popular Cultural Production," 29.
58. Papacharissi, *A Private Sphere*, 65.
59. "Oz the Great and Powerful – Movie Forum – Rotten Tomatoes."
60. See Dahlberg, "The Internet and Democratic Discourse," 622, 620.
61. Itzkoff, "Rotten Tomatoes Halts Comments on 'Dark Knight.'"
62. Dahlberg, "The Internet and Democratic Discourse," 620; see also 623.
63. Shepherd, "Rotten Tomatoes in the Field of Popular Cultural Production," 38-40.
64. Dahlberg, "The Internet and Democratic Discourse," 618; see also Papacharissi, *A Private Sphere*, 62-3 and Hague and Loader, *Digital Democracy*, 12.
65. "Flixster."
66. See Shepherd, "Rotten Tomatoes in the Field of Popular Cultural Production," 39: "online film criticism contributes to fragmentation (not cohesion) of specific (not general) audience markets." See also Hindman, *The Myth of Digital Democracy*, 9.
67. See "Rottentomatoes.com Traffic and Demographic Statistics by Quantcast."
68. Shepherd, "Rotten Tomatoes in the Field of Popular Cultural Production," 41.
69. See Hindman, *The Myth of Digital Democracy*, 89.
70. Cf. "Film Criticism in the Lay Press," 50-2.
71. Cf. Shepherd, "Rotten Tomatoes in the Field of Popular Cultural Production," 33.
72. See Shepherd, "Rotten Tomatoes in the Field of Popular Cultural Production," 41. See also Baumann, *Hollywood Highbrow*.
73. Demsetz, "Barriers to Entry," 47-57; here especially 47.
74. Demsetz, "Barriers to Entry," 47.
75. Hindman, *The Myth of Digital Democracy*, 13.
76. Hindman, *The Myth of Digital Democracy*, 86-7.
77. Hindman, *The Myth of Digital Democracy*, 13, 16-17, 19.
78. Hindman, *The Myth of Digital Democracy*, 101.
79. Hindman, *The Myth of Digital Democracy*, 128.
80. Demsetz, "Barriers to Entry," 50.
81. Hindman, *The Myth of Digital Democracy*, 101.
82. Papacharissi, *A Private Sphere*, 124.

Conclusion

1. Haberski, *It's Only a Movie!*, 5.
2. See also Evans and Young, "Can Crix Fix Niche Pix?," 1-2.
3. Reinstein and Snyder, "The Influence of Expert Reviews on Consumer Demand for Experience Goods," 48.
4. Shrum, "Critics and Publics," 369.
5. See Wolcott, *Lucking Out*, 93-6, for an example of this sort of nostalgia.
6. Roberts, *The Complete History of American Film Criticism*, 15.
7. See, for example, *1972 Ayer Directory of Publications*, 597, 599, 607.
8. Williams, *Ethnicity and Cultural Authority*, 24.
9. Williams, *Ethnicity and Cultural Authority*, 24.

10. Haberski, *It's Only a Movie!*, 9, 190, 8.
11. McDonald, *The Death of the Critic*, ix.
12. McDonald, *The Death of the Critic*, 120.
13. McDonald, *The Death of the Critic*, ix.
14. McDonald, *The Death of the Critic*, 116, 125.
15. McDonald, *The Death of the Critic*, 134.
16. Carroll, *On Criticism*, 5, 8.
17. Carroll, *On Criticism*, 6.
18. Carroll, *On Criticism*, 15.
19. Denning, *Culture in the Age of Three Worlds*, 3.
20. Denning, *Culture in the Age of Three Worlds*, 142, 145.
21. Denning, *Culture in the Age of Three Worlds*, 148.
22. See Denning, *Culture in the Age of Three Worlds*, 122, 137.
23. Denning, *Culture in the Age of Three Worlds*, 138.
24. See Denning, *Culture in the Age of Three Worlds*, 139, 152. See also Ross, *No Respect*, 42-64.
25. See Carey, *What Good Are the Arts?*, esp. 14, 134, 167-8, 171, 249.
26. Koselleck, "Some Questions Concerning the Conceptual History of 'Crisis,'" 15.
27. "Film Criticism in the Age of the Internet," 34.
28. Roiphe, "With Clarity and Beauty, the Weight of Authority."
29. Koselleck, "Some Questions Concerning the Conceptual History of 'Crisis,'" 20-1.
30. Roiphe, "With Clarity and Beauty, the Weight of Authority." For a discussion of critics' outsider and insider positionings, see Williams, *Ethnicity and Cultural Authority*, 5.
31. Phillips, *Contested Knowledge*, 9.

Bibliography

1972 Ayer Directory of Publications. Philadelphia: Ayer Press, 1972.

Abel, Richard. *French Cinema: The First Wave, 1915-1929*. Princeton, NJ: Princeton University Press, 1984.

Abel, Richard, ed. *French Film Theory and Criticism: A History/Anthology 1907-1939, Volume 1*. Princeton, NJ: Princeton University Press, 1988.

"About Critics." *Rotten Tomatoes*. Accessed 26 April 2013. http://www.rottentomatoes.com/help_desk/critics.php.

Acland, Charles. "Theatrical Exhibition: Accelerated Cinema." In *The Contemporary Hollywood Industry*, ed. Paul McDonald and Janet Wasko, 83-105. Oxford: Blackwell, 2008.

Adler, Renata. "The Perils of Pauline." *New York Review of Books*, 14 August 1980. Accessed 25 May 2014. http://www.nybooks.com/articles/archives/1980/aug/14/the-perils-of-pauline/.

Anderson, Lindsay. "Angles of Approach." *Sequence* 2 (1947): 5-8.

Anderson, Lindsay. "French Critical Writing." *Sight and Sound* 24.2 (1954): 105.

Anderson, Lindsay. "*Positif*, September-October 1954: Aspects du Cinéma Americain; *Cahiers du Cinéma*, October 1954: Alfred Hitchcock." *Sight and Sound* 24.3 (1955): 161.

Anderson, Lindsay. "Stand Up! Stand Up!" *Sight and Sound* 26.2 (1956): 63-9.

"Anstelle eines Programms." *Filmkritik* 1.1 (1957): n.p.

"Are Film Critics Really Needed Anymore ... Or Is It a Washed-Up Profession?" *Variety*, 25 April 2007. Accessed 26 July 2013. http://www.variety.com/article/VR1117963778?refCatId=1043.

Armitage, Peter. "The Current Picture." *Film* 26 (1960): 4-6.

Armitage, Peter. "The Current Picture." *Film* 27 (1961): 6-7.

Armitage, Peter. "The Current Picture." *Film* 28 (1961): 4-5.

Armitage, Peter. "Free Criticism." *Film* 28 (1961): 8-10.

Arnheim, Rudolf. *Film as Art*. London: Faber and Faber, 1983 [1933, 1957].

Arnheim, Rudolf. "The Film Critic of Tomorrow" [1935]. In *Film Essays and Criticism*, trans. Brenda Benthien, 105-10. Madison: University of Wisconsin Press, 1997. Originally published as "Der Filmkritiker von morgen," *Intercine* 8-9 (1935): 89-93.

Arnheim, Rudolf. "Note" [1927]. In *Film Essays and Criticism*, trans. Brenda Benthien, 101. Madison: University of Wisconsin Press, 1997. Originally published as "Vom Film," *Das Stachelschwein*, December 1927, 43-4.

Arnheim, Rudolf. "Old Chaplin Films" [1929]. In *Film Essays and Criticism*, trans. Brenda Benthien, 145-7. Madison: University of Wisconsin Press, 1997. Originally published as "Alte Chaplinfilme," *Die Weltbühne*, 2 July 1929, 20-3.

Arnheim, Rudolf. "Professional Film Criticism" [1929]. In *Film Essays and Criticism*, trans. Brenda Benthien, 101-5. Madison: University of Wisconsin Press, 1997. Originally published as "Fachliche Filmkritik," *Die Weltbühne*, 19 February 1929, 300-4.

Arnold, Matthew. "Culture and Anarchy" [1869]. In *The Portable Matthew Arnold*, ed. Lionel Trilling, 469-573. New York: Viking, 1949.

Arnold, Matthew. *Culture and Anarchy and Other Writings*, ed. Stefan Collini. Cambridge: Cambridge University Press, 1993.

Arnold, Matthew. "The Function of Criticism at the Present Time" [1865]. In *The Portable Matthew Arnold*, ed. Lionel Trilling, 234-67. New York: Viking, 1949.

Balázs, Béla. *Béla Balázs: Early Film Theory: Visible Man and The Spirit of Film*, ed. Erica Carter. Trans. Rodney Livingstone. New York: Berghahn, 2010.

Balázs, Béla. "Die Branche und ihre Kunst: Eine Rechtfertigung des Filmkritikers" [1924]. In *Béla Balázs, Schriften zum Film: Band I*, ed. Helmut H. Diederichs, 316-18. Berlin: Henschel, 1982. Originally published in *Der Tag*, 28 November 1924.

Balázs, Béla. "Film Criticism!" [1922]. Trans. Russell Stockman. *October* 115 (2006): 55-6. Originally published as "Kinokritik!," *Der Tag*, 1 December 1922.

Balfour, Betty. "The Art of the Cinema." *The English Review* 37 (1923): 388-91.

Barry, Iris. *Let's Go to the Pictures*. London: Chatto & Windus, 1926.

Baumann, Shyon. *Hollywood Highbrow: From Entertainment to Art*. Princeton, NJ: Princeton University Press, 2007.

Bazin, André. "Comment présenter et discuter un film" [1953]. *Cahiers du cinéma*, March 2008, 68-70. Originally published in *Regards neufs sur le cinéma*, ed. Jacques Chevallier (Paris: Seuil, 1953), 354-9.

Bazin, André. "Toward a Cinematic Criticism" [1943]. In *French Cinema of the Occupation and Resistance: The Birth of a Cultural Esthetic*, ed. François Truffaut, trans. Stanley Hochman, 53-65. New York: Frederick Ungar, 1981. Originally published as "Pour une critique cinématographique," *L'Echo des étudiants*, 11 December 1943.

Beaton, Welford. "We Salute You." *Film Spectator*, 20 March 1926, 2.

Beaver, Frank. *Bosley Crowther: Social Critic of Film, 1940-1967*. New York: Arno Press, 1974.

Berger, Maurice, ed. *The Crisis of Criticism*. New York: New Press, 1998.

Berger, Maurice. "Introduction: The Crisis of Criticism." In *The Crisis of Criticism*, ed. Maurice Berger, 1-14. New York: The New Press, 1998.

Berger, Ronald. "The Film Critic Is Dead. Long Live the Film Critic." *Guardian*, 7 April 2010. Accessed 17 May 2013. http://www.guardian.co.uk/film/filmblog/2010/apr/07/film-critic.

Berghahn, Wilfried. "Zum Selbstverständnis der *Filmkritik*." *Filmkritik* 8.1 (1964): 4-8.

Beylie, Claude. "1895-1930." In *La critique de cinéma en France: Histoire, anthologie, dictionnaire*, ed. Michel Ciment and Jacques Zimmer, 11-27. Paris: Ramsay, 1997.

Bickerton, Emilie. *A Short History of Cahiers du Cinéma*. London: Verso, 2009.

Biskind, Peter. *Easy Riders, Raging Bulls: How the Sex-Drugs-and-Rock 'n' Roll Generation Saved Hollywood*. New York: Simon & Schuster, 1998.

Boenisch, Vasco. *Krise der Kritik? Was Theaterkritiker denken – und ihre Leser erwarten*. Berlin: Theater der Zeit, 2008.

Bolter, Jay David, and Richard Grusin. *Remediation: Understanding New Media*. Cambridge, MA: MIT Press, 1999.

"Bonnie and Clyde." *Variety*, 9 August 1967, 6.

"'Bonnie and Clyde' Building in N.Y." *Variety*, 13 September 1967, 4.

"Bosley's 'Bonnie'-Brook Adding New Chapters; Times Interviews Penn." *Variety*, 20 September 1967, 22.

Bourdieu, Pierre. "Intellectual Field and Creative Project." Trans. Sian France. In *Knowledge and Control: New Directions for the Sociology of Education*, ed. Michael F.D. Young, 161-88. London: Collier-Macmillan, 1971.

Bradshaw, Peter. "How Twitter Users Became the Industry's Favourite Critics." *Guardian*, 16 January 2013. Accessed 21 April 2013. http://www.guardian.co.uk/film/shortcuts/2013/jan/16/twitter-users-film-industrys-critics.

Bradshaw, Peter. "Why Warren Beatty's Attack on Pauline Kael Failed." *Guardian*, 3 February 2010. Accessed 2 August 2013. http://www.theguardian.com/film/filmblog/2010/feb/03/warren-beatty-pauline-kael.

Bryher. *Film Problems of Soviet Russia*. Territet: Pool, 1929.

Buor, Myron. "Reliability of Ratings of Movies by Professional Movie Critics." *Psychological Reports* 67 (1990): 243-57.

Burzynski, Michael H., and Duwey J. Bayer. "The Effect of Positive and Negative Prior Information on Motion Picture Appreciation." *Journal of Social Psychology* 101 (1977): 215-18.

Bush, W. Stephen. "The Triumph of the Gallery" [1913]. In *American Film Criticism: From the Beginnings to Citizen Kane*, ed. Stanley Kauffmann with Bruce Henstell, 67-9. Westport, CT: Greenwood Press, 1979. Originally published in *Moving Picture World*, 13 December 1913.

"B'way Labor Day Boom: 'Heat of Night' Torrid $98,000, 2d; 'Staircase' 225G, 3d; 'Clyde' 74½G, 2d; 'Millie' 49G, 24th." *Variety*, 6 September 1967, 9.

"B'way Soars; 'Staircase' Huge 245G, 'Clyde' Sock 59G, 'Hawaii' Hotsy 36G, 'Losers' 30G, 'Birds' Ditto." *Variety*, 23 August 1967, 9.

Callenbach, Ernst. "Editor's Notebook." *Film Quarterly* 14.2 (1960): 2-3.

Cameron, Ian. "All Together Now." *Film* 25 (1960): 12-13.

Cameron, Ian. "Editorial." *Oxford Opinion* 38 (1960): 36.

Cameron, Ian. "What's the Use?" *Film* 28 (1961): 10-11.

Canudo, Ricciotto. "The Birth of the Sixth Art" [1911]. Trans. Ben Gibson, Don Ranvaud, Sergio Sokota, and Deborah Young. In *French Film Theory and Criticism: A History/Anthology 1907-1939, Volume 1*, ed. Richard Abel, 58-66. Princeton, NJ: Princeton University Press, 1988.

Carey, John. *What Good Are the Arts?* London: Faber and Faber, 2005.

Carr, Steven Alan. "From 'Fucking Cops!' to 'Fucking Media!' Bonnie and Clyde for a Sixties America." In *Arthur Penn's Bonnie and Clyde*, ed. Lester D. Friedman, 70-100. Cambridge: Cambridge University Press, 2000.

Carroll, Kathleen. "Bonnie and Clyde Brutal and Brilliant." *Daily News*, 14 August 1967, 44.

Carroll, Noël. *On Criticism*. New York: Routledge, 2009.

Carroll, Noël. *Philosophical Problems of Classical Film Theory*. Princeton, NJ: Princeton University Press, 1988.

"Chi Uneven; 'Clyde' Wham $42,000, 'Bobo' Good 13G, 'To Sir' Socko 35G, 'Heat' Hotsy 25G, 'Park' Perky 25G." *Variety*, 27 September 1967, 8.

Chmielewski, Dawn C. "Warner Bros. Buys Social Network Flixster, Parent of Rotten Tomatoes." *Los Angeles Times*, 5 May 2011. Accessed 21 March 2013. http://articles.latimes.com/2011/may/05/business/la-fi-ct-flixter-20110505.

Ciment, Michel, and Jacques Zimmer, eds. *La critique de cinéma en France: Histoire, anthologie, dictionnaire*. Paris: Ramsay, 1997.

Clayton, Alex, and Andrew Klevan, eds. *The Language and Style of Film Criticism*. London: Routledge, 2011.

Collin, Robbie. "Who Cares What Twitter Critics Think?" *Daily Telegraph*, 18 January 2013. Accessed 26 March 2013. http://www.telegraph.co.uk/culture/film/film-blog/9810807/Who-cares-what-Twitter-critics-think.html.

Comolli, Jean-Louis, et al. "Vingt ans après: Le cinéma américain, ses auteurs et notre politique en question." *Cahiers du cinéma* 172 (1965): 18-31.

Cooke, Alistair. "The Critic in Film History." In *Footnotes to the Film*, ed. Charles Davy, 238-63. London: Lovat Dickson, 1937.

Corliss, Richard. "All Thumbs Or, Is There a Future for Film Criticism?" *Film Comment* 26.2 (1990): 14-18.

"Correspondence." *Sight and Sound* 26.2 (1956): 110.

"Correspondence." *Sight and Sound* 26.3 (1956-1957): 163-5.

"Correspondence." *Sight and Sound* 26.4 (1957): 220.

"Correspondence." *Sight and Sound* 28.1 (1958-1959): 48.

"Correspondence." *Sight and Sound* 28.2 (1959): 101.

"Correspondence." *Sight and Sound* 28.3-4 (1959): 190.

"Correspondence." *Sight and Sound* 30.1 (1960-1961): 48.

"Correspondence." *Sight and Sound* 30.2 (1961): 101-2.

Cousins, Mark. "Situation Critical." *Sight and Sound*, February 2014, 13.

Crist, Judith. "Movies: Bonnie and Clyde, 'Triumph.'" *Vogue*, 15 September 1967, 68.

"Critics Honor 3 Pix." *Variety*, 23 August 1967, 11.

Crompton, Sarah. "Critics Are Important – Even in the Blogosphere." *Daily Telegraph*, 11 January 2013. Accessed 26 April 2013. http://www.telegraph.co.uk/culture/tvandradio/9795521/Critics-are-important-even-in-the-blogosphere.html.

Crosthwaite, Paul, ed. *Criticism, Crisis, and Contemporary Narrative: Textual Horizons in an Age of Risk*. New York: Routledge, 2011.

Crosthwaite, Paul. "Introduction." In *Criticism, Crisis, and Contemporary Narrative: Textual Horizons in an Age of Risk*, ed. Paul Crosthwaite, 1-11. New York: Routledge, 2011.

Crowther, Bosley. "Screen: Bonnie and Clyde Arrives." *New York Times*, 14 August 1967, 36.

Crowther, Bosley. "Shoot-Em-Up Film Opens World Fet [*sic*]." *New York Times*, 6 August 1967, 32.

Dahlberg, Lincoln. "The Internet and Democratic Discourse: Exploring the Prospects of Online Deliberative Forums Extending the Public Sphere." *Information, Communication & Society* 4.4 (2001): 615-33.

De Kuyper, Eric. "Le théâtre comme 'mauvais objet.'" *Cinémathèque* 11 (1997): 60-72.

Delahaye, Michel. "Allemagne ciné zero." *Cahiers du cinéma* 163 (1965): 58-67.

Delahaye, Michel. "Leni et le loup." *Cahiers du cinéma* 170 (1965): 42-51, 62-3.

Delluc, Louis. "Abel Gance après *La Zone de la mort*." *Le Film*, 22 October 1917, 7.

Delluc, Louis. "The Crowd" [1918]. Trans. Richard Abel. In *French Film Theory and Criticism: A History/Anthology 1907-1939, Volume 1*, 159-64. Princeton, NJ: Princeton University Press, 1988. Originally published as "La Foule," *Paris-Midi*, 24 August 1918.

Delluc, Louis. *Photogénie*. Paris: M. de Brunoff, 1920.

De Man, Paul. "Criticism and Crisis." In *Blindness and Insight: Essays in the Rhetoric of Contemporary Criticism*, 2nd rev. ed., 3-19. London: Methuen, 1983.

Demsetz, Harold. "Barriers to Entry." *American Economic Review* 72.1 (1982): 47-57.

Denby, David. "My Life as a Paulette." *New Yorker*, 20 October 2003, 170.

Denning, Michael. *Culture in the Age of Three Worlds*. London: Verso, 2004.

Dery, Mark, ed. *Flame Wars: The Discourse of Cyberculture*. Durham, NC: Duke University Press, 1994.

Diamant-Berger, Henri. *Le Cinéma*. Paris: Renaissance du livre, 1919.

Diederichs, Helmut H. *Anfänge deutscher Filmkritik*. Stuttgart: Robert Fischer + Uwe Wiedleroither, 1986.

Diederichs, Helmut H. "Herbert Tannenbaum – der erste deutsche Filmtheoretiker." *Kinematograph* 4 (1987): 7-30.

Diederichs, Helmut H. "Über Kinotheater-Kritik, Kino-Theaterkritik, ästhetische und soziologische Filmkritik: Historische Aspekte der deutschsprachigen Filmkritik bis 1933." In *Filmkritik: Bestandsaufnahmen und Perspektiven*, ed. Irmbert Schenk, 22-42. Marburg: Schüren, 1998.

Doherty, Thomas. "The Death of Film Criticism." *Chronicle of Higher Education*, 28 February 2010. Accessed 17 May 2013. http://chronicle.com/article/The-Death-of-Film-Criticism/64352/.

Donald, James, Anne Friedberg, and Laura Marcus, eds. *Close-Up, 1927-1933: Cinema and Modernism*. London: Cassell, 1998.

Dort, Bernard. "Pour une critique brechtienne du cinéma." *Cahiers du cinéma* 114 (1960): 33-42.

Dupin, Christophe. "The Postwar Transformation of the British Film Institute and Its Impact on the Development of a National Film Culture in Britain." *Screen* 47.4 (2006): 443-51.

Duquesnel, Félix. "La Quinzaine théâtrale." *Le Théâtre*, 1 March 1907, 2.

Dureau, Georges. "Le Cinéma et l'aviation – Écho de Béthuny." *Ciné-Journal*, 23 August 1909, 1-2.

Dureau, Georges. "Le Film national." *Ciné-Journal*, 20 December 1909, 3-4.

Durus. "Notizen zur Frage 'Fachmännische Kritik.'" *Arbeiterbühne und Film*, June 1931, 6.

Dyer, Peter John. "Counter Attack." *Film* 26 (1960): 8-9.

Eagleton, Terry. *The Function of Criticism*. London: Verso, 1984.

Eberly, Rosa A. *Citizen Critics: Literary Public Spheres*. Urbana: University of Illinois Press, 2000.

Ebert, Roger. "Film Criticism is Dying? Not Online." *Wall Street Journal*, 22 January 2011. Accessed 15 May 2014. http://online.wsj.com/news/articles/SB10001424052748703583404576080392163051376.

"Editorial." *Cineaste* 33.4 (2008): 1.

Eliashberg, Jehoshua, and Steven M. Shugan. "Film Critics: Influencers or Predictors?" *Journal of Marketing* 61 (1997): 68-78.

Elster, Alexander. "Zur Frage einer Kinokritik." *Bild und Film* 11-12 (1912-1913): 261-2.

Evans, Greg, and Paul F. Young. "Can Crix Fix Niche Pix? 'Batman' Is Critic-Proof, But Not Today's Highbrow Fare." *Variety*, 22 May 1995, 1-2.

Faber, Ronald, and Thomas O'Guinn. "Effect of Media Advertising and Other Sources on Movie Selection." *Journalism Quarterly* 61 (1984): 371-7.

Färber, Helmut. "Versuch über Hitchcock." *Filmkritik* 10.8 (1966): 463-74.

Fehrenbach, Heide. *Cinema in Democratizing Germany: Reconstructing National Identity After Hitler*. Chapel Hill: University of North Carolina Press, 1995.

"Film Criticism in the Age of the Internet: A Critical Symposium." *Cineaste* 33.4 (2008): 30-46.

"Film Criticism in the Lay Press" [1911]. In *American Film Criticism: From the Beginnings to Citizen Kane*, ed. Stanley Kauffmann with Bruce Henstell, 50-2. Westport, CT: Greenwood Press, 1979. Originally published in *Moving Picture World*, 20 May 1911.

"Flixster." *Wikipedia*. Accessed 25 April 2013. http://en.wikipedia.org/wiki/Flixster.

Freeburg, Victor Oscar. *The Art of Photoplay Making*. New York: Macmillan, 1918.

Freeburg, Victor Oscar. *Pictorial Beauty on the Screen*. New York: Macmillan, 1923.

Frey, Mattias. "Critical Questions." In *Film Criticism in the Digital Age*, ed. Mattias Frey and Cecilia Sayad. New Brunswick, NJ: Rutgers University Press, 2015.

Frey, Mattias. "Cultural Problems of Classical Film Theory: Béla Balázs, 'Universal Language' and the Birth of National Cinema." *Screen* 51.4 (2010): 324-40.

Friedman, Lester D. *Bonnie and Clyde*. London: British Film Institute, 2000.

Gabler, Neal. "Everyone's a Critic Now." *Observer*, 30 January 2011. Accessed 16 July 2013. http://www.theguardian.com/culture/2011/jan/30/critics-franzen-freedom-social-network.

Gans, Herbert J. *Popular Culture and High Culture: An Analysis and Evaluation of Taste*. 2nd rev. ed. New York: Basic Books, 1999.

"Geschichte der Filmkunst." *Filmkritik* 1.2 (1957): n.p.

Gilliatt, Penelope. "The Party." *New Yorker*, 19 August 1967, 77-9.

Gitlin, Todd. *The Sixties: Years of Hope, Days of Rage*. New York: Bantam, 1987.

Gold, Ronald. "Crowther's 'Bonnie'-Brook Rap at Violence Stirs Brouhaha." *Variety*, 30 August 1967, 5, 28.

Goldstein, Patrick. "Are They Still Relevant? Everyone's a Critic." *Los Angeles Times*, 8 April 2008. Accessed 25 May 2014. http://articles.latimes.com/2008/apr/08/entertainment/et-goldstein8.

Goldstein, Patrick. "Commentary: TV Film Critics Go for the Glitz. Roll Clip, Please." *Los Angeles Times*, 3 January 1988. Accessed 6 August 2013. http://articles.latimes.com/1988-01-03/entertainment/ca-32442_1_tv-critics.

Grafe, Frieda. "Diskussion: Zum Selbstverständnis der *Filmkritik*." *Filmkritik* 10.10 (1966): 588.

Gregor, Ulrich. "The German Film in 1964: Stuck at Zero." Trans. Marigay Graña. *Film Quarterly* 18.2 (1964): 7-21.

Grimond, Jo. *The Liberal Challenge*. London: Hollis & Carter, 1963.

Haas, Willy. "Film Resümee 1922/23." *Das blaue Heft* 4 (1922-1923): 447-9.

Haas, Willy. "Sprechbühne und Lichtbildbühne: Brief eines Filmwesens an ein Theaterwesen" [1921]. In *Kino-Debatte: Texte zum Verhältnis von Literatur und Film 1909-1929*, ed. Anton Kaes, 153-5. Tübingen: Niemeyer, 1978. Originally published in the *Prager Presse*, 15 May 1921.

Habermas, Jürgen. "Further Reflections on the Public Sphere." In *Habermas and the Public Sphere*, ed. Craig Calhoun, 421-61. Cambridge, MA: MIT Press, 1992.

Habermas, Jürgen. *The Structural Transformation of the Public Sphere: An Inquiry into a Category of Bourgeois Society*. Trans. Thomas Burger with Frederick Lawrence. Cambridge, MA: MIT Press, 1989.

Haberski, Raymond J. *It's Only a Movie! Films and Critics in American Culture*. Lexington: University Press of Kentucky, 2001.

Häfker, Hermann. *Kino und Kunst*. Mönchengladbach: Volksverein Verlag, 1913.

Hague, Barry N., and Brian D. Loader, eds. *Digital Democracy: Discourse and Decision Making in the Information Age*. London: Routledge, 1999.

Hake, Sabine. *The Cinema's Third Machine: Writing on Film in Germany 1907-1933*. Lincoln: University of Nebraska Press, 1993.

Hamburger, Ludwig. "Zur Frage: 'Filmkritik.'" *Die Lichtbild-Bühne*, 6 June 1914, 14.

Hamilton, Clayton. "The Screen." *Theatre*, January 1923, 34, 54.

Hardekopf, Ferdinand. "Die Karriere des Kinematographen." *Münchner Neuste Nachrichten*, 28 November 1910, 2.

Harris, Mark. *Pictures at a Revolution: Five Movies and the Birth of the New Hollywood*. New York: Penguin, 2008.

Harrison, Louis Reeves. "The Art of Criticism." In *American Film Criticism: From the Beginnings to Citizen Kane*, ed. Stanley Kauffmann with Bruce Henstell, 72-4. Westport, CT: Greenwood, 1979.

Harrison, Louis Reeves. "Mr. Lowbrow." *Moving Picture World*, 7 October 1911, 2.

Hasan, Irshad-ul. *Criticism in Crisis*. Lahore: Progressive Publishers, 1992.

Hauptmann, Carl. "Film und Theater." In *Kino-Debatte: Texte zum Verhältnis von Literatur und Film 1909-1929*, ed. Anton Kaes, 123-30. Tübingen: Niemeyer, 1978.

"'Heat' Mighty 127G on Big B'way; 'Beach' Brisk 22G, 'Enter' $41,500; 'Park' – Stageshow Record 200G, 12th." *Variety*, 16 August 1967, 13.

Heller, Heinz B. "Massenkultur und ästhetische Urteilskraft: Zur Geschichte und Funktion der deutschen Filmkritik vor 1933." In *Die Macht der Filmkritik: Positionen und Kontroversen*, ed. Norbert Grob and Karl Prümm, 25-44. Munich: edition text + kritik, 1990.

Hembus, Joe. "Der Film und die deutschen Illustrierten." *Filmkritik* 6.4 (1962): 158-60.

Herbst-Meßlinger, Karin. "Der Kritiker als Intellektueller." In *Herbert Ihering: Filmkritiker*, ed. Rolf Aurich and Wolfgang Jacobsen, 13-67. Munich: edition text + kritik, 2011.

Hess, John, Chuck Kleinhans, and Julia Lesage. "The Last Word: Fretting about Film Criticism." *Jump Cut* 52 (2010). Accessed 25 September 2014. http://www.ejumpcut.org/archive/jc52.2010/lastWordCriticism/index.html.

Hindberg, Matthew. *The Myth of Digital Democracy*. Princeton, NJ: Princeton University Press, 2008.

Holbrook, Morris B. "Popular Appeal versus Expert Judgments of Motion Pictures." *Journal of Consumer Research* 26.2 (1999): 144-55.

"Holiday Hypos L.A.; 'Twice' Smash 285G in 23 Sites, 'Clyde' Wow 29G, 2d, 'Family Way' Torrid $18,000, 3d." *Variety*, 6 September 1967, 9.

Houston, Penelope. *The Contemporary Cinema*. Harmondsworth: Penguin, 1963.

Houston, Penelope. "The Critical Question." *Sight and Sound* 29.4 (1960): 160-5.

Houston, Penelope. "The Festivals." *Sight and Sound* 28.3-4 (1959): 137-43.

Houston, Penelope. "Pauline Kael." *Guardian*, 5 September 2001. Accessed 5 August 2013. http://www.theguardian.com/news/2001/sep/05/guardianobituaries.arts1.

Hull, David Stewart. "Correspondence & Controversy: German Cinema." *Film Quarterly* 19.1 (1965): 64.

Hull, David Stewart. *Film in the Third Reich: A Study of the German Cinema, 1933-1945*. Berkeley: University of California Press, 1969.

Ihering, Herbert. "Filme und Filmkritik" [1923]. In *Herbert Ihering: Filmkritiker*, ed. Rolf Aurich and Wolfgang Jacobsen, 77-8. Munich: edition text + kritik, 2011. Originally published in the *Berliner Börsen-Courier*, 21 January 1923.

Ihering, Herbert. "Der Volksverband für Filmkunst" [1928]. In *Herbert Ihering: Filmkritiker*, ed. Rolf Aurich and Wolfgang Jacobsen, 78-80. Munich: edition text + kritik, 2011. Originally published in the *Berliner Börsen-Courier*, 27 February 1928.

Ihering, Herbert. "Zwischen Plüsch und Kelchesrand" [1932]. In *Herbert Ihering: Filmkritiker*, ed. Rolf Aurich and Wolfgang Jacobsen, 90-1. Munich: edition text + kritik, 2011. Originally published in the *Berliner Börsen-Courier*, 16 April 1932.

Indiana, Gary. "Critical Condition." *Artforum* 40.7 (2002): 126, 154.

"International Sound Track." *Variety*, 4 October 1967, 26.

Itzkoff, Dave. "Rotten Tomatoes Halts Comments on 'Dark Knight.'" *New York Times*, 17 July 2012. Accessed 25 April 2013. http://artsbeat.blogs.nytimes.com/2012/07/17/rotten-tomatoes-halts-reader-comments-amid-dark-knight-furor/.

James, Nick. "Rip It Up: Revitalizing Film Criticism." *Film Quarterly* 62.3 (2009): 14-15.

James, Nick. "Who Needs Critics?" *Sight and Sound*, October 2008, 16.

Jarvie, Ian. "Comeback." *Film* 28 (1961): 18.

Jarvie, Ian. "Preface to Film Criticism." *Film* 25 (1960): 13.

Jones, Janet, and Lee Salter. *Digital Journalism*. Los Angeles: Sage, 2012.

Kael, Pauline. *The Age of Movies: Selected Writings of Pauline Kael*, ed. Sanford Schwartz. New York: Library of America: 2011.

Kael, Pauline. "Bonnie and Clyde." *New Yorker*, 21 October 1967, 147-71.

Kael, Pauline. "Circles and Squares." *Film Quarterly* 16.3 (1963): 12-26.

Kael, Pauline. *I Lost It at the Movies*. Boston: Little, Brown, 1965.

Kael, Pauline. "Is There a Cure for Film Criticism? Or: Some Unhappy Thoughts on Siegfried Kracauer's *Nature* [sic] *of Film*." *Sight and Sound* 31.2 (1962): 56–64.

Kaes, Anton. "Einführung." In *Kino-Debatte: Texte zum Verhältnis von Literatur und Film 1909-1929*, ed. Anton Kaes, 1-36. Tübingen: Niemeyer, 1978.

Kaes, Anton, ed. *Kino-Debatte: Texte zum Verhältnis von Literatur und Film 1909-1929*. Tübingen: Niemeyer, 1978.

Kallay, Jasmina. "The Critic Is Dead ..." *Film Ireland*, September-October 2007, 26-7.

Kammen, Michael. *The Lively Arts: Gilbert Seldes and the Transformation of Cultural Criticism in the United States*. New York: Oxford University Press, 1996.

Kehr, Dave. *When Movies Mattered: Reviews from a Transformative Decade*. Chicago: University of Chicago Press, 2011.

Kellow, Brian. *Pauline Kael: A Life in the Dark*. New York: Viking, 2011.

"Kinematographische Bilder I." *Der Kinematograph*, 13 January 1907, n.p.

Koch, Gertrud. "Rudolf Arnheim: The Materialist of Aesthetic Illusion – Gestalt Theory and Reviewer's Practice." *New German Critique* 51 (1990): 164-78.

Kompridis, Nikolas. "Crisis and Critique." In *Critique and Disclosure: Critical Theory between Past and Future*, 3-8. Cambridge, MA: MIT Press, 2006.

Koselleck, Reinhart. *Critique and Crisis: Enlightenment and the Pathogenesis of Modern Society*. Trans. Berg Publishers Ltd. Cambridge, MA: MIT Press, 1988.

Koselleck, Reinhart. "Some Questions Concerning the Conceptual History of 'Crisis.'" In *Culture and Crisis: The Case of Germany and Sweden,* ed. Nina Witoszek and Lars Trägårdh, 12-23. New York: Berghahn, 2002.

Kracauer, Siegfried. *From Caligari to Hitler: A Psychological History of the German Film.* Princeton, NJ: Princeton University Press, 1947.

Kracauer, Siegfried. "Letter to the Editors of *film 56.*" Trans. Johannes von Moltke. In *Siegfried Kracauer's American Writings: Essay on Film and Popular Culture,* ed. Johannes von Moltke and Kristy Rawson, 226. Berkeley: University of California Press, 2012. Originally published in *film 56* 3 (1956): 155.

Kracauer, Siegfried. "The Little Shopgirls Go to the Movies" [1927]. In *The Mass Ornament: Weimar Essays,* trans. and ed. Thomas Y. Levin, 291-304. Cambridge, MA: Harvard University Press, 1995. Originally published as "Freie Bahn," *Frankfurter Zeitung,* 11 March 1927.

Kracauer, Siegfried. "The Task of the Film Critic" [1932]. In *The Weimar Republic Sourcebook,* ed. Anton Kaes, Martin Jay, and Ed Dimendberg, 634-5. Berkeley: University of California Press, 1994. Originally published as "Über die Aufgabe des Filmkritikers," *Frankfurter Zeitung,* 23 May 1932.

Krupnick, Mark. *Lionel Trilling and the Fate of Cultural Criticism.* Evanston, IL: Northwestern University Press, 1986.

Kuhlbrodt, Dietrich. "Und morgen Veit Harlan?" *Filmkritik* 8.8 (1964): 395.

Kundnani, Hans. *Utopia or Auschwitz: Germany's 1968 Generation and the Holocaust.* London: Hurst, 2009.

Kürschner, Eugen. "Zur Kritik und Aesthetik des Films." *Die Lichtbild-Bühne,* 4 April 1914, 40.

Kurtz, Howard. "Media Notes: Are Newspaper Critics Old Hat Amid the Flood of Online Critics?" *Washington Post,* 12 April 2010. Accessed 17 May 2013. http://www.washingtonpost.com/wp-dyn/content/article/2010/04/11/AR2010041103215.html.

Kuttner, Alfred. "A Question of Faith." *Exceptional Photoplays,* October 1923, 6.

Lambert, Gavin. "The Cobweb." *Sight and Sound* 25.4 (1956): 197.

Landry, Robert J. "Montreal Discovers H'Wood: Glamor Opening, Next Day Blah." *Variety,* 9 August 1967, 5.

Lant, Antonia, ed. *Red Velvet Seat: Women's Writing on the First Fifty Years of Cinema.* London: Verso, 2006.

Laroche. "Die Kinokritik." *Der Kritiker* 1.25 (1919): 9-10.

"L.A. Trade Soars; 'Heat' Sockeroo $39,000, 'Clyde' Record 28G, 'Trip' Mighty 16G; 'Dozen' Beefy 30G, 9th." *Variety,* 30 August 1967, 11.

"Lebensläufe." *Filmkritik* 9.4 (1965): 236-9.

Lejeune, C.A. *Cinema.* London: Alexander Maclehouse, 1931.

Lejeune, C.A. "Me to Myself." *Theatre Arts Monthly,* February 1939, 82-3.

Lejeune, C.A. *Thank You For Having Me.* London: Hutchinson, 1964.

Lejeune, C.A. "The Week on the Screen: Qualities of the Good Lay Critic." *Manchester Guardian,* 4 February 1922, 7.

Lenk, Sabine. *Théâtre contre Cinéma: Die Diskussion um Kino und Theater vor dem Ersten Weltkrieg in Frankreich.* Münster: MAkS, 1989.

Lennon, Elaine. "Riding the New Wave: The Case of *Bonnie and Clyde.*" *Senses of Cinema* 38 (2006). Accessed 2 August 2013. http://sensesofcinema.com/2006/feature-articles/bonnie_and_clyde/.

Lenssen, Claudia. "Der Streit um die politische und die ästhetische Linke in der Zeitschift *Filmkritik*: Ein Beitrag zu einer Kontroverse in den sechziger Jahren." In *Die Macht der Filmkritik: Positionen und Kontroversen*, ed. Norbert Grob and Karl Prümm, 63-79. Munich: edition text + kritik, 1990.

Lenz-Levy, Paul. "Die Eröffnung des neuen großen 'Union-Theaters' in Berlin." *Die Lichtbild-Bühne*, 9 September 1909, 752.

"Leserzuschriften." *Filmkritik* 9.5 (1965): 296.

"Leserzuschriften." *Filmkritik* 10.6 (1966): 354.

Levinson, Jerrold. "Artistic Worth and Personal Taste." *Journal of Aesthetics and Art Criticism* 68.3 (2010): 225-33.

Levy, Emanuel. "Art Critics and Art Publics: A Study in the Sociology and Politics of Taste." *Empirical Studies of the Arts* 6 (1988): 127-48.

Lichtenstein, Alfred. "Retter des Theaters" [1913]. In *Kino-Debatte: Texte zum Verhältnis von Literatur und Film 1909-1929*, ed. Anton Kaes, 82-3. Tübingen: Niemeyer, 1978. Originally published in *Die Aktion*, 29 November 1913.

Linder, Herbert. "Godard – Instinkt und Reflexion." *Filmkritik* 10.3 (1966): 125-38.

Lindsay, Vachel. *The Art of the Moving Picture*. New York: Liveright, 1970 [1915, 1922].

Lopate, Phillip. *Totally, Tenderly, Tragically: Essays and Criticism from a Lifelong Affair with the Movies*. New York: Anchor, 1988.

Lounsbury, Myron. *The Origins of American Film Criticism, 1909-1939*. New York: Arno Press, 1973.

Low, Rachel, and Roger Manvell. *The History of the British Film, Volume 1 1896-1906*. London: George Allen & Unwin, 1973.

Lukács, Georg. "Gedanken zu einer Ästhetik des Kinos" [1913]. In *Kino-Debatte: Texte zum Verhältnis von Literatur und Film 1909-1929*, ed. Anton Kaes, 112-18. Tübingen: Niemeyer, 1978.

MacDonald, Richard. "Screening Classics: Film Appreciation Canons and the Post-War Film Societies." In *Movies on Home Ground: Explorations in Amateur Cinema*, ed. Ian Craven, 208-36. Newcastle upon Tyne: Cambridge Scholars Publishing, 2009.

Mann, Alfred. "Kino-Rezensionen in der Tages-Presse." *Ethische Kultur* 14 (1913): 109-10.

Marcorelles, Louis. "Interview with Roger Leenhardt and Jacques Rivette." *Sight and Sound* 32.4 (1963): 168-81.

Marcorelles, Louis. "Paris nous Appartient." *Sight and Sound* 28.1 (1958-1959): 34.

Marcus, Laura. *The Tenth Muse: Writing about Cinema in the Modernist Period*. Oxford: Oxford University Press, 2007.

McDonald, Rónán. *The Death of the Critic*. London: Continuum, 2007.

McKee, Alan. *The Public Sphere: An Introduction*. Cambridge: Cambridge University Press, 2005.

Means, Sean P. "The Departed – No. 55, Phil Villareal." *The Salt Lake Tribune*, 7 May 2009. Accessed 2 October 2013. http://blogs.sltrib.com/movies/labels/disappearing%20critics.htm.

Meltzer, Kimberly. "The Hierarchy of Journalistic Cultural Authority: Journalists' Perspectives According to News Medium." *Journalism Practice* 3.1 (2009): 59-74.

Mendelsohn, Daniel. "A Critic's Manifesto." *New Yorker*, 28 August 2012. Accessed 12 August 2013. http://www.newyorker.com/online/blogs/books/2012/08/a-critics-manifesto.html.

Michael, John. *Anxious Intellectuals: Academic Professionals, Public Intellectuals, and Enlightenment Values*. Durham, NC: Duke University Press, 2000.

Michelson, Annette. "Eco and Narcissus." *Artforum* 40.7 (2002): 128, 165.

Miller, Henry K., ed. *The Essential Raymond Durgnat*. London: British Film Institute and Palgrave Macmillan, 2014.

Morella, Joe, and Edward Z. Epstein. *Rebels: The Rebel Hero in Films*. New York: Citadel Press, 1971.

Morgan, James. "Books and Magazines." *Sight and Sound* 24.3 (1955): 161.

Mosco, Vincent. *The Digital Sublime: Myth, Power, and Cyberspace*. Cambridge, MA: MIT Press, 2004.

"National Boxoffice Survey." *Variety*, 30 August 1967, 5.

"National Boxoffice Survey." *Variety*, 13 September 1967, 4.

"National Boxoffice Survey." *Variety*, 4 October 1967, 5.

"National Boxoffice Survey." *Variety*, 11 October 2013, 7.

"National Boxoffice Survey." *Variety*, 18 October 1967, 7.

"National Boxoffice Survey." *Variety*, 25 October 1967, 7.

"National Boxoffice Survey." *Variety*, 1 November 1967, 4.

"National Boxoffice Survey." *Variety*, 8 November 1967, 10.

"News Corp. Acquires IGN for $650 million." *Bloomberg Businessweek*, 10 September 2005. Accessed 21 March 2013. http://www.businessweek.com/stories/2005-09-10/news-corp-dot-acquires-ign-for-650-million.

"Newsweek Reverses 'Bonnie' Stand: Calls First Review 'Grossly Unfair.'" *Variety*, 30 August 1967, 5, 24.

Nowell-Smith, Geoffrey. "The Rise and Fall of Film Criticism." *Film Quarterly* 62.1 (2008): 10-11.

Nowell-Smith, Geoffrey, and Christophe Dupin, eds. *The British Film Institute, the Government, and Film Culture, 1933-2000*. Manchester: Manchester University Press, 2012.

N. W. Ayer and Son's Directory Newspapers and Periodicals 1967. Philadelphia: Ayer Press, 1967.

"N.Y. Biz Still Strong; 'Flim Flam' Fancy $38,000, 'Trip' Lively 27G; 'Staircase' 240G; 'Heat' Wow 93G." *Variety*, 30 August 1967, 11.

O'Hara, Daniel T. *Lionel Trilling: The Work of Liberation*. Madison: University of Wisconsin Press, 1988.

Orr, Gillian. "Movie Posters: 'Great Film!' – Dave from the Internet." *Independent*, 9 January 2013. Accessed 21 April 2013. http://www.independent.co.uk/arts-entertainment/films/news/movie-posters-great-film–dave-from-the-internet-8444967.html.

Owczarski, Kimberly. "From Austin's Basement to Hollywood's Back Door: The Rise of Ain't It Cool News and Convergence Culture." *Journal of Film and Video* 64.3 (2012): 3-20.

"Oz the Great and Powerful – Movie Forum – Rotten Tomatoes." *Rotten Tomatoes*. Accessed 25 April 2013. http://www.rottentomatoes.com/m/oz_the_great_and_powerful//forum/?threadid=328154726.

Papacharissi, Zizi. *A Private Sphere: Democracy in the Digital Age*. Cambridge: Polity, 2010.

Patalas, Enno. "A Bout de Souffle [*sic*]." *Filmkritik* 4.5 (1960): 129-30.

Patalas, Enno. "Anders als du und ich (§ 175)." *Filmkritik* 1.12 (1957): n.p.

Patalas, Enno. "Brief der Redaktion." *Filmkritik* 9.4 (1965): 178.

Patalas, Enno. "Die Chance." *Filmkritik* 6.4 (1962): 146-50.

Patalas, Enno. "Dr. K. erobert Venedig." *Filmkritik* 10.10 (1966): 547.

Patalas, Enno. "The German Waste Land." *Sight and Sound* 26.1 (1956): 24-7.

Patalas, Enno. "Liebe Filmkritik-Leser!" *Filmkritik* 10.2 (1966): n.p.

Patalas, Enno. "Perspektiven." *Filmkritik* 10.12 (1966): 705.

Patalas, Enno. "Plädoyer für die Ästhetische Linke: Zum Selbstverständnis der *Filmkritik* II." *Filmkritik* 10.7 (1966): 403-7.

Patalas, Enno. "Reise in die Vergangenheit." *Filmkritik* 9.11 (1965): 649.

Patalas, Enno. "*Ugetsu – Erzählungen unter dem Regenmond (Ugetsu Monogatari)*." *Filmkritik* 4.1 (1960): 22.

Patalas, Enno. "Von Caligari bis Canaris: Autorität und Revolte im deutschen Film." *film 56* 2 (1956): 56-66.

Patalas, Enno. "Wie kann man Hawksianer sein?" *Filmkritik* 10.5 (1966): 290.

Patalas, Enno, and Wilfried Berghahn. "Gibt es eine linke Kritik?" *Filmkritik* 5.3 (1961): 131-5.

Patalas, Enno, Theodor Kotulla, and Heinz Ungureit. "Panorama 1955." *film 56* 1 (1956): 2.

"Periodicals." *Sight and Sound* 26.4 (1957): 220.

Phillips, John. *Contested Knowledge: A Guide to Critical Theory.* London: Zed Books, 2000.

Pinthus, Kurt. "Quo vadis – Kino? Zur Eröffnung des Königspavillon-Theaters" [1913]. In *Kino-Debatte: Texte zum Verhältnis von Literatur und Film 1909-1929*, ed. Anton Kaes, 72-5. Tübingen: Niemeyer, 1978. Originally published in *Leipziger Tageblatt*, 25 April 1913.

Potamkin, Harry Alan. "The Plight of the European Movie" [1927]. In *The Compound Cinema: The Film Writings of Harry Alan Potamkin*, ed. Lewis Jacobs, 273-8. New York: Columbia University Press, 1977. Originally published in the *National Board of Review Magazine*, December 1927.

"The Press and the Moving Picture" [1909]. In *American Film Criticism: From the Beginnings to Citizen Kane*, ed. Stanley Kauffmann with Bruce Henstell, 24-5. Westport, CT: Greenwood, 1972. Originally published in *Moving Picture World*, 20 March 1909.

Putnam, Robert. *Bowling Alone: The Collapse and Revival of American Community.* New York: Simon & Schuster, 2000.

Quirk, James. "Art and Democracy." *Photoplay Magazine*, April 1918, 19.

Radcliffe, Cyril J. *Report of the Committee on the British Film Institute: Presented by the Lord President of the Council to Parliament by Command of His Majesty.* London: HMSO, 1948.

Regel, Helmut. "Zur Topographie des NS-Films." *Filmkritik* 10.1 (1966): 5-22.

Reinstein, David A., and Christopher M. Snyder. "The Influence of Expert Reviews on Consumer Demand for Experience Goods: A Case Study of Movie Critics." *Journal of Industrial Economics* 53.1 (2005): 27-51.

Rentschler, Eric. "American Friends and New German Cinema: Patterns of Reception." *New German Critique* 24-25 (1981-1982): 7-35.

Rentschler, Eric. "Kracauer, Spectatorship and the Seventies." In *Culture in the Anteroom: The Legacies of Siegfried Kracauer*, ed. Gerd Gemünden and Johannes von Moltke, 61-75. Ann Arbor: University of Michigan Press, 2012.

Rentschler, Eric. "Rudolf Arnheim's Early Passage between Social and Aesthetic Film Criticism." In *Arnheim for Film and Media Studies*, ed. Scott Higgins, 51-68. New York: Routledge, 2011.

Rich, Frank. "Roaring at the Screen With Pauline Kael." *New York Times*, 27 October 2011. Accessed 2 August 2013. http://www.nytimes.com/2011/10/30/books/review/roaring-at-the-screen-with-pauline-kael.html?pagewanted=all&_r=0.

Rivette, Jacques. "The Genius of Howard Hawks." Trans. Russell Campbell and Marvin Pister. In *Cahiers du Cinéma Volume 1 The 1950s: Neo Realism, Hollywood, New Wave*, ed. Jim Hillier, 126-31. London: Routledge & Kegan Paul, 1985.

Rivette, Jacques. "Jacques Rivette über Howard Hawks." *Filmkritik* 10.5 (1966): 291-4.

Rizov, Vadim. "Death to the Death of Film Criticism." *IFC*, 13 April 2010. Accessed 17 May 2013. http://www.ifc.com/fix/2010/04/death.

Roberts, Jerry. *The Complete History of American Film Criticism*. Santa Monica, CA: Santa Monica Press, 2010.

Roiphe, Katie. "With Clarity and Beauty, the Weight of Authority." *New York Times*, 31 December 2010. Accessed 25 May 2014. http://www.nytimes.com/2011/01/02/books/review/Roiphe-t-web.html?pagewanted=all&_r=0.

Rosenbaum, Jonathan. *Movie Wars: How Hollywood and the Media Conspire to Limit What Films We Can See*. Chicago: A Capella, 2000.

Ross, Andrew. *No Respect: Intellectuals and Popular Culture*. London: Routledge, 1989.

Ross, Stephanie. "Comparing and Sharing Advice: Reflections on Critical Advice." *Journal of Aesthetics and Art Criticism* 70.4 (2012): 363-71.

Rossmeier, Vincent. "Where Have All the Film Critics Gone?" *The Brooklyn Rail*, June 2008. Accessed 2 October 2013. http://brooklynrail.org/2008/06/express/where-have-all-the-film-critics-gone.

Rotha, Paul, Basil Wright, Lindsay Anderson, and Penelope Houston. "The Critical Issue." *Sight and Sound* 27.6 (1958): 270-9.

"Rotten Tomatoes: Certified Fresh." *Rotten Tomatoes*. Accessed 24 April 2013. http://www.rottentomatoes.com/help_desk/certified_fresh.php.

"Rottentomatoes.com Traffic and Demographic Statistics by Quantcast." *Quantcast*. Accessed 21 March 2013. https://www.quantcast.com/rottentomatoes.com.

"Rotten Tomatoes – Info: Facebook." *Facebook*. Accessed 24 April 2013. https://www.facebook.com/rottentomatoes/info.

"Rotten Tomatoes: Licensing." *Rotten Tomatoes*. Accessed 25 April 2013. http://www.rottentomatoes.com/help_desk/licensing.php.

"The Rotten Tomatoes Show." *Current*. Accessed 26 April 2013. http://current.com/shows/the-rotten-tomatoes-show/.

Roud, Richard. "The French Line." *Sight and Sound* 29.4 (1960): 166-71.

Roud, Richard. *A Passion for Films: Henri Langlois and the Cinémathèque Française*. New York: Viking, 1983.

Ryan, Paul. "Introduction: A Revolutionary Soldier." In Lindsay Anderson, *Never Apologise: The Collected Writings*, ed. Paul Ryan, 1-29. London: Plexus, 2004.

Ryan, Tim. "An Oral History of RT, Part One: The Beginning." *Rotten Tomatoes*, 23 June 2008. Accessed 23 April 2013. http://www.rottentomatoes.com/m/rumble_in_the_bronx/news/1736415/an_oral_history_of_rt_part_one_the_beginning/.

Ryan, Tim. "An Oral History of RT, Part Three: Ripe Tomatoes." *Rotten Tomatoes*, 15 July 2008. Accessed 23 April 2013. http://www.rottentomatoes.com/m/mean_girls/news/1736815/an_-oral_history_of_rt_part_three_ripe_tomatoes/.

Ryan, Tim. "An Oral History of RT, Part Two: Dotcom Daze." Rotten Tomatoes, 3 July 2008. Accessed 26 April 2013. http://www.rottentomatoes.com/m/e_dreams/news/1736808/an_oral_history_of_rt_part_two_dotcom_daze/.

Sadoul, Georges. "Notes on a New Generation." *Sight and Sound* 28.3-4 (1959): 111-17.

Sarris, Andrew. "The Auteur Theory and the Perils of Pauline." *Film Quarterly* 16.4 (1963): 26-33.

Sarris, Andrew. "Films." *Village Voice*, 24 August 1967, 21.

Sartre, Jean-Paul. *What Is Literature?* Trans. Bernard Frechtman. London: Methuen, 1967.

Schenk, Irmbert. "'Politische Linke' versus 'Ästhetische Linke': Zum Richtungsstreit der Zeitschrift 'Filmkritik' in den 60er Jahren." In *Filmkritik: Bestandsaufnahmen und Perspektiven*, ed. Irmbert Schenk, 43-73. Marburg: Schüren, 1998.

Schrader, Paul. "Fruitful Pursuits." *Artforum* 40.7 (2002): 129.

Schwartz, Sanford. "Introduction." In Pauline Kael, *The Age of Movies: Selected Writings of Pauline Kael*, ed. Sanford Schwartz, xi-xxiv. New York: Library of America: 2011.

Schweinitz, Jörg, ed. *Prolog vor dem Film: Nachdenken über ein neues Medium 1909-1914*. Leipzig: Reclam, 1992.

Scott, A.O. "A Critic's Place, Thumb and All." *New York Times*, 31 March 2010. Accessed 6 October 2012. http://www.nytimes.com/2010/04/04/movies/04scott.html?pagewanted=all&_r=0.

Seldes, Gilbert. *The 7 Lively Arts*. 2nd rev. ed. New York: Sagamore Press, 1957 [first edition 1924].

Seldes, Gilbert. "Complaint Against Critics: They Tell You What You Are and Where to Get Off." *Saturday Evening Post*, 1 June 1929, 18.

Seldes, Gilbert. "New York Chronicle." *The Criterion* 4.4 (1926): 733-40.

Seligman, Craig. *Sontag & Kael: Opposites Attract Me*. New York: Counterpoint, 2004.

Shepherd, Tamara. "Rotten Tomatoes in the Field of Popular Cultural Production." *Canadian Journal of Film Studies* 18.2 (2009): 26-44.

Sherwood, Robert E. "The Silent Drama: The Tenth Muse." *Life*, 27 January 1921, 142.

"The Shock of Freedom in Films." *Time*, 8 December 1967. Accessed 2 August 2013. http://www.time.com/time/magazine/article/0,9171,844256,00.html.

Shrum, Wesley. "Critics and Publics: Cultural Mediation in Highbrow and Popular Performing Arts." *American Journal of Sociology* 97.2 (1991): 347-75.

Siemsen, Hans. "Kino. Kritik. Und Kinokritik." *Die neue Schaubühne* 5 (1925): 34-40.

Siemsen, Hans. "Die Kritik." *Die Weltbühne* 23 (1927): 712-15.

Sitton, Robert. *Lady in the Dark: Iris Barry and the Art of Film*. New York: Columbia University Press, 2014.

"Smash-Hit Killers." *Observer*, 8 October 1967, 23.

Smith, Russ, and John Strausbaugh. "James Wolcott: A Q&A." *New York Press*, 24 April 2001. Accessed 5 August 2013. http://nypress.com/james-wolcotta-qa-by-russ-smith-john-strausbaugh/.

Smith, Scott. *The Film 100: A Ranking of the Most Influential People in the History of the Movies*. New York: Citadel Press, 1998.

Smoodin, Eric, and Ann Martin, eds. *Hollywood Quarterly: Film Culture in Postwar America, 1945-1957*. Berkeley: University of California Press, 2002.

"Soll das Filmdrama kritisiert werden?" *Erste Internationale Filmzeitung*, 19 October 1912, 21-4, 29-30.

Sorokin, Pitirim A. *The Crisis of Our Age*. Oxford: One World, 1992 [1941].

MATTIAS FREY

Sorokin, Pitirim A. *Social Philosophies of an Age of Crisis*. London: Adam & Charles Black, 1952.

Stalder, Helmut. *Siegfried Kracauer: Das journalistische Werk in der "Frankfurter Zeitung" 1921-1933*. Würzburg: Königshausen & Neumann, 2003.

Stam, Robert. *Film Theory: An Introduction*. Malden, MA: Blackwell, 2000.

Stanfield, Peter. "Maximum Movies: Lawrence Alloway's Pop Art Film Criticism." *Screen* 49.2 (2008): 179-93.

Stern, Laurent. "Voices of Critical Discourse." *Journal of Aesthetics and Art Criticism* 60.4 (2002): 313-23.

Sterritt, David. "Bonnie and Clyde." *Cineaste* 33.4 (2008): 63-4.

Sweney, Mark. "Warner Bros Buys Rotten Tomatoes Owner Flixster." *Guardian*, 4 May 2011. Accessed 21 March 2013. http://www.guardian.co.uk/media/2011/may/04/warner-bros-rotten-tomatoes-flixster.

Tannenbaum, Herbert. "Kino und Theater" [1912]. *Kinematograph* 4 (1987): 33-46.

Tannenbaum, Herbert. "Kunst im Kino" [1912]. *Kinematograph* 4 (1987): 47-8.

Taylor, Greg. *Artists in the Audience: Cults, Camp, and American Film Criticism*. Princeton, NJ: Princeton University Press, 1999.

Temple, Michael, and Karen Smolens, eds. *Decades Never Start on Time: A Richard Roud Anthology*. London: British Film Institute and Palgrave Macmillan, 2014.

Thiel, Reinhold E. "... und nichts als die Wahrheit." *Filmkritik* 2.10 (1958): n.p.

Thompson, Anne. "Crix' Cachet Losing Critical Mass." *Variety*, 7 April 2008, 12.

"Top/Ten." *Sight and Sound* 31.1 (1961-1962): 13.

Trilling, Lionel. *E.M. Forster*. 2nd rev. ed. New York: New Directions, 1964.

Trilling, Lionel. *The Liberal Imagination: Essays on Literature and Society*. London: Mercury, 1950.

Truffaut, François. "A Certain Tendency of the French Cinema." In *Movies and Methods, Volume I*, ed. Bill Nichols, 224-37. Berkeley: University of California Press, 1976.

Turvey, Malcolm. *Doubting Vision: Film and the Revelationist Tradition*. New York: Oxford University Press, 2008.

Ungern-Sternberg, Christoph von. *Willy Haas 1891-1973: "Ein großer Regisseur der Literatur."* Munich: edition text + kritik, 2006.

Vaughan, Dai, and Phillip Riley. "Letters from the Trenches." *Film* 27 (1961): 9-11.

Viertel, Berthold. "Das Kino." In *Kino-Debatte: Texte zum Verhältnis von Literatur und Film 1909-1929*, ed. Anton Kaes, 70-2. Tübingen: Niemeyer, 1978.

"W7's 'Bonnie & Clyde' 'Movie Month' Special." *Variety*, 27 September 1967, 22.

Wasson, Haidee. *Museum Movies: The Museum of Modern Art and the Birth of Art Cinema*. Berkeley: University of California Press, 2005.

Wasson, Haidee. "Writing the Cinema into Daily Life: Iris Barry and the Emergence of British Film Criticism in the 1920s." In *Young and Innocent? The Cinema in Britain 1896-1930*, ed. Andrew Higson, 321-37. Exeter: Exeter University Press, 2002.

Watts, Philip. "The Eloquent Image: The Postwar Mission of Film and Criticism." In *Opening Bazin: Postwar Film Theory and Its Afterlife*, ed. Dudley Andrew with Hervé Joubert-Laurencin, 215-24. Oxford: Oxford University Press, 2011.

Weigel, Herman. "Interview mit Leni Riefenstahl." *Filmkritik* 16.8 (1972): 395-410.

Weigel, Herman. "Randbemerkungen zum Thema." *Filmkritik* 16.8 (1972): 426-33.

West, Alick. *Crisis and Criticism*. London: Lawrence and Wishart, 1937.

White, Armond. "What We Don't Talk About When We Talk About Movies." *New York Press*, 30 April 2008. Accessed 17 May 2013. http://nypress.com/what-we-dont-talk-about-when-we-talk-about-movies.

"Who Are the Approved Tomatometer Critics?" *Flixster*. Accessed 23 April 2013. http://flixster.desk.com/customer/portal/articles/62675-who-are-the-approved-tomatometer-critics-.

Williams, Daniel G. *Ethnicity and Cultural Authority: From Arnold to Du Bois*. Edinburgh: Edinburgh University Press, 2006.

Wilson, David. "Introduction." In *Sight and Sound: A Fiftieth Anniversary Selection*, ed. David Wilson, 13-20. London: Faber and Faber, 1982.

Witoszek, Nina, and Lars Trägårdh. "Introduction." In *Culture and Crisis: The Case of Germany and Sweden*, ed. Nina Witoszek and Lars Trägårdh, 1-11. New York: Berghahn, 2002.

Wizisla, Erdmut. *Walter Benjamin and Bertolt Brecht – The Story of a Friendship*. Trans. Christine Shuttleworth. London: Libris, 2009.

Wolcott, James. *Lucking Out: My Life Getting Down and Semi-Dirty in Seventies New York*. New York: Doubleday, 2011.

Wolcott, James. "Waiting for Godard." *Vanity Fair*, April 1997, 46-53.

Woods, Frank. "Spectator's Comments." *Dramatic Mirror*, 23 October 1909, 14.

Woods, Frank. "Spectator's Comments." *Dramatic Mirror*, 24 January 1912, 32.

Wyatt, Robert O., and David P. Badger. "How Reviews Affect Interest in and Evaluation of Films." *Journalism Quarterly* 61 (1984): 874-8.

Yhcam. "La Cinématographie." *Ciné-Journal*, 11 May 1912, 9-16.

Zehder, Hugo, ed. *Die neue Bühne: Eine Forderung*. Dresden: Rudolf Kammerer, 1920.

Zenthner, Christoph. *Krise und Kritik*. Vienna: Passagen, 2013.

"Zum Selbstverständnis des Films I. Alain Resnais." *Filmkritik* 8.10 (1964): 508.

"Zur Uraufführung des Lindau-Bassermann-Films 'Der Andere.'" *Erste Internationale Film-Zeitung*, 1 February 1913, 24-5.

Index

FILM THEORY IN MEDIA HISTORY

Sarah Keller and Jason N. Paul (eds.)
Jean Epstein: Critical Essays and New Translations, 2012
ISBN 9789089642929

Mattias Frey
The Permanent Crisis of Film Criticism: The Anxiety of Authority, 2015
ISBN 9789089647177

Daniel Fairfax (trans. and ed.)
Jean-Louis Comolli. Cinema against Spectacle: Technique and Ideology Revisited, 2015
ISBN 9789089645548

Naum Kleiman and Antonio Somani (eds.)
Sergei M. Eisenstein: Notes for a General History of Cinema, Forthcoming 2015
ISBN 9789089648440

Printed and bound by CPI Group (UK) Ltd, Croydon, CR0 4YY